The HOME ARTIST

JANET ALLEN

JOHN HOLDEN

VAN NOSTRAND REINHOLD COMPANY
NEW YORK CINCINNATI TORONTO LONDON MELBOURNE

Published in 1979 by Van Nostrand Reinhold Company
A division of Litton Educational Publishing, Inc.
135 West 50th Street, New York, NY 10020, U.S.A.

The sale of this book outside of the United
States may violate copyright in country where
sold.

16 15 14 13 12 11 10 9 8 7 6 5 4 3 2 1

Library of Congress Cataloging in Publication Data

Allen, Janet.
 The complete home artist.

 1. Art—Technique. I. Holden, John,
 joint author.
II. Title.
N7430.A43 1979 751.4 79-9715
ISBN 0-442-24497-5

Contents

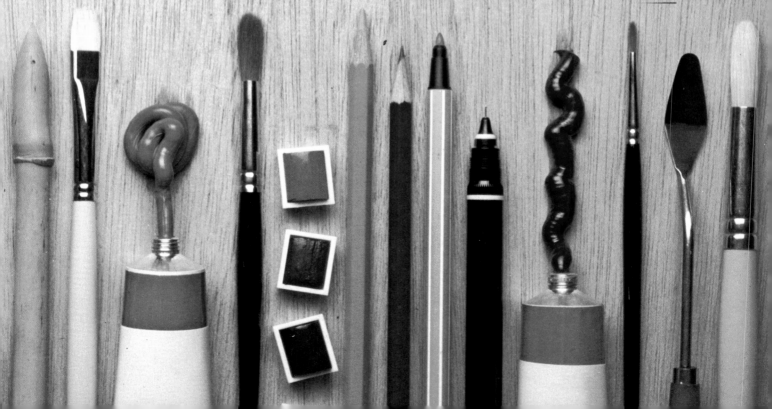

Foreword

The ability to draw and paint is one of the most joyful responses to the world about us, and is a vivid celebration of its abundance of colors, shapes and images. It is also a specifically human response, often conveying more than words the entire spectrum of our experience of life. A drawing or painting can appeal across the barriers of time and space with a language of its own – direct, immediate and alive. Every one of us has a latent sense of this language, a way of seeing which is too often buried and left unexpressed.

It is this vision that *The Home Artist* seeks to evoke and develop. If you are attempting a picture for the first time, you may feel a bewildering contradiction of feelings. On the one hand there is the excitement and curiosity of trying something new, and on the other the fear that you don't know how to begin. The authors' lively enthusiasm for their subjects will dispel any initial apprehensiveness however, and their practical approach quickly inspires confidence. *The Home Artist* is also helpful to the more advanced amateur, providing a wide range of technical skills, and opening the doors to alternative media.

The individual sections are self-contained, and cover the major areas of the visual arts, drawing, oils and watercolors. Since drawing is such a foundation skill it represents a natural starting-off place, but in fact you can begin anywhere. Each medium has its own special qualities, the precision of line, the richness of oils and the elusiveness of watercolors. These are explored in three teach-yourself projects – a self portrait in drawing, a still life in oils and a landscape in watercolors.

The Home Artist is beautifully illustrated with the works of famous artists and amateur students. They embrace a vast range of styles and traditions, and provide graphic examples of how to compose pictures, how to handle color, and how to use various brushes, pencils, pens, pastels and palette knives. They also supply an endless source of ideas for subject matter. In the final analysis however, it is individual self-expression which is important, and this is skillfully invoked, warmly encouraged and directed towards that irreplaceable satisfaction gained from achieving personal creativity.

Introduction

Any skill, be it an art, a craft or a sport, has a basic discipline—a set of guidelines. This applies to drawing too. The basics of drawing are examined here and shown not to be tedious, dreary rules, but the very foundations upon which your own personal drawing ability can develop. The different elements that constitute a drawing are explained and projects are suggested for you specifically to explore each of the elements and combinations of them.

Throughout the book drawings by artists of widely differing ages, experience and background are reproduced. Leonardo da Vinci, genius of the fifteenth century, appears alongside a first year art school student of the present day. We can, by all means, all learn and benefit by studying the drawings of the great masters. But their very appellation means that

The sketchbooks of John Constable are an excellent example of how an artist records his visual impressions for later use in a finished composition.

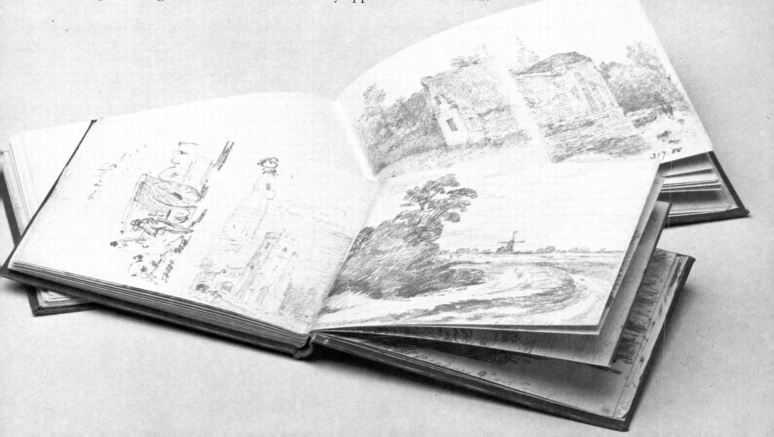

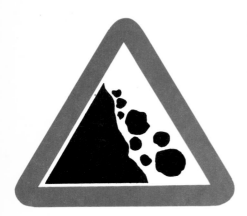

A warning road sign such as this is a fine example of how a drawing uses the most relevant details of a subject to convey a visual message quickly.

they are masters of the drawing art, highly skilled, highly advanced. You can often identify with and, therefore, glean useful help from seeing how someone nearer to your own stage of development has tackled problems very similar to those in which you yourself are at present involved.

What is the most straightforward way of conveying an idea to another person? To show him something. A picture of that thing conveys the idea without the need of that sophisticated device: language. A picture, a representation in two dimensions of something in the real three-dimensional world is universally understood.

Drawing is the most direct way of putting down ideas visually, and it is widely used as a note-making facility to record impressions of a scene or event to be developed later. Drawing is acknowledged as being the basis of all the visual arts.

Drawings are made for many, many reasons. Every artist, quite naturally, discriminates, selects and includes in his drawing those things which are relevant to its purpose. A warning road sign, showing a finely detailed rendering in eye-deceiving 3D of a cliff and a lump of rock falling from it, would leave the passing motorist confused and possibly buried under a heap of rubble—still trying to puzzle out just what that sign meant. Here immediate clarity is all important. What, in real life, is a very complex sight, must be simplified into a visual symbol that can instantly be understood. Conversely, the builder is not going to thank the architect who thought that, for artistic effect on his plans, it would be rather nice to fill in the whole of the south-facing side of a house in solid black.

Not only does the purpose for which the drawing is intended influence and shape its appearance, the 'handwriting' of the artist affects it too. No two people actually write in the same way. We settle down in school, at a tender age, to copy—in fact we are drawing—the shapes of the letters of the alphabet. Every single child will render them differently. By the time we are adult our handwriting styles, because of further outside influences, are diverse. It is just the same with drawing. Everyone, without trying, has his or her own style. So don't try to draw in the manner of somebody else. By all means study the techniques that others use but simply as a 'technical' study. When you then try out a particular kind of pen or pastel your style will come through anyway. Don't even think about cultivating a style; you've got one anyway.

Do remember that it is the doing of the drawing that is the important thing, not the end product. The end product will be interesting if interest has been maintained in the doing.

Anyone can take up drawing. It would appear that there are gifted people in the field of the visual arts as there are in music and languages. Perhaps, for some reason, they are especially aware and responsive to

things in a visual way. However, such people are few and far between and this certainly doesn't preclude others from studying and enjoying the subject.

Drawing seems to be a natural, automatic way of expressing oneself. All young children, from whatever cultural background, will draw unselfconsciously to convey to others what they think. A child may not arrange the things in his drawing in the way they actually appear. He may, for example, disregard a wall and draw the contents of a house and its rooms, detailing all the objects he knows to be there.

Regrettably, as we get older, we become increasingly concerned about whether or not the drawing looks like the object being portrayed; also, whether it looks like the type of drawing or painting we admire. The gulf between our perception of objects and our ability to represent them on paper widens. This, unfortunately, has a stultifying effect and usually results in the whole idea being abandoned. In so abandoning, not only

The spontaneity of a child's drawing is something that many artists admire as it precludes any laboured use of colour or form. What is seen in the mind's eye is quickly put down in the simplest terms.

do we jettison any attempts to draw, we also often discard the ability to observe—subsequently missing an enormous amount.

With a very few exceptions, the sort of life people in modern society lead means that the skills and pleasures of observing in order to draw are just simply not required. In the majority of jobs, objects—houses, plants, people, cups and saucers—become statistics. They are counted, tabulated, amassed and distributed—but hardly ever looked at. The kind of candid looking, which is observing to understand, as practised by the artist, is rarely required in everyday life. So it becomes irrelevant to existence. People behave rather as if wearing blinkers. They develop a high degree of proficiency in observing within certain strictly limited areas; outside those areas a dense fog persists. A mother, because of both familiarity and necessity, will instantly perceive any change in her child's appearance, an unaccustomed pallor will immediately alarm her. Yet, because it doesn't really matter to her, she won't be able to recall the shape of her brother's car. The railway ticket inspector will be

The Valley Thick with Corn, *Samuel Palmer. In this drawing pen, ink and wash were used to portray the rich texture of a country landscape.*

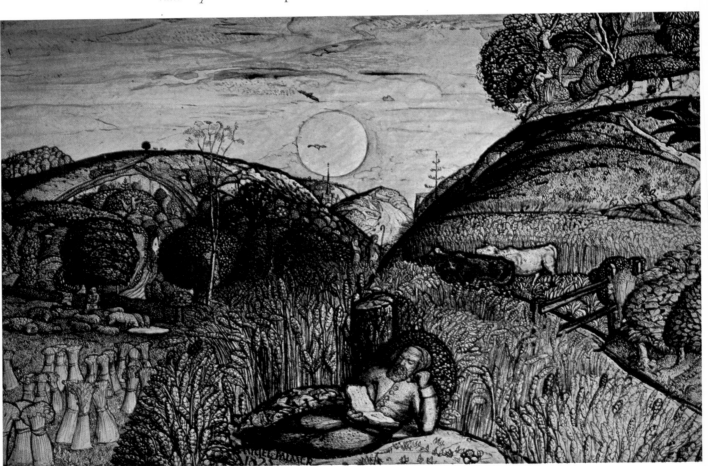

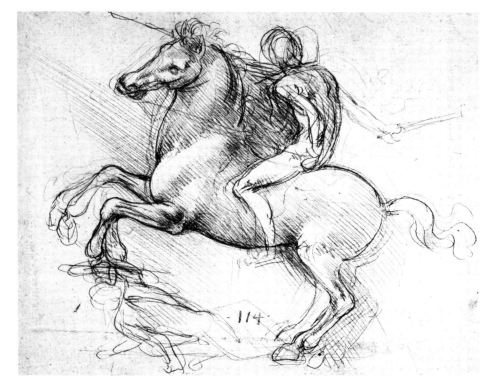

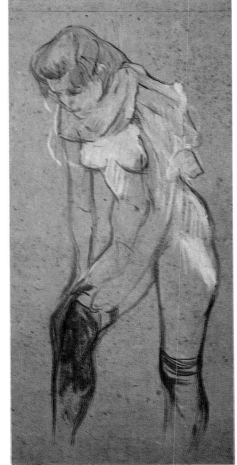

Left. Design for the Sforza Monument, *Leonardo da Vinci, crayon. The quick flowing lines and overdrawing capture the movement and posture of a horse and rider.*

Below. Woman Putting on her Stocking, *Henri de Toulouse Lautrec, pastel. Here quickly observed lines and areas of colour record the essentials of a scene in everyday life.*

intimately familiar with every detail of a ticket; but probably won't remember whether or not his neighbour, whom he passes daily, wears glasses.

Anyhow, in spite of what may seem a dismal situation, anyone can learn to draw. The most important prerequisite is an open mind. The basis of learning to draw is learning to observe in a perfectly straight-forward manner. In a way, it's as if you were to return to the childlike state. Of course, that is not possible for an adult, but the suggested projects in this book, which encourage you to look at particular visual aspects of an object, will help you to shed preconceived and irrelevant ideas. They will help you gradually to regain the confidence and enjoyment that the child has. The various projects will actually impose different sets of limits upon you. You will find that working within these limits, juggling around the cards you have been dealt, is infinitely more instructive and stimulating than being presented with the completely overwhelming choice of the entire pack—literally everything.

With drawing, as with any pursuit, to make progress you must work at it. Drawing is actually hard work. Any creative activity involves work. But it is work of an intensely absorbing kind; so different from your normal routine that you will find yourself completely refreshed after a really concentrated drawing session. Should you doubt the seriousness

of drawing try, if you ever have the opportunity, to look in on a life drawing class in an art college. Even in a large class the only sound to be heard is the scratching of many pencils on paper. The dedicated air of concentration equals that of any devoted chess player.

Once you've decided to take up drawing, however slow you feel your progress is at the beginning, you will find you have opened a door to a whole new exciting world of visual awareness. You'll never again see things in the same way. You may even feel that previously you didn't see them anyway. Never again will you be bored.

Look at these widely differing drawings. Consider the things being drawn—the subject matter. What do you draw? Anything and everything. There are no do's and don'ts. Look at all the different media that have been used, and see how the obvious delight in the materials comes across. All the styles are different, the materials are different, the cultural backgrounds and times when the drawings were made are different; but they all share the same essential quality—having something to say.

Woman and Child by the Sea, *Pablo Picasso, pencil. An immediate impression of people relaxing and playing on a beach is given through the use of line only.*

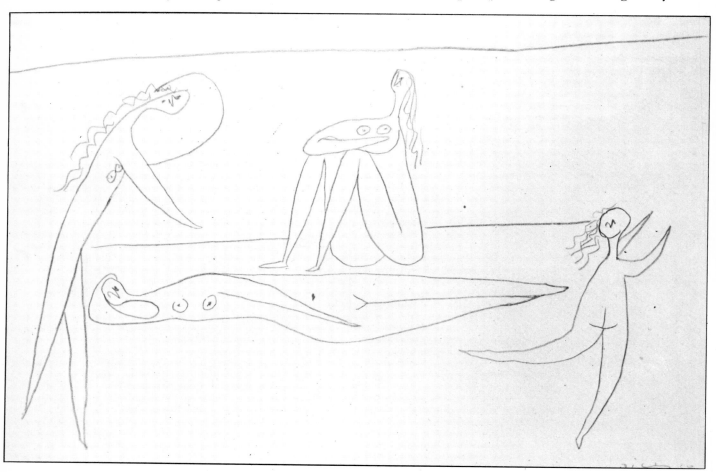

6

Materials

When you go into an art supply store you are confronted by a bewildering array of tempting-looking tools, materials, papers and boards. Generally there is no explanation of the way in which they are used or what they are used for. This chapter examines the vast range of drawing materials available, detailing their specific characters and discussing the ways in which they may be used.

As with all crafts, personal preference plays a large part. The tools and materials suggested here will give you a basis, enabling you to start work. Then you will have something by which to judge for yourself what you prefer to use. Do you, for instance, love the feel of a soft pencil on a heavily textured grey paper? Or is a sharp black pen line on a crisp white paper more to your taste?

Have a box or tin in which you keep your drawing kit. This means things are less likely to be mislaid (you can even hide the tin itself if you are plagued by borrowers); also, the tools will be protected and consequently will last longer.

Lead pencils

The wooden pencil, that most commonplace of writing and drawing implements, is manufactured with leads in many degrees of hardness and

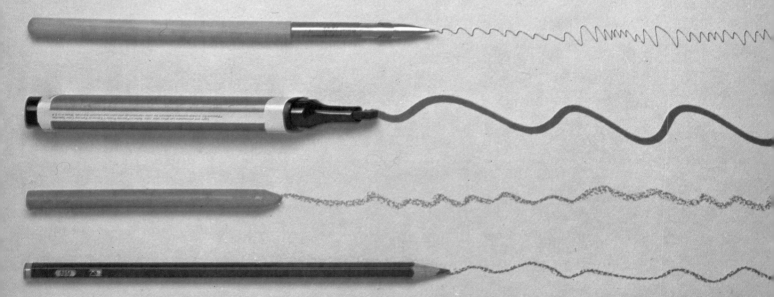

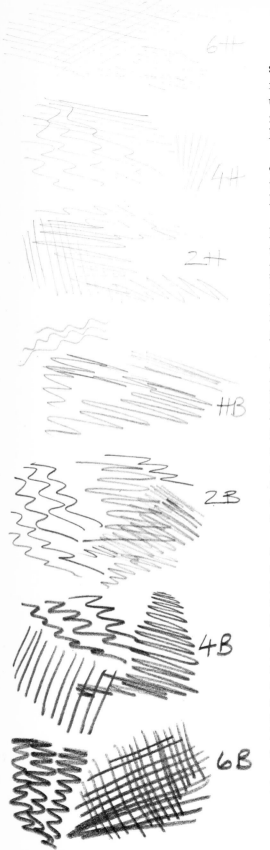

softness. There are also good and poor quality pencils—a fact directly related to their price. The lead in a cheap pencil may be gritty and unpleasant to use, sometimes even failing to make any mark at all. It might also have a tendency to break frequently, so it is worth paying a little extra to buy a reputable brand.

The lead of a pencil does not, in fact, contain any lead. It is a mixture of graphite dust, which makes the black marks, and clay, which carries the graphite dust. This mixture is highly fired so that the clay becomes like glass.

Pencils are graded by the letter H for hard, and B for black or soft. A hard pencil lead contains a high proportion of clay and a small proportion of graphite, so it produces a grey, not very dark, line. In a soft pencil the proportions of clay and graphite are reversed, resulting in a blacker line. Drawing pencils range as follows: 6H, 5H, 4H, 3H, 2H, H, HB, B, 2B, 3B, 4B, 5B, 6B. There are some further grades of pencil manufactured but these are for particular technical purposes, outside the general drawing use.

If possible, try out the pencils in the shop to get the feel of all the different grades before you buy. The HB is a medium, all-purpose pencil so you'll need one of these. The pencils at either extreme of the hardness/softness range are for specialized work. Using a 6H is rather like drawing with a needle, while a 6B gives a thick, broad black mark, inclined to smudge all over the place. Most useful as a start, in addition to an HB, are a 2B and a 2H. The 2B will acquaint you with the delightful responsiveness of a soft pencil, without being so smudgy and black that it gets out of control. Its very responsiveness encourages you to draw freely. The 2H demonstrates how controlled and fine a pencil-drawn line can be.

The type of paper on which you are working has a direct, and very obvious, effect upon the sort of mark your pencil will produce. To use an extreme example, a 6H on cheap shelf paper will simply shred the paper to ribbons. The suggested HB, 2B and 2H pencils will perform adequately on inexpensive drawing paper which is a sensible sort of paper to use for your first drawings.

It is very important to keep your pencil point really sharp, so when you are drawing always keep a craft knife or a sharp penknife handy. To maintain a really good point, every so often rub the lead on the striking edge of a matchbox or on a piece of fine sandpaper. (This is sold in convenient little blocks especially for this purpose.) Pencil sharpeners tend to devour pencils and they don't give such a good point as the knife and sandpaper method. Fig. 1 shows how to sharpen a pencil with a craft knife.

Don't draw with some ancient little pencil stub. Apart from it giving you no pleasure and pride of ownership, a longer pencil will give the

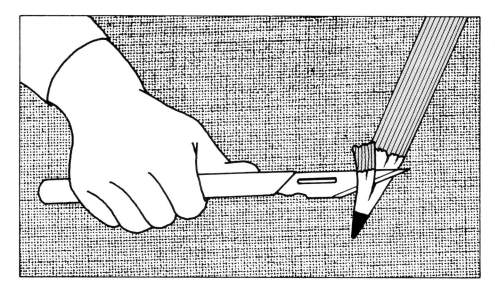

Fig. 1 Sharpening a pencil with a craft knife.

correct balance. The stub would soon make your hand ache.

There are several kinds of leadholders available which will take different grades of pencil or compressed charcoal lead. They are used with fine sandpaper for point sharpening. Rather than going to the expense of buying a leadholder and a selection of leads at the beginning, see first which grades of pencil you prefer. Then invest later if you feel a leadholder will be more convenient than conventional pencils.

When drawing you may find it helpful to keep a piece of plain scrap paper between your work and your drawing hand. This keeps the drawing clean, prevents the pencil lines being smudged and stops grease from your hand getting onto the paper (very relevant on a hot summer's day).

Erasers for pencil drawing
Some people feel that the eraser should be banned. A possible, and understandable, reason for that school of thought is that the nervous beginner will tend to rub out every line as it is drawn, because he or she lacks confidence and feels it must all be wrong. Rather than make yourself neurotic, have a rubber eraser available; but do consider before you employ it. Frequently one rubs out a line because it's felt to be incorrect, only to go and repeat it in exactly the same place. If you think you have drawn something wrongly, re-draw over it. Being able still to see the old incorrect lines will help you to make the new ones more accurate. If you want to, you can erase the mistakes afterwards.

A small, pliable eraser made of rubber or vinyl is suitable for most pencil work. The Blaisdell eraser is shaped like a pencil, the eraser forming the lead. You 'sharpen' it by peeling away a little of the paper strip

from which the casing is made. This is useful for erasing small sections on finely detailed work.

Certain pencils have a rubber tip—very convenient if you wish to carry as little equipment as possible, as when drawing outdoors. These eraser tips are supplied on a limited range of medium pencil grades, sometimes only on HB.

Charcoal

Charcoal is a most delightful and versatile medium but it does take a little time to become accustomed to it. Don't be discouraged if, at your first attempt, you feel you simply can't cope—all your carefully applied black drawing seems to have transferred from the paper onto you.

The answer to the smudging problem (whereby you're liable instantly to remove an hour's work with one careless sweep of the hand) is to cultivate a delicate touch. Your drawing hand should be held away from the paper. You may find this easier if you stand up to work with your drawing board supported on an easel.

Charcoal is made from carbonized lime, vine or, more commonly, willow twigs. It is available in different sizes, ranging from very thin sticks to thick chunks (scene painter's charcoal). There are soft and hard versions. As you draw it gives off a fine black dust—so don't wear your best clothes. It washes easily off the hands when you have finished work. If you are drawing in a seated position, a good plan is to fix a stiff paper trough along the bottom of the board to prevent you receiving a lap full of fine black powder.

Charcoal can be used for drawing lines—snap a stick to give you a sharp edge for delicate work—or for filling in masses. For the latter either draw repeated lines, or use the charcoal on its side. By varying the amount of pressure you apply you can achieve exceedingly delicate or tentative lines or heavy black masses. It is immensely versatile because of the wide range of light and dark it can encompass.

Wooden pencils are also made with hard and soft charcoal 'leads'. Because of their shape, they obviously produce a more limited range of marks than the conventional, simpler charcoal sticks.

With your finger you can intentionally smudge and smooth together parts of a drawing (you may like to keep a rag handy here). There is also

Below. Study in charcoal of a dancer at rest by Edgar Degas.

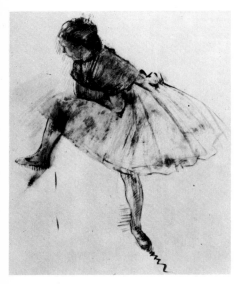

the agreeable prospect of being able to work back 'in reverse'—from black to white—by drawing with an eraser. An ordinary eraser will do but the best for any kind of drawing in a soft medium is the kneaded eraser. This is sometimes known as a putty rubber (as it resembles a lump of putty) and it can be moulded with the fingers into a point. You can use it to draw whites or greys into a previously filled-in black area. An alternative, and effective, eraser is a squashed-up piece of soft new white bread.

Coloured pencils

Coloured pencils are made in a similar way to lead pencils, except that pigments replace the graphite. They are produced in very many different

Royal Hawaiian Hotel, Honolulu, 1971, *David Hockney, coloured pencil.*

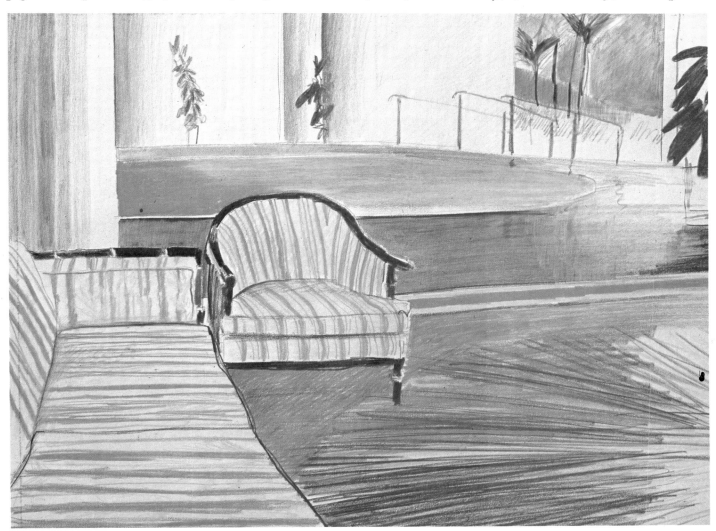

colours and in various degrees of hardness. Those with a hard 'lead' can be sharpened to a needle point for detailed drawing. These kinds of coloured pencil are non-smudging, so they do not require fixing. A disadvantage, in certain brands, is that the density of colour is rather poor and only pallid colours result, however hard you press. Once again, experiment, if possible, with the pencils before purchasing. Aim for those that are responsive to both a light and a heavier touch. Some brands of coloured pencil can be rubbed out with a pencil eraser.

Water-soluble coloured pencils

Some specially made coloured pencils can be used for a technique that is a mixture of drawing and watercolour painting: you wet the paper with a brush and clean water and draw into it with the pencils; or you can draw on dry paper and then apply water to create washes as you go along. The two methods may be combined.

For the best results use a good quality, somewhat textured paper. Any technique like this that involves dampening the paper and then drawing on it with a sharp instrument demands a tough surface. A poor quality paper would break down and possibly tear.

Wax crayon sticks

There is a wide selection of wax-type stick crayons on the market, varying greatly in size, colour range and brilliance, quality and price. They require no fixing and are very similar to coloured pencils.

Some newly-developed stick crayons are harder than the original wax type, do not melt and can easily be sharpened to a good point. Some may be erased with an ordinary eraser.

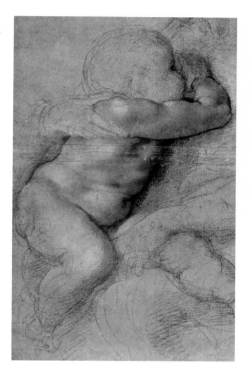

Above. Detail from Madonna and Child, *Michelangelo, chalk.*
Left. Doorway, *Alison Turnbull, pastel.*

Conté crayons

Conté crayon is a French-made refined type of compressed chalk. It is available in square stick form and in wood drawing pencils. There are several natural earth colours, and black and white. Both types of crayon are available in three different degrees of hardness. Conté is an extremely sensitive medium, capable of a wide range of lines and tones. In black it is a little harder and darker than charcoal and less smudgy. It has a special quality all its own. Fixative should be used on a Conté drawing.

The crayon stick may be used on its side to draw a large area of tone. As with charcoal, break the stick to give a sharp drawing end. Both sticks and pencils are rather delicate and they break easily so keep them in some suitable protective packing.

Pastels

Pastel is the drawing medium perhaps most closely allied to painting. The pastel sticks give you the drawing versatility of charcoal—the

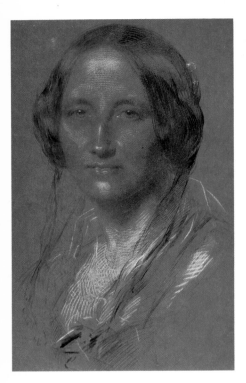

Chalk drawing of Mrs Gaskell, artist unknown.

ability to produce delicate lines or to block in solid area—and colour at the same time.

Pastel is a very refined type of coloured chalk. The sticks have a beautiful velvety quality—delectable to use. Artists' pastels are manufactured in soft (exceedingly so), semi-soft and semi-hard grades. There are literally hundreds of colours in some brands, but don't be deterred by this fact. You can buy pastels singly, so initially invest in the basic colours recommended for all media.

Pastel sticks are very fragile so handle them carefully and make sure to keep them in the plastic packing which the shop should supply, if you have no other suitable box. They are, in fact, bound to break. This doesn't matter because you can still use the smaller pieces just as well, but you want to avoid reducing them to dust. In spite of their fragility, pastels are one of the most permanent (least likely to fade or alter) of all the picture-making materials.

There are some pastels available that are harder than the artist's type. They are not so powdery, but in quality they are inferior. Wooden pastel pencils are also on the market. Because of the thinness of the drawing 'lead' the usual scope of the pastel technique is diminished.

The paper trough suggested earlier is also recommended when drawing with pastels. They create a lot of dust which you may occasionally need to blow off your work.

If you need to, use fixative in mid-drawing. Certainly use it when your drawing is completed. All the details given in the charcoal section on fixative and erasers apply equally to pastels.

Chalks

Nowadays the word 'chalk' is generally applied to the material, usually white, which is used so extensively on school blackboards. It is employed in that sense as a drawing material here. Many old masters' works are classified as 'chalk drawings' in museums and in books. This, however, means a drawing medium similar to pastel or Conté. Artists used to make their own drawing and painting materials, to their own individual recipes.

Chalk, of the schoolroom variety, is inferior to pastel in quality and colour choice but it can be used effectively, especially in drawings on a large scale. Go for the softer type, as hard blackboard chalk is not really suitable for use on paper. Chalks are supplied in a very limited range of pale colours. They can be combined most successfully with charcoal. Also, they are extremely cheap. Fixative is essential on a chalk drawing.

Oil pastels and crayons

Oil pastels, which rather resemble sticks of theatrical make-up, are an oil-bound drawing material. Oil crayons are very similar but generally

slightly harder. Both are available in a wide range of lovely clear, brilliant colours. They combine a lot of the features of the original type of pastels with those of wax crayons. Neither oil pastels nor crayons require fixing.

Felt and fibre tipped pens and markers

There is a huge choice of felt and fibre tipped pens and markers (which have fatter nibs). They are sold singly or in sets. Some sets contain a

Head of a Woman, *Pablo Picasso, black crayon and gouache.*

vast number of inviting-looking different coloured pens. As they have a somewhat limited life, tending to dry out easily, it may prove more reasonable to choose and buy singly just those colours that you know you need. If you forget to replace their caps the pens will dry up very rapidly.

Some of these pens contain waterproof ink, others are non-waterproof. Ascertain this before you buy, particularly if you intend to use them in a pen and wash drawing as explained in Techniques. The hardness and durability of the nibs vary greatly too. Some of the cheaper brands start life with a nib that draws a clear, precise line. After an alarmingly short time this may well deteriorate into a thing like a chewed stick. The best buy is a refillable felt tipped pen (also made in the larger marker size) which has a range of interchangeable different shaped nibs. Several coloured inks and a cleaner are also available.

No type of felt pen drawing can be erased successfully.

Inks

For the densest black line use waterproof Indian ink. This ink is completely waterproof when dry. It can be diluted when in use, distilled water being recommended. It has, however, a tendency to separate and cannot be successfully stored in a dilute state. Non-waterproof black drawing ink keeps better in dilute form, especially if, again, distilled water is used. Very subtle greys can be achieved for lines or washes.

You can make your own black non-waterproof ink using the ancient method of rubbing a stick of solid Chinese ink in a saucer and gradually adding water. This means that you can control the consistency of the ink—making it paste-like, if you wish—to suit whichever drawing technique you are using. This ink dilutes well.

There is an excellent selection of waterproof coloured drawing inks on the market. These may also be thinned with distilled water. White ink and some metallic colours are available too.

Fountain pen ink is suitable for line drawing and wash work.

Do be sure to wash out your dip pen or brush in clean water after using ink as it stains and clogs badly.

The manufacturers state that the coloured inks are impermanent—they have a tendency to fade.

Pens

Dip pen holders and nibs (the old-fashioned kind) especially intended for drawing are sold in art shops. They differ in the width and pliability of the nib. Varying the pressure applied to the pen when drawing alters the width of the line and, if dilute ink is being used, the tone or darkness of it too. Do not confuse drawing nibs with lettering nibs. The latter are made to give a thin upstroke and a thick downstroke. You can use any

kind of ink with a dip pen.

You may find you like to draw with an ordinary writing fountain pen (providing the nib is not too broad), and this eliminates the bother of carrying a bottle of ink around. Use only fountain pen ink as drawing inks will almost certainly clog up the pen.

There are several different brands of barrel fountain pen specifically made for drawing. They have interchangeable nibs in different sizes which produce a clear line of even thickness and constant colour, unlike the dip pen nibs. These are rather expensive, delicate drawing instruments and, for the pen to function properly, you must follow the manufacturer's instructions. Use only the ink and the cleanser that he recommends and don't fiddle with the mechanics—beyond what you are told to do.

Special ink for barrel drawing pens is supplied in a good dense black, and in several colours. All are waterproof.

Inset. A barrel fountain pen made specifically for drawing.
Above. This type of pen makes a very clean line and is good for very detailed drawings.

The quill pen was the drawing and writing tool used in the West until metal pens were introduced in the last century. It is a very responsive, flexible drawing instrument. If you can get hold of some goose, turkey or similar feathers, a quill pen is easy to make (try the butcher, perhaps, as a source). You'll need a very sharp, thin-bladed craft knife. Slice diagonally through the shaft of the feather near the tip, making a cut about 2cm (1in) long. Then split the centre of the nib approximately 6mm ($\frac{1}{4}$in) up. Finally sharpen the point down to whatever width you desire. Fig. 2 shows how to make a quill pen.

Below. Making a quill pen. (fig. 2)
Cut shaft of quill feather diagonally, trim off the end, then split nib up the centre to form the ink channel.

The reed pen is a traditional Oriental drawing instrument made from bamboo. This is a more rigid pen than the quill. It too is simple to make from a short length of bamboo that's about 1cm ($\frac{1}{2}$in) in diameter. Cut it in the same way as the feather, at a slope, and slit the centre. If there is any pithy stuff inside the bamboo, remove it.

Both the quill and reed are superb for rapid drawing. Any type of ink may be used with them.

Ballpoint pens can be used for drawing but, compared with the pens already mentioned, they are somewhat limited, insensitive tools. They have the advantage of not requiring the accompanying bottle of ink. Ballpoints are supplied with fine and medium points in a number of colours. The inks are inclined to fade.

Drawing with a pen on a vertical board is not a good idea. The ink runs back: at best inside the body of the pen, at worst, down your arm. Work seated or standing, with board or sketchbook at a slight slope.

This Japanese brush and ink drawing shows a samurai warrior and servant.

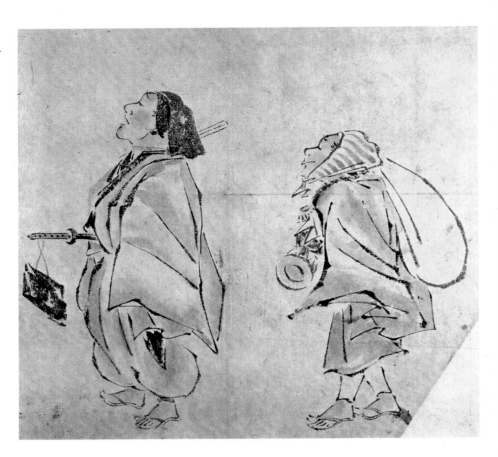

Fixative

Charcoal, pastel and chalk are pigments not contained in a gum or *vehicle*. Because they tend to smudge and eventually disappear such drawings should be fixed. Fixative is a resin and spirit mixture which is sprayed on to the drawing, giving it an invisible, non-shiny coating which secures the drawing to the paper. It is sold in aerosol cans or in bottles—to be applied with a spray diffuser. This is a little device of two hinged metal tubes. You place one end in the liquid and the other in your mouth, and blow. A fine mist spray comes out. Experiment on a scrap charcoal scribble first to see how far away you should be in order to avoid the spray making the drawing run. You'll also discover how hard you should blow. Wash and dry the diffuser after use or it may become blocked up.

You may use the fixative halfway through doing a drawing. Just wait a few seconds for it to dry before continuing.

Fixative should be used on all drawings executed in soft media which are liable to smudge; that is, drawings in very soft pencil, pastel or certain types of crayon.

Brushes

Drawing with a brush is a true pleasure. Because of the structure, natural hair brushes hold liquid better than those made with synthetic fibres. Buy a round sable hair watercolour brush for line and smaller scale washes, in say, size 4. These are expensive but infinitely preferable to the other types and, with due care, will last a long time. Sable hair is firm and springy and, as with all sympathetic tools, can be used to make the finest, delicate line or a bold dash. In comparison, line drawing with a squirrel hair brush is a sad, frustrating experience.

The squirrel, ox or blended hair brushes are best for use on a bigger scale for doing large areas of wash.

Polyester brushes are a reasonable alternative to sable. They are springy and will retain a fine point.

For broader brush drawing you may be interested in trying oil painting hogs' bristle brushes. These are shaped either oval, round, flat (like miniature house decorating brushes), or filbert—a cross between round and flat.

Nylon brushes, although very hardwearing, are not very suitable for wash drawing as they do not retain water well enough. They hold a paste-consistency medium better. They are totally unsuitable for fine line work.

All types of brushes are supplied in different qualities and, consequently, different prices. With the sable particularly, it's well worth buying one of the more expensive, fine quality brushes.

Always clean your brushes properly after use. Use cold water to remove ink and watercolour paints and white spirit to remove any oil-bound medium. To clean a brush thoroughly, after the initial rinsing, rub the bristles gently on a bar of soap and then in the palm of your hand

From left to right the brush shapes are oval, round, flat and filbert.

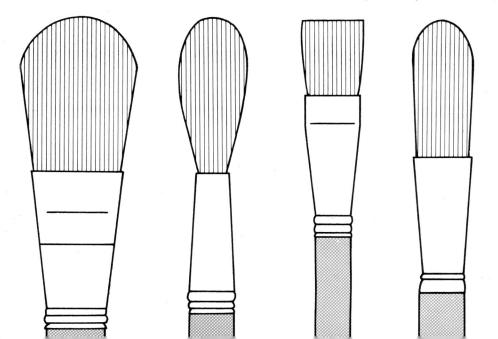

to create a lather. Rinse the brush under cold running water. Repeat this until the lather is clean. Finally rinse the brush thoroughly and shake the water from the bristles and shape it to a point in your lips.

Store your brushes standing vertically, bristles uppermost, in a jar. Don't lie them flat and certainly never stand them on their bristles.

Paints

Watercolour paint may be used as a drawing medium with a brush, either as a wash added to a line done in another material, or for making both washes and lines.

Oil paint too, diluted with turpentine, is used by a number of artists for direct, spontaneous drawing.

Craft knives

An essential adjunct to drawing is a knife. The kind of craft knife with easily replaceable blades made in different shapes is a useful tool. This means that the different blades will do for diverse jobs. You can keep certain of them sharp for cutting cardboard and paper, using the blunter blades for things like pencil sharpening.

Craft knives are sold by art supply shops and ironmongers or hardware stores. There are some inexpensive but effective types with plastic handles, and some all-metal types which are more expensive.

Drawing boards

You will need a rigid board on which to fix your drawing paper. An A1 size (841mm × 594mm [roughly 33in × 23in]) board is recommended as paper is being increasingly supplied in the international sizes. Drawing boards are available in different grades, so obviously are at different prices. If you treat it carefully (don't, for example, keep it leaning up against a hot radiator), an inexpensive board should last well. A smaller board in plywood or hardwood, measuring say, about 35cm x 25cm (14in x 10in), will be convenient to carry around and useful for drawing outdoors.

Don't use drawing-pins, thumb tacks or straight pins on your board. The holes they will make will obviously destroy the smooth surface and, after some years' use, lots of holes in the same area can actually break off the corners of the board. Attach your paper instead with bulldog clips, available at most stationers, or with drawing board clips, bought from an art shop. These will not damage the board or the paper.

Easels and the drawing position

An easel is not essential for drawing and it is certainly not a piece of equipment you need to buy at the beginning. The advantages of a good sturdy easel (not a cheap, wobbly one that falls over and comes

unscrewed) are that it will hold your work vertically or at any angle you wish and at any height, so that you may stand or sit to draw. The box type of easel is very useful. It can be used indoors and out, and the box design means it will conveniently store and transport your materials too.

However, you may have no easel and yet wish to draw standing up, especially if you like working on a large scale. You can either fasten your paper to a suitable wall or to a large board which is then propped up against some furniture.

When you sit down to draw don't crouch over your work with the board horizontal in front of you; this is inclined to make your back ache. On a biggish drawing it means the far end is quite a long way away from you and a certain amount of visual distortion takes place; it also means that while you're drawing up at the far end, your drawing arm, and possibly part of your body, is covering an area of the drawing.

If you are seated at a table, prop your drawing board up against a pile of heavy books or something similar. There are table easels on the market with an adjustable slope.

Frequently the reason you do not want to sit at a table is because the table will obstruct your view. So place another chair in front of you, with its back toward you, and lean your drawing board against the chair back.

When you are drawing a subject—a model or still life, say—endeavour to position yourself so that you need only to move your eyes and not your head or body between looking at the subject and looking at your work. The less intrusion between what you see and what you put down on paper the better.

Papers

Do experiment by trying out different media on some of the many kinds of papers available to see which combination you particularly like.

Paper is made in different weights, which means different thicknesses. Measurements vary but the large sheets, which is how you will normally buy paper, will measure Imperial [Standard] (775mm x 572mm) or Al (841mm x 594mm) [roughly 30½in x 22½in and 33in x 23in respectively].

Cartridge paper is relatively inexpensive and is the most widely used drawing paper. This is made in several different qualities and weights, and is always either white or cream. The surface will be found to vary in the different qualities and brands, some being very smooth, others fairly rough and textured. A good quality cartridge paper will suit all media.

Watercolour paper is a superior quality paper. The finest is still handmade but it is expensive. Mould-made papers use the same basic

materials as handmade paper but they are made on a machine. Watercolour papers are white, off-white or cream. There are three types of finish: hotpressed or H.P., which is smooth; Rough, a coarsely textured surface; and Not, which is an intermediate, between heavily textured and smooth. The best quality watercolour papers are made from cotton rags, the less expensive from wood pulp. Although named 'watercolour paper', don't let this restrict its use; try pen, pencil, charcoal, etc. on it. The character is unique, and the paper will stand up to a great deal.

Ingres paper, made in white and a range of very attractive colours, has a slightly textured surface. Its distinctive feature is the hair-like pattern of fibres that runs all over it, so that a sheet will contain several colours, like a very fine tweed. Ingres paper is suitable for pastels, charcoal, Conté and ink work.

Sugar paper [construction paper] is a soft paper available in off-white and some muted colours. It is unsuitable for pencil and pen, but fine for pastels and similar media. It tends to fade.

Pastel paper, as the name implies, is primarily intended for pastel drawing. It is a better quality coloured paper than sugar paper. A good pastel paper has a *tooth,* that is, the type of texture that will hold the grains of pastel as it is drawn across the surface. Some of these papers, too, unfortunately fade.

Very cheap paper like newsprint (newspaper before it is printed) and lining [shelf lining] paper should be avoided for drawing. They do not respond well, tear easily and turn yellow after a short while. In preference, if you have no drawing paper handy, use writing or typing paper.

Detail paper is a very thin white paper, rather like the bank paper used for typing. Sometimes it is useful for tracing work. It is sold in pads, known as layout pads, or by the roll.

Tracing paper is available in sheet, roll or pad form.

Sketchbooks and pads

You can make up a sketchbook with your own selection of different types of paper in a loose-leaf binder or clipped to a small drawing board. Slip a large elastic band around the lower part to keep the sheets flat when not in use. When drawing outdoors the elastic band is often helpful if there is a breeze that would cause the sheets to be blown about.

Sketchbooks are on sale in a range of sizes. They have different types of binding: some are hard-backed and the stiff board cover folds right back, some are spiral bound and some have the pages pasted together along the top edge to form a pad. Sketchbooks are manufactured in cartridge, watercolour, pastel and Ingres papers. A sketch block has the pages pasted on all sides. You tear a sheet right off when you have finished with it.

The surface upon which you are working, that is, the support beneath your drawing paper, will affect the way in which your drawing instrument responds. Some, such as coloured pencils, work best on a hard, glossy underlay. So fix a sheet of hard, glossy cardboard or paper underneath your drawing paper. In other instances a softer support may prove more responsive—several sheets of newsprint, perhaps. Finding this out is very much a matter of experience and personal preference but it is certainly worth experimenting with different combinations. When drawing in your sketchbook it is helpful to slip a piece of cardboard

Paper should be stretched as shown here, if you intend to use a very wet drawing technique.

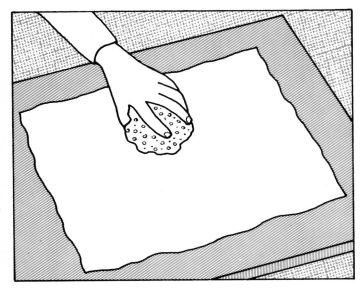
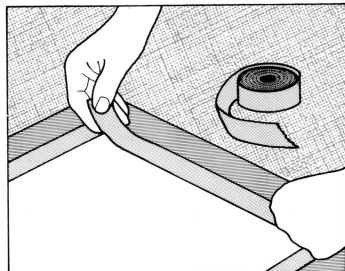

under the page you are using, both for the reasons just mentioned and also because it will protect the following pages.

Stretching paper

If you intend to use a very wet technique, a lot of fluid washes, for instance, it is advisable to stretch your paper first. This prevents it from buckling. Thoroughly dampen the paper with cold water and lay it out flat on the drawing board. Leave it for a minute or two to expand. Cut some brown paper gumstrip (not masking tape) to size for each edge. Dampen the gumstrip and, overlapping it about 1cm ($\frac{1}{2}$in) on the paper, stick the sheet of paper down onto the board. Place it flat so that the paper dries evenly. As it dries out, the paper will shrink slightly, resulting in a taut, flat surface. It will remain so when the wash is applied.

When the drawing is finished and quite dry remove the paper by pulling the gumstrip away; any left adhering to the drawing can be trimmed off; any on the drawing board may be removed by dampening.

Scraperboard

In most types of drawing, dark lines are made on a light background. With black scraperboard the reverse applies. The board is a sheet of cardboard coated first with a specially prepared white chalk and then with a layer of black ink. The drawing is made by scratching through the black ink. This gives a very precise white mark. Drawing can be done with special scraperboard tools, which are like pen nibs and fit into an ordinary pen holder, or any kind of scratching implement. The blade of a craft knife is particularly versatile. Use it without the handle as this means you can slope it at all sorts of angles. To make it more comfortable

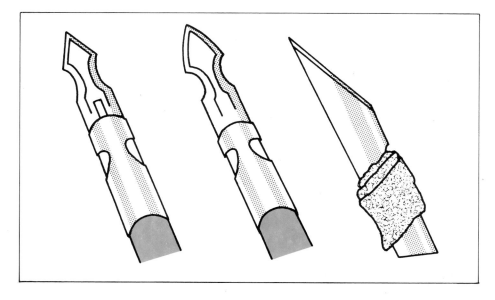

The tools at the left and middle are specially made for use on scraperboard, the one on the right is a home-made tool made by binding a scalpel blade to a pen holder.

and safer to hold, bind a little adhesive tape around the end you are holding.

There is also a white scraperboard available. You can draw on it in black Indian ink with a pen or brush and then (after ascertaining that the ink is completely dry) use the scratching technique too. Try out coloured scraperboards as well. Use watercolour or ink to coat the prepared white board. Make some tests first, though, because some colours penetrate the chalk coating. This means the scratches won't show up as white lines.

Avoid bending your scraperboard as this cracks the coating. For this reason, always cut it with a craft knife against a metal ruler, not with scissors.

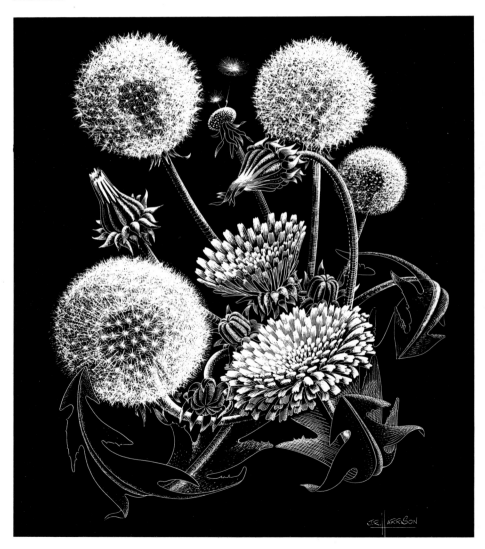

Dandelions, *Joseph Harrison*.
A scraperboard can be used for highly detailed white on black drawing.

26

Handling Colour

The mixing of colour has its own simple basic rules, so once you have learned them you will know how to control your palette. Paints are used in this chapter for the examples but the same principles apply to coloured inks, pastels, crayons and so on. For colour experiments use a good, opaque white ground (the surface on which you paint; sized or oil painting paper is best). Any colour, cream, for example, would influence the colours.

The three *primary* colours are red, yellow and blue. They are called primary because they cannot be mixed from other colours, that is, you can't make red, yellow and blue. In theory you should be able to mix all the colours you wish with different proportions of red, yellow and blue. They represent all the colours there are. In practice, this doesn't work because it is impossible to manufacture pigments that do not contain traces of other colours. Again, in theory, if you mix all three primaries together you should get black but, for the reasons already mentioned, you would end up with a darkish grey. But the principle is the same— mix all the three primaries together and you get a 'non-colour'.

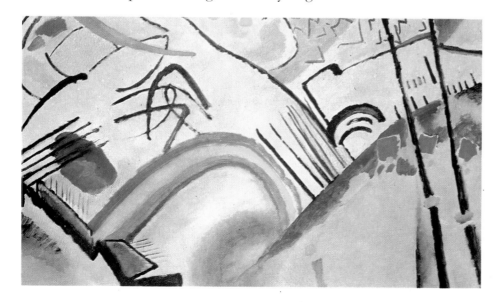

Battle *by Kandinsky.*
This artist explored the use of colour as a means of expressing emotion.

It is virtually impossible to find a true red, a true yellow and a true blue because of the fact that all colours tend to have traces of other colours in them. A compromise, which partially gets around this problem, and at the same time gives you an excellent range of colours for mixing and general use, is to choose two versions of each primary colour. Here is a recommended basic set of colours, accompanied by the reasons for choosing them. The names correspond with the Winsor and Newton colour chart for Artist's Oil Colours. These particular names may not be used for these particular colours in another medium—pastels, for instance, or in another brand, but you can compare the colours visually with the chart.

Cadmium yellow—is a yellow containing some of the primary colour red.

Cadmium lemon yellow—contains traces of the primary colour blue.

Cadmium red—is a red veering slightly towards the primary colour yellow.

Alizarin crimson—is a red which contains some blue.

Cobalt blue—has a little yellow in it.

French Ultramarine blue—contains a little red.

Ivory black—blacks can be brownish, greenish or bluish; aim for as neutral a black as possible and one that is good and dense.

Titanium white—not a transparent, silvery or bluish white.

Unfortunately the names of colours are not standardized, so what may be called magenta in one manufacturer's paint or ink is a totally different colour when made by another company.

Because the mixing theory does not actually work in practice—you cannot achieve a clear, brilliant purple by mixing—Winsor violet is recommended. Similarly, you may like to purchase Viridian green too. The colour wheel is a traditional way of showing how colours relate to one another. This is how to make your own version of the colour wheel. It will teach you a great deal about the mixing of colours. Keep it, it will be very useful to refer to later.

Have ready a pure white ground. Use each of the colours straight from the tube. Be particular about the brushes being clean, so that the colours remain pure and untainted. First, paint an area of the Cadmium yellow and next to it a similar sized area of Cadmium lemon. On the Cadmium lemon side, working around in a circle, add Cobalt (the blue that contains yellow), next, French Ultramarine. Then paint the Alizarin crimson area. This follows on as it is the red containing some blue. Finally paint in the Cadmium red section.

On the palette try mixing the primary colours together until you have achieved a neutral grey that doesn't lean in the direction of any of its three components. You cannot do this by combining precisely measured equal amounts of each colour. Some colours are inherently darker or

stronger than others so you must judge the quantities by carefully watching the mixtures. Try the mixed colours out on scrap paper. When you have achieved as neutral a colour as you can, paint a patch of it in the centre of the triangle formed by the three patches of red, yellow and blue.

Secondary colours are pure (not 'greyed') colours mixed from any pair of primary colours. They are orange, green and purple. Mix the Cadmium yellow and Cadmium red to get a clear orange, visually mid-way between yellow and red. Paint a rough arc around the outside of the yellow and red patches. Make a green from the Cadmium lemon and Cobalt and paint a green arc around the yellow and blue section. The purple, as previously mentioned, is difficult to make. However, for this experiment, mix the best purple you can from the Alizarin and Ultramarine and complete the outer circle by painting in the purple arc.

Each of the three secondary colours is a mixture of two of the primary colours. For instance, purple is made of red and blue. The remaining primary colour is yellow and yellow is the *complementary* colour of

This is how the finished colour wheel should appear.

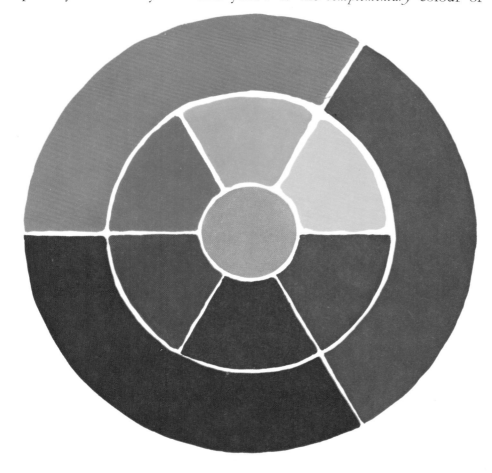

purple. Any pair of complementary colours when mixed together will tend to go grey or 'non-coloured' because you are again combining the three primaries—mixing together all the colours there are. From your own painted colour circle you can see which colours form complementary pairs. Look at a primary colour patch. The arc of colour opposite it on the far side of the circle is its complementary colour, i.e. the colour which is made by combining the remaining two primaries.

Try some experimental mixing, working gradually from one colour, Cadmium yellow for example, adding increasingly larger amounts of purple (yellow's complementary colour). Paint small patches of the mixed colours on paper to keep a record of the strange 'mid-way' colours you will achieve. Adding a touch of the colour's complement will always dull it down—but not in the dreary way that splodging black into it does. Yellow is extremely light in tone, purple is quite dark. Purple is a very powerful colour, and, as you add it to the yellow, be very sparing. A small amount of purple will have a dramatic effect upon the yellow. Follow this by mixing other pairs of complementary colours.

The type of mixing used so far in these colour experiments has all

been done on the palette, prior to applying the paint to the ground. This is the method most generally adopted when using oil paints. However, oil paint is extremely versatile and can also be used in the ways suggested for the other types of media.

Colour mixtures with drawing materials like coloured pencils or crayons, felt pens or pastels can be produced by laying down one colour in a series of strokes and then laying another colour over it, and so on. Here you can vary the closeness of the strokes and, depending upon how hard you press, the strength of the colour. There are infinite variations. The first base colour, a light blue, for example, may be solid with no white paper showing through. The second colour, red, might be applied in an open cross-hatching. At this point you will have produced a slightly irregular-looking purple. Add some dots of yellow and some dashes of green. The effect is very like a woollen tweed. Tweed is, in fact, made up in a very similar way from little dots or lines of different colours. The colours mix optically—that is, as you look at them they appear to merge together. Heather mixture, a type of tweed, is just like its name, all different colours—imagine the colours in a real heath.

Modern half-tone reproduction uses a system of red, yellow, blue and black dots to print a photograph. Thus the primaries are used to create the colours and the black to provide tone.

When you are next standing by a large advertisement with a photographic image on it, try to take a really close look at the surface to see how it is made up. The sun-tanned thigh of the lady on the beach will be seen to be a myriad of different coloured dots. Half tone colour printing breaks a coloured phtograph down into these dots. All the red dots are printed from a red printing plate, the blue dots from a blue plate, and so on. The whole combines optically to read as a normal, full-coloured image. Georges Seurat, the Frenchman who lived from 1859 to 1891, was an artist who exploited the idea of visual or optical mixing to the full. He followed the ideas about colour that Delacroix, and then the Impressionists, introduced. They were moving away from the rigid attitudes of Neo-Classical art which prevailed in the late-eighteenth and early-nineteenth centuries. They studied, drew and painted from real living subject matter, observing the effect of light upon the appearance of things. Seurat's technique is known as pointillism (although he himself preferred to call it divisionism). He used small dots of primary and secondary colours, intermingled to read, in the same way as the printed poster, as figures, scenes, etc. He was a master of design and a superb draughtsman. In the hands of a lesser artist such a scientific approach could have deteriorated into a boring, mechanical exercise.

Try out the optical mixing methods with your own materials. Try different proportions of both the colours themselves and the white paper, mixing them together. A strong, sturdy paper may be required if, as with felt pens, the surface tends to roughen up. The manner in which you apply the colours can, at the same time as creating new optically mixed colours, suggest textural qualities too. Circular scribbling marks, for instance, might combine with cross-hatching.

Laying a wash of one colour over another is an alternative colour mixing technique. This lends itself particularly to watercolour and coloured ink work as these are transparent media. One colour will show through another. You can combine washes of different strengths and solid washes with broken ones (i.e. incomplete areas with the gaps allowing the other colour to show through unevenly).

Experiment with a technique that is a combination of the two above methods. Water soluble coloured pencils are particularly suited to this. Lay down a wash of colour and, while it's still wet, draw in dots, dashes or spots of another colour on top of it. These will partly merge into the background colour but will still retain a slightly uneven quality.

Each colour you use—each tube of paint, each crayon—is comprised of these elements: hue, tone, brilliance, warmth or coldness, opacity or transparency and associated qualities. Therefore, each colour, like each person, has its own character and traits. To further the comparison, each behaves in a particular way in a given situation. None is ever seen alone, without interrelating, being affected by and affecting the others.

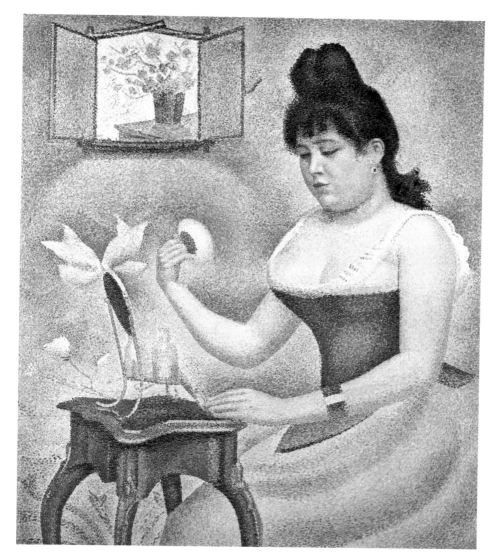

La Poudreuse, *an oil painting by Georges Seurat who helped to develop the method of optical mixing by using dots of pure colour side by side on the canvas. This style is sometimes called pointillism.*

The above terms, hue, tone and so on, are unfortunately interpreted in different ways and diverse words are used to mean, in effect, the same thing. In this book the definitions are as follows. *Hue*—the actual colour itself, green as distinct from red. *Tone*—how light or dark a colour appears. Imagine looking at a still life group of objects which are, as always in normal conditions, many-coloured. Try to think how light or dark the various colours are in relation to one another. Is the apple darker than the orange? It is rather as if you were seeing the objects as a black and white photograph, replacing the colours by an equivalent range of greys, running through from black to white. *Brilliance*—how much a colour glows or shows up. Brilliance is especially influenced by

33

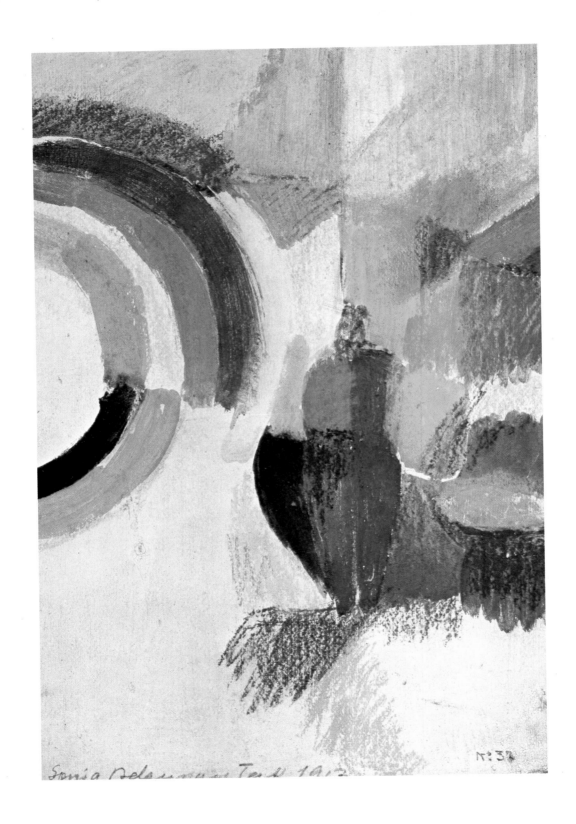

Sonia Delaunay Terk 1912

N°.32

the surrounding colours. *Warmth or coldness*—some colours actually appear to come toward you and these are called warm colours; others seem to recede and are known as cool colours. *Opacity or transparency*—these two aspects very much relate to the medium you are using. Within one medium (oil paints, for example) the covering ability (opacity) or lack of it (transparency) can vary greatly from one colour to another. *Associated qualities*—colour is a very emotive subject, perhaps still forming a powerful link with our ancient past. We still have strong associated ideas about what colours are 'correct' for what purposes. Who, for instance, would fancy eating a plateful of blue cauliflower?

Local Colour is the term used for the inherent colour of an article. The local colour of a ripe tomato is red, although on close inspection the fruit may prove to look white or pale blue in the highlight areas and may be purple or brown in the shadows. *Reflected colour* is, as the name implies, colour reflected from one object to another. Place a white cup next to the tomato and the outside of the cup near the tomato will pick up a pinkish glow. The nature and texture of a surface very much affects the way in which it reflects light and thus colour, and is also influenced by other colours. Caucasian flesh is very susceptible to colour reflection. Recall the 'Do you like butter' game played by children. The child holds a buttercup under a person's chin. If the chin looks yellow, as in good clear lighting conditions it almost certainly will because of reflecting the yellow flower, the person does like butter.

Additional terms to define are: a *shade*, which is a colour with black added to it: a *tint*, a colour with white added to it. Strictly speaking, 'pastel shade' is a distinct contradiction in terms. In certain media, watercolour or coloured inks, for example, tints are obtained not by adding white, which would make the colour mixture more opaque, but by adding water, thereby allowing more of the white paper background to shine through the colour to lighten it. Similarly, with crayons and coloured pencils a lighter application of the colour will produce a tint version of that colour.

In order to really begin to acquaint yourself with the fascinations of colour, colour mixing and matching, try doing some colour studies. Choose a theme, say, green, and gather together several different green items. Choose things of a small scale for this project. These could be a leaf, a length of ribbon and a ball of knitting wool, all laid on a sheet of green paper. Immediately, the diversity within the term 'green' will become glaringly apparent. Create a composition, a coloured painting or coloured drawing, with the specific aim of matching up the colours in the little still life group.

Try to fix which object, or which part of an object (and this is going to be difficult), is a real, true green. That means a green that is not bluish or brownish or yellowish, and at the same time is mid-toned and not too

Left. Etude de Lumière: Prismes Electriques, *Sonia Delaunay. A mixture of drawing mediums— watercolour and pastel—used to create colour mixes. Notice how secondary colours are formed where the primary colours intermingle.*

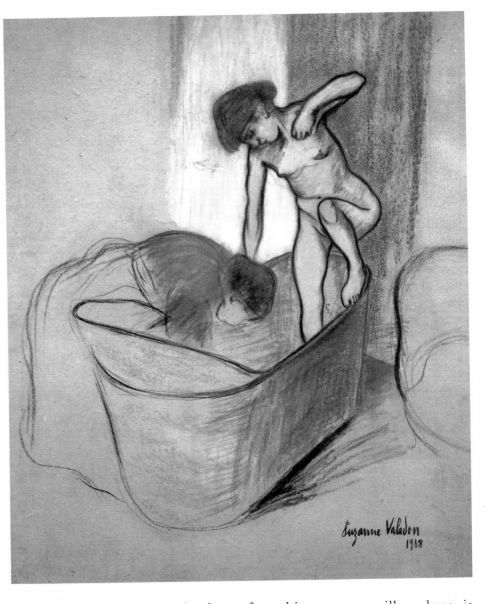

dark or too pale. The local colour of an object, as you will see here, is greatly altered and influenced by its surroundings, so you may find you have to select one tiny part of an object as your 'true' green patch. Use this true green as your guide. Compare other greens in the group— is this part of the leaf like the true green? If not, why not? Is it different in actual hue? Is it somehow a duller green (perhaps it contains some red, its complement) or is it a much darker toned colour all together? How does it compare in tone with the rest of the articles in the arrangement, including the green paper background?

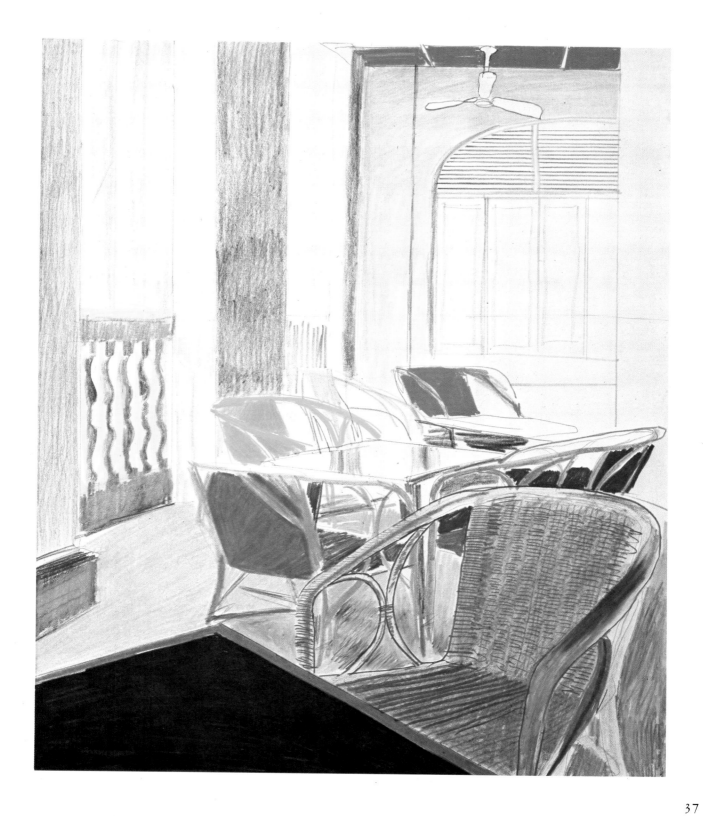

Field of Corn in the Moonlight, *Samuel Palmer, ink and watercolour. Colour conveys mood, and in this night-time landscape the use of purple warmed by red gives the viewer a comfortable feeling of tranquillity.*

While observing the colours don't, of course, forget about the shapes, proportions, and so on of the over-all composition. After you have completed your green study move the objects onto a white paper background and arrange them in the same way as before. See how now the colours and the general appearance of the items seem so different. Each object shows up as much more clearly defined. Its outside shape can be seen much better because of the contrast between the green lines and the white background, and also because of the strength of tone of the greens against the white. Also, the non-colour background makes it easier to discern the strength of the various greens.

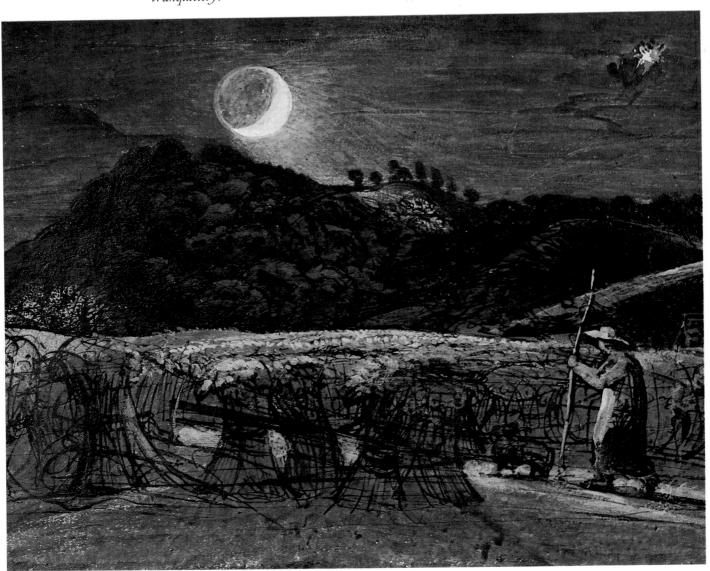

If possible try to take your little green and white still life into some entirely different kind of lighting conditions to see what a marked effect light has upon colour. We come upon this all the time in our everyday life. You take a bolt of fabric to the door of the shop to see what colour it really is, knowing that artificial lighting can't be trusted. An example of this is trying to find a pale-coloured car in a sodium-lit car park. In those lighting conditions, all the light-coloured cars look a similar sort of yellow ochre colour.

This light and colour phenomenon is deeply ingrained in our lives. There are many commonly used phrases associated with it which conjure up moods: the blues, blue with cold; black depression; in the pink; to see red; to ginger up. The warm/cool idea is not only a visually apparent occurence, it is linked up with associated ideas in language too. The blue associations are cold and dull; the red connections are warm and fiery.

To see further effects of colour against colour, still using the green objects, slide some different coloured paper backgrounds under them. The complementary colour of green is, as you know, red. It is the colour most unlike green, most opposite to green. Place a piece of a middle (Cadmium) red paper under your most true green item. As the background colour is now the most opposite to the colour of the object, the object will appear at its most intensely green. The maximum brilliance of the green is now being displayed.

This method of using complementary colours to enhance each other's brilliance was a favourite device of the Op artists of the 1960s. By placing complementary colours that are the same tone side by side, the edge where they meet will begin to dance as the colours move back and forth optically. This occurs because the colours are the same tone and one does not dominate the other.

The gummed coloured paper squares that are sold in packets intended for craft work are very useful for these kinds of colour experiment projects. The colours are flat and clear. Buy a packet and try different colour combinations. Another interesting facet of colour can be seen by varying the proportions of the area of one colour to another. This can be used to alter the importance of a colour.

Having considered these ideas, look out particularly for these instances in whatever subject matter you are going to examine for your drawings.

Colour is an immensely emotive and strangely irrational subject. People will say that they have a certain favourite colour, for reasons they can't define, or that they never wear green because it is unlucky. Associated qualities play an extraordinarily strong part. The following experiment produced some very interesting results. A group of art students were asked to paint small, 5 cm (2 in) squares of different colours. These were then to be arranged together into groups—groups

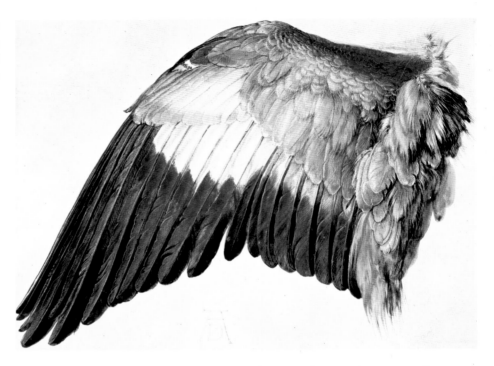

of squares of colours that they really like together, and groups of squares of colours that they detested together. The colour samples were to be flatly painted in oil paints and accurately cut out into identically sized squares. Any type of colour mixing was permissible. Oil paints were used because (as with the examples at the beginning of this chapter) there is the greatest range of colours. The flat, non-textured painted square shape was chosen to remove, as far as possible, any associations that could be linked with the shape itself or the surface quality. The students dutifully set about preparing their little squares with the accompanying mutterings of: 'What a hideous pink', and 'I can't stand purple', etc. The final outcome of the project, when the sets of colours were displayed on the wall, produced the surprising fact that nobody, in spite of their earlier protestations, could honestly find a pair, let alone a group of colours, that they disliked. As anonymous patches of colour, not being applied to anything, they were all acceptable. Immediately when uses for the colours were suggested, the likes and dislikes arose—quite vehemently. A pair consisting of a sage green and a greyish-brownish beige (how impossible it is to describe colours verbally), when considered rendered in glossy paint as a bathroom decoration scheme, produced howls of dismay. Yet the same green and beige pair would make an elegant and highly sophisticated watered silk evening dress. It is only when seen in context, not as abstract concepts, that colours appear appropriate or otherwise.

A Project: A Self Portrait

Drawing a human figure as your initial attempt may possibly seem a daunting prospect. Your response may be: 'But I can't even draw an apple!' Consider the following reasons for doing a self-portrait.

Virtually everyone would like to draw people and faces. A human being is, of course, a complicated object—or *subject,* as the thing you are drawing is usually called. But you are particularly familiar with the appearance of this specific human being, having studied it in the mirror every day for many years. You know the way its hair falls, the very texture of that hair, the way it won't go in a certain direction; you have first-hand knowledge of the structure of the face—the roundness or gauntness of it, the lumps and bumps on this particular nose—and so on. If you draw yourself, you, the model, will be available whenever it suits you, the artist, to work. You may find, once you get under way, that you'll wish to return to, and work on, the drawing at odd times.

If you ask a friend to model for your first drawing there is inevitably going to be a slightly awkward situation. Your sitter is bound to want to see the drawing. You may feel that politeness requires you to flatter—rather than the reverse, which may well occur. As you struggle with your drawing, which probably doesn't look like much at all during certain stages of its development, you can well do without uninformed criticism or advice. Doing a self-portrait is beautifully private. For your first, quite possibly fumbling attempts, you will be alone, thereby avoiding any sort of embarrassment. You've no need to be constantly conscious of your model's well-being—is he or she comfortable, getting bored, cold, thirsty, etc? You can wrestle with your problems, get in a mess, plod on and endeavour to sort things out, becoming fully involved and free of interference. So, have a try. This is how you set things up.

Choose a place to do your drawing where you won't be disturbed and where you won't be disturbing others. You want to avoid being pressured by anything. Doing a drawing means you need time to think. You are going to be studying the subject, making the marks and judging and weighing up all the various factors. Not an easy thing to do without complete solitude, and virtually impossible with the baby crawling all over you or the television going at full blast. So, if you can, work in

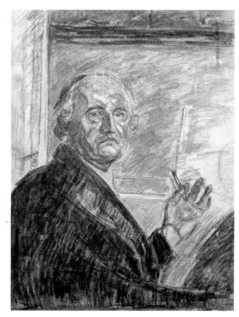

Self portrait by Edward Munch, charcoal and chalk on canvas.

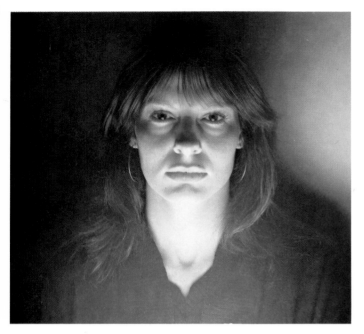
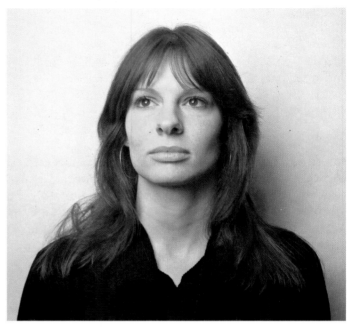

seclusion, preferably in a room where you can leave your drawing things set up; or where they can easily be stored, unpacked and re-assembled whenever you wish to continue.

Try to think of this self-portrait as something that is going to take a considerable amount of time. There's no need to do it all in one go, unless you have the time available and wish to do so. There's no need to limit yourself to one drawing only. All creative processes spark off ideas and you may wish to explore and develop such thoughts in other drawings. Keep several going at the same time if you wish.

Returning to continue work on an unfinished drawing often has the advantage that, during the time you've been away from it, further thoughts have formed (possibly subconsciously) about how you might tackle certain areas. Also, a fresh new look may make you realize that you had become too involved in one section or one aspect, to the detriment of the rest of the composition.

Arrange your paper and drawing board as described previously, and have ready all your materials and some scrap paper on which to try things out. Fix up a mirror so that you can look with ease, moving your eyes only, from mirror to drawing and *vice versa*. Do make sure that both the mirror and the drawing board are properly supported and that neither is likely to crash to the floor in the middle of the proceedings.

The height, the distance from you, and the angle at which you place the looking glass will affect the view you see of yourself framed within the mirror. Experiment with these three factors, height, distance and

angle and observe how the apparent size of your face and body alters in relation to the area of the room you can see as you move the mirror about.

The way in which light falls upon an object influences its appearance and consequently our response to its appearance. This is happening all the time, wherever we are, in many, many subtle ways. We are familiar with certain well-known instances. The older woman, when dining out, blesses the candles that are so much kinder to her wrinkles and grey hairs than a 150 watt electric bulb would be! Brilliant sunshine will transform a beach which yesterday, under the clouds, looked like the end of the world. A face lit from below can appear quite fearsome (a popular device in the making of horror films) but the same face with a more usual top or side lighting becomes benevolent. So, consider the lighting for your self-portrait. Is it going to remain constant, an electric light in the same position, for instance? Or will the changing time of day alter the look of things? If so, and you intend to work on the drawing at different times of the day, it may be wise to take some simple precautions before you begin. As artificial light is unchanging, possibly you should work under electric light, with the curtains drawn too—if the light coming through the window has a strong influence on what you see.

This may all seem like a lot of fuss, but if you remove as far as is possible, any extraneous disturbances that are likely to occur you will be able to work with much more concentration. You'll also be confident that, when you return to continue your drawing, possibly a day or so later, things will still look the same.

Decide upon which view of yourself in the looking glass you want to draw. Don't choose some fantastically awkward pose or a position that is going to be very difficult to resume after each time you move. Relax. Don't attempt to draw yourself smiling, frowning or clenching a pipe between your teeth—you'll never be able to sustain the pose.

Here are just a few suggestions to get you started. Roughly draw in the main shape of your head (and, if you're drawing the body or part of it, that too) to make sure you will be able to get all you want onto the paper. You might think too, of using the edge of the mirror as a sort of frame around your drawing, actually drawing it in. This kind of device can prove a great aid to sorting out the relative positions of things in a drawing. For instance, does your left ear come halfway down the edge of the mirror—that kind of thing.

Think how one part of anything is built up upon another part. In the case of your head, there's a firm underlying base—the skull. Use your sense of touch to help you work out how the vertical egg shape of the face part swells out into the spherical shape at the back of the skull. Feel how your neck, which is a cylinder, supports and pushes up into the egg shape and the sphere. Study the way your face is divided into planes, or

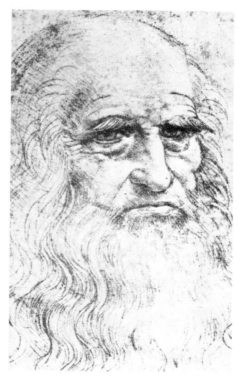

Fig. 1 Self portrait by Leonardo da Vinci, red chalk.

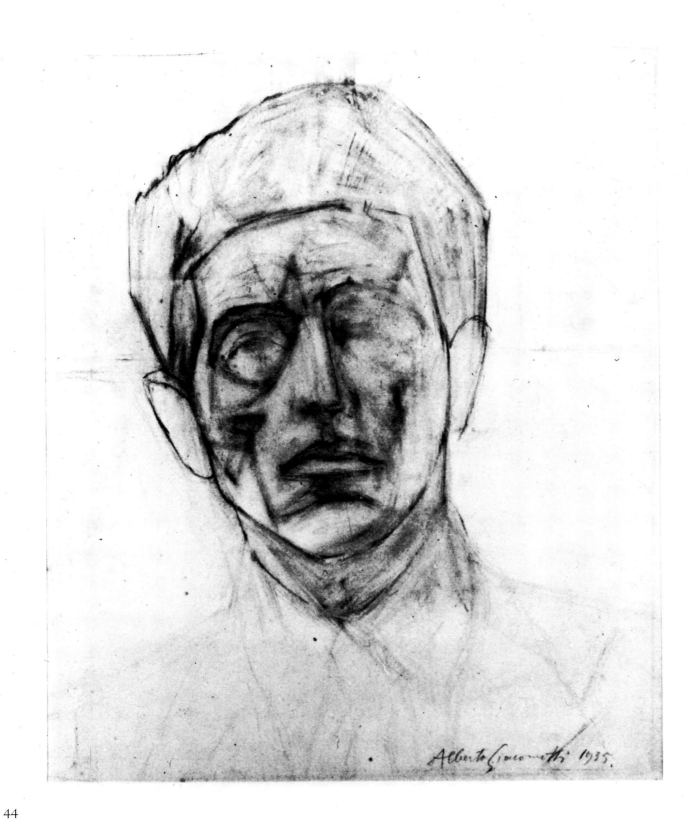

44

surfaces, sloping in different directions, running gradually or sharply from one to another. Look at the way the nose is a collection of planes sticking out from a flatter area. Think again of the skull. Even if you are not very familiar with its shape, you will recall that there are large, dark holes where the eyes go. In your living face, these holes, the eye sockets, are filled by the spherical eyeball, surrounded by all the muscles, fat and skin that make up the eyelids and so on in that section of your head. Thinking a little about how your face and head are constructed will help you to understand better what you are looking at.

Now, continuing all the time to look closely, work within your roughly drawn shape, gradually building up the portrait. If you realize the first drawn shape is wrong somewhere, alter it. Nothing is sacrosanct. Alter, change and improve anything you like.

Use whatever methods you wish to put across your thoughts. If drawing shadows seems like a good way of explaining how the head is solid and how the nose protrudes, use shadows. If you become fascinated

Fig. 2 (left) Self portrait by Alberto Giacometti, pencil.

Fig. 3 Self portrait by Janet Allen, pencil.

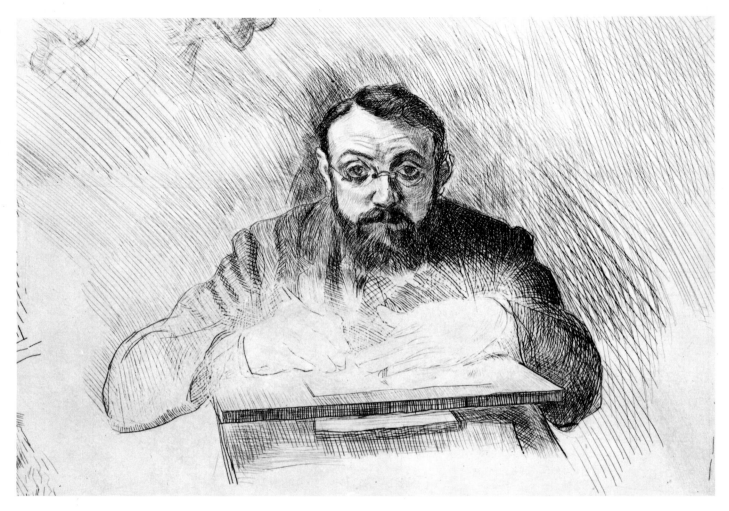

Fig. 4 Portrait of the Artist (as an etcher), *Henri Matisse, etching.*

Opposite. Self portraits, drawings, done by Matisse thirty-five years after the etching shown above. They display a brilliant economy of line employed to convey a highly complex subject.

by the apparent edges of things and a fine line would seem appropriate—use a fine line.

Consider, and think how to express in drawing terms, the way the skin or the flesh of the lips is so different from that of the cheek. How do you convey the quality of the hair? How do you make it seem to grow from the head?

Remember you are very fortunate. You have plenty of knowledge and inside information about this particular model.

The intention of a drawing is to convey ideas visually to the viewer. Describing a drawing verbally can be rather futile, but here it seems worth trying in order to start you thinking about and looking at other self-portraits to find aspects that you too have encountered in your own work.

Leonardo da Vinci's self-portrait (fig. 1) was drawn in red chalk when

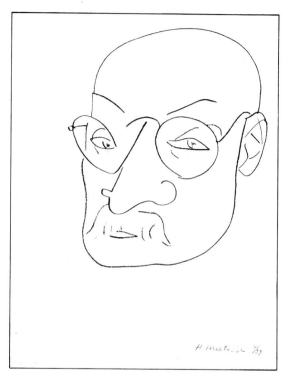

H. matisse /39

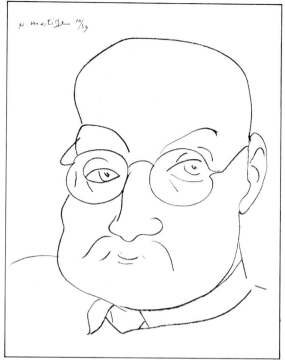

H. matisse 10/39

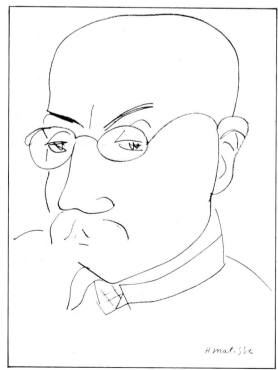

H matisse

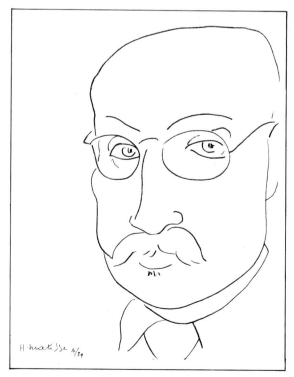

H. matisse 10/39

47

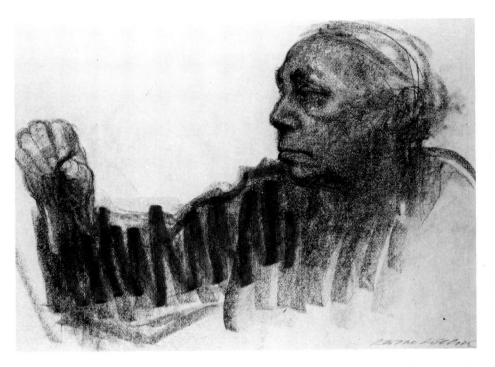

Self portrait by Kathe Kollwitz, charcoal.

he was about sixty years old. He is one of the greatest draughtsmen the world has ever known, and his supreme confidence and control of the medium are well displayed here. The delicate line work instantly conveys the idea of thinning white hair; the subtle shading shows the slight slackness of older flesh.

The self-portrait by painter/sculptor Alberto Giacometti (fig. 2) was drawn in 1935. At that time the artist was working a great deal from the human head, sculpting and drawing. This pencil drawing is clearly very much concerned with solidity and the planes of the structure.

The self-portrait by Janet Allen in fig. 3 shows the face reflected in a multi-convex mirror. This produces a complex set of different reflections of the head and the background behind the head. This makes fascinating repeating, but slightly differing effects, especially with the patterned clothing. Pencils ranging from 6B to 4H were used on a rough textured watercolour paper.

Henri Mātisse's self-portrait (fig. 4) is an etching, that is a print from a drawing made, in this case, directly from the subject straight onto the etching plate. The fine etched line is similar to the sort of line a very fine barrel pen will give. See how the different methods of *cross-hatching* (criss-crossing lines) build up tones of different strengths. Compare it to the four Matisse drawings, also self-portraits, in fig. 5, which were done thirty-five years later than this one. Those thirty-five years were packed with concentrated drawing, painting and sculpting.

Elements of Composition

Now that you have had some practical experience of drawing you will appreciate the points to be discussed in this chapter. Reading endless theorizing without having tried any drawing could easily frighten you off.

Think about how you got on with your self-portrait. Does the composition of your drawing look right? That is to say, does the figure seem to be placed in a satisfactory way on the piece of paper, or does it appear to be slipping to one side or slithering downwards out of the bottom of the picture? Composition—the very word 'composed' has a dual meaning, 'constructed' and 'restful'—means sorted out and organized within the area of the paper on which you are drawing. This does not mean that the entire surface of the paper must be filled in with drawing. There is nothing wrong with doing so, but alternatively, there is nothing wrong with drawing the figure isolated, but composed within the paper space. Compare the Picasso portrait in Techniques with these two approaches in mind. However you go about your drawing, packing it

Look about you and notice how the surroundings often form natural compositions.

full or being highly economical with your lines, you must be selective about the arrangement, or the design, within the paper shape.

Composing and/or designing is an entirely natural function. Everyone appears to start life with an inherent sense of design. Just look at the way children will draw, selecting and deciding on arrangements and colours as they go along. We all do it, to a greater or lesser degree, every day. Each morning you comb and arrange your hair and choose what to wear with what. You have definite preferences for certain designs, styles and shapes in all things, but especially so in the subjects which particularly interest you, be they cars, gardening, cake decoration or postage stamps.

In most cases, because of the nature of our modern lives, this designing ability becomes very much pushed into the background, not to say atrophied. There's doubtless a small vestige still lurking there and, having taken up drawing, you can encourage it to grow.

When you take a photograph you automatically compose the picture. You look through the viewfinder and, if your aunt has no head, you move the camera around so that her head appears inside the picture shape. Then you probably will go a step further and, assuming her patience will hold out, you move the picture space around to accommodate other things, part of the rose bush, a little of the lawn or whatever. This is composing and designing.

When you decide to study something with a view to drawing it, a whole gamut of experiences hits the senses. In the open air, contemplating a scene, there are all the physical experiences of the weather conditions. Perhaps the sun is burning hot, making your drawing paper glare; maybe there's an irritating cold breeze which, because you are standing still will gradually numb you to the bone. There are all the sounds—bees buzzing, traffic noise, birds singing; all the smells; the sensation underfoot of coarse grass, ploughed field or tarmac; in short, complete awareness. One of the great delights of taking up drawing is that it necessitates your putting yourself into a calm, reflective frame of mind, in order to be ready to concentrate and observe.

Similarly, faced with a still life, you not only see the objects sitting there, past experience instantly feeds you with numerous facts and thoughts. You know the slight rubbery feel of an orange without actually touching it and you recall its delicious smell. You know that a drinking glass is hard and shiny and that the basket is of a totally different texture and would creak if you were to touch it.

When drawing a figure—your own or someone else's, it is impossible to look at that person solely as an object. Initially all your preconceived impressions are bound to come welling up.

So, with all this diverse knowledge flooding in, how do you sort out something to put down on your paper?

If a solid three-dimensional object is shown on a two-dimensional, or flat, surface a great deal of selection must take place during the translation process. A camera, which produces a two-dimensional image of an object, makes the selection by recording only the effect of light falling on the object; if there is insufficient light, the camera simply does not record the object.

A camera doesn't reproduce the 'touchable' qualities of the object, although a good photograph will evoke them.

The colour photograph of the still life shown here can be seen as one stage in the selecting process. It is of an arrangement of coloured shapes on paper. The black and white photograph overleaf is another stage of the selecting process—not inferior, merely different. In the coloured photograph the very fact that the colour is still there means that the image is in one way more representative of the actual objects. Not so much selection or discarding has taken place as in the black and white

Below. The still life group shown here illustrates the ability of colour to add a particular dimension to an image.

photograph. Here the colours have been changed into different degrees of grey, ranging through from black to white. The camera has had to decide whether to represent a green area, for instance, as black or a dark grey. In a similar way, when you are going to make a drawing, you must decide how you are going to represent the multi-coloured, three-dimensional objects before you on a flat, two-dimensional sheet of paper, using the kind of marks your particular drawing tool makes.

The statement, 'I wish I could draw' surely means, 'I wish I could put over visually what I feel about the thing I am looking at.' It seems, as with word communication, that there are twin aspects to learning to draw. First, there is the physical dexterity—in language this means either getting your tongue around the pronunciation or coping with handwriting, two things we generally master at a very early age. Secondly, comes the organization and expression of ideas—a vastly more complex affair.

Below. This is a black and white reproduction of the still life shown on the previous page. The printing process has translated the colours into different shades of grey.

Consider this parallel in relation to learning to draw. First, you must have some sort of control over the drawing instrument. This control will develop the more drawing you do.

Now think about the second similarity. As with composition in the language or literary sense, there is also a basic 'grammar' for the visual arts. In order to communicate an idea in words one person will compose a sentence according to certain principles which are understood by those with whom he is communicating. These principles are so well known that the speaker does not have to think about them at all. This only happens when he encounters a new medium, as for example, when he attempts to speak in a foreign language.

You are going to make drawing the vehicle for your ideas. So what are the basic principles of the grammar of drawing—the components that make up a composition?

To begin with you must plan your drawing. You want to be sure that you will be able to get all you want to onto your piece of paper. A helpful device is the viewfinder. This acts in the same way as the viewfinder of a camera. It helps you to decide how much to incorporate out of what you see in front of you, isolating an area from its surroundings, thus enabling you to study that section in particular without being sidetracked.

Before making a viewfinder just try this simple experiment. Form your thumb and first finger to enclose a roughly square space. Hold your hand as far from your eye as you can and look at the view out of the window or within the room through the little square space. Move your hand around, still with your arm extended, so that you see different little pictures enclosed in the finger-thumb frame. Now bring your hand much closer to your eye. You will notice how much more of the view you can see when the frame is closer to your eye.

To make a simple viewfinder, cut out two L-shaped pieces of cardboard (cornflake boxes are fine for this). They should each measure 10cm (4in) along each inside edge. The width of the frame should be approximately 4cm (1½in). Having two L-shapes means you can combine them to make any sort of rectangular viewing space shape. Fig. 1 shows how to use a viewfinder.

Having decided on the shape of the rectangle you want, you can hold the frame together in that position with paper clips. They can then easily be unstuck and reassembled in a different shape for use with another drawing.

The viewfinder loses all its effectiveness if you set out to draw on a piece of paper which is not the same shape, i.e. a rectangle in the same proportion as the viewfinder itself. An easy way of ensuring that proportions relate is to lay the viewfinder on the paper so that two adjacent sides of the hole correspond with the top left-hand corner of

Fig. 1 A viewfinder will help you to decide which part of the scene to draw and how to arrange a successful composition.

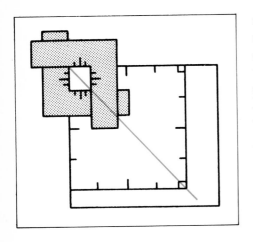

Use the viewfinder to establish an area of similar proportion on your drawing paper. (*Fig. 2*)

the paper. Lightly rule a diagonal line through the viewfinder rectangle and across your drawing paper. (It doesn't matter that the line will have a gap in it where it passes over the lower right-hand corner of the viewfinder frame.) Decide upon the size you want to draw within. Draw a line at a right angle to the top edge of the paper down to the diagonal line. At this point, where it meets the diagonal line, draw another line across, again at a right angle and parallel with the bottom edge of the paper, out to the left-hand edge. This forms a rectangle which is larger, but the same shape as, the viewfinder. Fig. 2 shows how to do this.

A further useful aid is to measure and divide the edges of the viewfinder hole into half and quarter measurements. Use a soft pencil which can be erased later. Lightly indicate on your drawing paper these half and quarter measurements too.

Each time you hold the viewfinder up you must be sure your hand is in the same position relative to your eye. Otherwise (as you saw in the thumb and forefinger experiment), the size of everything will be vastly altered. The half and quarter measurement markers will help you to establish the position of things: that tree in the landscape corresponds with the three-quarter mark; the roof shape fits vertically just left of the halfway mark and horizontally is just above the halfway mark. It means that, instead of being faced with a slightly frightening expanse of plain paper, you have some practical aids to help you get the drawing going.

As with all the grammar guidelines, the viewfinder procedure can be used with most kinds of subject matter. It will help you organize a still life or a drawing from the figure (it should steer you around that common pitfall of finding you can't get the feet in).

Regrettably, the viewfinder device does not work in such a straight-forward way when doing a self-portrait. Because you are looking at a reflection you find yourself looking at a reflection of your hand holding up a viewfinder which obscures your face!

You are doubtless familiar with the standard joke of the artist (complete with smock and floppy Rembrandt hat) doing something peculiar by holding his arm outstretched with thumb upright in front of his subject. This is, in fact, a very useful measuring device, easier to do with a pencil than with your thumb. Your arm must be fully outstretched. If you bend your arm the change in the scale of the pencil, which you are using as a measuring stick, in relation to the subject is really dramatic. Test this to see for yourself. Making sure your arm is fully extended, hold the pencil upright and slide your thumb down it to measure the height of an object—a building in the distance or an object on the table. Say the height of the building measures half the length of your pencil. Keeping your thumb in the same place on the pencil, bend your arm so that the pencil comes toward you. With the arm bent, line the pencil up with the object that you measured. When your arm was fully stretched

the building was perhaps half a pencil high. Now your arm is bent, the pencil is nearer and therefore looks larger. The building would now measure only one-quarter of the length of the pencil; your thumb, down at the halfway mark, is completely in the wrong place. This clearly demonstrates how, when you use this measuring device, you must always remember to keep your arm fully outstretched. All the measurements will then remain constant. During a drawing you use this aid to check the size of one thing against another.

Try this intriguing exercise to see for yourself how remarkable are the changes in scale in what we see. You'll need a piece of clear cellophane or acetate, some pieces of adhesive tape and a drawing medium that will adhere to the shiny surface of the cellophane or acetate. A few types of felt pen will do this, otherwise make a mixture of ink or poster paint and liquid detergent which you can apply with a brush. Fasten the cellophane or acetate to a window and draw, in outline, onto it, the objects you can see. To do this you will find it essential to close one eye. Each time you move, even a very little, the objects will slip out of their outlines, so you must carefully line them up again before resuming work. This is more difficult than you might think. It's most interesting to see how remarkably small familiar objects, that you know to be large, like houses, can actually appear. This is called 'drawing sight-size'.

Use the same principle when working from a still life group or a figure. We in fact rarely draw sight-size naturally. This time don't draw on a transparent material, use your normal paper. Endeavour to make your drawing absolutely the same size as you are actually seeing the subject. Measure frequently, using the pencil as a measuring stick, and the viewfinder device too, if you like. Before you begin the drawing it is wise to check the measurement of the total subject. If it is a standing model, and he or she appears to be only about 5cm (2in) high, you would be well advised to move in a little closer. Of course, don't get so close that the model is much longer than the pencil!

Perspective

While doing these sight-size drawings you will have become particularly aware of the way in which things, especially those objects whose form is based on a rectangular or cube-like shape, such as buildings, appear to be full of sloping sides and angles. This feature is perspective. This needlessly awe-inspiring subject is, in fact, only one method of conveying the idea of three-dimensional space on a two-dimensional surface. It is really a kind of trick and not an exact parallel of what we actually see. We see with two eyes—with binocular vision. As our eyes are spaced apart, we see a slightly different view with each eye.

Hold a matchbox up in front of you so that the narrow end, with the drawer, is facing you, and just a very little of the right-hand rough

Although you know that the lines are parallel, the two sides of this track across the desert seem to converge at the horizon. This is the basis of perspective.

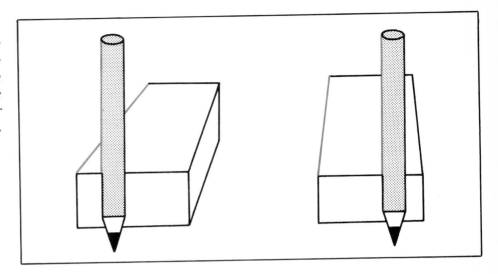

Fig. 3 Because of binocular vision, how things appear with both eyes open (the matchbox on the left) will be quite different from how they are seen with one eye shut (matchbox on the right). Thus we perceive depth in our field of vision.

striking side visible. Hold it so that you can see it comfortably, without squinting. Now close your right eye. The striking side will disappear. You don't see that view of the box with the right-hand striking side with your left eye, which is now open, only through your right eye.

Now, with both eyes open, look at the long left-hand top edge of the box that is coming toward you. Alternately open and close left and right eyes, the whole box itself will appear to jump across a little each time. Observe the apparent change in the angle of the slope of that long left-hand side. When viewed through your left eye, the angle is much nearer the vertical than when it's viewed through the right eye. Hold your pencil up in front of the box to verify this. (Incidentally, watch how the position of the pencil in relation to the box mysteriously changes.) Fig. 3 illustrates this.

These simple tests demonstrate how we actually see slightly around the side of things with our own particular human type of binocular vision. This ability assists us in assessing the three-dimensional aspect of objects—how they come forward or recede.

The theory of perspective drawing was developed during the Renaissance. It is one of those subjects that has become cloaked in mystique, but the basic principles upon which it all rests are not difficult to understand. The theory assumes that you see through one eye only, remaining in a fixed position—just as you do when you make a sight-size drawing on cellophane. Normally when we look at a scene our eyes flicker all over it, gathering and assessing information. So drawing in perspective is like catching and freezing one phase of this scanning process, as if seen through one eye.

If you have tried the sight-size exercise on cellophane, you will know that it is not a very convenient way of working. It is also surprisingly

difficult. You don't always have a handy window between the subject
and yourself, and you certainly don't want to confine your materials to
clear cellophane and an ink and detergent mixture. If you grasp the
simple principles of perspective you can apply them wherever and with
whatever you are drawing. Fig. 4 shows a woodcut print by Albrecht
Dürer depicting an artist making a perspective drawing of a figure,
using various aids. The procedure shown here is a natural follow-on
from the clear cellophane drawing exercise, so do try something similar
yourself. The artist placed a vertical glass screen between himself and
the model. On it and the paper he painted an accurate grid of squares. He
used the obelisk-like object in front of him on the table to line his eye up
as his head was bound to move about while doing the drawing; this
enabled him always to return to exactly the same position. He looked
through the screen and he could see the way in which each piece of the
model fitted within each square. He could then draw what he saw in the
glass squares onto the squares on his paper.

The glass screen represents what is known as the *picture plane*. That
would normally be an imaginary upright surface between the artist and
what he is observing and drawing. In the case of the Dürer illustration
the glass screen forms an actual, touchable picture plane.

When you look out of your single (for perspective purposes) eye, you
perceive, in effect, a cone of vision radiating out from the eye. Fig. 5 is a
simplified version of Dürer's artist who has substituted three apples, all
of similar size, for his model. The lines radiating from his eye represents
the lines of vision to each of the apples, passing through the picture
plane (the glass screen).

The apples are arranged one behind the other, but not quite in a
straight line. Were they in a straight line in front of the artist's eye,

*Fig. 4 This woodcut by Albrecht
Dürer shows an artist studying
perspective. The screen between the
artist and the model represents what
is known as the picture plane.*

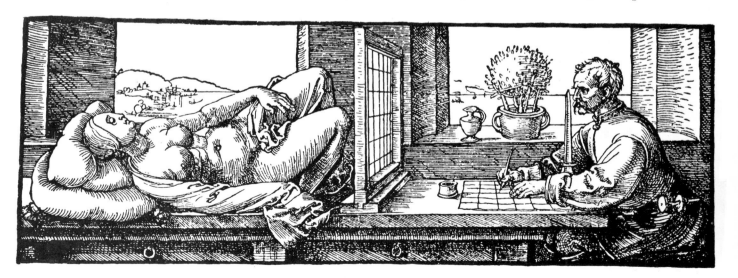

apple C, because it is nearest to him, would appear largest and would obliterate the other two.

Where the lines of vision pass through the picture plane, they are, as it were, trapped on it to make the picture. Imagine yourself in the same room as Dürer's artist. You are looking straight at the apples from the viewpoint of Dürer himself. Each apple is more or less the same distance away from you and therefore each appears approximately the same size. From the viewpoint of the artist who is portrayed, they vary considerably in their distance from him. Apple C features large in his cone of vision and is shown as the tallest on the picture plane. Apples B and A diminish markedly.

Try a similar drawing yourself using tea cups, sugar cubes or any group of objects that are more or less equal in size and shape. As you go about, look out for the phenomenon too. See how the heads in a crowd diminish in size toward the back rows; how the pebbles on a beach merge from being distinct oval shapes into a texture in the distance.

The René Magritte painting (fig. 6) done in 1955, creates a delightful joke out of the conception of the picture plane.

Next, consider the eye-level. This is a horizontal line right across what you are looking at and across your drawing. It is literally at the level of your eye. If you squat down, your eye level goes down with you; stand on a ladder and it goes up with you. The earth's horizon always coincides with your eye-level. Note this in the Van Gogh drawing in fig. 7. The horizon/eye level is high up on the drawing. The straight line of the horizon is here interrupted by the irregular edge of the hills in the far distance. The artist was drawing from a high point—the title is *La Crau, seen from Mont-Majour*—looking across a wide valley. Imagine the flat, cultivated plane seen from the viewpoint of someone standing in the lane that slants across approximately the lower third of

Fig. 5. Distance alters the appearance of size as shown by this adaptation of Dürer's woodcut.

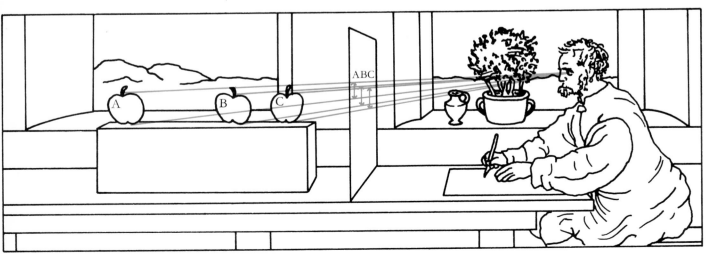

Fig. 6 In this painting, Euclidean Walks *by René Magritte, the canvas becomes the view out the window which, after all, is the subject of the painting.*

the picture. Their horizon/eye-level would be much, much lower down and consequently they would see far less of the fields laid out before them.

In the John Constable sketch of Salisbury Cathedral from the north-west (fig. 8), the artist is drawing positioned on the flat ground plane, not above the scene.

We have seen in the Dürer illustration how the lines of vision form angles for the eye to take in objects. The further away an object, in our

Fig. 7 La Crau, seen from Mont–Majour, *Vincent Van Gogh, pen and ink.*

example an apple, the narrower the angle becomes. If our artist were supplied with a great many more apples, all placed one behind the other on boxes of equal height to the original one, the apples furthest away from him would appear minute. If circumstances permitted, enough apples could be laid out so that the ones right at the back appeared so tiny he wouldn't be able to see them.

No doubt you have observed a similar phenomenon when looking at a long straight line of telegraph poles. You know they are all the same height and all equally spaced and yet they literally seem to disappear into the distance, getting smaller and closer together. The angles of

vision through which you perceive each telegraph pole are getting narrower and narrower.

Any pair or more of lines that are parallel to one another will appear to converge as they recede into the distance. This is very apparent when looking down a rail track. The word 'line' here does not necessarily mean an actual visible line, but it can be an imagined line linking, for instance, all the bases or all the tops of the telegraph poles together. It can also refer to the edges of a surface or plane.

The place at which the parallel lines meet is called the *vanishing point*. Any parallel lines receding from the viewer (sides of a building, edges of a road, sides of a table), that are horizontal will always appear to meet at a vanishing point on the horizon/eye-level. These horizontal lines are always parallel to the ground. They can be on the ground like a roadway, or above or below the horizon like the sides of a building.

Fig. 8 Salisbury Cathedral from the Northwest with cottages, *John Constable, pen and bistre ink.*

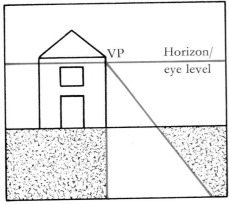

The diminishing effect does not apply to horizontal lines that are viewed parallel to the observer's eye; that is straight in front of you, as the apples that were straight in front of Dürer himself.

If you stood in the window on the first floor room of a building next door to this house, it would look like the drawing in fig. 9. The only perspective angles here are in the road. Move into a similar first floor window on the opposite side of the street and the angles immediately appear in the house (fig. 10). All the parallel horizontal lines can be seen to be extending to meet at vanishing points on the horizon/eye-level. The parallel lines of the sloping roof meet in a vanishing point way above the horizon. This is because the plane of the roof is not parallel to the

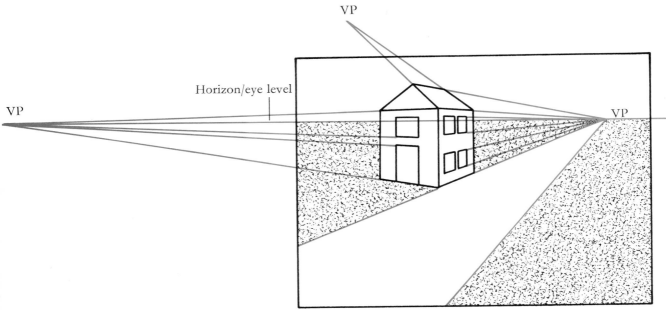

Fig. 9 (above), fig. 10 (right) In both drawings VP is the vanishing point. Fig. 11 far right, The Annunciation, Carlo Crivelli. Use a ruler to trace the lines in the composition back to the vanishing point. Although the painting is very complex there is only one vanishing point.

ground, but at a different angle. The vanishing points of such lines can be situated anywhere, that is, wherever they logically extend to and meet.

As you see, the vanishing points, whether of horizontal or other types of parallel lines, may well be outside the actual picture. If you need to, you can always add extra pieces of paper to help with your perspective construction.

Fig. 11, *The Annunciation*, painted by Carlo Crivelli in 1486, is a classic example of the use of perspective. In fig. 10 the house is viewed slightly from the side so there are two vanishing points of the horizon/eye-level. In Crivelli's picture, which at first glance looks very complex, the scene is represented from a straight-on viewpoint. Therefore there is only one vanishing point.

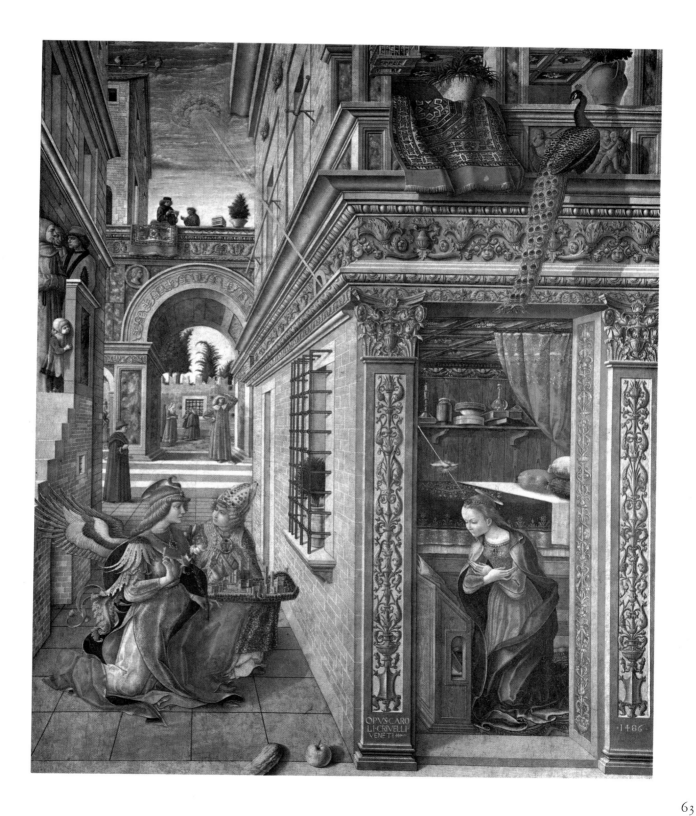

63

Fig. 12 In his pen and ink drawing of The Sea at Saintes-Maries, *Van Gogh uses several tricks to give an impression of depth: lines of diminishing size and variety and less detail on the distant boats.*

Look at the brickwork on the wall in the centre of the picture. The lines of mortar are all parallel and all horizontal (parallel to the ground). Find, with your ruler or a set square, the one that is actually horizontal on the picture. This is the one that coincides with the horizon/eye-level. Look across to the smaller scale bricks on the other side of the passageway. There you will also find a corresponding horizontal line. Above this, all the parallel lines that go back into the picture slope downwards toward the vanishing point. Below it, all parallel lines slope upwards to the vanishing point.

The lines between the paving stone upon which the angel and the

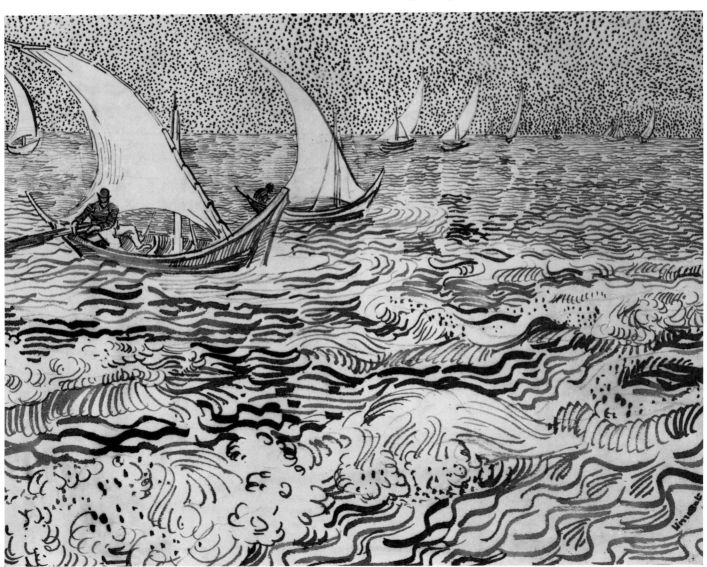

saint are kneeling obey the same rules. Follow the central one, which is vertical. The vanishing point lies where this line and the horizontal brickwork line intersect. The point is positioned in the bottom right-hand corner of the coat of the distant figure with a red hat. All the other horizontally parallel lines in the composition can be extended to meet at this point—even the steep edges of the roofs and the interior decoration of the ceilings on both floors.

Do have a good, long look at this picture—at the original in the National Gallery, London, if you can. In addition to the beautifully painted building it is full of wonderfully observed studies of still life groups, birds, sky and people, all considered in perspective, and thus contributing to the illusion of three-dimensional space.

The device of diminishing size to give the illusion of space can be used with any subject matter. As well as the possibly more obvious examples like buildings, it can be applied to textures or patterns. The Van Gogh landscape in fig. 7, again demonstrates this well. Similar drawn textures are used on the fields bordering the lane and on some of the fields way over in the distance. The scale of the texture is much reduced in the latter.

Objects nearer to the viewer not only appear larger, they also appear more clearly defined; detail is more evident; they are stronger in colour and more contrasting in tone too. Think of looking out to sea, especially on a mild hazy day. Standing by a boat that is lying on the beach you can see all its details, every nut and bolt, the grain of the wood, the texture of the seat. In a similar boat, some fifty yards out to sea, you will still be able to discern the colours quite clearly and know what the occupants are wearing. A craft much farther out will appear as a blue-grey silhouette shape. You'll probably be able to tell if there are one or two people on board but your eyes will be unable to give you any information as to the boat or the occupants' clothing. An object appears less distinct the farther away it is from you because there is more atmosphere between you and the object. See the Van Gogh drawing in fig. 12 for an illustration of this fact.

The types of marks we make in a drawing are largely governed by the medium being used. When wishing to convey an idea via a visual symbol—which is, after all, what drawing is about—the automatic action is to draw in line. Imagine you are on a holiday abroad and you cannot speak a word of the language. You are looking for a camping site. You accost a native and either with a ballpoint pen on a scrap of paper or with your finger in the sand you outline the shape of a tent. This is the basic drawing method—putting a line around something. The native will either get the message or not depending on how convincingly you have captured the shape. If he stands there looking vacant no amount of shading, however exquisitely applied, will help.

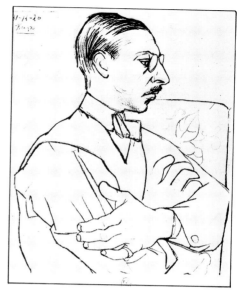

Fig. 13 Portrait of Stravinsky, *Pablo Picasso, pencil.*

65

Tents don't have lines around them, any more than human figures, or trees, or buses do. The line is an abstract convention and it is universally understood as such. Also, the line is a mark made spontaneously, as if it's instantly seen as being the way to convey an idea—think about this. It is totally automatic in handwriting, we are so very familiar with drawing the various letters in linear form (in line) that we don't think twice about it. We only stop to think how we are going to form the letters when we are faced with writing or printing in some unusual circumstances. This occurs, for example, when hand-lettering a notice or a poster or handwriting an important letter.

Writing is, however, putting a line around a flat shape. It is not concerned with representing the illusion of a solid object (or objects). How can line be used in this context? As with the tent example, an outline can produce a most telling image. But it is worth noting that it

is only certain views of an object that will convey the message so clearly in outline alone. It must be a view that succinctly sums up the character of the object, rather in the same way as a silhouette does. In many instances, a line around the outside alone would mean very little. An outline of a human head, with plenty of hair, facing toward you will give you much less information than a linear profile of the same person. Look out for trade marks, symbols and other examples of design that exploit the significant shape idea, either in outline or in silhouette form.

The various ideas mentioned in the section on perspective can all be brought into play in a line drawing. However, and this applies to whatever kind of drawing you are doing, it is no good simply applying a mechanical formula. That will produce a lifeless, mechanical drawing. You must study your subject and think your way around it; imagine what it feels like—in fact, let all those feelings that were discussed at the beginning of the chapter come flooding in.

Objects can be shown diminishing in size in a linear way. The actual nature of the line itself can also be changed and adjusted to suit what it is portraying. Its thickness and density may be altered. It can be made strong or tentative, definite or nervously dotted. With your own drawing materials see how many types of line you can make.

Objects, or parts of an object, can be shown to overlap and partially obscure other parts. This indicates that one thing is in front of another. It can also show that one thing is affecting another. This can be seen in the linear Picasso pencil drawing (fig. 13). The sitter's left hand is clearly near the viewer. The attitude of the hand (the way in which the outline correctly captures the shape) and the tension lines as the shirt sleeve is pulled down indicate a model slightly ill at ease. Look at his face—he doesn't look relaxed. Note the way in which, all in the minimum of lines of a similar weight, the left arm is shown to recede.

The fine Matisse self portraits (fig. 5 in the Project chapter) are drawn in a crayon line. During his very active working life, Matisse made many, many drawings from the figure. Frequently, he would make highly detailed studies, often of the same pose, several times over. He would be familiarizing himself with the form. This knowledge gave him the confidence to put down these rapid kinds of drawings, where shapes are sized up and expressed in such a pithy way. If you are unsure of the idea you are wishing to express you cannot put it down with such assured nonchalance.

As you think your way around, over and across the subject you will find that you are using line, this abstract convention, to explain different types of things. As we have seen, line not only goes around the edges of an object, it can go up and over it, following the contours.

It can be used to indicate an edge where one colour changes to another and where one plane meets another plane.

Tone

In his pen and ink drawing of a dazzling day at the sea (fig. 12), Van Gogh uses line technique in a way that builds up areas. This approach is rather like making a painting. One area is seen against another; all are seen as parts of the entire composition. The lines are massed together in their different ways to constitute the appropriate texture and the appropriate tone or weight for that section of the picture. In the foreground there is plenty of contrast between the heavy, tempestuous black lines on the white, making the waves sparkle and splash about. Going back toward the horizon the water is drawn in a series of gradually diminishing lighter, parallel, slightly wiggly lines with some white gaps. This part of the sea seems to shimmer. Amazingly enough, seen in this context, against this particular shimmering texture of the water and the intense white of the sails, lots and lots of little black dots read as a bright blue sky! The sails appear bright and white because they are surrounded on all sides by textures.

Here Van Gogh is using different weights, or tones, in his drawing to parallel, in black and white, the colours and the surface qualities of what he sees.

Tone, that is, areas of light and dark and all the grades in between, can be used in an infinite number of ways in drawing. An artist can employ tone to model the shape of an object, to give the illusion of its being three-dimensional.

The way in which light falls on an object has a profound effect upon explaining what that object looks like. Take a commonplace example: In the dusk it's difficult to recognize a person walking toward you, there is only a limited amount of light falling on that person—sufficient for you to know that it is a person and not a camel approaching you. Only when they step onto the lighted porch do you recognize them.

When you were setting up your self-portrait it was stressed that the lighting should remain constant. Natural light is extremely capricious, moving around all the time with the sun going in and out of clouds.

Here is a very useful exercise which really helps you to see how light explains the three-dimensional forms of objects. Gather together several white objects to set up in a still life group on a piece of white paper with a white background. Find something based on a cylinder, this might be a mug or a roll of paper; a spherical object, say a table tennis ball; and something cube-like, perhaps a white box. Use a drawing medium that you feel happy with as a tone-maker. This may be pencil, different grades can be used gently to construct tones, or charcoal, both perhaps worked in conjunction with an eraser which is also used as a drawing tool; brush and dilute ink—whatever you wish. Try to work with the minimum of lines. Use them only to construct (tentatively) and plan out the drawing.

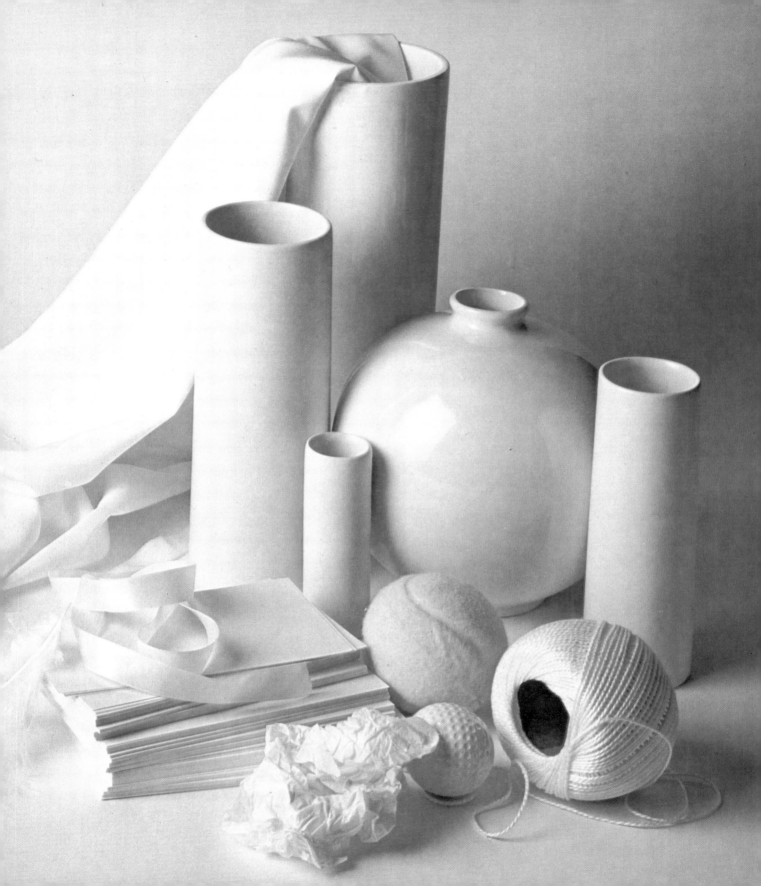

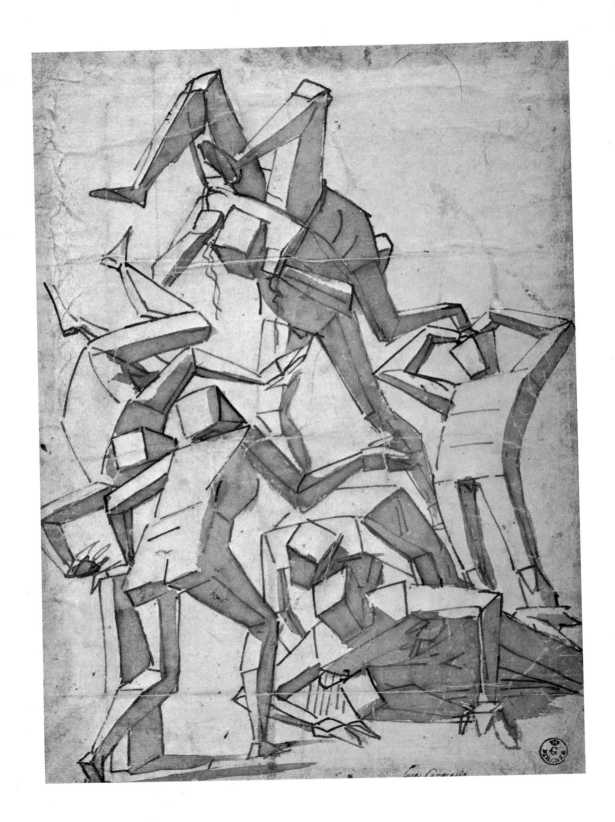

Luca Cangiasi

Arrange your still life so that it is lit, more or less, from one side, as opposed to being lit from above. Place the objects so that parts of each of them are in front of the others. Make your drawing, using any of the measuring devices that seem applicable. The viewfinder will be especially useful here. Study the group carefully and compare how light or dark the parts of the objects are, one against another and against the white background and the white base. See how very much the tones vary, even on a flat piece of white paper. In some cases the lighted side of an object will appear to be much, much brighter than the background behind it. In other instances the reverse will apply. There will be reflected light catching the objects too. This is illumination, not from the main source, but reflected back onto the articles off the wall or the surroundings.

Remember that your white paper is the lightest tone you have at your disposal. Try to chart the different grades of tone there are in the whole group. Don't forget that, as in the Van Gogh sea picture, a white can appear extra white because it is isolated in the middle of several tones.

Upon reading this, the description of the contents of the still life may seem monumentally dull. However, as soon as you grasp the essential aim of the exercise you'll see that going right to the basics is vital. These forms, the cylinder, the sphere and the cube are the fundamental bases of all natural forms. They may be distended or compressed, the sphere may become egg shaped, the cube more rectangular—but everything can be sorted out to be seen to be based on these three forms. Do remember this when faced with a complicated object—the human figure for instance. The Luca Cambiaso pen and wash drawing in fig. 15 clearly shows him planning a composition with this sort of practice in mind. The drawing was done in the sixteenth century, but it presages the twentieth-century Cubists.

Having made your study with the light coming from one side, try some different lighting just to see how drastically the appearance of the still life group changes. Shine a flashlight on it, from different directions, in a darkened room. This produces stark, sharply contrasting results like dramatic theatre lighting.

Tone and line may, of course, be used together in a drawing, as in the Luca Cambiaso example, the Constable in fig. 8 or the Holbein in fig. 16. The use of tone alone in the exercise was to emphasize the point and to encourage you to look in a new way. Notice in the Holbein, as you will see in many other drawings, how the surface on which the hand is resting is indicated in tone. Objects are not seen in isolation but always in relation to other things. Even this slight suggestion places the hand in a three-dimensional situation.

Another intriguing project to try with your all-white still life group is interpreting it in colour. When you look long and hard at it you will see that the whites themselves vary considerably. The actual materials that

Fig. 15 (left) Group of Figures, *Luca Cambiaso, pen and wash.*

the different items are made of are all different kinds of whites. This is local colour, the basic, inherent colour of something. Some objects will be bluish-white, some creamish, some even pinkish. The tones of the shading on them are not merely shades of a nondescript, equal grey. There are all manner of subtle colours within the greys. Colour has a grammar of its own.

Try out some different kinds of linear interpretations of the group. These could be in colour too. Keep your basic still life forms and use them for exercises of your own devising.

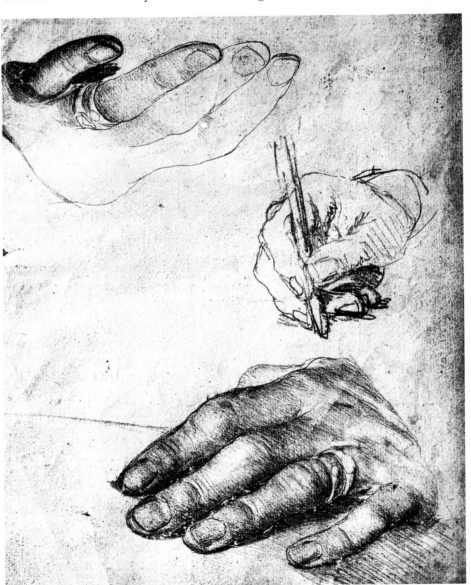

Fig. 16 Study of Hands, *Hans Holbein, pencil and red chalk.*

Improving Observation

Having looked at the constituent elements of the visual language, consider further how these elements can be used. Several examples are shown in this chapter which study either one particular element, or a group of them. Use these illustrations to stimulate your own ideas, trying a similar approach yourself, but not necessarily of the same subject matter or in the same drawing medium. Pick out certain elements and examine them closely in relation to your drawing.

The art student who did the drawing in fig. 1 has tackled perspective drawing by, first of all, marking out a grid of squares on the floor in masking tape. The furniture is then positioned randomly over the grid. In the Dürer perspective drawing shown earlier, the network of lines made a flat grid superimposed on the drawing. In these examples the grid is an integral part of the still life group. It, as well as the objects in the group, is seen to be receding and diminishing in size (perspective). You can sense that the parallel sides of the squares that go back across the floor would, if extended, eventually meet at a vanishing point.

The squares assist the artist in plotting the position of each article and in checking the scale of one item against another. Both drawings use a linear pencil technique.

Try a project of this kind yourself. Either set up your objects on an accurately constructed network of squares or use a suitable, already squared surface to serve the same purpose. Square tiles would be ideal—or a check tablecloth. Deliberately set out to draw what the spaces between the objects look like. You'll be looking at irregular areas, with on some occasions, the rigid divisions of the grid lines cutting across them.

Remember the suggestions for measuring and composing the drawing. Another useful aid to help you sort out what kind of an angle a line is lying at is to use a small, transparent 45° set square (this is the type with a right angle and two equal 45° angles). It is often very difficult to decide just how an angle is sloping or whether a line is actually horizontal or vertical. To check a line that is near the horizontal, hold the set square up in front of you and line the vertical side up with some subject you know to be vertical. In a landscape this might be the corner where the walls of

a house meet. You'll be able to see, because the set square is transparent, whether the near-horizontal line coincides with the horizontal edge of the set square, or at what sort of angle it slopes up or down away from the horizontal. The same principle applies to near-vertical lines. In the same way, you can use the 45° angle to estimate the direction of similar types of angles. Is the line on the 45° line, halfway through the 45° angle, and so on?

The sensitive drawing in fig. 2, is another visual statement of a way of thinking that links up with the two previous drawings. A large and very varied still life was set up—all sorts of things. The idea in this project is to take the viewer for a walk across a section of the still life group; to follow a trail across it. The string that snakes around and over the objects and across the floor marks out the trail. Careful observation is called for to note the effect of perspective upon the objects and to see just how one

Fig. 1 (below) Upturned Stools, *Debbie McCarthy, pencil.*
Fig. 2 (right) Still Life, *Nicola Fredricks, pencil.*

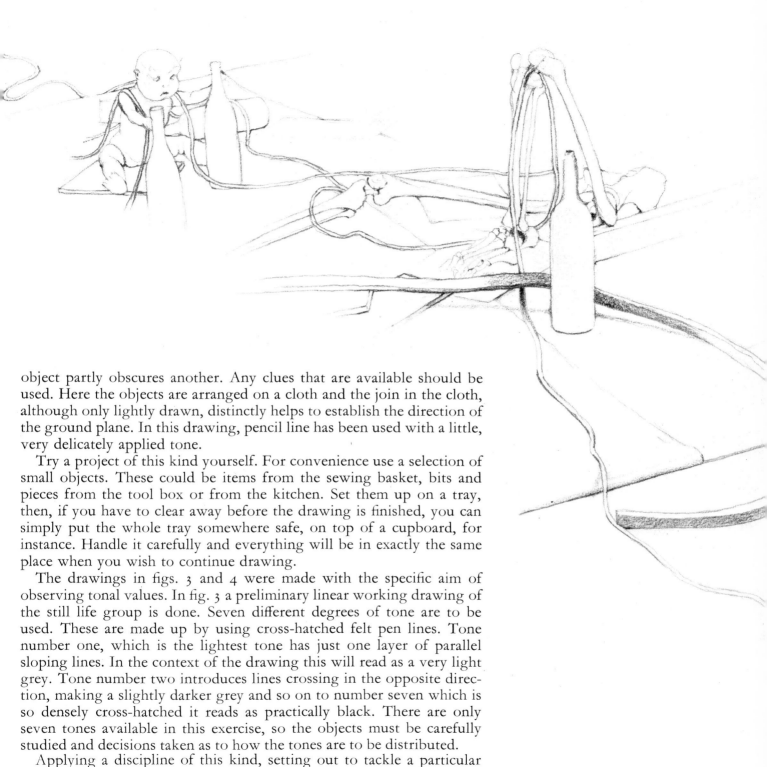

object partly obscures another. Any clues that are available should be used. Here the objects are arranged on a cloth and the join in the cloth, although only lightly drawn, distinctly helps to establish the direction of the ground plane. In this drawing, pencil line has been used with a little, very delicately applied tone.

Try a project of this kind yourself. For convenience use a selection of small objects. These could be items from the sewing basket, bits and pieces from the tool box or from the kitchen. Set them up on a tray, then, if you have to clear away before the drawing is finished, you can simply put the whole tray somewhere safe, on top of a cupboard, for instance. Handle it carefully and everything will be in exactly the same place when you wish to continue drawing.

The drawings in figs. 3 and 4 were made with the specific aim of observing tonal values. In fig. 3 a preliminary linear working drawing of the still life group is done. Seven different degrees of tone are to be used. These are made up by using cross-hatched felt pen lines. Tone number one, which is the lightest tone has just one layer of parallel sloping lines. In the context of the drawing this will read as a very light grey. Tone number two introduces lines crossing in the opposite direction, making a slightly darker grey and so on to number seven which is so densely cross-hatched it reads as practically black. There are only seven tones available in this exercise, so the objects must be carefully studied and decisions taken as to how the tones are to be distributed.

Applying a discipline of this kind, setting out to tackle a particular

problem of observation and drawing interpretation is far more useful and informative than idly sketching with no real aim in view.

A coat hanger, seemingly most linear of subjects, is interpreted in fig. 5 completely in terms of tone against tone. As well as the changing values within the coat hanger itself the varying tones of the wall upon which it is hanging have been discreetly used to help describe the form. Because of the careful observation you can tell that this is a metal object against a flat matt surface.

From the range of drawings reproduced in this book it will be evident by now that subject matter is incidental. You can draw anything. Looked at with the attitude of an artist, any article is potentially interesting. New sensations, new sights are, of course, stimulating, but hurrying down to the south of France is not an essential prerequisite of the artist. What you see in the mirror, through your own window or in your own backyard can supply you with a profusion of material from which to work, now that you begin to know what you are looking for.

Traditionally artists have always made a practice of drawing from the

Figs. 3 and 4 Tonal Study, *Debbie McCarthy, felt pen*.

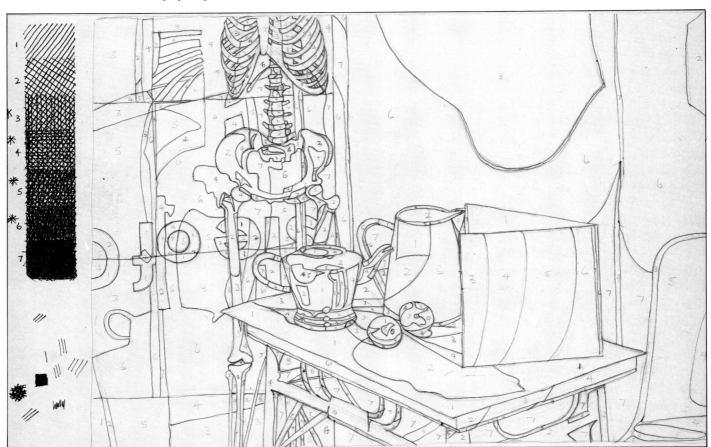

nude. Very probably they like nudes, but this isn't the sole reason. It is, once again, a case of getting down to basics. The clothing on a figure obviously obscures and disguises the form. If you can, try to get some experience of drawing from the nude. There may well be a life drawing class somewhere in your locality. Alternatively, a group of people who are interested in drawing and painting might club together and hire a model. If you simply can't obtain a life model perhaps someone would pose in a swimming costume; you will be able to see the structure of the body.

The local museum may have a human skeleton for you to study. Get an artist's anatomy book from the library and see how the muscles, etc. are fitted onto the basic framework of the skeleton. Have the book by you when you are drawing from the figure so that you can sort out why things look as they do.

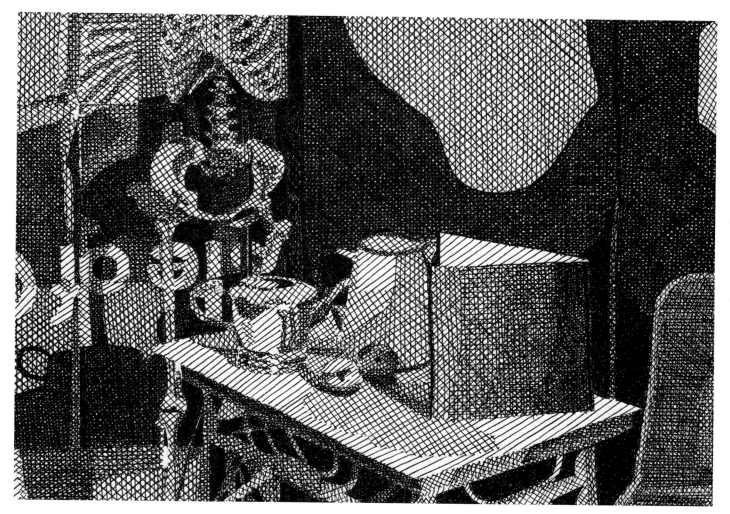

Fig. 5 Coathanger, *Hannah Hatchman, pencil.*

Try, if at all possible, to arrange for the same model to be available for a number of sittings. Use the time sensibly. Have a set pose for a drawing that is going to be worked on over a period of time. Use chalk to mark the position of the model's feet, hands and other relevant parts on the floor and also the furniture so that he or she can easily resume the pose after taking a break.

Use part of the session to make some quick drawings. Work in a medium that lends itself to producing rapid, immediate marks—perhaps charcoal or Conté. Or, like Rembrandt in this swift study of a sleeping girl (fig. 6), you could use a brush and wash. Ask your model to take up a pose for a very short time, three minutes, say. As the pose is brief it can be a more than usually energetic one. Do a number of these short pose studies, a new pose after every three minutes. Then, ask your model to walk around, perhaps repeating a movement like dropping a scarf and picking it up again. Draw as the figure is actually moving; this is an excellent way to train your visual memory. You will find you have

to do a great deal of looking and careful observing. You have to fix a phase of the movement in your mind and then try to put the whole thing down on paper. When your memory fails you, pause for a second until the model again goes through the particular motion that you are studying, and watch out for the part that's eluding you. Try this same approach to drawing children and animals.

A great help in figure drawing is to think yourself into the pose. Imagine you were actually standing, leaning or sprawling like the model. Think which part of your body would be supporting your weight.

The Michelangelo drawing (fig.7) shows his skill in anatomy. The figure is under strain and the muscles are tensed and hard. It is

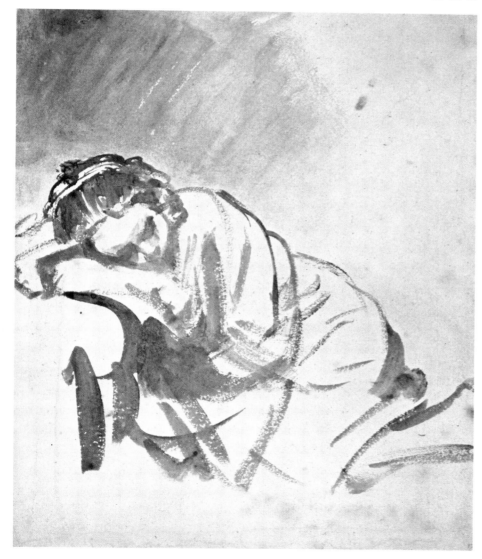

Fig. 6 Study of Sleeping Girl, *Rembrandt, brush, ink and wash.*

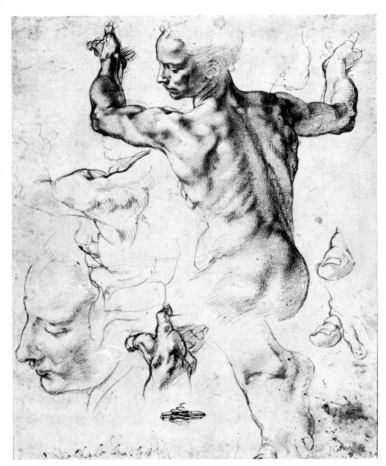

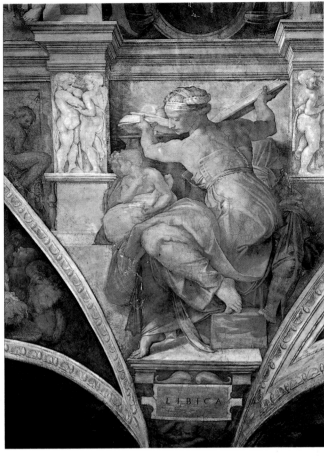

Fig. 7 (left) Study for the Libyan Sibyl, *and right, the completed fresco in the Sistine Chapel, both by Michelangelo.*

interesting to see how the use of the lighting conveys the rectangular space beyond the figure's head, enclosed by the upheld arms. Note also the various drawings of toes, etc. This is absolutely a working drawing, clearly demonstrating the process of discovery through observation.

As with any pursuit one can become quite complacent when drawing from the figure. There's always the danger of slipping into a comfortable way of drawing, of developing a reasonably successful formula and forgetting all about looking and observing properly. The next project, illustrated in fig. 8, gives such possible creeping complacency a shuddering jolt. A group of art students made self-portrait drawings on a massive scale. If you have a large enough room, you can try it too. A number of sheets of paper must be joined together and fixed to a suitable working area. A drawing medium of an appropriate scale is chosen, thick charcoal sticks or very soft pencils.

The artist must study his or her face in a looking glass, memorizing not only a particular feature or section, but how that section appears in

relation to the whole. He then has to move away to work on the immense drawing surface, standing on a ladder, if necessary. He must keep standing back from the drawing to see it as a whole; to see if the various parts are being kept in proportion to one another and correctly positioned within the total framework. Manoeuvring tones and textures is vital too. Working on a scale where the drawing of the iris of your eye is actually the size of your own torso means you are looking at a familiar subject in a completely new way.

This same enquiring type of visual investigation can apply to anything. Of course, this doesn't mean everything must be drawn on a gargantuan scale! Next time you are cutting up vegetables, stop and consider them as potential drawing study material. The intricacies of the construction of a cabbage or cauliflower—this same relating of the parts to one another and to the whole—could provide a superb drawing subject. Flowers and plants offer a wealth of material too.

The fascinating idea behind the drawing by Hannah Hatchman in fig. 9 could be applied to a limitless selection of materials. The idea is to choose some objects with very different textural qualities and to try to

Fig. 8 Giant self portraits by the students of the West Surrey School of Art and Design.

represent these qualities in drawn form. The objects used here are feathers, fibreglass, a paper doily, fur fabric, and crumpled tissue paper.

In the same way as you think yourself into the model's pose, think your way around and over the objects in a still life group or a landscape. If it's feasible, walk around the subject so that you can get a more complete understanding of what it is like and how it is constructed. Remember how the cylinder, the cube and the sphere are the forms upon which all objects are based. Thinking of this can help in sorting out apparently amorphous things like clouds and trees.

Draw as much as possible from the real thing although drawing from photographs is sometimes necessary. For instance, you may need some

photographic reference for an object that is unobtainable. What a photograph can give you is always limited, compared with your direct experience of the object. A photograph is only one single view. There is no chance to walk around and see the thing from different points of view. Also the photograph is, as it were, some other person's way of transferring the three dimensional into the two dimensional. You have not been in control at all.

Endeavour to bring the elements of the visual grammar all together in your drawing. This is, obviously, no easy task. Clearly, as with any pursuit, the more you practice it, the better you become. Do THINK about your drawing. Give yourself a specific project or aim so that you

Fig. 9 Texture studies by Hannah Hatchman, pencil.

have a definite direction in which to work. As you progress, increase the number of aims within your projects. Consider how many factors Degas was dealing with in the coloured pastel drawing in fig. 10.

Date and keep all your drawings. You will then be able to chart your progress. Do also make written notes, even only the odd sentence about what you are endeavouring to achieve and how successfully—or otherwise—you have fared. Analyzing your progress in this way helps you to sort out what you are doing logically. Discussion with other people who are also involved in drawing and the visual arts will stimulate ideas, and looking at original drawings in museums and galleries is invaluable. You can approach them now to see how other artists have handled what you yourself are working with.

Fig. 10 Before the Mirror, *Edgar Dégas, pastel.*

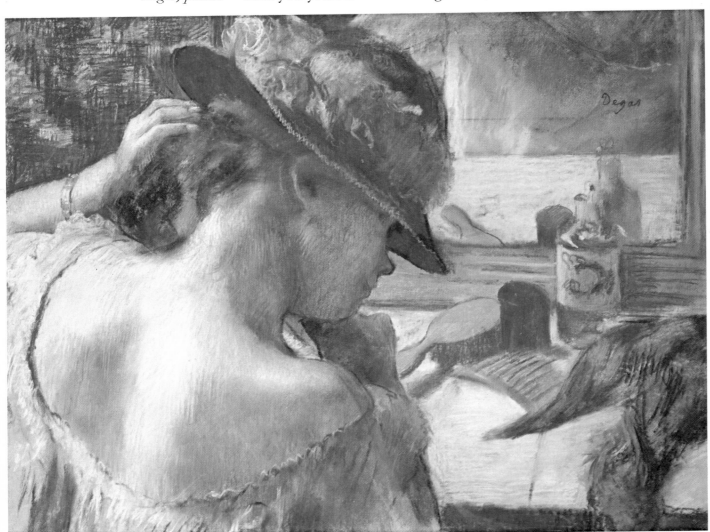

Techniques

The idea behind showing examples of different artists' work is not to urge you to copy a particular method of doing, say, noses. Rather it is to demonstrate the diverse ways in which the various drawing media may be used. Seeing examples of how ink, crayon and so on have been employed stimulates you actually to get hold of the materials to try them out for yourself. In your own drawing experiments, enjoy and savour the many techniques.

You need to establish a rapport with your materials. Observing what you are drawing and noting it all down is complicated enough, without the added difficulties of struggling with a seemingly recalcitrant medium.

Experiment with your drawing tools and the paper you intend to use before you begin a drawing. In this way you'll start discovering the possibilities and the limitations of the materials. If scratching with a pen

Reclining nude, *Hannah Hatchman, pencil. Here the pencil point has been used to make clearly defined lines and the side of the lead used to introduce areas of tone. Experiment with your tools and discover the many ways in which they can be used.*

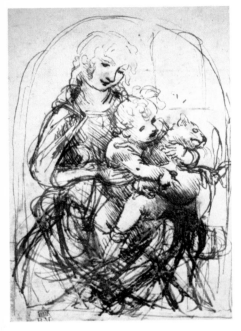

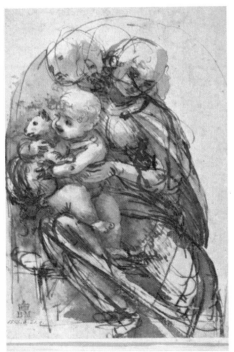

Fig. 1 Madonna and child with cat, *Leonardo da Vinci, pen, ink and wash.*

is your metier, you will find out how hard you can scratch on a particular type of drawing paper from light- to heavy-weight, without actually tearing through. Maybe you need a tougher paper—an H.P. watercolour paper for instance. If you are using a lot of very fluid washes combined with, perhaps, a felt pen line, stretching the paper before you start may prove useful, to prevent it cockling badly.

Whatever the medium you are using, try out a good selection of different types of lines and tones. Use the drawing tool to make as many experimental marks as you can—tentative, delicate, fine lines; strong, heavy lines; wiggly lines; straight lines; thick lines made with the side of a crayon (these can shade from the hardly perceptible to the intense). Lay one colour across another too. If the medium is suitable, try out various smudging, blending and eraser-drawing techniques.

Pen and ink

Looking at some Van Gogh drawings may well inspire you to try using ink and a pen. In Materials you will find instructions for making a reed pen from bamboo, such as Van Gogh would have used; but any pen with a flexible nib will do. The spontaneous vitality, which is so much a hallmark of all Van Gogh's work, is clearly demonstrated in the pen and ink drawing of La Crau, seen from Mont-Majour (fig. 7, Elements of Composition). This spontaneity could never have been achieved if the artist had first meticulously drawn the scene in pencil and then gone over the pencil lines in ink. This is not to denigrate such a method (although simply 'going over' is questionable), merely to state that it does not lend itself to producing a spontaneous result.

Perhaps you would like to try drawing a landscape? This fascinating occupation combines the pleasure of being outdoors with that of making an entirely personal record of the places you visit.

So, you are all set up, comfortably seated in front of your view, armed with pen and ink—and with a glaring piece of white paper staring starkly at you. A flutter of nerves is inevitable but try not to panic. Don't draw anything until you've had a good, long look at the landscape. Use your viewfinder to select which bit you are going to do. The very act of looking through this enclosing frame is one definite step toward getting things under control. At least now, instead of fifteen square miles, or whatever it may be in your sight, you can actually hold in your hand the area you want to draw.

Look through your viewfinder and consider things at some length. Is the section you have elected to draw the same proportion as your piece of paper? If not, it's a good plan, at this point, to draw onto the paper a rough outline of an area that corresponds to the proportion of your chosen view. Whereabouts in the view does the horizon fall? The main line of this can be lightly indicated on your paper. In a similar way, look

at, check the position of, and lightly draw in the main features of the landscape. Look for decisive lines and divisions made by roads, hedges or a river, dominant blocks of buildings, clumps of trees and rocks. Lightly map all this in. Don't get bogged down at this stage with the fascinating details of a tree's branch or the intriguing patterns in its bark. Save these up as little treats for later on. The aim is to keep the complete drawing in balance all over so that it progresses, as far as is possible, at a similar pace throughout. Getting involved in one particular area, or with one object, however fascinating, in the early stages of a drawing is rather dangerous. The reasons for this danger are that you may well over-emphasize that object in terms of too much detail or too heavy a tone. It will be difficult and also illogical to bring the rest of the drawing up the same degree so that that specially-favoured piece doesn't stand out like a sore thumb. Also, having spent a good three hours working it up to perfection, you may find that it is in the wrong place!

While making sure you keep the weights, that is, the tones and textures of the different parts of the drawing in balance, think how, with your black ink and variable pen line, you can interpret the diverse qualities of the landscape. It is like a game. You must obey the rules—recording what you can see accurately without cheating—but at the same time, it's your individual interpretation of the rules that counts, coupled with the way in which you wield your drawing tool. Be as inventive and as ingenious as you can with it. Have some scrap paper handy on which to try out different kinds of marks. If you wish to experiment with a little area of texture to represent, for instance, a hayfield, draw it on the scrap paper, tear it off and hold it in the appropriate place over your drawing. This will show you if that kind of mark is too regular and mechanical, too heavy in tone or too large in scale. It may be helpful to do just a bit of one textured or patterned area and then bits of the ones adjacent to it. This again helps you to keep the whole drawing related and balanced.

This attitude toward drawing should apply regardless of the subject matter. Keep the whole thing, all the various parts, in balance; whether it be a picture of a still life, a figure drawing, a close-up study of a plant or a densely peopled composition like a battle scene.

If you draw something wrongly, and it becomes apparent to you as you progress with the drawing that it is wrong, draw over it. Re-do it in the right place or alter its construction. This conviction of your having understood what you were looking at, and of having appreciated the form of an object and its place in relation to the rest of the things in the drawing, will come shining through. Never mind about the fact that it is not so neat any more. You are merely rephrasing, more explicitly what you want to say, as you would do in the course of a verbal conversation. If you want strongly enough to say something you might initially

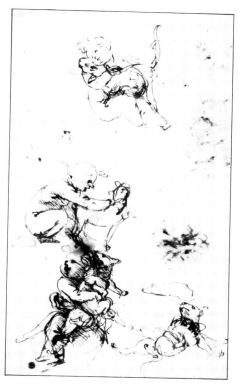

Fig. 2 Sketches of a child with cat, *Leonardo da Vinci, pen and ink.*

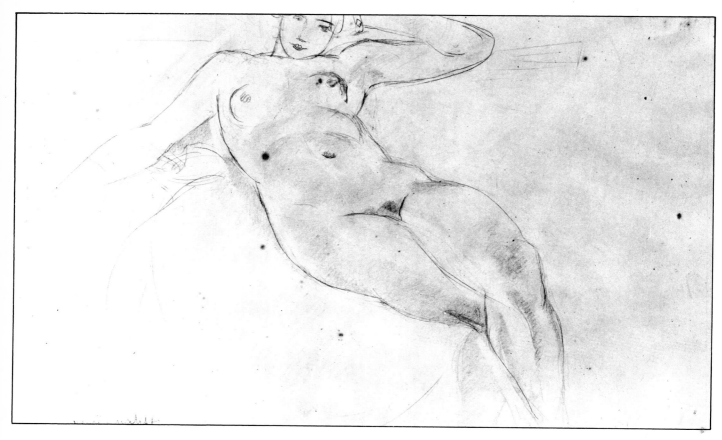

Etude de nu allongé, *Henri Matisse,*
charcoal. Using the charcoal to
establish line and tone, the artist
then erased some of the marks to give
highlights to the figure.

stammer it out, but ultimately you'll restate it so that there can be no doubt as to your meaning.

Freedom of expression is a thing so often advocated in books on art. Going out to search for freedom is a useless exercise; you are so self-conscious that it is the last thing you will find. Drawing in the way suggested here you may encounter it, without your realizing it at all.

The Leonardo da Vinci pen, ink and wash drawing in fig. 1 (so modern looking although it was done in the fifteenth century) demonstrates the restating process at work. The drawing is actually traced through from the pen and ink sketch which is on the other side of the paper—so much for any sort of reverence and preciousness! In the first drawing he's clearly had several different ideas about where the Madonna's legs should be. With the second version he has tried out, and settled for, a new position for her head: the drawing of her arm is greatly improved, it now tenderly supports the child. Christ sits much more securely in his mother's lap and the whole group is made to appear more solid by the addition of the cheerfully applied washes. It is interesting to note that this drawing is designed within a niche-shape, not a rectangle.

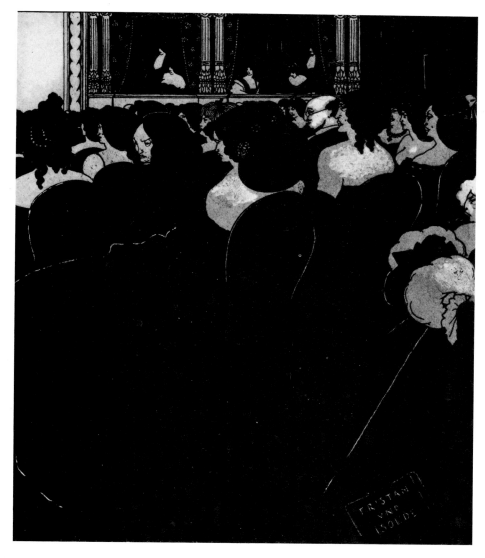

Fig. 3 The Wagnerites, *an opera-house audience, Aubrey Beardsley, pen and ink.*

With objects on the move, drawing over previously drawn lines is almost inevitable. No animal or child is going to remain stationary for any length of time (even if asleep). The lovely Leonardo quick pen sketches in fig. 2 show how the importance of getting it down on paper overrides anything about neatness, or fussing with the technique. Leonardo would have used a quill pen, which is even more flexible than a reed pen.

Aubrey Beardsley, the well-known Victorian illustrator, used pen and ink with a specific purpose in mind. His illustrations were to be reproduced by the line block process. This photo-mechanical method reproduces only black and white, no intermediate greys of any sort.

Thus Beardsley became highly skilled in getting the maximum out of black and white. Sometimes he would use large areas of white with very fine detailed black line drawing plus the occasional accent of solid black.

Fig. 3 is a fine example of Beardsley's skill. Here the same material, drawing ink, is used to produce a drawing in complete contrast to the previous examples. The use of huge areas of solid black makes the composition really dramatic—these would be inked in with a brush. The details of the architecture and the sly caricatures of the exclusive opera house clientele are pen drawn. Beardsley usually drew the composition roughly in pencil first and then, over the top of this sketched layout, drew meticulously with pen and ink. Notice the odd isolated area of texture, like the blond hair in among the black and white masses. Look too at the reverse use of the medium—white lines on black.

Fig. 4 Window and Rock, *Steve McMahon, pencil.*

If you are drawing in this sort of technique, watch yourself to see that, having done the initial pencil drawing, you don't just mindlessly ink over it. Use the pencil as a tool for mapping out the composition, constructing and working things out. Then, with just as much concentration, draw with the pen using it to elaborate details in the subject and convey tones by varying the thickness and types of line. Look again at the objects of your preliminary sketches and work from them as you use the pen and ink. Allow the pencil drawing to act merely as a guide. There is nothing so dead as a thoughtlessly inked-over pencil drawing.

The pencil drawings shown here demonstrate the enormous possibilities of the medium. Aside from the purely technical aspects, each drawing—as with all drawings—conveys its own distinct mood.

Fig. 5 Rhododendron, *Graham Rose, pencil.*

Pencil

Steve McMahon, who made the drawing in fig. 4 draws with an extremely hard pencil, a 6H or even a 7H, on good quality white drawing paper. He enjoys and exploits the way such a hard pencil actually carves a groove in the paper. Having drawn a line, one can shade up to it, the groove automatically stopping the shading lines and giving the area of shading a clearly defined edge.

The drawing in fig.5 by Graham Rose was done on smooth drawing paper using HB, 2B and 6B pencils. Two other pencil drawings on drawing paper from the same group of students are the townscape by Hannah Hatchman (fig. 6) and the tube by Jane Thoday (fig. 7). In the drawing of the tube, 2B and 4B pencils were used and this smooth type of shading was achieved by rubbing the pencil marks with a finger. Whites, as on certain of the ridges, were drawn in by erasing the pencil marks.

In the townscape the edge of a rock in the foreground forms a natural boundary for the drawing. An HB pencil has been used throughout. Drawings were being done in pencil as early as the fourteenth century. In those days, the pencil, sometimes known as stylus, was a solid rod of metal—zinc, lead or silver. The wooden casing was introduced later. Later still came the graphite-clay mixtures giving the wide range of pencils we now use.

These early instruments required a paper with a tooth to which the traces of metal could adhere as the pencil was drawn across it. Artists had their own particular methods of preparing the surface or ground with mixtures of, for example, chalk and gum. They would also frequently colour the ground. The Leonardo da Vinci study of hands

Fig. 6 Townscape, *Hannah Hatchman, pencil.*

(fig. 8) is done in silver point (a silver stylus) on a pink-coloured prepared surface. White drawing in chalk is added too.

A coloured or toned ground means the background starts off halfway, or some of the way, as it were, along the scale of tones. You can then draw marks that are lighter or darker than the background. With a white background you start at one end of the scale and you can only add darker marks.

The Leonardo silver-point drawing of a soldier in the full uniform of the time (fig. 9) is done on a prepared cream-coloured ground. It is rather unusual to see such a finished-looking drawing by this artist. Generally his drawings are clearly preparatory work for paintings, sculptures or the construction of machinery; or they are of the analytical, exploring kind, like his plant and anatomical drawings. Perhaps here he just got carried away by sheer enjoyment of the drawing techniques?

One of the greatest of innovators, Picasso, made the highly delicate pencil portrait of Max Jacob in 1917 (fig. 10) three years prior to the other, purely linear, portrait (fig. 13, Elements of Composition). These two examples demonstrate, once again, how versatile a familiar drawing instrument can be, even in the same hand.

Pastels

Pamela Day, who did the oil pastel drawing in fig. **11**, works on a fairly large scale. Oil pastels lend themselves to this broad, painterly approach. Contrast this with the technique of Delacroix's pastel drawing in fig. **12** where little dashes of colour have been used.

It's a good idea to keep a rag handy to wipe the tips of oil pastel

sticks. As you draw one colour over another, the second stick picks up some of the first colour. So when you start drawing again that colour may be badly dirtied.

Experiment by combining pastels with liquid for some exciting combined drawing, wash and painting results. Use a brush and water for ordinary pastel, either before, after or during the drawing process. This does, in fact, make the colours less likely to smudge, but it is best to fix them anyway to be on the safe side. In a similar way, add white spirit (or turpentine—white spirit is less expensive) to oil pastels and to oil crayons. Have two small containers, as you do for oil painting; one with spirit to wash the brush in, and the other kept clean and used for diluting and mixing with the pastel colours. Consequently, the colours on the paper stay cleaner and you don't waste the white spirit. With water, whether with the pastel technique or when using ink washes, use just one container for both functions. The water will remain clean for a considerable time. Simply renew it as necessary.

In any painting technique, cultivate the habit of rinsing your brush frequently and drying it off on a rag after rinsing. This means you avoid splodging a lot of diluting liquid into the next colour. Pick up on the brush just the amount of liquid you mean to use.

Fig. 7 (below) Tube, *Jane Thoday, pencil.*
Fig. 8 (right) Study of Hands, *Leonardo da Vinci, silver point with chalk.*

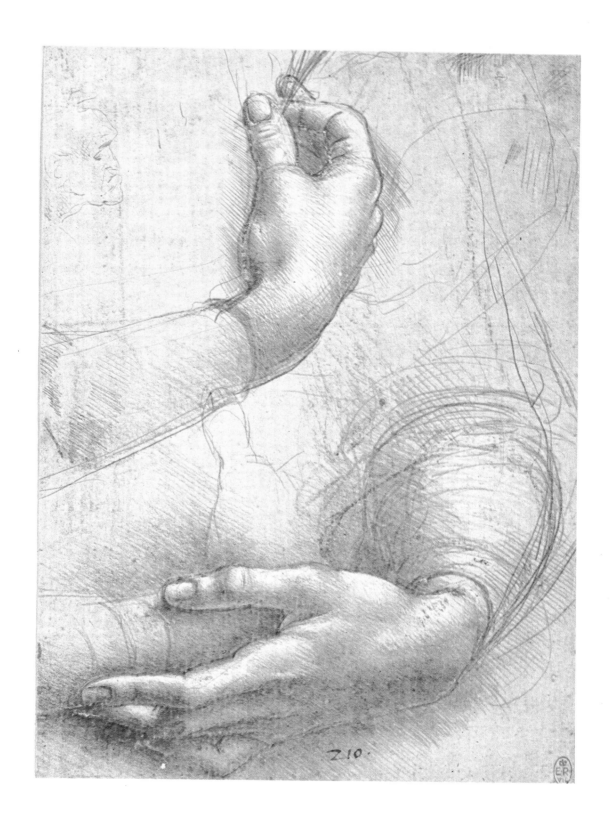

210.

Resist drawing

As you know, grease and water don't mix. This fact can be exploited in what is known as resist drawing. Use oil pastels, wax crayons or an ordinary candle to draw in the parts that are to act as a resist. Paint watercolour or ink over the drawing. The previously waxed areas will not accept the liquid colour. Henry Moore, the sculptor, often uses this technique to draw in the light areas when representing three-dimensional objects. Fig. 13 is an example of his use of the technique.

Fig. 9 (*right*) Warrior wearing Helmet, *Leonardo da Vinci, silver point.*
Fig. 10 (*above*) Portrait of Max Jacob, *Pablo Picasso, pencil.*
Fig. 11 (*far right*) Children's party, *Pamela Day, oil pastel.*

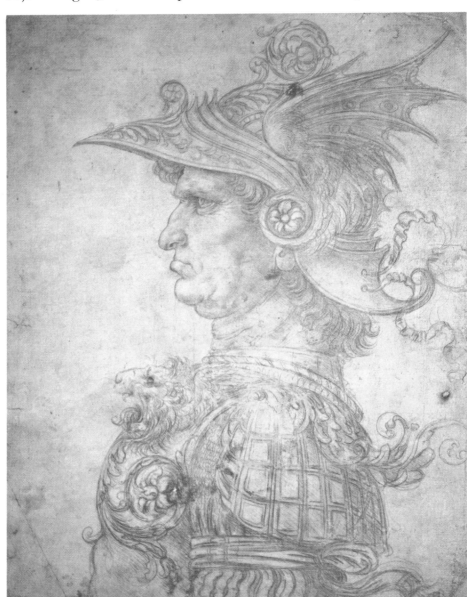

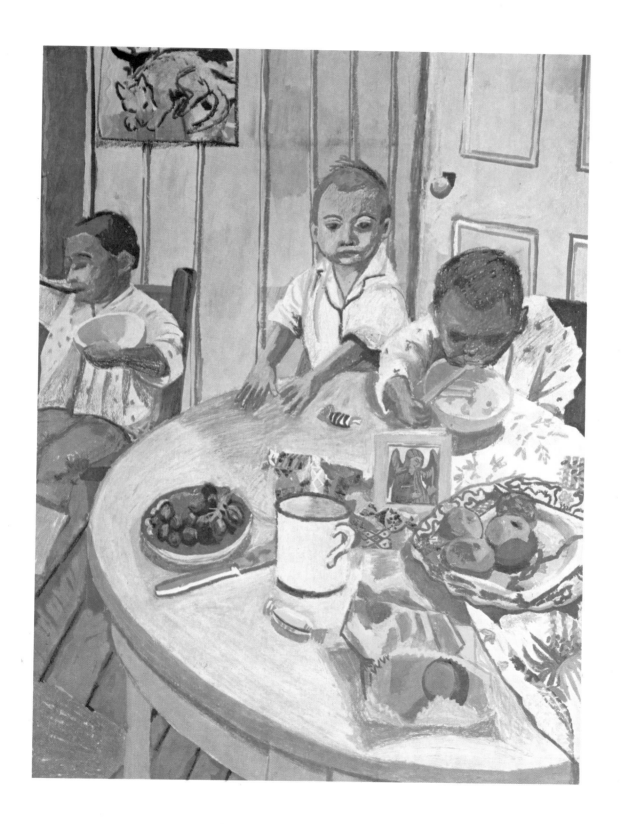

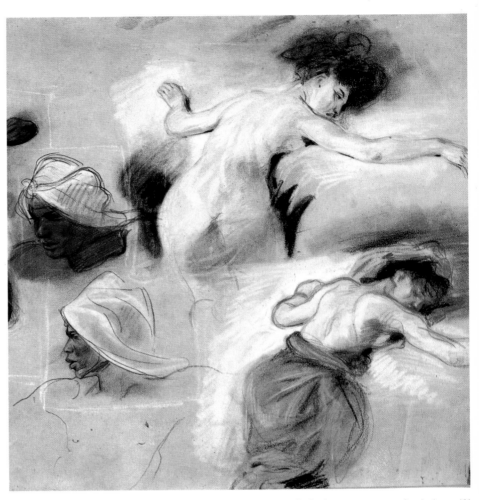

Fig. 12 Study for Algerian Women,
Eugène Delacroix, pastel.

If you add a drop of liquid detergent to ink (or water paint) it will adhere to a waxy surface. In this way you can prepare a ground for the *sgraffito* technique. Use a stout paper or cardboard and crayon thickly all over it. Then cover it with the ink-detergent mixture. When this has dried you can scratch through the layer of ink to produce a clear, precise line in the crayon colour (or colours). Make yourself a scratching-drawing tool by inserting a sewing needle in a lead holder or a cork. Try out other tools too for different qualities of line—the blade of a craft knife, a nail, a small screwdriver, etc. This can produce quite a colourful result, like the drawing in fig. 14.

Felt pens

The two children's book illustrations shown in fig. 15 were drawn originally in different types of felt pens and markers. The first actually shows the child how to do the felt pen and wash technique. Obviously,

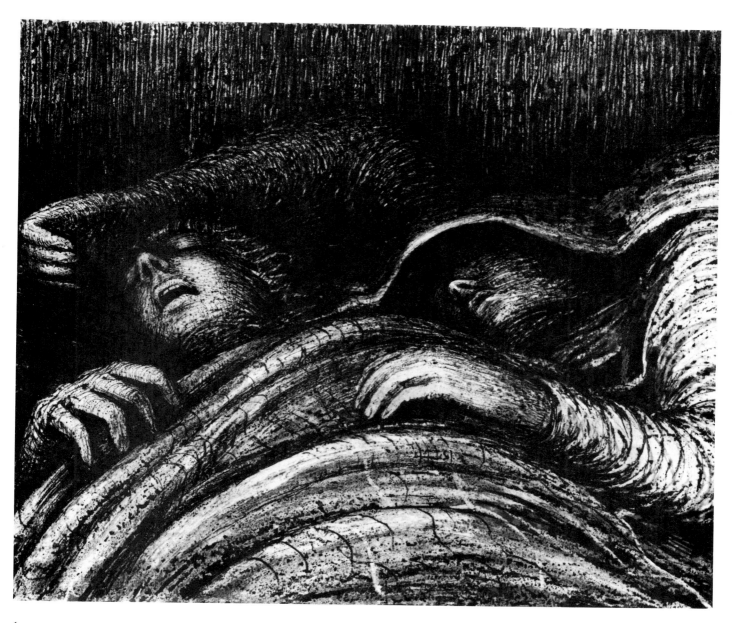

here you must use non-waterproof felt pens. Wet the paper first to achieve the irregular, blotchy effect. Alternatively, introduce water with a brush as the drawing progresses, to create washes and subtle shading.

In the second illustration fine pointed pens were used for the brown outlines and for the yellow ochre wood grain. The clay was coloured with two different tones of beige markers with thicker nibs. The darkest beige tones were achieved by several coats of colour. With certain pens and markers it is necessary to allow a colour to dry before going over it

Fig. 13 Detail of The Pink and Green Sleepers *from the Shelter Sketchbooks, Henry Moore, wash and wax resist.*

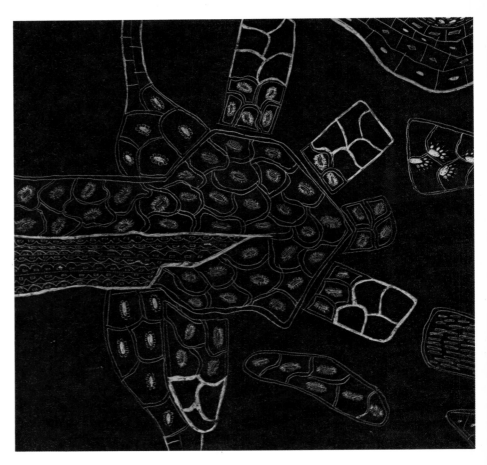

Fig. *14* Study of Cells, *Martin Harris. This child's drawing makes use of the* sgrafitto *technique, a type of wax resist drawing.*

again, thus avoiding scuffing up the paper. Also, with some makes of pen, adjacent colours will *bleed* (run) when wet and some felt pens may bleed on certain kinds of paper. Clearly you need to experiment first to find these things out.

Experiment by combining different media. There are no hard and fast rules as to what goes with what.

The glorious freedom that some of the drawings of the great artists achieve comes from the confidence and assurance of years of observing and practising. This same assurance, summing-up and judgement, this making of decisions and going into action can be seen expertly performed in all spheres of life. The star tennis player or golfer brings to bear all his knowledge to make the incredible winning stroke; the engineering craftsman or the chef performs his task eloquently with a finesse resulting from years of experience.

Clearly a beginner, because of his lack of experience, cannot expect to draw with this fluent confidence but he can admire and emulate the masters.

Extending the range

The more drawing you do the more your skills will improve, and consequently the greater your enjoyment will be. If you approach your subject in a thoughtful way, the more you draw the greater the number of facets you will begin to tackle. Sometimes, however, the process may feel to be anything but enjoyable; but this will not matter if you know the sort of thing you are trying in your own mind to sort out. At these frustrating periods your dexterity is lagging behind your ideas. The two, dexterity and ideas, go along inseparably hand-in-hand. Drawing, which at first you may have thought meant merely learning a few neat tricks that would enable you to put passable representations of things on paper, can lead the mind along all manner of avenues. Drawing is a process of enquiry, so it stimulates the mind. Take up drawing seriously and you will find your life enriched.

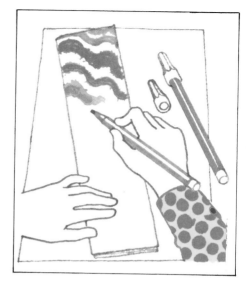

You may enjoy doing drawing for its own sake or you may wish to become more proficient at it as a means to aid some other creative pursuit. The ability to put down ideas in a visual form, i.e. to draw, is the foundation of many creative processes. The faculty of drawing is indispensable to virtually any kind of visual artist. Anybody who works in a design media uses drawing at some stage in the development of an idea. Consider the architect, engineer, painter, sculptor, couturier, stage designer and graphic artist. Drawing is the only logical way in which they can give form to and clarify their own thoughts. It is the means used to convey their message to others—both the final consumer and the intermediary craftsman. The architect must communicate visually with the builder and the client; the engineer with the tool-maker and the client; the couturier with the pattern cutter and the client.

The sketchbook and notebook

Cultivate the habit of carrying a sketchbook or notebook about with you. In this way you can jot down your observations in visual and written form. Some types of school exercise books are particularly suited to the writing and drawing form of notemaking as they have alternate plain and lined pages. You can always insert a stiff cardboard support inside the back cover.

Fig. 15 These book illustrations were done in non-waterproof felt tip pen.

The odd half hour spent in, say, waiting for a train can be profitably filled by using your sketchbook. Study your fellow travellers, the station itself, reflections in the waiting room window, a pigeon wandering up and down the roof, details of the architecture—anything that interests you.

Drawing in a sketchbook is frequently an impromptu affair and so it calls for instant mark-makers. On the station platform, with your train imminent, tidying up bottles of coloured inks, palettes, a water pot and brushes would seem hardly appropriate. Much more suitable would be

one or two pencils in different grades (one with an eraser tip), thus giving a range of possible tones and lines, or a felt pen or two. Apart from the convenience of such drawing tools, there may be occasions, as when drawing the person sitting opposite you, when you wish to remain inconspicuous.

The sketchbook/notebook can become a fascinating illustrated diary. Quite aside from your using it to improve your skills in drawing and general observation, it makes a most interesting and entirely personal record of your past experiences. Use your sketchbook as an adjunct to your other drawing and related activities, but don't confine all of your drawing to it. Were you to do this you could become so used to the sketchbook page size, the particular type of paper it contains and those drawing materials that you become quite sluggish. For a healthy approach vary the size of the drawing, the location and subject matter and the drawing technique as you would vary your diet.

Written notes are very helpful to you, working in conjunction with your drawn information. It is often useful, when starting a drawing, to write down, simply in the form of a list, the things that strike you about the subject you are studying. Endeavour to elucidate what your aims are.

Make it clear to yourself, and there will be a good chance of making it clear to others via the drawing. Referring once again to the still life group previously shown (Elements of Composition) you might note how the whole atmosphere of this particular selection of objects conveys a feeling of well-being, the feeling is one of relaxation and leisure. Many of the shapes and patterns appear to echo this unhurried voluptuous theme. Rounded fruits (the pears have a look reminiscent of the slightly overweight), the elipses of the bowls, the glass, the lampbase and the cheeseboard, the wood grain of the tabletop, the wallpaper design—form comfortable curves. Sharp and jagged angles, which are the signals of movement and action, are absent here.

Early civilizations used pictures to record the history of their cultures. This rather gory scene is a page from a manuscript recording the Aztec practice of human sacrifice to the gods of their religion.

Look at the rich tonal contrasts. In some areas, for instance the bottles and the grapes, the definition of the forms on the unlit side is lost in the heavy shadows.

Are you using colour? For the initial mapping out perhaps a gold/sienna or soft greyish-purple? Secondary colours are much in evidence here. Pure primary hues, which suggest a more active feeling, are almost absent. Most of the colours are muted, so try using the complementary mixing methods to achieve these subtleties. Don't, however, allow the colours to become turgid. Although they are not bright in the way primaries are, they are rich and glowing. Retain clarity as in the orange and green of the fruit.

All this helps you to clarify to yourself what you are doing. As the drawing progresses and you make new discoveries, jot them down too. This is especially practical if you are engrossed in a certain aspect of the drawing, and you don't wish to stop working on it when a particular thought enters your mind. Just a single word written down will remind you to consider that additional idea later on.

If you are drawing in monochrome—perhaps a quick sketchbook study—a written note of the important colours of the objects may prove useful, particularly if the drawing is to be used as preparatory work for a painting, illustration, etc. Similarly, notes on the effect of the type of light that prevailed at the time and the quality of the atmosphere all help to build up the picture. Occasionally, time and circumstances may not permit you to get all you want to down on paper in drawn form, but little written clues will help recapture it. Was the landscape looking brilliant and pristine after a sudden shower; was everything clearly defined with crisp edges; or were shapes merging as the misty autumn evening approached? All the time this kind of 'open-minded' attitude sharpens your powers of observations. You begin to discover things you never thought existed; colours in shadowed areas that had formerly just looked grey, and delightful contrasts of shapes and textures in the everyday things around you. Faces in a crowd will become fascinating. How marvellous are the amazing, endless permutations on the two eyes, nose and a mouth formula in colour, texture and proportions. Consider how you can use all these elements.

You will find yourself planning how you would arrange things in a drawing, what part of the view you would choose, what medium would seem suitable, how much space you would leave around the outside edge—would you make that section as dark in tone as this one—and so on. In short, you are creating compositions in your mind.

Even if you are passionately interested in one particular subject, try to vary the range of the things you draw, simply in order to refresh yourself. Do think about this. It is so easy to become stale. Have bad weather conditions meant that you've been forced to work entirely

Male Nude, *Angelo Visconti,
chalk*. This drawing illustrates how
when the weight is shifted, the
normally horizontal lines of the
shoulders, waist and hips assume
acute angles. Watch for this when
drawing from a model as it will help
you to get the figure correctly onto
the paper.

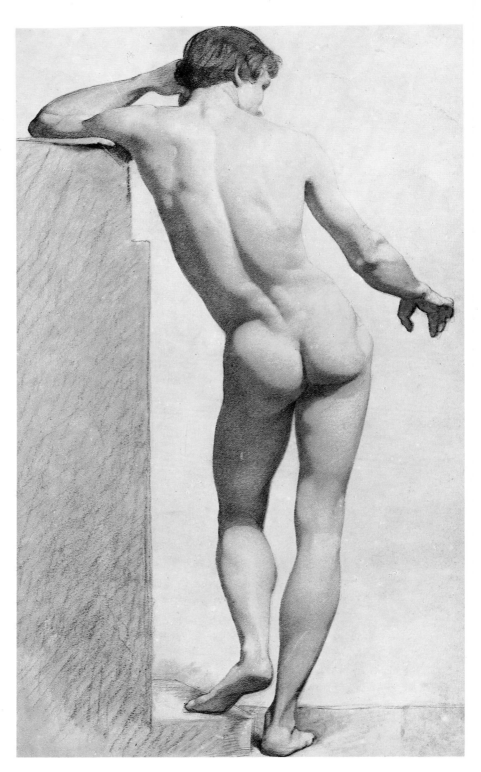

indoors for rather too long? Is your still life getting very dusty and, frankly, boring? Have a total change. If it's still too cold and wet for outside work what about a visit to the zoo, an aquarium or the glasshouses at a horticultural garden? (Check first, sometimes you need permission to draw in these places, so a preliminary telephone call is advisable).

If you've been immersed in huge rolling landscapes for quite some time, up to your ears in charcoal, perhaps a little close work would be a welcome alternative? Try some close-up studies of intricate plants or sections of plants, shells, jewellery or small articles with very differing qualities. How, for example, do you set about drawing such unlikely articles as a cupful of flour, a spoonful of sugar, some raisins and some dried lentils? (Think how you would set that up; what sort of background would you use?) This is the curious kind of problem that confronts the artist in the advertising world.

A total change of subject matter will make you think about what medium to use too. Never stop experimenting. Combine several mediums in the same drawing if that's the way you can explain what you want to say.

The same principles of drawing are applicable whatever the subject matter may be. Some subjects, of which figure drawing and plant drawing are two examples, are, unfortunately, classed as distinct and somehow special undertakings. This suggests that they have certain rules and know-how peculiar to themselves. This is not the case. Anything, any object, will serve as a subject to be drawn. Figures and plants are objects too. Exactly the same form of approach, the same method of enquiry can be exercised whatever the article that is being studied.

When working from the human figure as a drawing subject, some elementary knowledge of basic anatomy is required. This does not mean that you have to know all the Latin names for the bones and muscles (unless, for some other specific reason, you need this information). Being the possessor of a human figure you certainly have some understanding of how the body is constructed and how it moves. With the aid of a book that shows the skeleton from different viewpoints and a long, hard look at yourself in a full length mirror, you can grasp how the essential framework—the skeleton—supports the rest of the body. You can feel, as well as see, how one part is attached to another. By shifting your weight, bending or leaning to one side you can observe how the various sections stretch or contract. See how lines that are horizontal when the figure is standing erect—the line across the shoulders, the waistline and the hipline—assume quite acute angles in movement.

Study and draw the human figure by using a large mirror and,

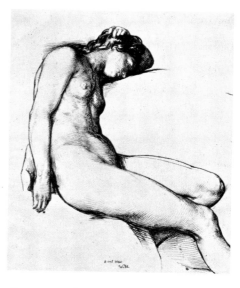

In repose the muscles relax. Contrast this drawing by William Mulready with the standing nude on the opposite page, where the muscles of the leg and arm are tense as they take the weight of the stance.

whenever possible, a model. Draw from the nude and from clothed figures too. Observe the way in which different styles of clothing, made in different fabrics, cling to and hang from the body. Think again about what sort of drawing medium to use.

Just the same kind of enquiring observations should be applied to plants when you set out to draw them. If it is at all possible have available more than one specimen of the type of plant you are studying. This means that you can cut up one of them in order to comprehend its structure more completely, while another remains intact. Use a razor blade or very sharp craft knife for the cutting.

Plants are constructed upon a geometric symmetrical framework. In this way they resemble humans and other animals, with their symmetrical skeletons. Removing whole petals of a flower will enable you to see just what shape they really are. Often they are compressed or partly obliterated in the complete flower. A vertical cut across a flower head will reveal how the component parts form the shape—frequently far more complex than at first sight. (A magnifying glass might also be useful here).

Be thoughtful about the medium you choose for your plant drawings. For monochrome work use a tool that will give delicate, controlled lines. Harder pencils, fine pens or brushes are suitable. If you are working in colour be sure once again that the medium can be used in a delicate, subtle way. You'll need, especially for flower work, a coloured medium with the appropriate brilliance and 'living' quality. Experiment with coloured inks and water-soluble coloured pencils. These two types of materials are like watercolour paint, transparent, thus allowing the white of the paper to shine through. Consequently the colours have a quality nearer to that of flower petals than say, poster paint. Poster paint is thick and opaque. Petals painted with it will appear dull and heavy, lacking life. It's worthwhile trying out some different types of paper too. H.P. watercolour paper is eminently suited to coloured plant studies.

Try drawing a plant actual size. Select the view of it that you like best and arrange it so that the background immediately surrounding it is plain and uncluttered. If you are using a living cut specimen, as opposed to a dried one, it may be wise either to place it in water, or to wrap the end of the stem in some dampened tissue inside a small plastic bag. It takes some considerable time to draw flowers properly and you don't want to end up with just a limp stalk and a small pile of wilted petals.

If you are working in colour the area of the background immediately surrounding your specimen is important. The colour of the background is going to have an effect upon the colours of the plant itself. So don't unthinkingly draw the plant on your white paper as an isolated thing on a white background. You may match up a pink petal colour beautifully, but what might look a pale pink against the brown background of a

BLACKTHORN
CHIDDINGSTONE
KENT 1910
CRM MMM

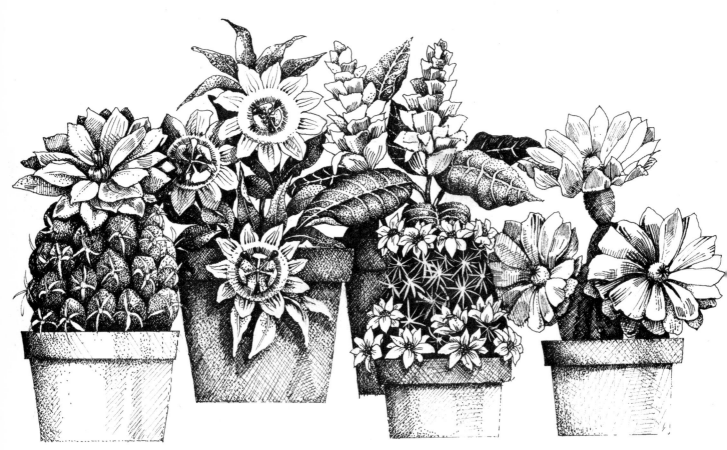

The detail in this illustration of cacti is achieved through the use of a fine point barrel pen and drawing ink.

table-top will read as a much stronger pink against the white paper background. Interpret the background colour in your work too. This applies similarly in a monochrome drawing. The tonal relationship of plant to background must be carefully observed. Even if your plant specimen is lying on a white background; check to see in which ways that white background differs from the white drawing paper. Your plant may be influencing the background by causing shadows (if so, what colours are they?), or by reflecting its own local colour onto it.

In contrast, at least regarding scale, consider your approach towards drawing architecture. There is a rich source of subject matter here, ranging from the suburban house through to the ornate Gothic cathedral. Have a good look around your own local environment, possibly now with new awareness, to select some interesting views that will show you this diversity in different styles of buildings. In addition to their shapes look for variations in building materials. See how, for example, a wall made of marble contrasts with one in new brick; how does stark, new brick look against some older, mellow brickwork—and how are you going to portray that very difference in your drawing? Is it to do

with the nature of the edges, the textures or the colour? How will you treat glass, modern cladding materials and wood? Look too at the way in which natural forms and elements are intermingled with the architecture. These will be figures and animals, trees, plants, water and on a broader scale, the sky and the terrain in which the buildings are set. Once again, consider how you will show these vastly differing qualities.

Having had some experience in observing and drawing you will now have used basic linear perspective construction. Walking around a town or village observe how the change in your viewpoint produces a dramatic alteration in the perspective lines. This is particularly noticeable if you climb some steps, stopping every so often to see how things do change. Why not make some drawings to record your observations? Take your cardboard viewfinder along to help you select an area to study. If you stand at the foot of the steps your horizon/eye level is going to be as high as you are tall. All the horizontal lines or edges of things that are not parallel to picture plane will, as always in perspective, appear to slope toward the vanishing point. (To reiterate briefly, those above the horizon/eye level slope downwards, those below upwards). As you are quite low down at the foot of the steps there is only a small area below your horizon/eye level and a large area above it. The top edges of any buildings that are directed, as it were, into the picture plane (edges where a wall meets a roof, for instance) will appear to slope downwards quite dramatically. Such angles can be seen to be getting less and less acute the nearer they get to the horizon/eye level. When they coincide with it they are horizontal; below it they start to slope upwards.

In fig.16, the artist Canaletto, in his eighteenth century pen and watercolour drawing, is viewing the scene standing on the same ground level as the other figures in the crowd. His viewpoint is to the right of the centre. The Venetian architecture is highly decorated and the piazza is full of detailed incidents, so that the whole picture looks extremely complicated. In spite of this, there is, underlying the entire scene, still the basic simple perspective construction. Note how any element that is repeated diminishes in size as it recedes from the viewer. This can be seen in the windows, the architectural decoration and the people.

Returning from the festivities of Venice to your own hometown, continue climbing up the steps and observe what has happened. The pavement or road, or whatever constituted the ground, formed a very small area of the composition when you were actually standing on it, has now greatly increased in size. You have moved upwards above the ground level and so your horizon/eye level is now much higher up. There is a great deal to see now below the horizon/eye level. Remember how a vast panorama stretches before you when you look out from a high tower. Up to the steps you may even be in a position where the

Fig. 16 Canaletto, pen and wash

line of a building that is made by the wall meeting the roof coincides with your eye level and appears as a horizontal. Perhaps you can go above it and see it as a line now appearing to slope upwards, away toward the vanishing point.

Canaletto's Venetian drawings show how architectural subjects can absorb an artist thoroughly, presenting him with endless vistas and perspectives. Venice has, of course, always held a fascination for painters with its wonderful contrasts of stone and water, permanence and shifting surfaces. In fact artists such as Guardi were far more sensitive to these contrasts than Canaletto, whose work conveys a great sense of mathematical precision and order. This is where his draughtsmanship comes into play most forcibly. It is certain that he made a consistent practice of drawing his verticals with a pencil and ruler, and he also used a technique called 'pin-pointing' mapping out distances.

Maintaining Observation

In drawing as, in fact, in any craft (or perhaps even any way of life) once one becomes fairly proficient one has to guard against complacency occurring. This can creep up in a most insidious way. Unfortunately some seemingly proficient drawings are nothing more than a collection of accomplished tricks. Once acquired these tricks lead the artist to cease looking at the subject being drawn. The subject no longer suggests how the drawing should be formed; the 'artistry' steps in and takes over. The artist has forgotten that the subject is there to supply information to him. The following is the sort of instance that can all too easily occur.

You are contentedly drawing out of doors, comfortably positioned in front of a most interesting view—a charming jetty, boats and some

Pen, ink and wash drawing by Giovanni Piranesi.

cottages, under a partly clouded sky. The temperature is just right, the breeze so slight that it refreshes without irritating. What a perfect way to spend an afternoon. You have previously found yourself enjoying quite a measure of success when drawing skies. This pleases you particularly as you found the sky such a problem when you first took up drawing as a hobby. You've developed an effective method of first applying light shading as a tone, made up of evenly sloping parallel strokes, to represent the clear blue areas. You then delicately outline the cloud shapes with a hard pencil. One or two people have, in fact, commented favourably on your clever treatment of the sky.

So, off you go again this afternoon—first the sensitive shading (careful, even sloping lines) leading up to the outlining of the clouds.

From Paysages Urbains, *Stanley Hayter, dry-point engraving.*

But stop a minute! Do you realize that apart from the first moment when you arrived at this place to select which view you would draw you haven't looked at the sky at all? It has registered in your mind—"Ah yes, sky with clouds"—and almost like a machine your hand has automatically started to produce the much-admired cloud rendering.

If this description rings an uncomfortable bell—take yourself in hand. Concentrate upon that particular subject or technique about which you were becoming so complacent. Try these three suggested remedies. First, deliberately set about doing drawings with a particular emphasis on the beastly subject. Secondly, use a material or a combination of materials new to you. This, in a way, forces you back nearer to the innocent stage of the beginner. Try, for example, working in a way that is quite the reverse to your normal technique. If you generally use a dark pen or pencil line on white paper try out a white line drawing on black scraperboard; or blacken your paper first with charcoal and draw into it with whites and greys made with an eraser. Finally, track down, either via museums or books from your local library, examples of the work of artists who have successfully handled your particular *bete noire*. In the case of skies, for instance, John Constable's sketches and paintings cannot fail to inspire you. J.M.W. Turner, another English painter who lived from 1775 to 1851, was also deeply interested in this nebulous subject.

Studying the work of other artists and seeing how they have approached the many and varied problems of drawing is invaluable to you. Being able to examine the original work in a museum or art gallery is, of course, best of all. Do, however, also look at reproductions in

Above. This engraving is taken from Sebastiano Serlio's Second Book of Perspective *and is a design for a stage back drop.*

Below. Boulevard, *Pierre Bonnard, lithograph.*

Right. Relativity, *M. C. Escher, lithograph*.
Far right. System of Iconography; plug, mouse, good humour bar, switches and lipstick, *Claes Oldenburg, pencil. Many artists rely on their imagination for subject matter, assembling the objects and scenes of everyday life in unreal situations*.

books, especially in the more expensively produced volumes, some of which should be available in your library. The higher the quality of the reproduction, the closer it will resemble the original. While you are looking at these works, remember the different aspects that were discussed in the general theme of 'the grammar' of drawing. See what diverse poetry this grammar can produce.

Feedback from other people who are also engaged in painting or drawing is important to you. Discussion around a shared and loved subject inevitably activates ideas. Hearing new points of view can lead you into previously unexplored and unimagined territories of drawing. Working entirely alone, especially in the early stages, is not really a good idea. You need the stimulus of conversation and argument with like-minded people. Unless they too are studying the subject, the reactions

three way plug geometric mouse

lipstick

switches

good humor

This *Arthur Rackham illustration is from the* Ring of Nibelung *by Richard Wagner. Myths and fairy tales offer great scope for imaginative drawing. Presented with a narrative, it is left to the artist to create a fanciful world peopled by magical beings.*

of your family and friends to your work, however well-intentioned, will give you no constructive criticism. Consider the idea of attending a part-time class or joining a local art group or club. The fees are generally reasonable. Such an organization may well be able to offer you a number of advantages—qualified tuition, ample space in which to work, professional models, possible lectures and museum visits and an atmosphere conducive to quiet study. You will be able to benefit from (and also

Cartoons, such as this one by L. S. Lowry, are the most obvious example of how a drawing is able instantly to convey a message. Most often the cartoon is humourous, but its success always relies on well-observed expression portrayed in an economical manner.

contribute toward) the helpful criticism and suggestions of your colleagues, and compare your progress to that of others.

Imaginative drawing

When drawing from the imagination, or from your memory bank of accumulated visual information, all the same 'grammar guidelines' discussed earlier still apply. Indeed, and this is important, if you lack the technical understanding of how the component parts of a drawing are assembled into the final whole you will never be able to give shape to your image, no matter how exotic and exciting the pictures may be inside your head. Planning the composition is still just as important in a work drawn from the imagination. Consider carefully how the elements of the drawing are to be arranged. Is the desired effect going to be achieved with a cluttered, closely filled, highly detailed picture in which the observer is led along all sorts of mysterious and possibly disturbing paths, or is an air of tranquility, an enviable dreamland, to be suggested by carefully placed items isolated in space.

If you feel you would like to try some kind of imaginative drawing but you just can't think how to set about it, here are a few suggestions that may help you to get going. The process is rather like recalling the balmy days of childhood, when your own personal idiosyncratic brand of logic linked one thing with another, quite regardless of the so-called rational world. A similar state seems to prevail in dreams.

Take a container that you have in the house—a vase, a jug, a bottle or a box. What might its contents be? Ordinarily the bottle holds, say, cooking oil. Maybe the box contains a motley collection of paper clips, used stamps, rubber bands and odd buttons. Supposing the normal state of things was entirely changed. The box became full of little people, all pushing and shoving to open the lid and climb out and escape, or the bottle was knocked over onto its side. Instead of cooking oil spilling out, a curious misty vapour swirled out from its neck; rather like Aladdin's lamp, the vapour eddied upwards and transformed itself into elegant oriental bird shapes. The birds finally took flight, and with a great flapping, a bizarre, screeching, brilliantly coloured flock rose into the sky.

Here is another idea that may spark off ideas for an imaginative composition. Place two seemingly unrelated objects together—selected at random—perhaps a rose and a rotary beater. How can these two things be linked together? Think of all the ways in which they could—write your thoughts down if it helps to stimulate the imagination. Beaten roses, pink, creamy and with a delicate froth, to which one added ingredients to make a floral cake? (Do the thorns survive the mixing process and remain intact in the cake?) Alternatively, the invasive living plant taking over the inanimate metal machine, stifling

it with relentless growth? Other emotive associated thoughts suggest themselves when the concept of rose and beater is considered. There are many literary illusions to the rose—rosy dawn; rose pink; the rose thorn pricks and flesh and draws blood—the beater; the victorious and so on. Following a train of thought like this often leads to final concepts that are far removed from the original source of stimulus, but this sort of creative thinking shows that you are aware of possibilities and not restricted by what you actually see.

Vision de Tondal, *Hieronymous Bosch, oil. This 15th century Dutch artist is noted for his juxtaposition of the realistic and fantastic.* (*fig.* **19**)

On another track, are there visible similarities between the two objects? Does the flower head, with its concentric arrangement of petals at the end of a stalk rather resemble the heads of the beaters? Do the leaves jutting out at right angles to the stalk look somewhat like the cranking handle on the side of the beater? Perhaps there are certain similarities in design, but in quality the two articles are poles apart. How, in your drawing, do you explain the dead hardness of the metal in contrast to the living plant?

This is only the merest taste of how you might begin to approach imaginative drawing. If the subject appeals to you, do follow it up in books on Dada and Surrealism. These were two artistic movements, starting with Dada in 1915, which sought to shake free from the artistic conventions of the time. However, the surrealist, dream-like approach has been present in literature and the visual arts for centuries. Hieronymus Bosch (1450-1516), for instance, portrayed the most nightmarish creatures in his paintings (see fig. 19); many old fairy tales are full of surrealist allusions. What Shakespeare says of the poet could just as well apply to the artist:

> " as imagination bodies forth
> The forms of things unknown, the poet's pen
> Turns them to shapes, and gives to airy nothing
> A local habitation and a name."

The Finished Drawing

Try to be reasonably methodical about the way in which you keep your drawings. As you progress you will produce more and more, and proper storage is essential. Paper is a vulnerable material and should be protected from damage, dust and dirt. It is wise to invest in a portfolio. These are available in several sizes and are made of stout, covered cardboard. The portfolio has inner flaps so, when it is closed, the drawings inside are protected on all four edges. The whole thing fastens with ribbon tapes. Portfolios vary in quality and price. Some have reinforced corners for extra protection. A more expensive type is the folio case. This, generally in leather-look plastic, has a zipper or a flap and is like a giant, flat briefcase. Obviously, these are more expensive than the cardboard portfolios but they are useful if you have to travel a lot with your work.

Store your drawings flat and never roll a drawing except inside a strong cardboard tube. This is a good way to send them through the mail. A roll of paper alone, even just being carried home after a day's drawing outdoors, can all too easily get squashed, resulting in permanent creases down the drawing. Charcoal, pastel and similar kinds of drawing, although they have been treated with fixative, are still a little inclined to smudge. Lay a sheet of thin paper over each drawing in the portfolio. Use tissue, tracing or layout paper for this.

Mounting drawings

A cardboard mount around a drawing performs the same function as the viewfinder that you use when actually making a drawing. It isolates the picture from the surroundings, so that it may be seen free from interference. You can simply stick a drawing onto a sheet of mounting board but the best way of presenting a drawing is to use a window mount. The picture is recessed behind a flat surround, or frame, of cardboard. For this you will need two pieces of cardboard. One piece goes behind the drawing to act as a support. This can be a cheaper, thinnish type of board: it's not going to be on view, serving only to protect the back of the drawing. However, especially if your drawing is on thin paper, choose a white backing as a colour might show through. The other

Fig. 1 The colour you choose for a picture mount must be carefully considered. These three examples show the effects produced by a dark, light and brightly coloured border around the same drawing. The brown mount tends to subdue the colours, the blue to highlight them and the cream serves no purpose at all.

piece of cardboard forms the flat frame shape. Here the quality should be well considered. Mounting board, as this second type of cardboard is called, can be bought at an art shop or a stationers. They will also stock the thinner type of board. Mounting board is available in several different thicknesses and in a range of colours.

You will also require some masking tape, a craft knife (with a good sharp blade), a metal ruler and a surface on which to cut. This could be a piece of heavy cardboard or a sheet of glass. Masking tape is the best type of adhesive tape here, and for a variety of similar jobs. Should you want to lift it off, you can do so without its spoiling the surface of the cardboard or paper. Also it does not become sticky on the back as do some types of transparent adhesive tapes after a period of time.

Be sure when mounting drawings that everything is absolutely clean— the surfaces on which you are working and your own hands. It's so easy to get unfortunate finger marks on a piece of pristine white board, and so difficult to remove them without trace. Keep some clean white paper handy (perhaps a few sheets of typing paper). These will be useful to place between the work and your hand when you need to press down, as when sticking two layers together.

Deciding how big the mount should be and what colour is best brings your judgement of composition into play again. A great deal depends upon the kind of drawing being mounted; whether it is a strong, heavy image or a very delicate one. As a general rule, be generous with the mount. A narrow edging just looks thoughtless. The colour and tone of the mounting board should be carefully selected in relation to the drawing. The illustration in fig. 1 shows the completely different effect on a picture (which has a light background and lightweight colouring) that a dark toned, a light toned and a strong coloured mount produce. Take your drawing along to the art shop so that you can see how it looks against the various coloured mounting boards.

The mount should be of similar proportion to the drawing, larger by the amount of margin you have chosen. If you place a picture exactly in the centre of a mount, it will, curiously enough, look as if it's too low. Always make the lower margin a little wider than the top one to compensate for this optical illusion. The two side margins will be the same width as each other.

Before you cut the mounting board down to the required size, do some practice cutting, just to get the hang of it. Mark out the outer dimensions of the finished mount and then you'll know how much cardboard you have got to spare for practising. Lay the board on the cutting surface. Press down on the metal ruler and cut slowly and firmly running the knife against the ruler's edge. Don't use anything but a metal ruler. Plastic or wooden ones are bound to get cut. If yours is a bevel-edged ruler, you can try cutting a bevel, that is, making your cut at an angle. This adds an air of quality to the mount. The edges of the window will slope in toward the drawing. To cut a bevel, slope your

Fig. 2 Lightly trace around the window opening onto the backing.
Fig. 3 Tape the drawing in position.
Fig. 4 Then tape the window mount in place over the drawing.
Fig. 5 Finally attach the backing to the window mount.

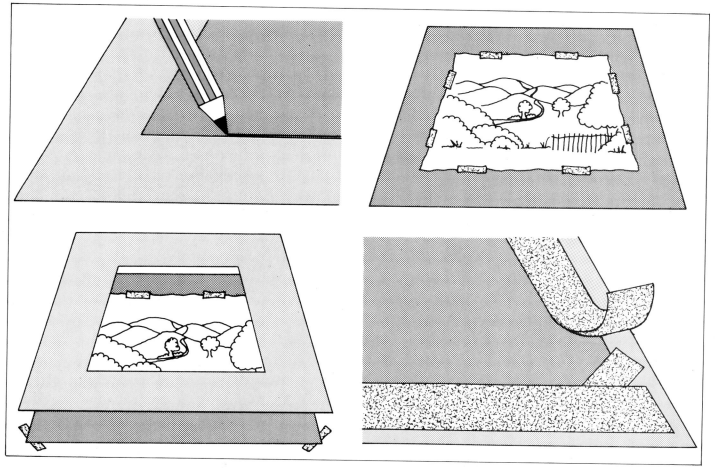

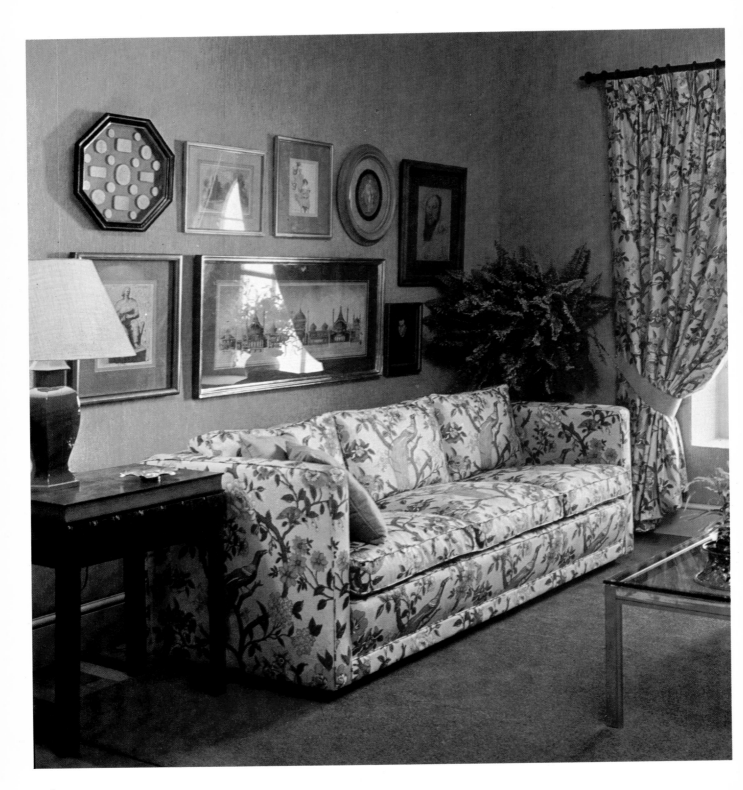

knife blade to rest against the edge of the ruler and keep it at that angle throughout the cut. Whether cutting out a straight or a bevelled mount, practise doing a few corners too.

A window mount slightly overlaps the drawing by a minimum of 3mm ($\frac{1}{8}$in) all the way around. When you measure out the area that is to be cut away, do not forget to allow for this overlap. It makes each margin 3mm ($\frac{1}{8}$in) wider on the cardboard. Lightly pencil in the window area on the front face of the mounting board. Carefully cut around it and remove that central section. Cut the backing card down so that it is 1cm ($\frac{1}{2}$in) smaller all around than the mounting board. Place it on the table and centre the mounting board on top of it. Now, very lightly and carefully, making sure you don't mark the window edges, pencil through the cut-out window onto the backing card to show the cut-out area (fig. 2). Lift the mounting board away. You can now position the drawing on this lightly pencilled shape. It should overlap the shape by at least 3mm ($\frac{1}{8}$in) on all sides. Fasten the drawing down to the backing card with short lengths of masking tape. Make sure you arrange these so that they protrude over the drawing by no more than 3mm ($\frac{1}{8}$in). Use short lengths of masking tape rather than continuous long pieces. They are easier to handle (fig. 3).

Having fixed the drawing to the backing board, place four short pieces of masking tape at the outer corners of the backing card, attached to the back of it and sticking out just a little, with the sticky side uppermost. Lower the window mount into position over the drawing (fig. 4). Press the outer corners down, enough to make contact with the pieces of masking tape on the backing card. Gently lift the whole thing, turn it over and place face down. Now fasten the backing card securely to the back of the mount with more lengths of masking tape (fig. 5). The window mount is then complete. Should you wish to remount the drawing at a later date or want to store it unmounted you can easily remove this type of mount without causing any damage.

A further refinement which may be added to the window mount is to rule a line or lines around the aperture. A felt pen is useful here as it gives a line of even thickness.

Framing

If you wish to display a drawing on the wall or you are entering one for an exhibition, framing is essential. Being vulnerable, a drawing needs the protection of glass. The frame should harmonize with the drawing and the mount. A frame-maker or a wood supplier will show you a selection of different frame mouldings. If you are a competent carpenter, by all means make your own frames. The corners need to be mitred. Otherwise, as making a traditional wooden frame is quite a skilled job, use the services of a professional framer.

As with the mount, be selective in your choice of frame. Don't choose one that is going to dominate the drawing because it is too thick and heavy, elaborately decorated or too strong in colour.

It is advisable to ask a frame-maker to use acid-free materials when he frames your drawing. A sheet of board is used at the back of the picture frame, and some types of board contain chemicals which can cause the paper of your drawing to discolour. Also, consider the use of non-reflecting glass. It is more expensive, so ask to see some examples before making your decision.

There are several do-it-yourself framing kits on the market. Most of these have fairly plain mouldings in wood, aluminium or plastic. They are supplied complete with backing board and glass. The wooden frames may be left as natural wood or painted, waxed or varnished. These kits are quite easy to assemble. Their only disadvantage is that they are available only in certain set sizes, which of course, may not fit your particular purpose.

Below. Modern aluminium frames can look very attractive, and are widely available in kit form. Unfortunately the range of sizes is rather limited.

Introduction

The art of painting dates back many thousands of years, and is one of the primary forms of human creativity and communication. The emotional impact of the early cave paintings at Lascaux in France and Altamira in Spain is still powerful twenty thousand years later. Although there are many theories about how and why these paintings were made, their overwhelming artistic effect is one of vibrant movement, as bison and deer leap and bound across the cave face, heads outstretched, muscles flexed and rippling. As a beginner in watercolour, your approach is closer to this early creative experience than to that of a fully trained modern painter. Perhaps you last painted when you were a child, and you often look back wistfully at the unselfconscious way in which you mixed your colours and water, and laid them on paper with complete freedom and spontaneity.

Left: Prehistoric cave paintings such as this magnificent horse, and a bison from the Altamira caves in Spain (below) are among the earliest records of our artistic endeavours.

Since you are neither a cave-dweller nor a child, however, you may feel rather inhibited by your awareness that every art form has its unique skills and special problems. You have probably been made aware of the staggering variety of painting techniques simply by visiting art galleries, or looking at illustrated books on the visual arts. From this comparatively sophisticated standpoint, it is completely bewildering to know where to begin. The purpose of this book is to act as a practical guide to watercolour painting, providing clear information about the equipment you'll need, describing the various technical developments, discussing the possibilities of the medium, and above all, de-mystifying the art itself. As you gain more knowledge in the introductory chapters, you will be encouraged to develop more confidence to start on your own work as soon as possible.

Painting is one of the most satisfying ways of expressing yourself. You look at the world around you with renewed interest, noting colours and textures, and achieving a completely new insight into the most common scenes of daily life. Watercolours in themselves are an ideal medium in which to learn to paint, since you don't need expensive equipment to start, and at the same time, you are able to explore a wide range of painting elements and techniques, including colour sense, composition, the use of various kinds of brushes, and also the values and textures of different varieties of paper. You can also take advantage of

Right: This detail from an Egyptian wall painting shows that beautiful results could be achieved even with a limited range of pigments. The artist is depicting a goose rising from a bed of papyrus.

the latest advances in the technological area of paint and binder preparations, which will inspire you to experiment with a really exciting range of texture and colour effects.

What are watercolours?

A great deal of the initial fear you may experience when you approach a completely new skill is caused by some of the special terminology used—almost a secret language in itself, which lends an intimidating aura of mystery, especially when used in the context of art. Perhaps you have heard or read the term *gouache* in connection with watercolours. You

Above: An Egyptian tomb painting c. 1450 B.C. shows a nobleman and his family hunting waterfowl. The style is highly formalized compared to the scene depicted opposite, and incorporates a lot of detail. Notice the hunting cat on the left, as it leaps up to seize a bird.

may have even already come across the word *aquarelle*. What do they mean? In fact what are watercolours? One of the most confusing features of any special terminology is that some words are used in more than one sense. For example, let's start with the word watercolour itself. As a term to describe a kind of paint, it simply refers to any pigment or colouring agent which is used diluted with water. It also serves as a classification of a painting technique, for example watercolour as opposed to oil, which might suggest a delicate transparent kind of painting, as opposed to the richly glowing effects associated with oil. In fact the term aquarelle is more accurate to indicate this sense, and is used to describe the kind of watercolour technique which allows the paper or ground of the painting to show through. Aquarelle is less commonly used nowadays however, and the term transparent watercolour is normally employed to make the distinction between this effect as opposed to other kinds of watercolours. The other major kind is known as gouache. This is again a description of a kind of paint as well

Above: A graceful Etruscan dancer adorns the tomb of the Triclinum at Tarquinia (c. sixth century B.C.) Right: An idyllic garden scene painted on an indoor wall of the house of Livia, wife of the Roman emperor Augustus. The tradition of fresco art continued right through to the Renaissance.

as a technique. Gouache is opaque watercolour paint, and lacks the transparency of aquarelle or transparent watercolour. This is achieved by adding a white pigment to the original pigment. Gouache is also used to describe any painting done with this adapted pigment. Another term you may come across is *body colour*, which is simply another word used to describe gouache—the two are interchangeable. There are various other colouring agents used with water, including inks; however, these will be discussed later on.

Below: Wall paintings often show intimate glimpses of domestic life. This is from Herculaneum, near Pompeii, and depicts a music lesson. It was painted c. first century A.D.

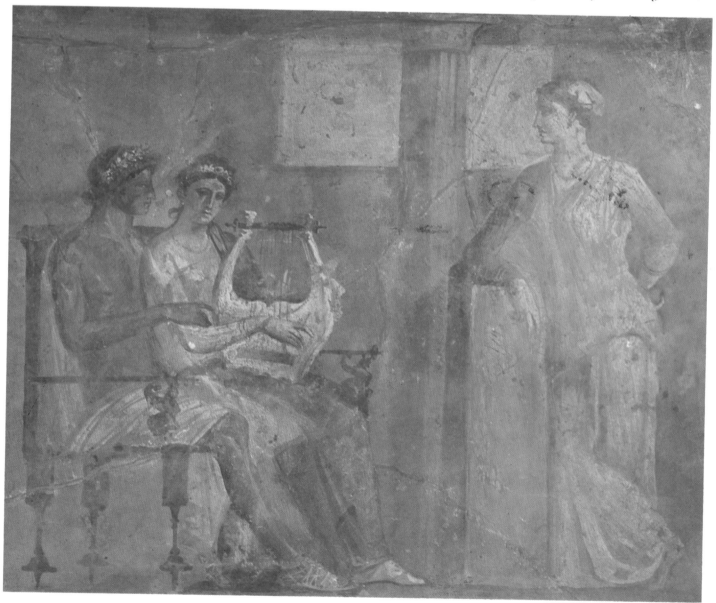

Above: One of the views shown in the early thirteenth century Chinese scroll called Twelve Views from a Thatched Cottage *by Hsia Kuei. The delicacy of the brushwork and the subtle use of sepia ink creates a peaceful and timeless mood.*
Below: The rich colours of this medieval manuscript are enhanced by the addition of gold leaf.

Watercolour past and present

Watercolour is certainly the oldest painting technique, for the simple reason that the methods used to prepare the paint were very simple—the development of oil paint came relatively late in the history of art. The early painters, like those who executed the wonderful wall paintings on Egyptian tombs, relied on pigments found in their natural state, in the earth itself, or in plants. Mediterranean civilization managed to develop a variety of techniques of mixing these basic pigments with different substances, so that a wider range of technical effects was evolved. One of the earliest methods of painting was *buon fresco* in which the pigments were mixed with water and lime, then applied directly onto damp plaster surfaces. A constant problem early painters encountered was that of stabilizing their colours so that they retained their original freshness, and also gained some element of waterproofing. A technique called *tempera* was developed, which in its most pure form used egg yolks to bind the pigments into a sort of emulsion before diluting with water. This gave a much richer quality to colour. Other experiments with tempera used such materials as combined yolk and egg white, fig milk, and several kinds of vegetable juices and gums. Tempera was commonly used between the twelfth and fifteenth centuries. Yet another ingenious technique involved the mixing of pigments with wax, and the final colour was applied in the heated state. This method is known as *encaustic,* and variations of the technique are still used today. Finally, the paints that we most readily recognize as watercolours were developed by mixing the pigments with natural gums, such as gum arabic. Nowadays honey is often added to counteract the brittleness of the gum.

The glories of watercolour painting are displayed in all parts of the world. Chinese and Japanese artists produced the most exquisite effects with transparent watercolour, while medieval artists created glowing

Left: *A sixteenth-century Persian painting shows the Shah Abbas welcoming a visiting dignitary. The brilliant colours and flowing calligraphy are beautiful examples of the heights of artistic creativity achieved during the Shah's rule. Many of the colours were made by grinding up precious and semi-precious stones.*

illuminated manuscripts such as those from Kells and Lindisfarne. Persia, India, and of course the Mediterranean countries all used varieties of watercolour to produce wonderful paintings, and later on the medium was used to illustrate books on natural history and travel. By the fourteenth century however, oil paints were thoroughly established as the main colour medium for painters, and watercolours were relegated to a secondary position, occasionally used by Old Masters such as Dürer and Rubens, but only in small and comparatively minor studies.

The Dutch influence and the rise of English watercolourists

In the late eighteenth century however, there was a major development in English watercolour painting. This was influenced by the changing

Above: A very early example of illustrated natural history, this thirteenth-century manuscript shows the herb vervain which was regarded as a cure for all ills.
Right: This fine watercolour of a hare by Albrecht Dürer (1471–1528) is typical of his sensitive and minutely detailed studies of animal and plant life.

situation in Holland, where the subject matter of painting had been
gradually broadening in scope. Before the eighteenth century, much
of the work produced by European painters was on a grand scale and
supported by heads of state and the Church, with the human figure as the
dominant element. The situation in Holland began to alter when the
country achieved political independence from the Spanish Netherlands
in the sixteenth century, and thereafter developed a highly prosperous
mercantile system. During the seventeenth century, a rich middle class
of traders emerged, and they demanded a wide range of subject matter
from artists, including a continuation of portraiture, still life, interiors,
seascape, and most important, landscape, which was to be the key
influence on English painting.

A century later, England was in a similar state of growth and pros-
perity, and during this period there was a unique development in the
art of watercolour painting. Under the influence of the Dutch, the
subject matter was usually landscape, the figure being incidental, if
used at all. An exception to this was William Blake, a visionary artist
and poet, who invariably included the human figure in his paintings.
Most landscape painters worked from nature on so small a scale that a
directly applicable, fast-drying medium was needed. Watercolour was
ideally suited for this purpose, and the qualities of the pigment enabled

Above: Turner was a brilliant exponent of both the watercolour and oil medium. In this watercolour Caernarvon Castle *his genius for painting light through delicate washes, with misty vistas of architecture and sky is fully realized. Again, as with the Cotman on the previous page, the foreground scene is more representational, but is not the real focus of the work.*

the artists to capture the subtle colour nuances of the English landscape. Wealthy patrons commissioned fashionable paintings of their homes and the surrounding countryside. This period of English watercolour painting produced some fine, sensitive artists, such as Bonington, Cozens, de Wint, Crome, Cotman and Girtin, to name only a few. They all helped to push the medium to new heights of expression. It was, however, the genius of J. M. W. Turner (1775-1851) which most fully explored the possibilities of watercolour, for he really understood the fundamental directness of application necessary to achieve the finest effects (the only other areas where watercolour has produced such brilliant exponents are China and Japan).

Turner was the first great creative visual mind in Europe to exploit watercolour fully, producing such large, complex works as the view of Caernarvon Castle in North Wales. Often subjects such as these included small figure groups, and these were given a suitable historical title, since there was little popular demand for pure landscapes and the bulk of

purchasers continued to want mythological or historical subjects. Constable, who was his contemporary, also produced beautiful watercolour landscapes, but it is Turner's appealingly simple studies, particularly those of Venice that are so outstanding. A few brush strokes conjure up a whole atmosphere of extensive space and scale, yet few of these works are more than 30cm (12in) on their longest dimension.

The artistic revolutions

The criteria that had imposed rigid standards of style and subject matter were finally swept away during the successive artistic revolutions of Impressionism, Neo-Impressionism, Cubism, Fauvism, Dada and Surrealism. Consequently, the way was left open for a vast range of innovation in shape, colour, spatial effects and artistic content. Take the revolution in subject matter for example: scenes from mythology and history gave way to café and street life: regal portraits of the rich and aristocratic were supplanted by studies of prostitutes and dancers,

Above: This delicate but authoritative watercolour landscape called Mont Sainte Victoire (*Paul Cézanne*) *is one of sixty versions of the same view. The washes are brushed in with a few strokes, using a restricted range of blues, greens and yellows. Cézanne started using watercolours quite late in life, and produced some exquisite studies in the medium.*

140

women at their toilet, or at the ironing board. Sedate landscapes were abandoned in favour of railway stations, and urban scenes. The result is that nowadays the painter can choose any subject, whether it be a soup can or a formal portrait.

Although watercolour is not so widely used as oils, a number of major artists have used the medium extensively since the peak period of its popularity in the eighteenth century. At the end of the last century, Cézanne used the medium to achieve a brilliant economy of statement in contrast with the use of really wet, gestural application by Rouault early in this century, or the dynamic, direct application of Dufy. Paul Klee used the medium extensively, sometimes with rich, complex glazing, or else as a simple first-time application of stunning clarity.

In England, the tradition continued to flourish throughout the nineteenth century. There were numerous Victorian artists of repute, though the best loved is probably Samuel Palmer, who produced his finest work before 1840. During this century, artists like Sir Henry Rushbury continued the tradition of Turner's topographical works,

Opposite: The twentieth century revolution in painting styles and subject matter influenced watercolours too, as shown in this highly gestural nude by Rouault called La Fille au Miroir *(1906).*

Below: Artists like Dufy took much of their subject matter from scenes of sporting events such as this work called Racehorses, *painted in a direct, brilliantly colourful style.*

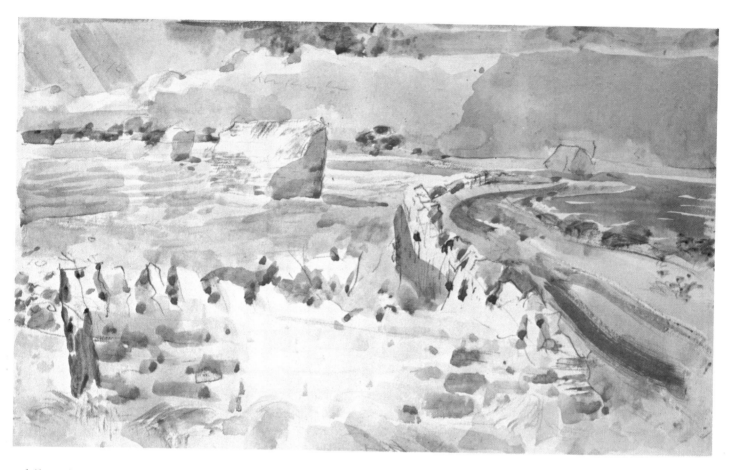

while others, notably Paul Nash and Edward Burra, developed highly particular visions of the world. Nash dealt primarily with landscape, while Burra was more cosmopolitan, drawing great stimulus from city dwellers, such as those of Harlem in New York. During this century, watercolour artists have produced portraits of stunning power, unusual landscapes and richly coloured flower groups, and a new generation continues to explore the medium, often mixing opaque and transparent water paints to achieve beautiful effects.

Given this impressive history, you may be overwhelmed and discouraged at the same time. However, as you are introduced to your materials, you'll soon realize that skills develop through your determination to express your own ideas—there is no single right way to paint, techniques and ideas evolve side by side. Ideas are developed from critical observation of your environment. Regular work will increase your power of observation, and although there are basic skills to learn, after a certain point it is your own vision and imagination that becomes the guiding factor in your progress. Painting, like every artistic activity,

Above: Oxfordshire Landscape *by Paul Nash (1889–1946) shows this artist's typically restrained use of colours—here, sombre greys and yellows. Some of the original sketch-work can be seen showing through.*

Opposite: The English tradition of watercolours developed throughout the nineteenth century. Samuel Palmer's idiosyncratic mystical vision is expressed through his skillful use of gouache in unusual colour combinations. His 'blob' brush technique effectively creates the magical atmosphere of this painting In a Shoreham Garden.

is highly individual. By viewing and analyzing different shapes and colours, and the way they interact, you will increase your capacity for aesthetic responsiveness. In fact it is unwise to lean too heavily on technical tricks, for each new work should be a fresh challenge. Your eye will gradually become more critical and alert, you will see each experience as a new painting problem—this way you control the medium rather than being overwhelmed by it yourself.

Materials

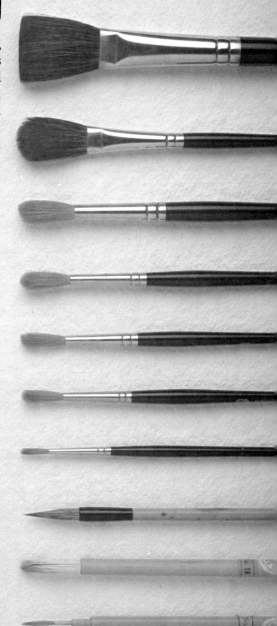

What do you paint with? There are literally dozens of different brushes, innumerable colours and a huge range of papers and other surfaces available on which to work. Many of the brushes have specific uses and the quality and nature of different waterbased paints have their own idiosyncrasies. Different surfaces can influence a single colour in different ways. The multiplicity of paper presents an alarming problem for the inexperienced. What is the difference between 'hand made' and machine manufactured? What does HP and poundage mean? This chapter will attempt to provide you with simple answers to these questions, indicating which basic materials are required from the massive array available and also how to maintain the quality of those materials once in use.

Brushes

When you first enter an art supply store, you will be faced with a bewildering array of brushes, many of which will have been specially designed for use with different media. Since you are basically concentrating on buying equipment for watercolour work, you'll need to be guided through the maze. Don't be afraid to ask for advice in the store if you are in any doubt. Many artist suppliers are highly trained and will be glad to help you make your selection. Brushes are available in two basic categories—hogs' bristle and hair of different types, qualities and cost. Hair brushes are normally considered to be most suitable for watercolour, and these are available in a wide variety of shapes and sizes. As you handle the brushes, check carefully to see that the bristles or hairs are set securely in the *ferrule,* which is the metal collar holding the hair or bristles and joining them to the brush handle.

Sables, and other hair brushes

As you examine the brushes, especially those made with hair, you will notice that some are much more expensive than others. The most expensive are those made from the guard hairs of the Russian kolinsky sable. These brushes really are magnificent, they are hand-made, and have a superb natural spring. If you use one, you'll discover that it is

highly sensitive to the brush stroke, and returns to its original shape when dry. But such expensive brushes are not essential for students.

If you are trying to keep down your initial financial outlay, look at the other varieties of hair brushes, many of which are still called sables to distinguish them from bristles. These are made from a wide variety of animal hair, including ox-hair, squirrel, pony and ringcat. The best policy is to spend as much as you can afford for a few good brushes. The really cheap varieties will last for a couple of months, and will then deteriorate. The best brushes, provided they are well looked after, always retain their shape. Whether loaded with paint or not, the curve of the brush should be natural, in order to give you the maximum control when applying your paint.

You will probably also notice that the brushes have differently shaped heads. The basic shapes are round, flat and filbert, the latter being a shape which is in between round and flat. Obviously, these different shapes will produce different kinds of brush strokes. At this point, you are advised to purchase about half a dozen round brushes in a range of sizes. The sizes are numbered so that the smaller brushes are described in low numbers, and the larger in higher numbers. A good initial selection should include a 2 or 3 round for detailed work, and then a range like 5, 7, 8 and 9 for heads which will be suitable for working with larger areas of colour. You may like to buy one flat brush, if so, choose one with a 18mm ($\frac{3}{4}$in) wide head.

Mops

As you work with watercolour paint, you will realize that there are many occasions on which you will need to apply a really large area of colour onto your surface, especially when you are painting on a fairly large scale. For this sort of work you will need a large headed variety of brush called a mop. To be really well equipped, you need both a medium and a large size, although initially the medium size will suffice.

Chinese brushes

Some art supply stores stock Chinese brushes which are usually made from goat or badger hair, and are often set in a bamboo handle. These brushes have very fine points, and have been developed over many generations for the fine calligraphic work so typical of oriental art. One or two of these might be useful, but they are not essential at the beginning.

Hogs' bristle

At the beginning of this discussion on brushes, it was mentioned that hair brushes are traditionally considered to be the most suitable for watercolour work. Brushes made from hogs' bristle have always been

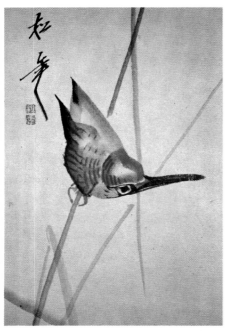

Below: This enchanting study of a kingfisher by Yamanaka Shōnen follows the Japanese tradition of delicate brushwork and glowing, transparent colours. It was painted between 1806–1820.

the basic tools for oil painting, since the hairs are very stiff, and are ideal for holding the creamy, thick consistency of oils. These brushes have always been considered too coarse for watercolours. Recently however, manufacturers in Britain have invented a special kind of jelly known as aquapasto which can be mixed with watercolour paints to achieve a really thick consistency, and you can certainly use hogs' bristle brushes with this. This substance should be available internationally in due course, and it provides a fascinating example of how technology changes the scope of painting. More information on the use of aquapasto jelly will be provided later.

Synthetic brushes

In recent years a number of manufacturers have been exploring the possibilities of synthetic fibres for brushes (obviously with the growing

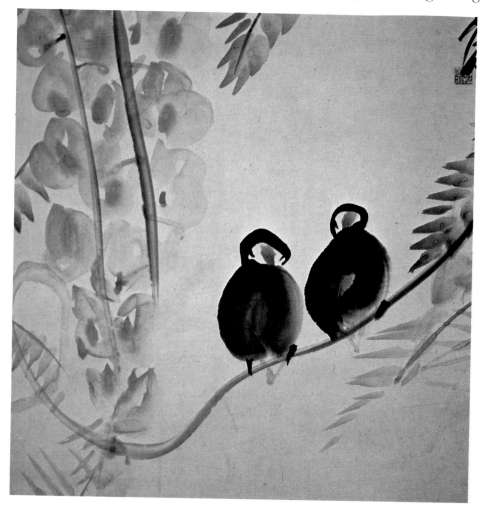

Left: Another exquisite example of oriental line brushwork used in combination with delicate washes. Java Sparrows on a Wisteria Bough *by Ling Feng-Mien.*

scarcity of good sable a synthetic alternative has much appeal). Nylon and polyester are the basic materials used. The initial problem seemed to be the lack of holding ability of the head, for unlike natural fibres the synthetic varieties would not absorb paint in any quantity. However, it must be said that recent design improvements in the structural shape of the fibres have improved their holding ability. A wide range of this type of brush both for oil and watercolour painting are now manufactured. They are relatively cheap and hard-wearing, though they do vary greatly in quality depending on the shape of the synthetic fibres used. Their strength makes them ideal for children to use.

Fig. 1 Brushes must be properly maintained, otherwise the heads can be completely ruined, as shown here.

Maintaining brushes

Brushes will last and maintain their particular characteristics for years if they are looked after properly. They should be kept in as perfect

condition as possible, otherwise damaged brushes will seriously affect your work. After any use, rinse brushes thoroughly in warm water and soap, making sure any surplus paint is cleared from the ferrule. Take the soap and warm water and gently work up a good lather in the palm of your hand with the brush. This motion should be gentle so as not to damage the very delicate structure of the head. The brush should then be rinsed, surplus moisture removed and the head shaped to a point between finger and thumb. Stand brushes in a jar, bristles uppermost for everyday storage allowing plenty of space between each brush. An old jug or jam jar is ideal for this purpose. When using brushes always remove them from the water jar after rinsing or they will become damaged. If you have to store hair brushes for any length of time, put some moth repellent in their container, or you might find that your precious brushes have been eaten up.

Transporting brushes

Too often brushes are thrown into boxes, thrust into bags and left without any sort of protection until they are to be used again. Sables are particularly susceptible to damage under these conditions. If the point is

destroyed as in fig. 1 the brush is ruined and will never be able to accomplish the job it was originally designed for. Take note that any brush can be damaged in this way so it is important that some form of protection be devised. This is easily done by making a small tube of some stiff paper secured with adhesive tape, that fits over the head of the brush and onto the handle. High quality sables have this type of covering when purchased. This simple inexpensive device will help to extend the brush's lifespan considerably. As an additional protection during transit, slot your brushes into a cardboard cylinder with one end sealed (a cardboard tube for example) or purchase a special container.

Paints

All paints are made from pigments, which, as was mentioned in the introductory chapter, come from a variety of sources. Pigments are simply the dry colouring agents which are mixed with different kinds of liquid binding materials. The dry pigment may be of natural origin, or produced artificially. They fall into four general categories, according to their source.

Natural mineral colours are often known as 'earth colours' (ochres, umbers, etc). They are mined from the earth, and derive their colour from various iron compounds in the soil, as well as varying amounts of clay, chalk and silica. The qualities of these colours depends very much on what these deposits are, for they produce many forms of colour, transparency and strength. Used since prehistoric times, they are made into all varieties of paints, and produce lively shades of warm browns and yellows.

Factory-made mineral colours are products of the laboratory, and have contributed many new shades to the artist's palette, such as Viridian green and Cobalt blue. Often these colours are equivalents of natural pigments, for example the earth colours mentioned above have been available in artificial form since the middle of the nineteenth century. Today these are generally known as 'Mars colours', and their value lies in the fact that they are freer from impurities than the natural colours.

Natural organic colours are of animal or vegetable origin, for example sepia, which is made from the ink bag of the cuttlefish or squid. These colours tend to be very rarely used, since they bleach out in strong sunlight.

Dyes are different from other pigments in that they dissolve completely in their binding medium. Most dyes are made from complex organic compounds. Some come from natural sources, like Carmine, which is made from an insect. Others, like Alizarin are artificially made, frequently from coal tar. Most dyes have to be mixed with a base, before adding a binder for the colour. These colours are described as 'lakes'.

Above: This full length miniature is a delightful example of the work of the Elizabethan painter Nicholas Hilliard.

Pigment colour groups

Before discussing the varieties of ready-made watercolour paints that are available in art supply stores, you should have some background knowledge of the basic colour groups, since all manufacturers have their individual names for colours, as well as great variations in the colours themselves. There are many more pigments in existence than the ones mentioned below, which are usually used for watercolours. In fact, many of them are also used in oils and other media. You will soon be familiar with the various pigments as you paint more.

White pigments

Zinc white, also known as Chinese white, is a brilliant cold white, and is excellent for watercolours. Titanium white, made from titanium oxide has good, fast drying properties.

Yellow pigments

Aureolin is made from cobalt-potassium nitrite, and has an excellent transparent quality. Cadmium yellows and oranges are manufactured from cadmium sulphide, and come in a range of bright, strong tints. Permanent lemon, and Barium yellow are names given to rather weak yellows made from barium chromate. Hansa yellow is a recently developed synthetic lake with a bright, strong colour. Yellow ochre, Gold ochre and Raw sienna are known as the earth yellows, with duller yellow tones. The synthetic equivalents, the Mars yellows, are also included in this group.

Red pigments

Alizarin crimson is a synthetic coal-tar lake, which has transparent properties, and leans toward blue tones. When mixed with Zinc white it produces violet shades. Cadmium reds are similar to the yellows and are available in various shades, in strong, bright colours. Earth reds, and their synthetic counterparts, Mars reds, come in a wide range of shades, from warm, brick reds to cool browns.

Blue pigments

Cerulean blue, Cobalt blue and Manganese blue are all excellent permanent colours, and dry rapidly. Since they are expensive, cheaper versions are made by mixing other blues. Monastral blue, also called Oxford and Winsor blue is a recently devised synthetic lake, very strong in colour, and closely resembling Prussian blue, which is strong in colour also, and transparent. Ultramarine used to be made from grinding the semi-precious stone, lapis lazuli. Nowadays, it is more usually made artificially, though the colour is still quite beautiful, as is French ultramarine.

Green pigments

Chrome oxide greens come in opaque and transparent forms. The former is a strong, mid-green shade, while the transparent kind (also known as Viridian) has a cool tone. Cobalt green is made of cobalt oxides and zinc. It dries rapidly, but has weak tinting properties. Monastral green, also known as Winsor green, is another recently devised synthetic lake, with powerful colour. Terre verte, or earth green is a natural colour, with a weak, grey-green tint.

Purple pigments

Cobalt violet is made either from cobalt arsenate or cobalt phosphate. The first is poisonous, the other quite safe, so check any paint of this derivation to be sure. Alizarin violet, like the crimson, is a synthetic coal-tar lake with transparent bright colour. Ultramarine violet is no longer very popular, though it is a useful tone, and is quite adequate in its tinting strength. Mars violet is a dull, violet brown, and has good, permanent properties.

Brown pigments

Bistre is made from charred beech wood, and has a pleasant warm colour. Sepia can be substituted for this colour, which was very popular with the nineteenth-century watercolourists. Raw and Burnt umbers, are very popular. The former has a warm, rather olive tone, while Burnt umber is a warm, reddish brown. Brown madder is made from one of the Alizarins, and has a deep brown tone with a crimson tinge. Raw sienna is a native Italian earth colour, leaning toward a deep yellow ochre. Burnt sienna is rather orange in tone. Burnt green earth is a burnt variety of Terre verte.

Grey pigments

Charcoal grey, made from various charcoals, is quite valuable for light watercolour washes. Davy's grey is made from powdered slate, and is also good for watercolour. Other grey pigments are mixed. For example Neutral tint is a combination of Alizarin crimson, artificial ultramarine and black. It should only be used in watercolours. Payne's grey is another mixed colour, using a similar mix as neutral tint.

Black pigments

These pigments are usually produced by charring or calcining various materials. Ivory black used to be made from charred ivory chips, though now bones are used. Blue-black comes from calcined wood and other plant sources, and has a slight blue tinge. Lamp black is made from soot obtained from burnt oil. Peach black is from a vegetable base, and has a delicate brown tinge. Vine black is made from charred vine roots.

Above: A Summer's Day: Coast Scene *by Eugène Boudin is a fine example of the use of delicate washes and transparent watercolour to achieve a dissolved, airy effect. Notice also the paper ground and the original pencil sketchwork showing through.*

Buying watercolours

Since it is highly unlikely that you are ever going to have to learn to grind and mix your own pigments, as apprentices did under the direction of master painters, you simply have to decide which paints are suitable to buy from art stores. Before considering which colours to choose, it would be wise to look at the various forms of watercolour paints. They fall basically under the main groupings of transparent watercolours and gouache or body colours.

Transparent watercolours

Transparent watercolours can be bought in tubes or pans. Those sold in tubes not only have the usual gum binder, but are also mixed with glycerine to help keep the paint moist. If you buy colours in tubes, remember to keep the tops tightly screwed or else your paint will dry out and harden. If this does happen, you can slit the tube open, and use the hardened colour as you would a pan watercolour. Another hazard is that over a period of time the glycerine separates, and you'll find a

transparent, oily liquid seeping from the top of the tube. This should be removed, because it slows down the drying process, however you can compensate by adding a little extra gum arabic, which helps to increase the luminosity of the colour.

As you browse around the store, you'll notice a wide range of colour boxes containing cakes or pans of watercolour in various sizes and shapes. Some boxes are very simple, with about 12 colours, and a white varnished lid with slightly recessed divisions which are meant to be used as mixing palettes. The more sumptuous kinds might have twice as many colours, a special mixing well, a large aluminium palette, its own brushes, and a brush holder. What's more, the whole kit may be packed in a glossy wooden box. Unless you are indulging yourself, your best policy is to use the smaller box, augmented with a selection of tube colours. Try to get a box which you can refill with new pans or cakes of colour; some have a clip mechanism so that you can easily renew the pan. Buy the best ones that you can afford, and economize on materials like mixing palettes. You don't need expensive porcelain ones, although they are very nice. A clean white dinner plate does just as well, and plain white saucers are fine for mixing single colours. If you do raid the china cupboard, remember that you should always mix your colours on a white background, so that it relates to the white surface of your paper. Colourful floral patterns may be fine for your dinner table, but their influence on your colour sense would be disastrous.

There is one form of watercolour colour paint that is sold in hexagonal sticks. These are called architects' watercolours, and although they do not come in a wide range of colours, they are very good quality, and also very economical.

Gouache or body colours

The cheapest variety of these colours are the powder paints usually used by children. They come packed in cans, and are in bright, cheerful colours. The main problem with these is that they tend to flake off when dry, so your painting is ruined. However, if you are really looking at economy as a primary object, you may find that more sophisticated powder colours are helpful. These are sometimes called New art powder colours, and they have a special acrylic medium in which to mix them, this also renders them virtually waterproof when dry. Again, the colour range is fairly limited.

There are various brands of poster paints available in both tubs and tubes. They are excellent in quality, have a good colour range, and maintain their opacity very well.

Designers' colours are the water-based paints used by graphic artists as their name suggests, and have outstanding brilliance of colour, and a stable matt opaque surface when dry. They can also be thinned to a

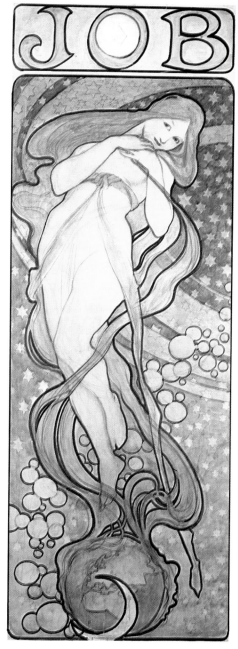

Above: The brilliance of designer's colours are seen at their best in posters. The Czech artist Alphonse Mucha (1860–1933) was a fine exponent of poster art.

153

fairly transparent film, but even so they are still coarser than transparent watercolours. When you gain some experience with using colours, you may find that you can experiment with combinations of gouache colours like these, and transparent watercolours.

The nearest form of the creamy consistency of oils that you are likely to achieve with watercolours is found in gouache colours, usually used to make a thick paste called an *impasto*. We have already mentioned the new invention, known currently as aquapasto, however. It is this substance that has lessened the restrictions previously encountered by watercolourists. Aquapasto is a virtually colourless transparent jelly, which can be mixed with both transparent watercolours and gouache colours. It even allows you to use a hogs' brush to apply large amounts of thick colour. You can mix any of the watercolours direct, except for the New art powder colours, which should first be mixed to a paste with water before adding the jelly. In all cases add an equivalent amount of the jelly to the paint. You will find that the tube colours are easiest to mix, since you can control the flow. The method of mixing is simple—squeeze the jelly onto a palette, add the colour, and mix with a palette knife. The resulting paste can be applied quite thickly, either with a brush or a palette knife. It will not crack when dry, although you should obviously choose a fairly rigid, coarse surface to hold the weight of the paint.

If you are using layers of wet colours, as you often do with impasto, you can prevent the colours running by spraying on a coat of aerosol

Right: Children have no inhibitions about using paints to express their ideas. They can achieve very graphic results like this using an inexpensive gouache, such as powder paint.

fixative, which you can buy from art supply stores. This applies to other kinds of watercolours, including the transparent ones.

Choosing your basic colours

Every artist has a personal 'core' palette, a range of colours which he can mix to produce a variety of other colours. Since you have been advised

Left: The Acrobat Family *by Picasso* (gouache) *uses the medium in a very subtle manner, and creates a mood of great tenderness.*

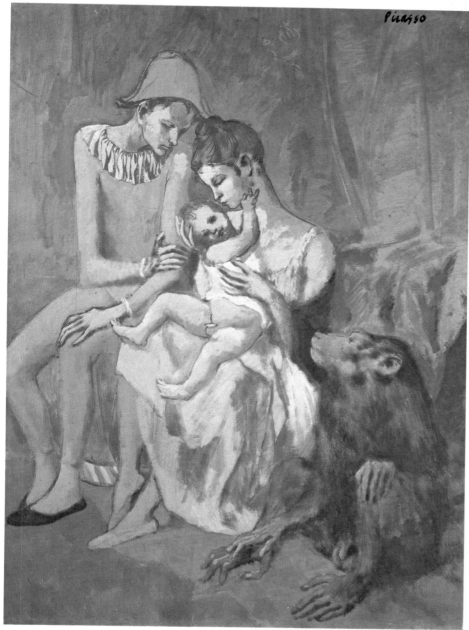

to start off with a small, good quality colour box containing about 12 colours, then all you have to do is to check that you have equivalents to the following list of colours.

1. Two yellows, one in a warm Cadmium shade, and another in a paler Lemon colour.
2. A strong, bright Cadmium red.
3. Alizarin crimson.
4. French ultramarine blue.
5. Winsor blue (also called Monastral and Oxford blue).
6. Viridian (the transparent variety of chrome oxide green described in the section on pigment colour groups.
7. Any good purple or mauve colour.
8. Black.
9. White.

Some artists also insist on having good brown shades, but you will soon discover for yourself how many colours you will want to add to your basic range.

Work supports

You will need to support your paper on a board surface, which in itself will require some sort of table or easel on which to rest. Water-colour paint tends to run while being applied, so your drawing board will normally be held in a horizontal position. You could sit in a deep seat with the board resting on your knees, and have a small low table placed nearby which would hold paints, brushes and other equipment. However this is not the most flexible situation in which to paint. An ideal structure would combine a seat, a prop for your board, as well as a table area for equipment. Such structures are made, sometimes known as 'donkeys'; they are usually found in fully equipped artists' studios. The most useful ones for watercolour work should provide at least two heights and four angle adjustments; also, some are provided with wells, which allows for extra storage space for some equipment. These are very expensive however, so consider the following alternatives.

Easels

Sketching easels are compact, light and easily handled. Their telescopic legs ensure stability on uneven ground. There are many to choose from, but try to find one with an adjustable central arm, allowing it to be pivoted into an ideal watercolour working position. Spiked metal shoes are available to fit some easels, to steady them in windy conditions. A simple alternative to these shoes are three wooden or metal spikes and some cord. After setting up the easel, align the spikes with the legs, hammer them into the ground, then bind the spikes and legs together

with the cord. (See fig. 2.) Your easel will be perfectly secure.

A heavier variety of easel, which is really only suitable for indoor work, is called the radial easel. This has a pivot at the juncture of the upright and tripod legs which provides for forward and backward tilting, as well as a central split that allows for an almost horizontal adjustment to the top. This type is an excellent, stable easel.

For indoor work, you can improvise your own support. Use a standard table, and a block of wood to prop up your board—in fact you could use several for different angles. The rest of the table can be used to hold your equipment.

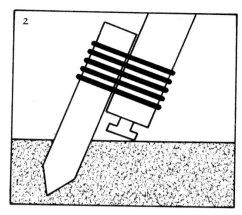

Fig. 2 In order to secure the easel firmly, push pegs into the ground and bind the easel legs to them.

Drawing boards

Boards come in a range of sizes, often with traditional names like 'Royal' or 'Imperial'. Before the introduction of more standard sizings for international purposes, and of course to allow for metrication, board sizes were related to the traditional sizes of paper. In fact the accompanying paper sizes were always a little smaller, so a Royal size in paper would not be the same as the board of that description. To confuse the issue further, many of the finest hand-made papers are still made in the traditional sizes, so you will always have to check carefully that your board is the correct size if you want to use these.

One of the major factors in choosing a board is comfort. You don't want to stretch too far when painting, and also you may have to carry your board around quite a lot when you work outdoors. A good average size would be about 525mm x 650mm (21in x 26in). This is comfortable to work with in a sitting position, for the average length arm will easily reach the top of this size board.

Making your own board

To save money you can make your own board. Always ask a good store to cut the wood to the size you need, making sure that the board is cut with squared edges; check also that it is flat, and has a smooth surface. Since you often need to stretch paper on the board, you must remember to choose a variety that is sturdy enough to withstand the pull of the paper while it is shrinking. (The method of stretching paper is described later in this chapter.) Thus, the wood you choose should be at least 8 ply, and marine plywood is particularly recommended. This material will provide an ideal base, without the danger of glues used in other kinds of wood seeping through and sticking the paper permanently to the board. If you are planning to stretch small sizes of paper, get some small sheets of hardboard as well, since this has sufficient tensile strength to accommodate smaller sizes. Pieces of hardboard are also useful for transporting sheets of paper that have not been stretched. You can simply clip them onto the hardboard.

Above: A cleverly used combination of the medium (watercolour) and ground (airmail paper) results in this attractive decoration for an airmail envelope. The design is called Sky High, *and is by Christopher Glanville.*

Manufactured boards

Commercially made boards are available in a wide range of size and quality. Buy the best that you can afford, but avoid any with a vinyl surface. These are specially made for projection drawing work, and it will be impossible to stretch paper on them, since the gumstrip used in this process will not stick to them. If you ever have to use very large sheets of paper, you might be able to buy a really large old drawing board from a sale or auction of office equipment. For many, they are too expensive to purchase new, but you might be lucky to spot one second-hand.

Paper

Paper is the most commonly used painting surface for watercolourists. It is available from many different sources and in an almost infinite number of colours, sizes, surfaces and above all else, qualities. What is ideal as a

surface for print, pen, pencil, charcoal or graphite, is not necessarily going to be of any use for watercolour painting.

The finest papers for pure watercolour painting have been traditionally hand-made from linen rags, as have the finest printing papers. Today, however, cotton is the more widely used material. Good printing papers, no matter how beautiful in texture, are not necessarily going to be suitable for painting due to the sizing which is added to all papers during manufacture. There are certain papers, however, that can be used for printing as well as watercolour, depending on the particular results required. The advantage of these papers is they do not yellow in daylight, a critical point when involved with delicate thin transparent watercolours that sometimes barely stain the surface of the paper. In pure watercolour painting all the light comes from the ground (the sheet of paper). Rag papers are extremely expensive for the beginner and a good quality mass manufactured white cartridge paper i.e. drawing paper, should be used instead, at least in the initial stages.

Below: John Sell Cotman's painting Ruin and Cottages, North Wales *is worked on his own hand-made paper. This kind of paper is made by a few specialist craftsmen nowadays, and is highly prized by watercolour painters.*

Imperial (standard) measurements

Half Imperial	15 in × 22 in
Royal	19 in × 24 in
Super Royal	$19\frac{1}{4}$ in × 27 in
Imperial	22 in × 30 in
Elephant	23 in × 28 in
Double Elephant	$26\frac{1}{2}$ in × 40 in
Antiquarian	31 in × 53 in

Standard international measurements

| A0 841mm × 1189mm ($33\frac{1}{8}$ in × $46\frac{3}{4}$ in) |
| A1 841mm × 594mm ($33\frac{1}{8}$ in × $23\frac{3}{8}$ in) |
| A2 420mm × 594mm ($16\frac{1}{2}$ in × $23\frac{3}{8}$ in) |
| A3 420mm × 297mm ($16\frac{1}{2}$ in × $11\frac{3}{4}$ in) |
| A4 210mm × 297mm ($8\frac{1}{4}$ in × $11\frac{3}{4}$ in) |
| A5 210mm × 148mm ($8\frac{1}{4}$ in × $5\frac{7}{8}$ in) |

Sizes and weights

In the discussion on drawing boards it was mentioned that their dimensions were traditionally related to corresponding sizes of paper. All these categories have particular names, and since some manufacturers still make papers under these descriptions the accompanying list will be useful. Metric conversions are not supplied, because these papers are only related to Imperial Standard measurements. Always remember to check that the paper size is suitable for your drawing board. Most papers produced today on a mass volume basis are standardized, and an International size range is available as listed in the accompanying chart.

If larger sheets than these are needed, they will have to be bought in cartridge paper, i.e. drawing paper, available in really large sizes.

Papers are also distinguished by their thickness, the weight is quoted per ream (480, 500 or 516 sheets). This term used always to be called *poundage*, e.g. 90lbs per ream. In metric the weight would be quoted at the number of grammes per square metre (i.e. gsm).

Papers have different terms used to describe their surface texture also. *Hot pressed* (HP) paper is ironed to provide a smooth, glossy surface which is excellent for the beginner; *Not pressed* (Not) or cold pressed paper is matt, with a fairly open surface, and is best for pure, transparent watercolour. *Rough* is a heavy grade paper with a really coarse surface, useful for impasto work.

Right: The Green Donkey (*1911*) *by Marc Chagall is painted in gouache on a board ground. Chagall's use of gouache is very appropriate in conveying the fantastical world of his childhood memories.*

Card and board

Various weights and qualities of card or cardboard are available, and are useful grounds for gouache and poster paints. Transparent water-colours can also be used if mixed with aquapasto. The paper surface would probably start to bubble otherwise.

It used to be thought that papers made from cotton were less fine than linen rag varieties simply because of the quality of the cotton itself. Some of today's manufacturers of hand-made paper attribute this misconception to the fact that the medium called 'size', used to control absorbency, was not correctly balanced. If no size were used you would have a blotting paper. So the amount and quality of size is important. Traditionally, a gelatine or hide glue was used for sizing, but today certain hand-made paper manufacturers use a synthetic type, and the quality of paper manufacture is improving. The shredded cotton is passed over a fine mesh and pressed, the size having been added at the pulping stage. This produces excellent paper with the rough edging characteristic of most hand-made papers. The uneven 'deckle' edge is caused by the seepage of pulp between deckle and mould. The various surfaces are the result of careful pressing and drying. Good papers often have a manufacturer's watermark, so you should check to see if your paper has one by holding it up to the light.

The weight of paper is important for the simple reason that the thicker it is the greater the absorption of water before it begins to cockle, i.e. before the surface starts to produce crinkles and bubbles when wet, allow it to dry before continuing to work. A cheap paper cockles almost the moment you apply your paint, making it impossible to have any control over the work because of the undulating surface. The

Above: This fine watercolour by James Abbott McNeill Whistler is painted on a fine linen which is a beautifully textured ground for the medium.

surface of cheap paper will also tear quickly, and is impossible to work on with any consistency. Obviously the longer you are able to work without interruption, the better. In addition, a paper on which a whole range of techniques can be used has distinct advantages. When using aquapasto as a base, the thicker the paper, the better rigidity it will provide; Not or Rough will provide a tooth (i.e. a coarse surface to hold the paint) similar to that which canvas provides for oil.

It is unwise to use a Rough or Not surface for really fine work: Rough and Not, however, do give additional sparkle to the colour due to the way light flickers across the surface. Begin with a good quality HP paper that allows for fine drawing control. You can buy several varieties of good quality mass-produced papers which only yellow slightly when exposed to sunlight. They are not so expensive that you feel afraid to use them. A possible economic alternative is to purchase the watercolour sketch pads that are available from all artist suppliers. The range of size and quality of paper is considerable and an added advantage is not having to bother stretching the paper. Once confidence has been established, you can start buying much better papers, and these will improve your paintings too.

Besides white paper, a number of tinted papers are also manufactured. For designers' colours and poster paint a white ground is not necessary, but a good quality heavy HP is vital to allow for lengthy uninterrupted work and good results. If used without some of the new additives these paints tend to be vulnerable to cracking, particularly if applied too thickly, so use as rigid a base as possible.

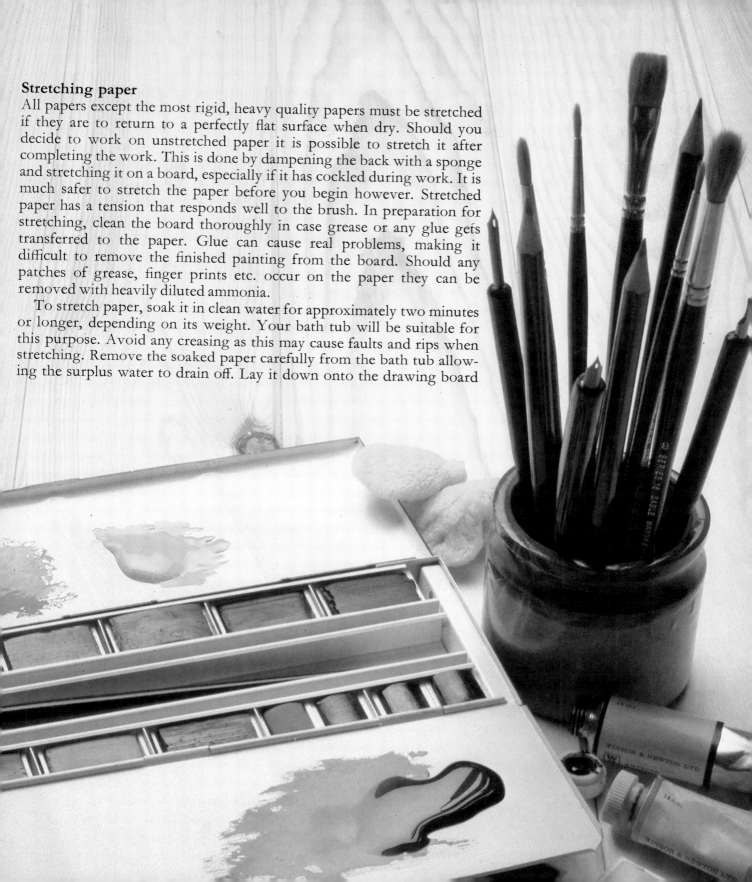

Stretching paper

All papers except the most rigid, heavy quality papers must be stretched if they are to return to a perfectly flat surface when dry. Should you decide to work on unstretched paper it is possible to stretch it after completing the work. This is done by dampening the back with a sponge and stretching it on a board, especially if it has cockled during work. It is much safer to stretch the paper before you begin however. Stretched paper has a tension that responds well to the brush. In preparation for stretching, clean the board thoroughly in case grease or any glue gets transferred to the paper. Glue can cause real problems, making it difficult to remove the finished painting from the board. Should any patches of grease, finger prints etc. occur on the paper they can be removed with heavily diluted ammonia.

To stretch paper, soak it in clean water for approximately two minutes or longer, depending on its weight. Your bath tub will be suitable for this purpose. Avoid any creasing as this may cause faults and rips when stretching. Remove the soaked paper carefully from the bath tub allowing the surplus water to drain off. Lay it down onto the drawing board

making sure the correct face of the paper is upwards. With hand-made papers it is relatively easy to see the right surface on which to work—in fact you can use either—but with some of the good, smooth finished mass manufactured types, it is difficult. Look carefully before placing it in the water and you will notice that one surface has a fine orderly texture on it; that is the back. Gently wipe the surface with a clean, soft dry cloth eliminating any bubbles as you would when wallpapering, then quickly lay a 5cm (2in) gumstrip around all four sides with approximately 18mm ($\frac{3}{4}$in) on the paper and 42mm ($1\frac{1}{4}$in) on the board. Avoid immersing the gumstrip in water, just moisten with a sponge. Leave the board flat to ensure even drying. If drying is uneven, and this easily occurs if the board is stood on end, the moisture drains from the top, allowing the top to begin tensioning as it dries. Meanwhile the heavy moisture content at the base will keep the gumstrip wet and not allow it to glue firmly to the paper. As the uneven drying continues the bottom edge often separates from the gumstrip. If this happens, you must start again with fresh paper. The paper will always cockle during drying but as long as it was flat when the gumstrip was attached, it will dry and tension into an immaculate flat surface.

Storing paper

As paper is so expensive, it is necessary to provide adequate storage where it will be completely free from dust, damp and light. Ideally it should be stored in a plan chest which has large, flat drawers. Wrap it in brown paper to keep off dust, or store in a portfolio. Never roll paper. It damages the structure. If storing vertically, support it with a board, but a horizontal position is preferable, since this provides the most secure all-round protection for your paper.

Other equipment

You will need several other items to add to your basic equipment. Buy a selection of pencils (HB, B, and 2B), also some pens with different sized nibs for fine work; a box of paper clips, a really soft rubber eraser; a small natural sponge; an aerosol spray fixative, which is used to prevent colours running into each other; a matt varnish, which will provide good protection for your finished painting, and which can be applied either in aerosol form, or with a brush. If you intend to use a brush for this purpose, buy a soft, flat hogs' bristle with a 2.5cm (1in), 5cm (2in) or 7.5cm (3in) head.

Watercolour work will require lots of clean water, which can be kept in large screw-topped coffee jars. Also keep a supply of clean absorbent rag and rolls of paper kitchen towels. In order to add gloss and transparency to your colours, you can buy additional gum arabic, which is also available in a more liquid form as gum water.

Handling Colour

The use of colour is one of the most vital skills which the budding artist must acquire. The aesthetic appeal of colour is more direct and immediate than either the form or content of a successful painting. A painting in which the composition is dull but the colours are vibrant and interesting is more likely to be judged a 'good' painting than one where the formal arrangement is well executed but the colours badly used. In its simplest terms, the act of painting is mainly concerned with the use of colour. Some paintings, particularly the modernist abstract works, are 'about' colour and nothing else. How can a painting be 'about' colour? One of the reasons is that colours, particularly in the natural world, have a life of their own. They react to light, distance and movement in multifarious ways. They also react to each other. Colours also,

Below: This attractive abstract gouache titled December V *1973 by Patrick Heron demonstrates a confident use of strong primary colours.*

of themselves, evoke emotions, sometimes intense emotions, in the people who are looking at them. Certain combinations of colours can induce sensations of almost physical repugnance, others of blissful pleasure.

Symbolic meanings

In addition to their purely physical impact, colours have meanings which can be, but are not necessarily, related to their visual quality. These symbolic associations are generally culturally derived and can change over time, from one society to another, and even from one person to another. In the West, white is usually taken to mean purity; in certain Eastern countries it is the colour of mourning and death, whereas, in the West, black and sometimes violet or purple are the funereal colours. Purple is also associated with royalty, as is, for obvious reasons, gold. Black can mean 'mystery', 'sophistication' and 'evil', as well as 'death'. Red is the colour of excitement and danger and is, therefore, appropriately used in road signs as a 'stop' or warning sign. For the same reasons, primitive tribesmen still decorate themselves with red, symbolizing strength. Green, the 'go' sign, is a restful, soothing colour. Recent research has shown that green does promote actual physical changes in the body; it is 'easy on the eye'.

These traditional associations of colour can be manipulated by the artist to control or create responses to his paintings. Our reactions to things are influenced by notions of what is the 'correct' colour for various objects. By turning these notions upside down and using the 'wrong' colours in a shocking or unusual way it is possible to convey a subtlety of meaning that would be difficult to achieve in any other way. Consider for example, the impact of a bride in a black wedding dress, or a green fried egg. There are no rules of colour which cannot readily be broken effectively. However there are a number of practical guidelines to do with the selection, mixing and handling of colour which the beginner will find useful.

What is colour?

There are a number of terms which artists use when referring to colour and some which indicate the various properties or attributes that colours possess. Unfortunately there is no general agreement on the precise meaning of these terms and many of them are used loosely or interchangeably so that their meanings overlap or coincide. However, for the purpose of this book the following definitions will suffice.

Hue is the actual colour itself. In everyday terms it relates to the name of the colour, in other words, it means 'red' as opposed to 'green', or 'yellow' as opposed to 'blue' or 'purple'. A tomato is red; red is its hue.

Tone refers basically to the lightness or darkness of a colour. The

easiest way to grasp the idea of tone is to imagine a colour photograph reproduced in black and white. Some of the distinctions between areas of the picture will have disappeared. This is because, although the colours are different, the tonal value is the same.

Brilliance means the extent to which the colour glows or shows up.

Intensity indicates the strength or richness of a colour.

Shade and *tint* are descriptions of variations in the full strength of a 'normal' colour. Strictly speaking, if it is lighter it is a tint; if it is darker it is a shade.

Left: In his study Trees at Harrow, *Cotman has juxtaposed an unusual combination of colours to produce a clean, fresh effect.*

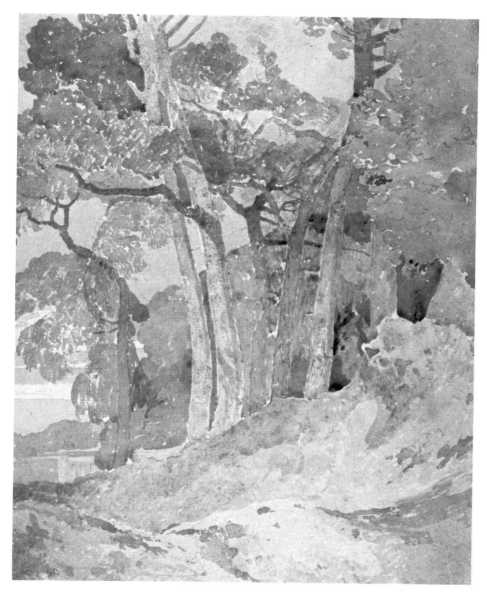

Warmth and *coldness* are elusive terms. Generally warm colours are those which seem to approach you, like reds and oranges. Cool colours are those which tend to recede, like blues.

Choosing colours

The wealth and variety of colours available to the artist today can only be bewildering to the beginner. The confusion is further compounded by the fact that different manufacturers frequently use quite different names to describe the same colours, and also the same names to describe different colours. What is called Magenta by one manufacturer may be quite different from a paint of the same name made by someone else. The temptation for the beginner, in the first flush of enthusiasm for the art, is to buy far too many colours, and to be seduced by those with appealing evocative names like 'Primrose yellow' or 'Forget-Me-Not blue'. In fact the colour box of a professional will almost always contain

Below: An oriental riot of colours, this painting by Bakst for the set of Scheherezade still maintains an overall control over the design scheme.

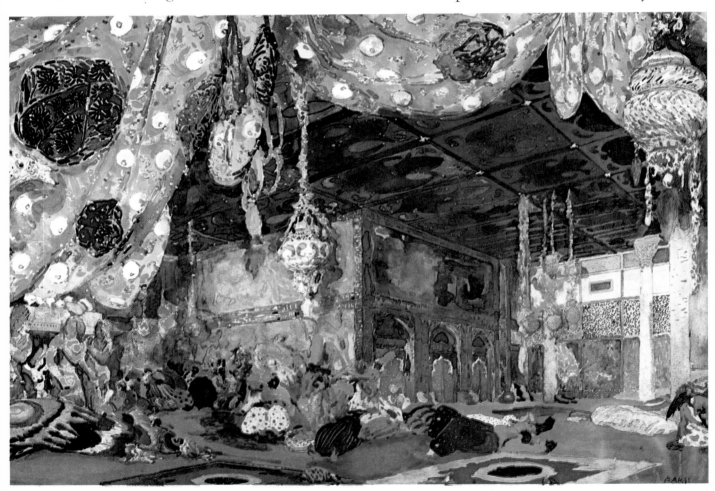

fewer colours than that of an amateur. This is because you can mix all the colours you need from a small number of basic colours. In theory you can mix all colours from the three *primary* colours, red, yellow and blue. However, in practice, you need more than that because impurities in the composition of the pigments occur in the manufacturing process and these affect the mixing of the colours. Manufacturing complexities also mean that it is almost impossible to obtain 'true' reds, blues or yellows. All of them will tend to have minute quantities of other colours in them which also affect the mixing. A practical solution is to include two varieties of each primary colour in your basic set. The following list of colours constitutes a good basic set which should fulfil most of your colour requirements:

Cadmium yellow	Alizarin crimson
Cadmium lemon	Ivory black
Winsor blue	Titanium white
Ultramarine blue	Mauve
Cadmium red	Winsor green

This list consists of two versions of each primary colour, white (which is a non-colour and can never be mixed), and black, purple and green (which, although they can in theory be mixed, in practice are affected by impurities in the manufactured colours).

Mixing colours

The best way to find out what your basic colours will produce is to experiment freely with them. Use a good opaque white paper as a ground. Vary the amount of water gradually with each colour. You will soon begin to find out quite a lot about the properties of your colours.

Pin your experiments on the wall where you can study them frequently and make notes on them to remind yourself which basic colours you have used in each case. The object of the exercise is to fix in your mind a mental impression of each colour as it comes out of the tube or off the pan, and of the ways in which the colours combine with each other to make new colours. This is especially important in watercolour where mistakes cannot be corrected by painting over. Make notes also on the length of time your colours take to dry. Notice how watercolours become lighter as they dry.

The basic rules of colour mixing will not be entirely unfamiliar to most people. As children we all learn that if you mix certain colours together you will get other colours. *Primary colours* are so called because they cannot be mixed from any other colour. They are red, yellow and blue. *Secondary colours* are colours mixed from any pair of primary colours. They are orange, green and purple. Variations on these secondary colours are obtained by mixing the primaries in different quantities so that you get, for example, greens ranging from a light yellowish

green to a very dark blue-green. *Tertiary colours* are all those colours other than primary or secondary colours, and are obtained by mixing three or more colours. If you mix all three primary colours together you will get a dark, neutral grey colour; in other words, the sum of all colours. In theory, this should be black but, in practice, impurities in the manufacturing process mean that it will be a muddy grey.

Complementary colours are those which when mixed together incline towards this grey because in some way they involve a mixture of the three primaries. For example, orange is mixed from red and yellow. Blue is the remaining primary colour so blue and orange are complementaries. Similarly, purple and yellow are complementaries, as are red and green. When mixed together, in effect they cancel each other out. When placed side by side, complementary colours tend to produce an impression of disharmony. In general terms, we say they 'clash'. This is because each intensifies the effect of the other. If large areas of complementary colours were used adjacent to each other the effect would, almost

certainly, be unpleasant. But if this contrast of opposites is cleverly manipulated the result can be enhancing rather than detracting. Imagine, for example, a field of bright green grass with a few brilliant red poppies scattered on it. The secret there is in the tiny specks of red against the large expanse of green. Each colour is intensified by the use of its complement. Experiment with complementary colours and explore the different effects which can be achieved.

The colour wheel

The relationships between colours are best demonstrated by the colour wheel. Make your own version of it in the following way and pin it up on the wall for reference. Draw a circle on a white ground. In the middle of it paint a patch of neutral grey obtained by mixing the three primary colours. Try it out on your palette until you have mixed a grey which does not lean in the direction of any of its components. Paint an area of each primary colour in a circle around this centre. Remember we have

Left: The completed colour wheel.

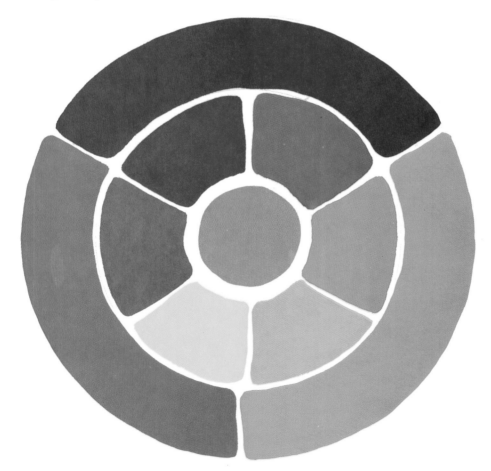

chosen two versions of each primary so the order should be as follows: Cadmium yellow, Cadmium lemon, Winsor blue, Ultramarine, Alizarin crimson, Cadmium red. Next paint the secondary colours in a circle surrounding the primary colours. Mix Cadmium yellow and Cadmium red to obtain a clear orange midway between yellow and red. Paint an area of this colour just beyond the areas of Cadmium red and Cadmium yellow in the inner circle. Mix Cadmium lemon and Winsor blue for a green and paint that just beyond the corresponding colours in the inner circle. Finally mix a purple from the Ultramarine and Alizarin crimson and complete the outer circle with an area of that beyond the colours of its components. From this you can see at a glance the relationship between primary and secondary colours. Look closer and you will also see that the colour on the outer circle which is opposite the primary on the inner circle is its complementary colour.

Below: In this exquisite watercolour by the German Expressionist artist Emil Nolde, he has used intense, brooding colours with a dramatic introduction of red into the sky. This is echoed in the shapes of the tiny houses. The work is called Friesland Farm under Red Clouds *and was painted c. 1930.*

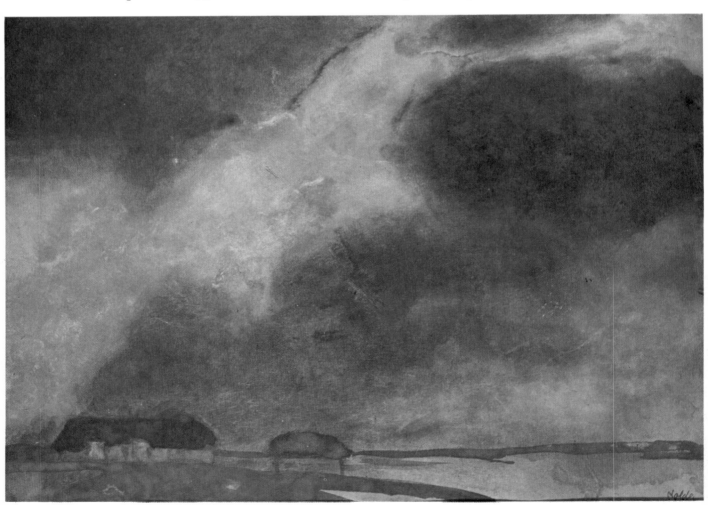

Colour changes

Colours are immensely volatile. They react to their surroundings almost as if they are living substances. We have already seen how complementary colours seem to react against each other, each one fighting for supremacy over the other. This absolute contrast intensifies each colour, sometimes to an unbearable extent. But all colours, to a greater or lesser degree, are influenced by those adjacent to them. This phenomenon is known as *induced colour*. Primary colours are relatively stable and are not markedly affected by other colours. Secondary colours are affected more than primaries but less so than tertiaries which are the most unstable. The appearance of tertiary colours can be profoundly affected by surrounding colour. There are various ways of demonstrating this effect. Try the following experiments. The colours must be as clear, clean and opaque as possible, so use gouache. Take several sheets of

Below: In this abstract called Gouache *(1936) by Ben Nicholson, the* colour red is again used as the central focus of the work which is composed of massed blocks of strong body colours.

paper and paint each one a different colour. Then mix a tertiary colour, say blue-grey or pink, and paint another sheet of paper evenly in that colour. Cut the last sheet into small squares. Place one square in the centre of each of the other sheets. The effect of this on the appearance of the colour of the small squares will be quite dramatic.

Having mixed the paint you will know that the *actual* colour of the squares is identical. The apparent colour change is entirely a result of the influence of the surrounding colour. This effect is most marked with tertiaries but observable changes will even be found with primaries and secondaries. Try, for example, small squares of green paper against a background first of light yellow and then of deep blue. Against the yellow the green will seem dark and lean towards blue, against the blue it will seem lighter and more yellowish. Experiment a little further and

Figs. 1 and 2 are examples of induced colour using different areas of colour to describe the process.

Figs. 1 and 2 are examples of induced colour using different areas of colour to describe the process.

you will find that this phenomenon is critically influenced by size or area. The larger the area of the square relative to the background the less it appears to undergo a colour change. In fig. 1, for example, where the square dominates the perimeter, the background has no obvious optical influence on the centre colour. Where the perimeter is dominant a colour change is induced even though the centre is a primary colour.

Distance and colour

To explore the influence of area further take a sheet of paper and paint on it two large areas of colour. Make the experiment more telling by choosing violently contrasting colours, say red and green. Next paint another sheet of paper with alternating narrow stripes in the same colours. Pin both sheets on the wall and stand back about 3m (10ft) to look at them. The first sheet will still show two distinct areas of colour. In the second, the stripes will appear to have merged into one over-all neutral shade. This tendency for small areas of colour to blend into each

other when viewed at a distance was exploited by Neo-Impressionist artists like Seurat and Signac. They developed a technique known as 'pointillism' in which the painting was built up out of thousands of tiny dots of different colours. In pointillist paintings the 'mixing' takes place in the eye of the beholder.

Local colours

Apart from the behaviour of colours in pigment form, the more you study the colours in the natural world the more you will discover that they, too, are influenced by factors other than actual pigmentation. These natural colours are known as *local colours*. The most immediately obvious effects on local colour are those produced by light and distance and both have been explored by artists for hundreds of years. If you try to match the colours in your painting exactly to those in nature you will soon realize that nature can be full of deceptive tricks. The colour of a barn roof one minute may change completely the next when the sky has clouded over. The effect of mist, for example, is almost to drain the

Below: In his painting Ajaccio (*1935*) *the Neo-Impressionist Paul Signac employs the difficult medium of watercolour to express the pointillist theory in which colour was applied in tiny dots. The basic technique is used here, but without the density of effect achieved in the oil medium.*

Above: The Raider on The Shore *c. 1945, by Paul Nash is one of the paintings commissioned by the British War Advisory Committee to contribute towards a visual/historical record of the Second World War. The metallic colour of the heavy grey machine in the foreground contrasts sharply with the delicate washes used to paint the cliffs as they recede into the distance.*

landscape of colour, to make it softer and more diffuse. Some surfaces appear to absorb colour, others—water, for example—reflect it.

Human flesh is amazingly receptive to light which is one of the reasons why portraits are so exciting and challenging to paint. An object which is part in and part out of shadow will exhibit marked differences in colouration. Distance also diffuses local colour. In a landscape, for example, the fields nearest you are strongly coloured. As they recede they become softer and dimmer, until in the far distance the hills on the horizon become almost blue or purplish-grey. Similarly in a town, look down a long straight street and observe how the colour gradually fades the further down your eye wanders. A knowledge of colour involves a great deal more than knowing how to mix your paints, although it involves that too. Careful observation is by far the best teacher. All the colour theory in the world is no substitute for the trained eye, sensitive to and appreciative of our natural surroundings.

Project: A Landscape

Once you have acquired your equipment and materials you will, no doubt, be anxious to get to work on a painting as soon as possible. The colour mixing exercises in the previous chapter will have given you some experience of the medium, but there are a number of basic techniques which you will do well to practise before you plunge into your first real painting. There are two major pitfalls for a beginner in any art or craft to overcome: the first is that you may be so overwhelmed by the technical complexities of what you are attempting that you are afraid to make a mark on the paper at all; the second is that you are so keen to get started that you want to run before you can walk and do not stop to learn the elementary tricks of the trade. The result in both cases is that many people become so disheartened that they give up altogether.

The solution to both these problems is to master the basic techniques

Below: A strong choice of a specific element in the landscape (the rocks and geological structure) is expressed by the artist James Ward (1769–1859). The work is one of the very few watercolours that he painted and is called Chisseldon, near Marlborough.

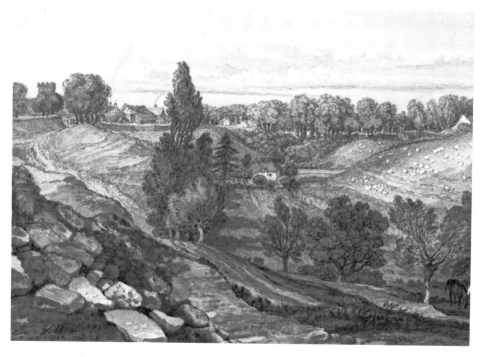

before you start, but leave the complexities till later. In the past many student artists were thoroughly trained in the technical aspects of their materials through the studio apprenticeship system. Nowadays there is a tendency to imagine that technique is unimportant and that 'self-expression' is the only thing an artist should be concerned with. In fact, the two are interdependent. Until you have a certain amount of technique you cannot express yourself, just as a small child cannot explain exactly what he means until he has acquired at least the rudiments of speech. This chapter will describe the rudiments of the art of watercolour painting. The more advanced skills of the art are discussed in the Techniques chapter.

Glazing

Traditionally transparent watercolour has been used as a series of thin layers of colour sometimes overlaid one upon another several times. This is known as glazing and is the core of watercolour technique. First find out the strengths of each of your colours. Use good quality white paper for the ground and pin the results of your experiments on the wall for reference. Taking each colour in turn, load the brush and paint a rough rectangle, establishing a fade of colour from maximum density to a thin film with one load of colour. You will find that some colours have considerably more covering power or strength than others; some change colour as they dry. When this exercise has been completed for each colour it will serve as a simple performance chart which you should keep constantly before you as a reminder of your practical discoveries.

Now try glazing. First explore the possibilities of the same colour laid over itself several times to achieve a rich density. Allow each layer to dry before applying the next. Then see what happens when one colour is glazed over another, for example, Viridian over Cadmium red produces a superb rich green. An influencing factor on glazing is the nature of the paper itself. Some are more absorbent than others. Experiment with different types of paper. The less absorbent the paper the more the colour sits on the surface and appears fresher as a consequence. The more absorbent papers tend to deaden the colour slightly. Another advantage of less absorbent papers is that washing out is easier.

Washes

Colour washes usually, but not always, form the basis of a watercolour painting. A wash is a film of diluted paint applied to the ground.

Flat wash

The flat wash or even-tone wash is the most basic kind of wash. The evenness of tone or colour must be maintained throughout the wash so first prepare sufficient colour to complete the job. If you have to stop

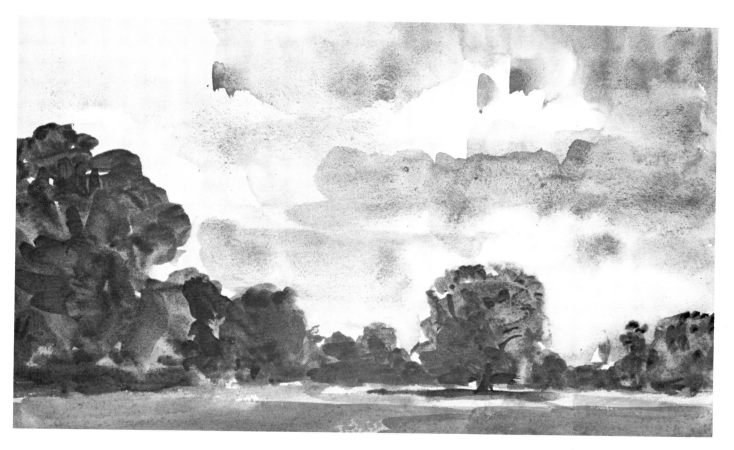

and mix more it is likely to be of a slightly different density and even minute differences can lead to an ugly overlap of colour. Use a large mop brush. Some artists like to keep the board flat when applying washes; others tilt the board slightly toward them allowing the paint to collect at the bottom of each stroke. This is then taken up in the next stroke. Whichever method you use, work swiftly and deliberately in horizontal brush strokes, from left to right if you are right-handed and right to left if you are left-handed. If you have made a mistake, start again. Do not touch the drying paint or try to correct uneven areas. Experiment on different pieces of paper with various colours and depths of colour until you can achieve a smooth even finish every time. If you like, try applying washes with a sponge. This must be a piece of natural sponge of the sort available from most art shops or pharmacists. Synthetic sponges do not hold the paint evenly and are not recommended.

Above: Haresfoot Park, near Berkhampstead, Herts. *(1915) by Philip Wilson Street is a typical example of the use of fast, impressionistic washes in building up the picture.*

Graded wash

Graded wash is a development of flat wash where a change in tone occurs gradually through the area covered. It is frequently used when the artist

wants to grade the sky from dark at the top to light at the horizon. It is applied in the same way as even-tone washes except that you begin at the top with the darkest pigment and add a little water to each brush stroke so that the colour lightens as you go down the paper. Or you can go from light to dark by adding pigment with each brush stroke. The most difficult part is to achieve a graded wash without noticeable breaks of colour which would give a striped effect.

Using background washes

Once you have practised flat and graded washes several times, using different colours and different brushes, you will begin to get a feel for the range of effects which can be achieved. With this confidence you can use the washes as the basis for a picture. Many watercolourists apply washes as the beginning of any picture, simply to give a softer colour as a base. A pale grey or sepia background immediately avoids the heavy contrasts implied by white. Virtually any subject has a predominant shading of, say, grey, blue or cream, from which the artist can begin his composition.

Below: The strong, bold brushwork used in John Marin's watercolour study called Deer Isle, Maine *(1937) demonstrates the artist's firm control over his technique.*

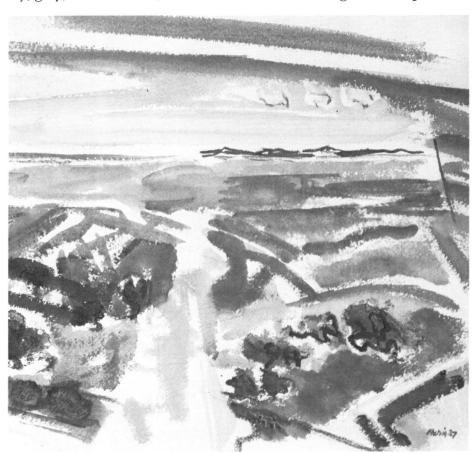

Washes are also used to apply the main colour areas on a picture. It is only when these have been applied that the artist will begin to fill in the details of a scene.

Brush strokes

It is important before you start painting to familiarize yourself with different brushes and the marks they can achieve. Some beginners make the mistake of using the same brush throughout a painting. Load each brush with sufficient paint and trail it across the paper gradually increasing the pressure as you go. As you lift the brush it should return to its natural shape. You will find the larger sables extremely versatile, being capable of creating both a clean line and a larger area of colour. The mop will be of little use beyond establishing large washes. The smallest sables (rounds) have fine points which allow real drawing control from fine lines through to thick, bold strokes.

Below: In complete contrast to the Marin painting (opposite) this meticulous watercolour, Ewer Street near Gravill Land (*1846*) *painted by Hosmer Shepherd uses the finest brush strokes to express the architectural lines of the houses.*

Right: In this wonderful painting called Light Coming on the Plains II, *Georgia O'Keeffe has skillfully used the wet-in-wet technique to convey the sense of bands of light dissolving into one another.*

Drybrush

Drybrush is a useful technique which can convey detail and supply textural interest. The brush is not actually dry, of course, but neither is it loaded with colour. It should be just moist. Hold the brush at a low angle to the surface of the paper and lightly skim over it. The paint should just touch the ridges on the irregular surface. The rougher the paper the more effective the technique will be, allowing the undertone to show through.

Wet-in-wet

This is a simple exercise and fun to do. Wet the paper with a pale coloured wash and, before it dries, place another brushful of darker colour on it. The second colour will run and blur into the first leaving a hazy outline. Used discriminately this technique can be very effective. The secret lies in controlling the outcome. A heavy-handed use of wet-in-wet can only lead to a soggy mess of colours running all over the paper. Remember that the wetter the first wash the more the second will spread into it.

Washing out the colour

Watercolour is ideally a very spontaneous art. Paintings should be completed swiftly and not 'worked on' too much if this spontaneity is to be achieved. However, mistakes are sometimes made and one does not always want to jettison the results of one's time and effort and start again. Fortunately there is a certain amount of scope for correcting errors. Most colours once applied can be mopped off with a soft sponge. Mask the area to be washed out with masking tape or a chemical masking agent available at art supply stores. This protects surrounding areas which you do not want to disturb. Then mop the colour off with a brush or soft sponge. Make sure your materials, brush, sponge and water, are perfectly clean. Afterwards peel off the tape or masking and allow the area to dry. Do not expect to get back to a pure white paper as a degree of stain is inevitable.

Whiting out

There will always be times when an area gets out of control and washing out is impossible because of potential damage to the surface of the paper. If this happens the area can be painted out with an opaque white waterproof poster paint. It must be waterproof or the white will dissolve into the overlay of fresh colour and make it chalky. It is inadvisable to use this procedure over large areas, for no matter how careful the application of subsequent colour it will not match exactly the colour applied directly to the paper.

Choosing a subject

Having mastered the basic techniques of watercolour painting you can now begin your first real picture. The previous exercises will not have transformed you into a Turner or Blake or Samuel Palmer, but from now on you will learn more by direct practical experience than by theoretical exercises. First you must choose a subject. Landscape painting has been a favourite of watercolourists for hundreds of years and, in many ways, is an excellent choice for a beginner. It allows you to explore the new-found knowledge of colour and technique without

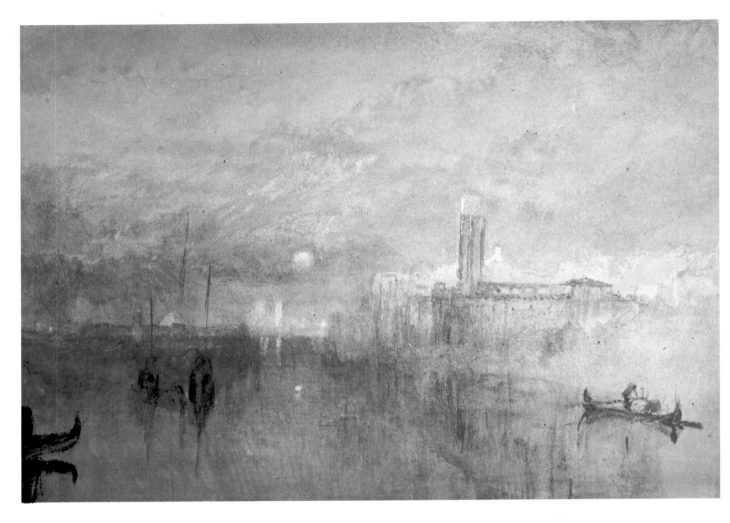

Above: One of J. M. W. Turner's exquisite Venetian watercolour studies, titled Punta della Salute. *The painting demonstrates Turner's supreme mastery of wash work to convey his sense of the magical effects of light and colour.*

involving the awesome complexities of human anatomy which would be involved in figure painting or portraiture. Nor does your choice of landscape painting necessarily involve you in cumbersome expeditions into the countryside with all the problems of transporting equipment, of weather and the vagaries of nature. You can simply take your sketchbook and make several sketches of subjects which catch your eye and paint the picture at home with all your materials and equipment at hand. Alternatively, go into your garden or look through your window and paint what you see there.

What is a landscape?

When we think of landscape we imagine a vast panorama of fields, trees, mountains and sky with, perhaps, a river running through it. But, in fact, there are almost as many different kinds of landscapes as there are

landscape painters. Generally speaking, a landscape is a picture of something which is outdoors rather than indoors, and in which the focus of interest is on natural or man-made surroundings rather than on the human figure or figures. This does not mean, of course, that you cannot have figures in landscapes, only that they are not what the picture is primarily about.

Rural landscape

The rural landscape, in other words, the countryside, has always been particularly fascinating to landscape artists. Its continuing popularity owes much to Constable, Turner and the great watercolourists of the eighteenth century. Even in the twentieth century it is still a favourite subject with painters, perhaps because of the contrast it offers to city life and because it provides a link between them and the great painters of the past. It is still possible to go into the countryside and imagine that you are seeing it just as Turner or Constable did. The natural light still plays over the cornfields and through the trees exactly as it did when they were alive. The sea crashes against the cliffs in the same way and the sky can be as cloudless or stormy as ever it was.

Below: A fine example of a perfectly balanced rural landscape called Kirkstall Abbey *by Thomas Girtin. Notice the proportions of sky and land, also the use of the powerful sweep of the river to give movement to an otherwise static vista.*

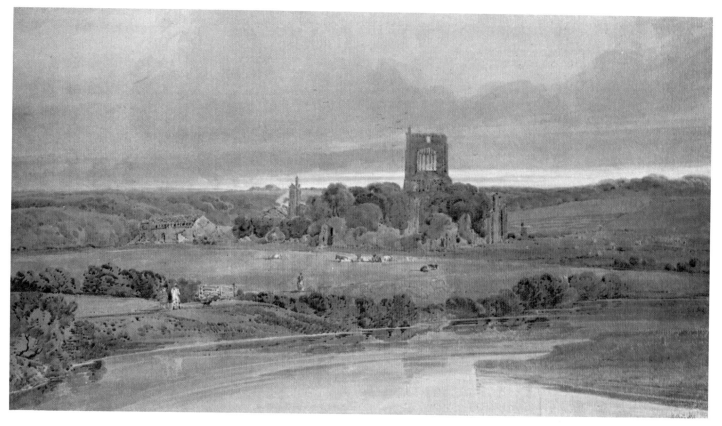

Urban landscape

If some painters are interested in the unchanging face of nature others are fascinated more by the effect of man on his surroundings. The urban landscape has proved of particular interest to a growing number of artists in the twentieth century, possibly because the changes have been so devastating and dramatic. The poetic beauty of the urban landscape seen through fog, in sunlight, at night, in rain or snow are well-established traditional themes. Nowadays, a more searching critical approach has developed, inspired in part by German artists like Max Beckmann, Otto Dix and George Grosz who confronted the viewer with the brutality of the urban vista. Other artists seem to relish the very artificiality of urban existence and their paintings may celebrate a service station or advertisement in the same way that traditional landscape artists may have celebrated a cluster of trees or a peaceful lake. As you will realize, a landscape today can mean anything from a fiery sunset, a pattern of clouds wafting across the sky or a ship on a storm-tossed sea to the latest automobile. The quality of your picture will depend on whether you succeed in conveying what you see.

Below: The stridency of urban life is brilliantly exposed in The Millionaires, *by the German Expressionist painter George Grosz. He used his art to satirize the horrifying contrast between rich and poor in the Germany of the inter-war period.*

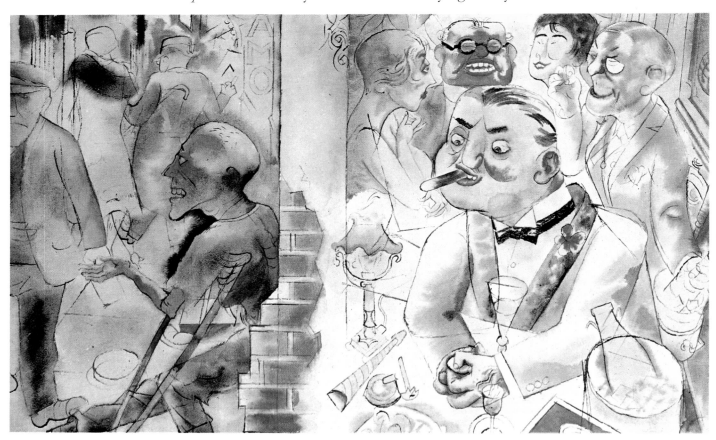

Establishing the view

Whatever subject you choose your initial difficulties will almost certainly be practical ones. The first is which part of the subject in front of you should you paint? You will undoubtedly be seeing more than you can transfer to your paper. If you are working from sketches you will already have selected your 'frame' i.e. the area that you are working within on paper. Perhaps, the window frame in your room can serve the same purpose. Otherwise cut out a number of viewfinders. These are cardboard frames with windows of different proportions cut in their centres. The window should be no larger than 10cm to 15cm (4in to 6in) square, and the surrounding frame roughly 2.5cm (1in) deep all around. The cardboard used for cereal boxes is ideal for the purpose. Measure the square to whatever size is required. The frame will provide a rigid viewer that can easily be held up without bending. The proportions of the opening should be related to that of the paper on which you intend to work. If it is square the opening should be square; if it is rectangular the opening should be rectangular.

Using the viewer

Now try the various viewers holding them up before your vista at half arm's length from your eye, moving them up, down or across until an interestingly balanced arrangement can be found. Make a mental note of the important points that are to be incorporated and quickly attach an armature of some kind to the back of your board or easel support and pin the viewer to it. It is important that you try to keep the position of your head constant as the slightest movement in relation to the viewfinder alters what can be seen through it. Now begin to work a simple delicate pencil drawing (using a soft graphite pencil, say, 6 or 2B) to establish the main shapes and rhythms as accurately as possible. If things go wrong just rub out the drawing gently with a clean kneaded eraser and restart. Do not re-work too extensively. The delicate lines are purely a guide and as you lay on colour you may be obliged to rethink shapes and positions. An additional reason for not re-working the surface of the paper with a pencil is the very real risk of damaging it.

Focus

One of the problems when working a painting is caused by the ability of the eye to change its focus of interest continually. This can result in a badly composed picture with no real centre of interest because, as you work, you are giving that particular part all your attention. A way of combating this tendency is, having chosen a view, to write down what it is that makes it interesting and refer to that statement regularly during the act of painting. Examine the Edward Bawden painting of the Canmore Mountain Range. Although the vertical lines of the crosses and

Above: In his painting The Canmore Mountain Range (*gouache*) *Edward Bawden has used the shapes of the grave surrounds in the foreground and the skyline of the mountain range to powerful effect.*

grave surrounds dominate the foreground, they also lead the eye straight to the focal point, the mountains themselves. Having decided on your composition, quickly and lightly map in the major movements and shapes. Lay in the main areas of colour, then gradually develop the details of colour texture and shape based on what you see, not what you think you see. For example, a tree seen at 20m (22yds) is very different from the same tree seen at 100m (120yds); the colour will apparently change owing to atmospheric light as will the visual pattern of leaves.

Practical problems

In your haste to complete your first picture do not neglect to refer back to your exercises when you encounter difficulties. Colour mixing may be proving troublesome. If your greens are too blue try adding a little yellow. If your reds are too orange, mix in blues, greens or purples to try and combat this. Consistency may be the problem if the paint is used thickly with aquapasto. Use a palette knife for mixing and apply the paint with a palette knife or hogs' bristle brush. Remember, this will take longer to dry than the traditional application of thin transparent films of colour. Removing thick impastos of paint is harmful to the paper surface, so begin the painting with thin films of colour and only begin to build impastos when you are sure of what you are doing. Pure watercolour from pans is so liquid that it mixes easily, but always be parti-

cularly careful when using aquapasto with tube colour. Gouache and poster colour can also prove awkward particularly with a white base and care must be taken to avoid streaks. Remember also to load the brush well. Even the tough hogs' bristle can be damaged if you try to force pigment from it onto the paper.

Restrictive colour

Another issue that could prove troublesome is the amount of colour involved in the vista. Although bright, strongly coloured forms may seem attractive, it is very difficult for a beginner to cope with strong colours. It is probably wise to begin with a fairly restricted colour range consisting mainly of the whole range of umbers, greys, greens and blues. This restriction is only a suggestion and does not have to be closely adhered to, but it may prove useful and will certainly help to make your progress to total visual harmony easier. These colours may seem simple or dull but they can provide exciting visual and technical problems.

Format

The choice of format is another factor which is often overlooked by beginners. In fact, the format of a painting can have a serious effect on its subject matter. Landscapes have traditionally been painted in a horizontal format but this is by no means a rigid rule. Consider the landscapes illustrated in this chapter. The Georgia O'Keeffe painting has a vertical format designed to encompass the dramatic oval shape in the foreground which is really the main point of interest. The horizontal format of the Girtin reinforces the sweep of the landscape. In the Ward painting the format remains horizontal but the apparent high vantage point allows the entire surface to be occupied by landscape, the sky being unimportant. It is worthwhile experimenting with different formats. You will find that some subjects work infinitely better in certain formats than in others. In fact it can make all the difference.

A sample project

By the time you have completed your first picture you will have encountered several of these problems and possibly more. Maybe you are not too happy with the result. Do not be disheartened. The more you paint the more you will learn. Be persistent and you will improve. Sometimes it is helpful to see exactly how someone else has built up a painting from the beginning. This is often very difficult to judge from a finished picture particularly if it is a complex one. The following step-by-step exercise has been devised to enable you to see at a glance the processes which went into painting one particular picture. This sample project was painted by Peter Morter.

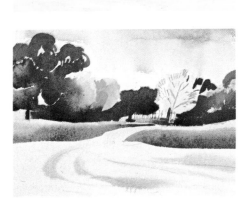

A Landscape step-by-step

After the drawing is roughly sketched in, mix a medium tone wash of Winsor blue. Because this colour on its own gives a somewhat raw effect, mix together a touch of Vermilion and pale Cadmium yellow with more blue. Add this mixture gradually to the blue wash to make a slightly greyer shade.

Dampen the area which is not to have the blue wash with a large brush and clean water. It should only be slightly damp. Then apply the wash with your largest brush over the sky area. Allow the paint to be very wet and then rinse your brush in clean water and use it on the wet paint to create cloud effects. While the paint is still wet you can also work in more blue paint to create a stormier sky. You must be careful not to overwork the area or it will become sodden and any subtlety of effect will be lost. Keep blotting paper handy to mop up any excess moisture around the picture.

When the blue wash is thoroughly dry, the green is applied. To create a good basic green, mix approximately equal amounts of blue and yellow. Apply the wash lightly and allow it almost to dry. Add more blue to the base to deepen the green and, using a chisel-edged brush on the flat side, boldly paint in the tree shapes and the curves of the grass.

The paper has a textured surface so, using the drybrush technique, lightly drag the brush over the surface to create a texture in the paint. Remember the brush should be only just moist with paint. Do not work in a constant colour but add small quantities of blue or red to deepen the tone.

The development of shapes within the picture is achieved by using a combination of the chisel-edged brush and a large brush loaded with clean water. To work in the darker areas, the colour is etched in, and then the brush is used with water working in from the outside of the colour area to create soft flowing edges.

Use the edge of the chisel brush to put in any fine detail required, although in this type of picture it is important to keep the effect loose and free. A small amount of detail will add interest and depth to the

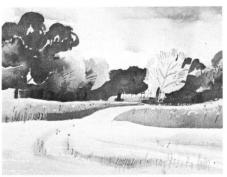

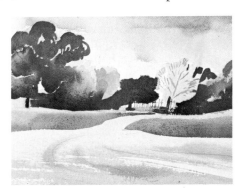

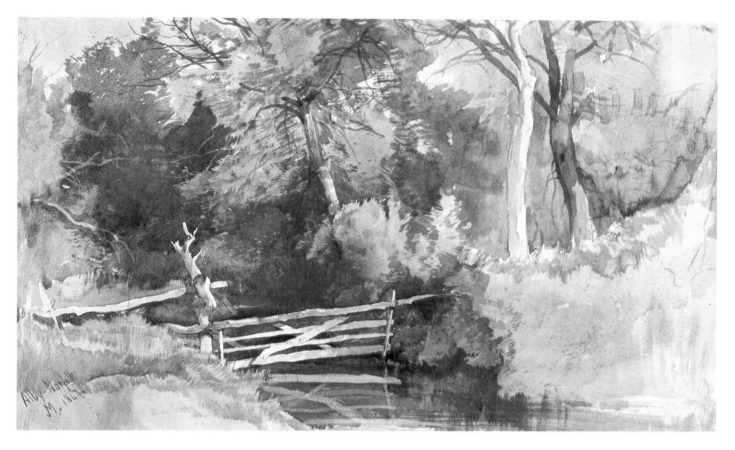

finished painting. Here a few dots of red were added to look like poppies and the point of a sharp knife was also used to scrape the surface of the paper lightly to create highlights.

Equipment for outdoor painting

As soon as you have gained some experience of painting your immediate surroundings, it will be time to venture further afield into the great outdoors in search of new subjects and sources of inspiration. It is advisable to choose a place with which you are relatively familiar to begin. Ideally this should be a fairly sheltered position away from the distractions of curious onlookers, high winds or straying cattle or sheep. Prepare your papers before you leave home. It is as well to keep the picture size small in outdoor situations, so prepare several small pieces rather than one big one. Remember that the light changes constantly in the open air and the secret is to work very quickly and spontaneously. It is also important to make sure that before you leave home you have everything which you are likely to need. There is nothing more infuriating than arriving at your destination only to find you have left some

Above: An intimate close-up view of the landscape is also possible, as shown in this delicate watercolour by John Middleton (1827–1856). The work is called Alby, Norfolk.

Right: Rooftops can make intriguing urban landscapes in their own right. Edward Hopper was fascinated with architectural details such as roofs, and this watercolour and pencil study called Roofs, Saltillo *is one of his finest studies in this genre.*

vital piece of equipment at home. Compile a checklist of items and consult it before you leave. The following list should supply most of your needs:

A sketching easel and seat
A variety of brushes
Paints
Palettes
A sketch pad
A palette knife
A sharp-edged knife
Several sheets of prepared paper
A supply of pencils and a blade or sharpener
A kneaded eraser
Rag for wiping surplus moisture off brushes and palettes
Blotting paper
Masking tape for masking out areas to be washed out
A natural sponge
Screw top water containers (preferably plastic) and a supply of clean water as you may not have access to any close by
A drawing board and clips to hold the paper.

Most of this can be transported in a large rucksack or carry-all. The board and paper, however, will require a large waterproof container. A simple ground sheet sewn up into an envelope slightly larger than the board is an ideal solution and makes for relatively easy movement.

Elements of Composition

By the time you have completed a few landscape studies you will be gaining in confidence as far as handling the materials is concerned. The composition of the picture has until now been a purely intuitive process. Perhaps you did not even realize that you were, in fact, composing your paintings. Surely in the case of landscapes, nature is doing the composing for you? Certainly the scenes you painted were not of your making. Nevertheless, the very act of choosing a particular vista from a particular vantage point is, in itself, an act of composition. Out of the millions of possibilities available to you, you selected a particular cluster of trees, buildings or pastures because in some way it appealed to you. The cardboard viewfinder helped you to find exactly the right viewpoint to

Below: The composition of a work is crucial to its success. In his painting Region of Brooklyn Bridge Fantasy, *John Marin maintains fine control over a wide range of elements in his urban landscape.*

emphasize the essential qualities of the subject matter. In making these choices you were composing the picture. It is now time to look at this question of composition more closely since it is an essential element in the making of a good picture in any medium.

What is composition?

Composition simply means the arrangement of the parts of a picture so that they add up to a harmonious whole. A well-composed picture will have a balance of forms, coloration and tonal values. It will have proportion, space, rhythm and a unity of subject matter so that the eye

Right: A classic compositional device is used by Tintoretto in The Saving of the Body of St. Mark *painted between 1562–1566. Notice the deliberate use of perspective lines to emphasize the depth of the background.*

travels around the picture in an orderly fashion rather than leaping from one part to another in a disjointed way. There will be a hierarchy of centres of interest so that no two points battle for attention with each other. Since painting is an art not a science there is no one foolproof way to compose a picture. It is something that you will learn by experience of your own work and by looking at the great masterpieces of the past and analyzing their achievements. The rest of this chapter will be devoted to some of the main elements of composition which you should bear in mind.

Perspective

An understanding of perspective is essential for anyone who wishes to paint naturalistically. Perspective is basically a device which enables the artist to create an illusion of three-dimensional space on a two-dimensional surface. All objects have three dimensions, height, width and depth. A sheet of paper has only two—height and width. The creation of an illusion of depth is not something which is common to the art of all peoples and all ages. Ancient Egyptian art, for example, took no account

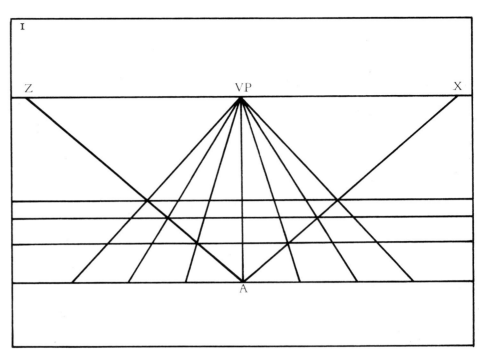

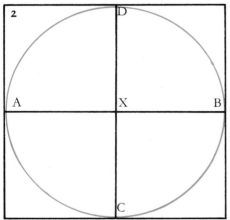

Fig. 1 *The basic principles of central perspective are demonstrated in this diagram.*

Fig. 2 *First stage in demonstrating the circle in perspective.*

Fig. 3 *The optical size of two identical semi-circles in space seems to have changed.*

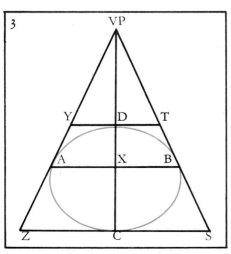

of perspective. Nor do the drawings of young children or those of most primitive peoples. In many cases, for example, in some Indian paintings perspective is distorted to an extraordinary degree so that there is no relationship at all between the sizes of people, animals and buildings in the paintings and their actual proportions in real life. Sometimes the most important figure, for example, the prince or ruler, was painted larger than less important figures. This is not because they were bad artists but because they were not interested in perspective. The great advances in the study of perspective in the West took place during the Renaissance, when many artists seemed to have been virtually obsessed with the idea. Most of our understanding of perspective today derives from them.

Central perspective

The most commonly used system today is that known as 'central perspective'. In simple terms it states that all parallel lines disappear at a point on the horizon called the vanishing point. The horizontal lines remain horizontal. The following exercise will help you to understand the basic principles of central perspective. Take a sheet of paper and draw a horizontal line about a third of the way down to represent the horizon (see fig. 1). Somewhere near the centre of this line mark the vanishing point. Draw another horizontal line about a third of the way from the bottom of the sheet and mark its central point A.

On either side of point A mark off a number of points spaced equally apart and draw lines connecting each of these points with the vanishing point. Just beyond the second horizontal line draw another line parallel to it. This will cut off areas that optically suggest squares drawn in perspective. From point A draw two lines along the diagonals of the two centre squares and project them to the horizon to points Z and X. Where the lines AZ and AX intersect the lines drawn through the vanishing point, draw a series of horizontal lines parallel to the others. This will establish an optically diminishing spatial plane. Notice how the horizontal lines get closer and closer together as they recede towards the horizon.

Remember all parallel lines within this theory meet at a vanishing point. This system will help you to recognize why certain points are optically smaller than others. Spatial illusions rely on this system or similar ones. The purpose of the exercise is to help you recognize shapes and angles and measure distance. Remember also that all verticals remain vertical, unless a very acute angle of view is presented.

The circle

The circle seen in perspective presents a particular problem. The ellipse, as it is called, is a simple form to construct if you remember certain points. Bearing in mind the central perspective system draw a square on a sheet of paper and quarter it (see fig. 2). Then draw a circle within the square. By rotating the sheet around the pivot AB you will begin to see the circle take on an elliptical form. Look along the axis lines CD which will remain vertical, though visually foreshortened. The flanking lines YZ and TS will seem to converge towards a point situated directly beyond the point D, the projected vanishing point. Look at what seems to happen to the two identical semi-circles in space. The semi-circle ADB becomes optically smaller than ACB because it appears to have moved towards YT from ZS. In other words the centre of the circle X moves closer to D than C (see fig. 3).

When drawing a tall cylinder, a chimney pot, for example, you must establish your eye level very clearly bearing in mind the points on the ellipse. The top of the chimney is above your eye level so you construct a quartered square in perspective with imaginary projection lines (see fig. 4). Bear in mind the acute angle of vision that might be presented when looking up at tall forms. Most chimneys have a natural taper built into their construction but some are simple cylinders held in position by guy wires. Remember what appears to happen to two parallel lines in a drawing. When you are constructing an ellipse the diagram structure can be useful, although with a little practice it can soon be dispensed with. Always take the ellipse just beyond the vertical. This is a trick but it does suggest structure beyond the field of vision.

Fig. 4 When viewing a cylinder, construct a quartered square in perspective in the imaginary projection lines.

Fig. 5 The perspective of a circle when viewed from a different angle.

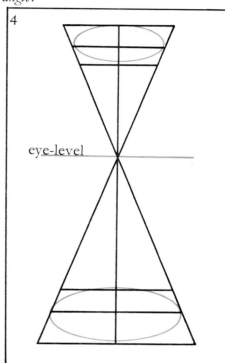

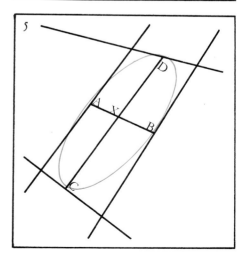

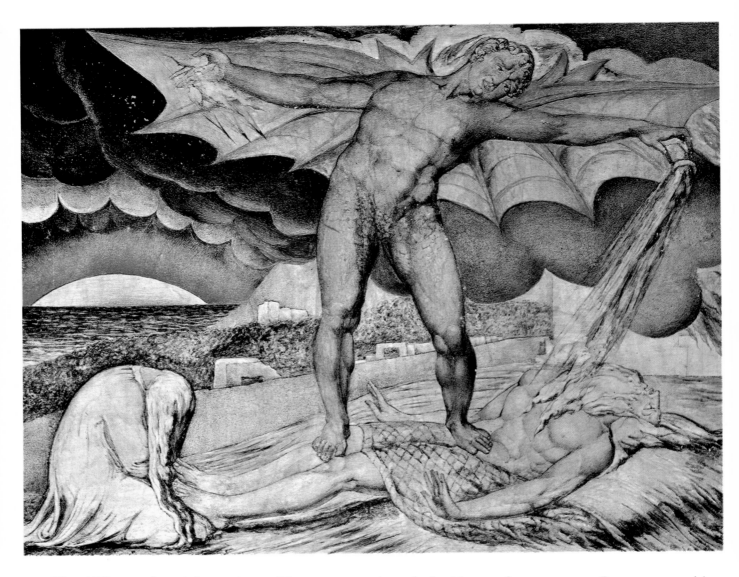

Fig. 6 The use of spatial areas is crucial to the success of the painting. In figure composition the foreground usually contains the major focal point, as in this painting by William Blake called Satan Smiting Job with Sore Boils.

These constructions deal with a perfect geometry. But not everything seen is immediately at right angles to your field of vision (see fig. 5). The centre X of the circle seems to be closer to CD than AB and also to CA rather than DB. In this particular diagram the four sections of the circle are each of a different size.

Scale

Scale must be established at the outset of any painting. A large vertical form, perhaps a gatepost, pole or tree will be useful here. The length of this mark is the key for all future marks. Refer back to it as each fresh statement is made. An inaccurate decision may make it impossible to

carry out your original intention, the scale chosen being either too great or too small. Do not hesitate to restate the scale if necessary. The nature of watercolour technique will allow this restatement early on as you build one transparent layer on another, working through from pale to dark. But always refer back to the original decision, or shapes and lines will lose their relative scale. A simple framework of shapes must be established to indicate an illusion of space through linear direction and

Fig. 7 Eric Holt's painting titled Smallholdings *demonstrates the use of circular composition, which leads the eye irresistably around the work.*

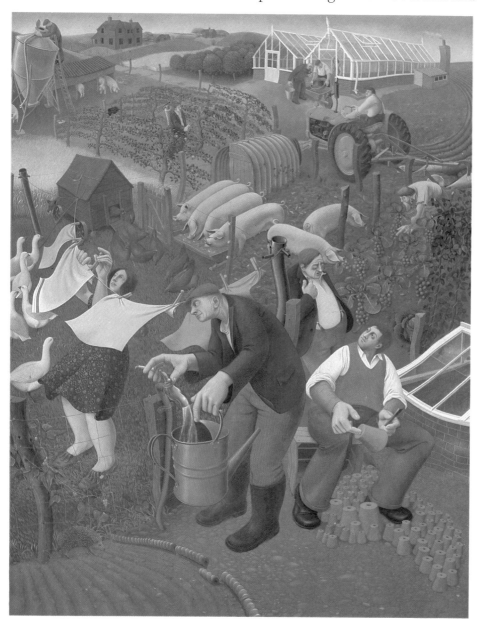

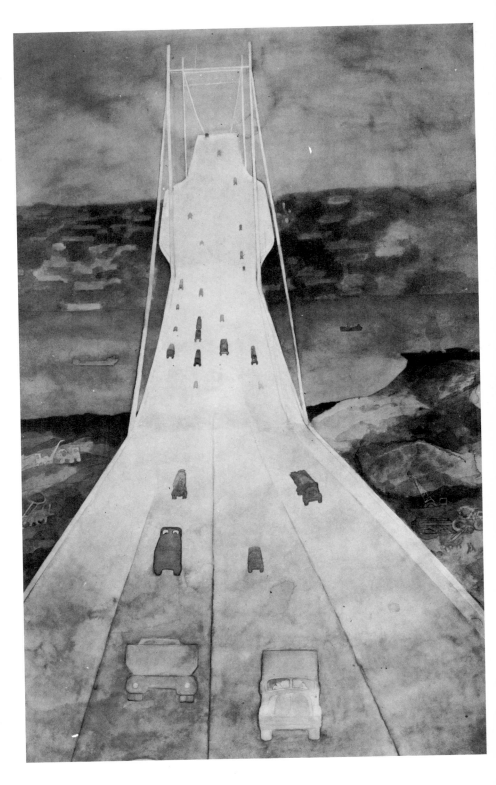

Fig. 8 (right) A brilliant use of space and proportion is shown in Edward Burra's work Forth Road Bridge. *The overhead viewpoint emphasizes the architectural lines of the bridge over the landscape, and its dimensions are further enhanced by the tiny scale of the traffic crossing it.*

scale change. This spatial illusion will be reinforced by an analysis of the way colour operates in space. A highly detailed foreground can also emphasize the impression of space.

Space

Every painting has three basic spatial areas: foreground, middleground and background. With figure composition the foreground usually contains the focal point of the painting. An example of this can be seen in *Satan Smiting Job with Sore Boils* by William Blake (fig. 6). All additional elements become stage props in support of the main intention. But this is not a sacred rule. The centre of interest of a painting can be much less obviously placed. For example, Eric Hart's egg tempera painting *Smallholdings* (fig.7) is a carefully organized complex composition allowing the viewer to be led in and around the whole diary of events before arresting on the focal point. Some painters are brilliant at creating unexpected moments, using foreground figures in soft focus, partially cut off by the edge of the canvas, or taking exceptionally high vantage points to capture unexpected moments of movement and colour. In Burra's *Forth Road Bridge* (fig.8) the dramatic intrusion of the giant bridge into a dark landscape is emphasized by the almost ant-like scale of the traffic.

Below: A grid helps to establish the different areas of a painting. Here a window has been used as a natural grid in this landscape by a twelve year old child.

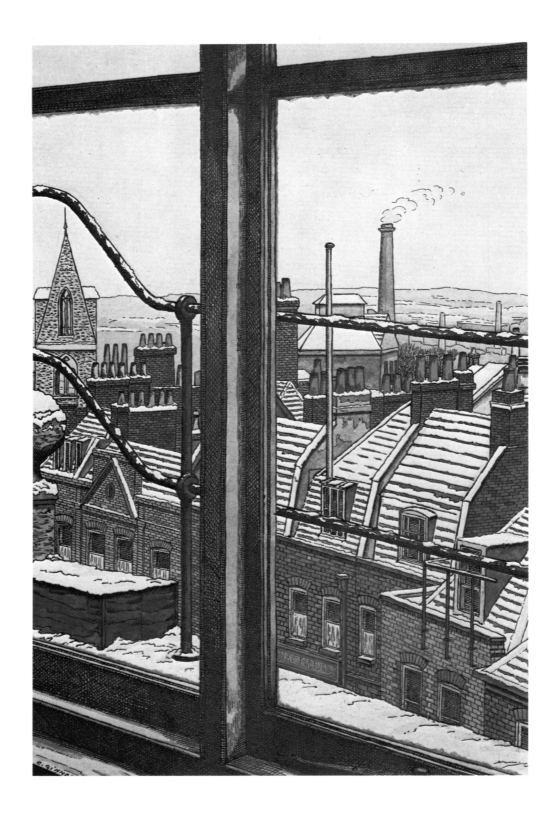

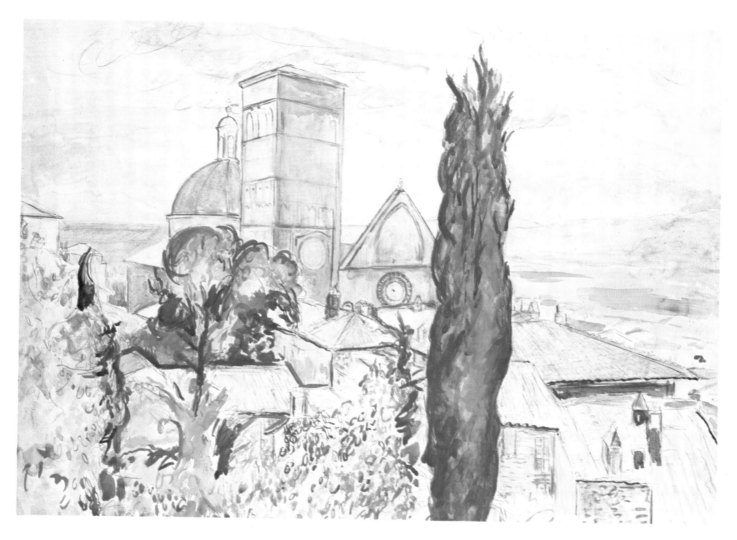

Centre of interest

The centre of interest need not be a physically large element in a painting but it must be a point that provides a natural axis for the composition. It may be an object or a person or even an area of unexpected colour in an otherwise sombre vista. Needless to say it is almost never located in the geometric centre of the picture and all other elements in the picture must be subordinate to it.

Urban landscapes

In theory urban landscapes should present no more difficulties than rural ones. In practice, the complex web of shapes, details and directions can be daunting for the beginner. It can help to reduce the confusion of this complexity if you first establish a grid on the paper of the major divisions

Above: Urban landscape can be both serene and beautiful as shown in this painting by Edward Wolfe, Assisi from Lady Berkeley's Garden *(c. 1960).*

Opposite: The view from a window can provide an exciting study in urban landscape, as demonstrated here in From a Hampstead Window *(1923). The painting is by Charles Ginner, and is done in a combination of pen, ink and watercolour.*

203

that occur within the chosen vista. Take a large sheet of glass, or if you are working from indoors use a window, and paint on a 5cm (2in) grid in thin white paint (emulsion paint is ideal: it dries quickly and can easily be removed with methylated spirits). Place yourself comfortably before the window or the sheet of glass mounted on an easel. If you are using glass, tape the edges. This prevents accidents and acts as a useful frame.

Using the grid
Make sure your eye level is approximately at the centre of the grid. Take a small sable brush and some thin gouache paint, preferably in a bright colour, and trace around the major shapes that you see before you. This exercise will make you very conscious of scale change through distance and foreshortening. You will also notice that with the slightest movement your trace lines will move out of alignment with the view behind. So always position yourself as accurately as possible to avoid this.

Establish the horizon. In a cityscape you may choose to make this the main feature of your painting. The rich ever-changing shapes of church spires, roof tops, chimneys or the view of your next door neighbour's neat herbaceous borders against the rich formal patterning of a brick wall may prove a rewarding choice of subject. In the latter case, you may choose to eliminate sky and concentrate on the flowerbeds or the garden tools leaning against the wall of the shed. Refer back to the original tracing and try to establish the basic linear shapes on the paper in lightly drawn pencil. Then begin laying in major areas of colour. Consider the shapes of objects at all times. Always build from big shapes to small. Involvement in detail will, however interesting, lead to isolated images and a complete breakdown in the fundamental relationships of the vista.

You must always look at the particular shapes carefully, seeing them in relation to the other elements of the composition. The mapping out stage tends always to be mechanical. It is only as colour and tone are applied that a greater subtlety and depth arises. Do not be sidetracked by complex architectural details until you have established the main elements.

If you are unhappy with your first efforts do not necessarily jettison the subject matter. It is unlikely to be that which was at fault. In fact, it is a useful exercise for a beginner to experiment with different approaches to the same view, each one emphasizing a different element in the picture. One could be concerned with patterns and textural aspects, another with light and shade, another could accentuate foreground detail. One vista can supply any number of different paintings. Trying to analyze such possibilities is excellent training for the artist's eye.

Improving Observation

Choosing a subject

Although landscape has always been regarded as the ideal subject for watercolours, there is no need for this to be regarded as a restriction for the beginner. In fact, you can paint anything you like. This chapter not only gives some extra hints on how to observe and capture specific elements in the landscape, but also looks at other traditional areas of painting, including portraiture, figure painting and still life. Many people—and this includes professional painters as well as beginners—experience great difficulty in deciding *what* to paint. Perhaps the ability

Below: Gordon Crosby's choice of pictorial subject dominated his artistic output. He was fascinated with cars, which he painted with great delicacy. Here he captures a dramatic moment, a car crash on the Le Mans racing track.

Above: Naive or primitive painting has a direct, literal charm of its own. Timber Hauling by the White Horse (*detail*) *by H. C. Baitup.*

to perceive a subject immediately with the eye, and therefore 'frame' a complete painting is inborn in some fortunate individuals. This sense of knowing what you want to paint becomes increasingly important to your development, since what and how you see is even more unique to you than your technical skills, and is the central feature of your own vision of the world.

Sources of inspiration

If you are not able to 'spot' your subject matter instinctively in the world about you, there are many ways of finding inspiration. Ideas for still life subjects are discussed later; however, you may want to explore other areas, such as the realms of your imagination. This will be particularly attractive to you if you have a good visual memory for images. Some people have extraordinarily strong memories of scenes and events from childhood, and it is fascinating how the original directness of the child's vision is expressed with the adult's power to recall it. The qualities of so-called 'primitive' or 'naive' painting express these combined visionary forces perfectly, and although this form of art is described as primitive, it is in fact very sophisticated. Naive painting is not always simply a matter of looking back to the childhood world—often people who take

up painting late in life (Grandma Moses for example) have never lost their childhood vision, and this totally suffuses their work.

Fantasy and surrealism

If you visit a gallery which has a good selection of modern art, you will probably see that one of the main features of painting in this century and the latter half of the nineteenth century is the high proportion of work

Left: In his painting Salome, *by Gustave Moreau (1826–1898) the artist has pursued his preoccupation with painting highly romanticized subjects, often taken from the Bible as the original source.*

which either uses fantasy and dream as its subject, or uses it to express a point of view. Whatever particular 'school' is represented, whether it be Expressionist, Dadaist, Surrealist etc. the different view of reality which is communicated is vitally important, and divides modern art from the more representational work of previous centuries. In one sense, this is not entirely new—Blake comes to mind immediately, also Bosch and Bruegel. However they were rare in their vision, while nowadays we take for granted that, in the most general sense of the word, 'surrealist' art is a natural part of our way of looking at life. Most of us have fantasies, though we often are not very conscious of them, and people vary in their capacity to visualize their inner world. Sometimes, just seeing other work of this type can stir up your own world of fantasy images. The ability to pay attention to what goes on in your head while you are going about your daily routine can be deliberately developed. Instead of letting an image go, notice it, follow its growth, and as soon as you have an image, draw it.

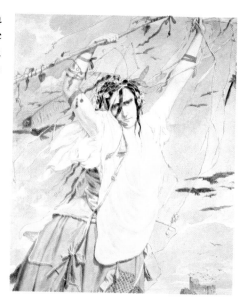

Dreams

Some people say that they never dream. Others that they have dreams every night, and experience incredibly powerful and vivid scenes while they are asleep. You may even dream in colour, although some say that this is impossible. The meaning of dreams is a fascinating subject in itself, but at this point we are looking at the images from the point of view of the painter, and how you can use them as subject matter. The problem with dreams is that they are so fleeting (although you may have a constantly recurring dream which is riveted on your mind). Generally, your dream will have disappeared from your consciousness very soon after you have woken up. People who make a habit of keeping a record of their dreams to interpret their meaning often keep a notebook at their bedside, and as soon as they wake up, write down what happened. You could borrow this idea, and keep a dream sketchbook. On waking, make visual notes of central images, and major shapes, and jot down details of colour and areas of light and shadow. Even this form of recording will only be of temporary use, and you should attempt to start your painting at once.

Making sketch notes

There is nothing more frustrating than seeing a particularly appealing subject for a painting, and finding that you have no way of capturing the main elements. The only way to avoid this is to always keep a sketch pad with you, even if you are just making a short journey, or going to the office. Some sketchbooks can be reserved for special subjects, such as nature studies, which will be discussed later. You'll find that you can use an all-purpose sketchbook in all sorts of ways, including making

Above: Sketch of an Idea for Crazy Jane *by Richard Dadd, painted in 1855. Dadd was always finely balanced on the edge of madness, and his work inhabits a highly idiosyncratic realm.*
Opposite: One of Dadd's talents was for entering the miniature world of fairyland. This study is called Songe de la Fantasie

Right: Animals are fascinting to sketch and paint. This charming study called Sketch of a Seated Cat *by Gwen John is done in pencil and watercolour.*

quick notes of events at home, involving pets, children, odd vistas of furniture and fabrics in different lights, in fact a multitude of ideas. Try to get as much significant detail down as possible. As with your dreams, there is always one particular quality that has made you pay attention—perhaps your cat's pose of total relaxation, or the concentration on a child's face while reading, or examining an object. As long as you have captured this central feature, the rest can be 'filled in' later. If you are

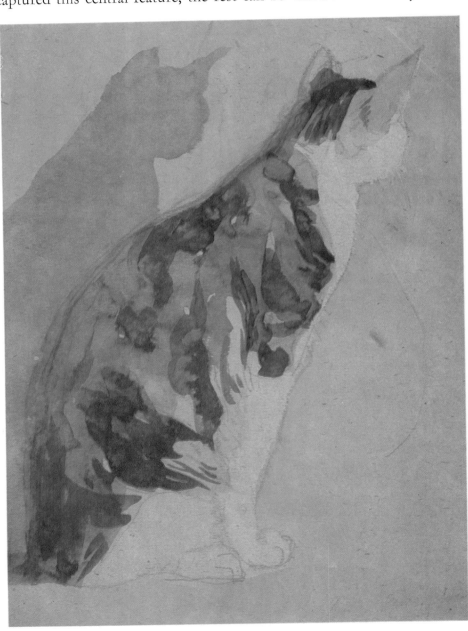

outdoors, and concentrating on a major element in a larger context, you might choose to take a photograph to supplement your sketch. Orthodox hands may be raised in horror at this suggestion, but many people find this extremely helpful, and as long as you are not planning to copy the photograph, and only use it for reference, then the camera is a perfectly legitimate supplement to your note-taking.

Other sources of inspiration

Sometimes other art forms can inspire your visual creativity—music can either act as a general source of stimulation while you are working, or act as a catalyst in its own right for all kinds of moods and images. On the other hand, some painters find that they can only work in complete silence, and music would confuse and distract them, rather than help them work. The imagery of poetry might evoke pictures—think of T. S. Eliot's *The Waste Land* for example, or an evocative classic such as Dante's *Inferno,* which provided Blake with so much of his inspiration. A modern painter might look at the enigmatic work of Samuel Beckett,

Below: Microscopic pictures of minerals reveal fascinating and beautiful structures which can be wonderful inspiration for a painting.

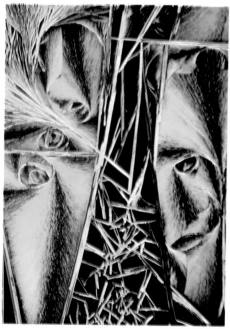

or children's stories, folk tales and nursery rhymes. Look also for pattern and detail—watch the sand at low tide, and the patterns made by the water. Examine rocks and crystals, try to get some microscope pictures: you'll discover an entire world with beautiful symmetry and structure, which will help to develop your own sense of form and composition.

Skyscapes

The importance of the sky to the landscape painter is self-evident. Within most landscapes it is the dominant feature, determining the mood or atmosphere of the whole. Painting a series of skyscapes *per se* will help you to develop your understanding of the changing nature of

Right: Cloud formations are a major feature of skyscapes. Here towering clouds build up over the sea, heralding the approach of a thunderstorm and providing a strong dramatic subject.

skies and cloud formations under different light and climatic conditions. By isolating this one, very important, feature of landscape you will sharpen your ability to observe its subtle variations in colour and mood. Use small sheets of paper so as to be able to make complete statements quickly. The deep luminous colour of the sky is one of the most difficult problems the artist may face. But, in many ways, transparent watercolour is the ideal medium for painting sky because it too has a luminosity which comes from the light reflecting from the white paper surface through the thin layers of paint. This transparency should be maintained in all your skyscape experiments. Thick, heavy layers of pigment should be avoided.

Even on a bright sunny day, when the sky appears to be a clear

Left: Cumulus clouds are challenging formations to paint, with their combination of fluffy, light textures and the hard, bright quality of their outlines against the sky.

uniform blue, closer observation will show that there are nevertheless considerable colour variations from, perhaps, deep bright blue at the zenith, moving down through paler tones to a pale yellow grey at the horizon. The appearance of clouds can be dramatic and, depending on their nature, they can totally alter the predominant mood of a painting. The colour, structure, shape and position of cloud formations must be closely studied. You cannot hope to copy all the details of shifting cloud masses or their infinite colour variations, but an understanding of the characteristics of each type will help you translate what you see in terms of the watercolour medium. Cumulus clouds, for example, are those large, white fluffy masses commonly seen against the vivid blue of a summer sky. They seem to be thick and almost tangible, billowing out

Left: A typical mackerel sky, composed of cirro-cumulus clouds. (The word cirrus is Latin for a curl of hair).

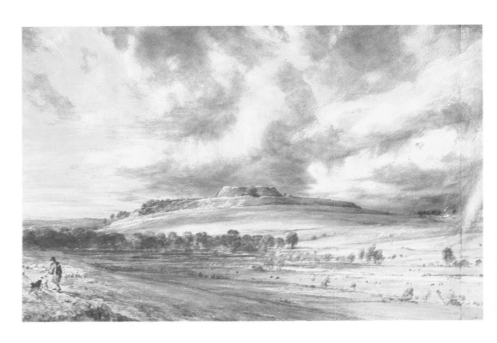

Above: Constable has handled the skyscape in this painting called Old Sarum, Wiltshire *with breathtaking skill. He normally used watercolour as a preliminary stage of his work in oils, and did not exhibit them. This work was painted in 1834.*

on one side and tapering on the other depending on the direction of the wind. The lightest, brightest white is at the top curvaceous edge of the cloud. The bottom edges are flatter and darker. Notice, also, the way certain clouds cast definite shadows on the ground beneath. Some windswept cloud formations seem to have almost no bulk or form at all, with almost no definition between them and the rest of the sky into which they merge. Rather than paint on areas of white, in such cases, you may prefer to lift off colour while the basic sky wash is still wet (see Techniques).

Similarly, rather than using heavy line to represent high, spare streaky cloud formations, use drybrush techniques (see the Project chapter) to give a light airy effect. Handle dark areas carefully. A storm cloud may seem to present an almost black-and-white contrast to an area of bright sky. In reality this is unlikely because forms in the foreground will probably be much darker than those in the distance.

As an experiment observe the colour relations on a very dark, stormy night between the sky on the horizon and the land adjacent to it. The land will almost certainly seem much blacker. Move your eyes up to the zenith and you will still see a very noticeable contrast between the blackness of the land in the distance and the lighter greys of the sky.

Weather conditions, of course, alter the character of the sky completely. In certain situations, fog, for example, the sky is virtually obscured completely. Fog diffuses the colour of everything. In a dense fog the landscape may well not be worth painting unless there are some powerful forms and shapes which push through the atmosphere.

However, a partial fog or light mist can present quite delectable subject matter for the watercolourist. The softness and subtlety of colour and shape seem ideally suited to the medium. The fuzzy images produced by wet-in-wet techniques are particularly appropriate to the merging of colour and form seen in foggy landscapes. Use the particular characteristics of the watercolour medium to help you with special effects. Rain falling in the distance, for example, can be suggested by applying a streaky wash over the basic wash at an angle to the edges of the paper. A spray of tiny drops of water from your brush onto the wet surface can indicate feathery snowflakes. Do not be afraid to experiment and try out your own ideas. They may well work!

Seascapes

Not surprisingly, watercolour is in many ways the perfect medium for painting the idiosyncrasies of water itself. But the painting of seascapes

Left: Water, with its wonderful reflective surface provides a constantly fascinating subject, especially for the watercolourist. La Rue du Soleil *by Charles Rennie Mackintosh (1868–1928) is a fine study by the gifted Scotsman. He is usually known for his fine architectural work, and as the most talented British exponent of Art Nouveau.*

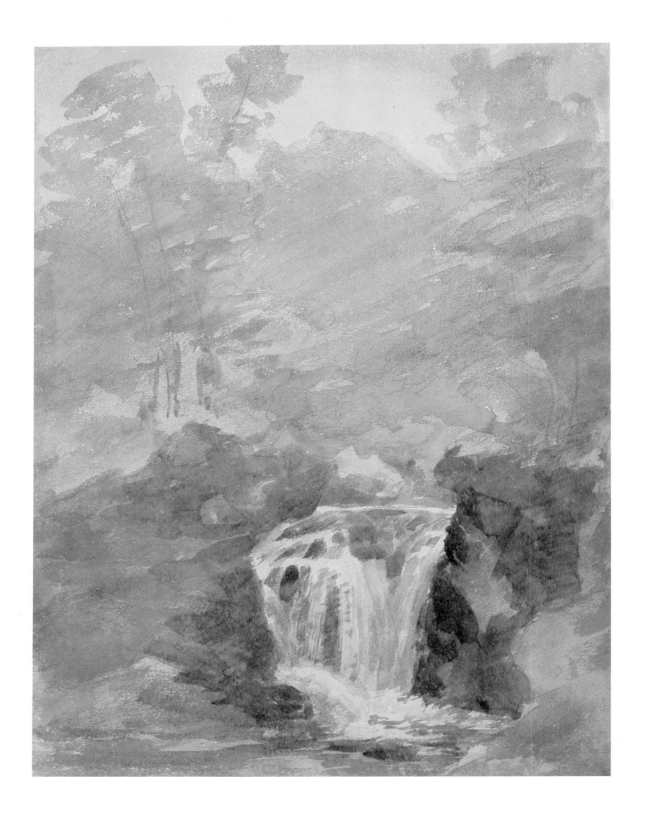

or any other watery landscape in watercolour is by no means a straight-forward matter. Water is constantly changing substance. It can, in certain conditions, appear to have immense bulk and form, as in the great rolling waves of the ocean, for example. In others, for example, in rain or the spray of a waterfall, it appears quite insubstantial. Water has two qualities which make it at once challenging and problematical to any artist: they are movement and reflectivity. Fortunately, they do not ordinarily occur together. Calm, still bodies of water are immensely reflective, whereas a bubbling stream reflects only flashes of sunlight, perhaps nothing more. Even the calmest pond, however, has a certain amount of movement in it. The artist can suggest this by painting in a few gentle swirls on the surface or by introducing a shimmer into the reflections. Notice how water on some other surface, a pavement or street, for example, also creates vivid reflections. Observe, too, how reflections are not only mirror images of their sources but are also usually darker and less defined. They may well be distorted by the angle of the surface or by a barely perceptible movement in the water.

Rivers, oceans, streams and waterfalls should always be painted with the direction of the movement of the water in mind. This must be clearly defined in the painting. One way to do this is to direct your brushstrokes in the same direction, taking account of rocks, stones or obstacles in the path of the flow. Observe how the water itself negotiates these objects and do likewise with your brush. The frothy, white tips of waves and water splashes can be effectively rendered with drybrush techniques. As to colour, do not begin with preconceived ideas, such as 'the sea is blue'. The sea is, in fact, colourless. Its apparent colour is the result of reflected colour, particularly from the sky, and this in turn is affected by objects in the sea such as rocks, sand-banks and so on. Homer described the sea as 'wine-dark'; to others it may seem a deep brilliant green, or a hazy blue-grey or brown and muddy. Your concern is only how it appears to you.

Mountains and rocks in landscape

Mountain scenery can be breathtakingly beautiful—and the majesty of the scene before him can often overawe the inexperienced painter. Consequently he is tempted to simply copy what he sees, and this often results in a typical 'chocolate box' effect, crowded with far too much detail, and utterly dependent on the raw influence of the panorama. To avoid this trap, stand back and look at the mass of shapes before you as critically as possible. What you are looking for are the key elements of composition and design, and you should always be considering how to simplify, and how to control the scene into a definite pattern.

If you think about it, underneath the covering of soil and trees, mountains have a distinct geological structure. If you stripped off this

covering, you would see how they were formed—perhaps by volcanic upheavals, or faulting, which produces all kinds of fascinating angles. Slabs of rock may be piled up at odd horizontal angles, or whole section of the earth may have subsided, to make almost perfectly sheer-sided structures. These geological details dictate the line and rhythm of the mountain landscape, and also the shape and texture of the individual rocks on the surface.

Composing the picture

Generally, the most successful paintings of mountains are either from a very long distance, where you are basically working with shapes and colour, or else really close up, focusing on some particularly dramatic element on the mountain face, or right inside a valley, where you can work with the texture and structure of the rock itself. If you are painting at a distance, use the sky area intelligently. You can either have more

Below: An Alpine scene by the English eighteenth-century watercolourist John Martin. It became fashionable for painters to travel long distances in search of high ground and rugged mountain landscapes.

sky than land, or land than sky, but avoid making them equal in emphasis —your picture simply won't be as interesting. If you are focusing on one mountain in particular, make sure that the lines from the foreground lead toward it, preferably with curved lines rather than straight. You don't want to rush the viewer through your picture. Another way of establishing your focus is either to paint it in the darkest tonal colour value, or else in the lightest. Similarly, on close-up views, select a definite focal point, a particularly interesting group of rocks perhaps, but avoid placing them at the centre of your picture. Do the most detailed work on this area, and select only the elements of the foreground which balance and enhance the focal point, and avoid painting everything that you see in the foreground. Again, select the areas which guide the viewer gradually to the detailed point that you have selected.

Above: Fig. 1 shows some of the many distinct variations that can be achieved on a basic tree silhouette

Painting outdoors

Trees and shrubs are a major element in landscape, and all too often we take them for granted, because they are such familiar features. Yet they add an entirely unique quality of texture and composition to your painting, and you should become as well informed as possible about the different varieties. Begin with a detailed approach. Look through books on trees and shrubs, and study them until you can easily identify the more common species. Now you need to build up a properly annotated sketchbook by going outdoors and drawing as a regular exercise, covering as many seasonal variations as possible. Use pen and pencil, and if you are able, add colour references too. The main purpose of this is to build up your confidence and skill, so that you are able quickly to identify the kinds of trees and shrubs in the landscape, even though you may be looking at them from a distance.

Below: This exquisite watercolour of a merlin hawk is by the Victorian novelist Emily Bronte.

With this detailed knowledge at your disposal, you should be looking for the individual shapes of different kinds of trees and shrubs. Never paint them as vague, impressionistic blobs, try to use their shapes as part of the composition of the landscape. One exception is when you are painting hedges, especially around fields, where they have been trimmed to a regular shape. Here you can use that regular shape as a feature in itself. Left to grow naturally, trees have distinct silhouettes, (fig. 1). If you want to have a tree or shrub prominant in the foreground, you can concentrate on the detail of trunk and leaves, while those in the distance will have to be identifiable from their individual outlines. When you paint trees at a distance, first sketch them lightly in pencil, then, using the lightest colour value, paint the over-all shape of the foiliage (remembering that the silhouette is most important) in a flat wash. While this first wash is still wet, lay in a second wash in a darker colour value to express the shadows. Always keep in mind that light comes in from above, and use this as the lower part of the foliage. This second

wash blends in wet-in-wet. When the two washes are dry, add a little drybrush for textural interest, then using a fine brush, finish with the details of the branches and trunk. While you are compiling your sketch book, you can try this technique with one colour, concentrating on the light and shadow effects for different species.

Nature sketchbooks

Watercolour studies of close-up views of botanical subjects have a special place in the history of painting. As early as the seventh century, Chinese artists used their exquisite brushwork to do fine flower studies, and the Japanese continued this tradition. The recent popularity of such books as *The Country Diary of an Edwardian Lady* show how beautiful this careful, detailed work can be, for small plants are part of the endless diversity of nature, and each has its individual appeal. If you

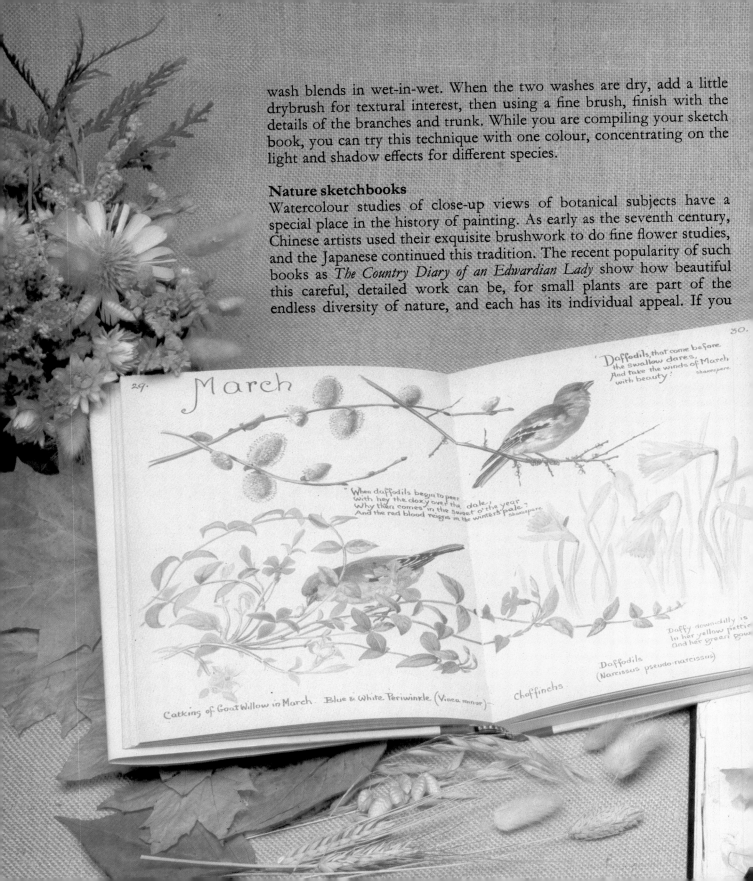

March

29.

30.

'Daffodils, that come before
the swallow dares,
And take the winds of March
with beauty.' *Shakespeare*

"When daffodils begin to peer
With hey the doxy over the dale,
Why then comes in the sweet o' the year,
And the red blood reigns in the winter's pale." *Shakespeare*

Daffy-down-dilly is
in her yellow petticoat
and her green gown

Catkins of Goat Willow in March. Blue & White Periwinkle (Vinca minor)

Chaffinchs

Daffodils
(Narcissus pseudo-narcissus)

visit a good antiquarian book dealer, you will find a whole section of old books which specialize in these watercolour illustrations. Many are quite formal in approach, and stress botanical detail rather than the pictorial effect. However, these precise studies of herbs, flowers and other small plants are works of art in their own right.

You really need an excellent eye for detail if you want to paint small plant subjects successfully. It would be wise to keep a special sketchbook to fill with your pen and pencil drawings. Remember that you can explore your own garden and public parks as well as the countryside itself. This will provide you with essential basic knowledge, and you'll soon discover that in addition to flowers, weeds and grasses can make enchanting subjects in themselves. As you need a basic foundation sketch for a painting, these preliminary studies are invaluable, and they also teach you to sketch quickly.

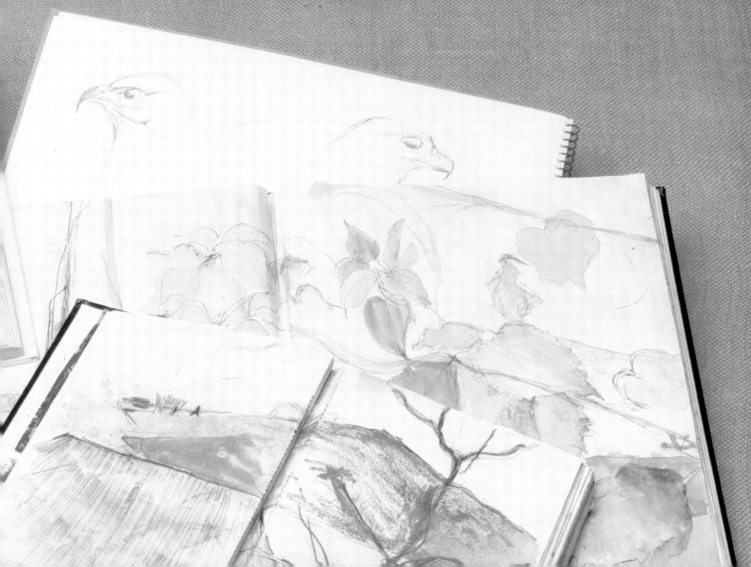

Painting flowers

When you paint flowers, the main danger to avoid is that of making your finished picture look like a photograph. Your painting should have a completely fresh, spontaneous feel—and you can start by looking at the blooms themselves. Look at how their shape is formed by the arrangement of the petals, and emphasize this deliberately. How are the flowers and buds set on the stem? Do the leaves fall in a particular way? You can exaggerate the line a little. If you are painting only one flower, try to highlight it as much as possible. The paper should be kept very small,

Below: Castle by the Sea *by Raoul Dufy. The artist's direct, immediate style of application is used to great effect in painting the palms and tropical flowers. His bold, loose brush strokes evoke a mood of gaiety and natural abundance.*

so that the flower can be almost life-size, and is not buried by the background. A useful approach is to focus on the petals of the flower first, drawing them in lightly with pencil. The background should be laid in with a flat wash, remember that it should be kept unobtrusive. After you have laid down the background wash, add some mere suggestions of details of any foliage and ground textures.

Now you can concentrate on the plant itself. Paint the leaves and stems, noticing where the shadows fall. Finally, paint the flower. You will need the purest colours to achieve the radiance and 'bloom' of the

Below: In complete contrast to the Dufy (opposite) this eighteenth-century botanical illustration of a nasturtium is utterly careful and precise in its detail, yet no less beautiful in its impact.

Tropæolum majus

Published by D.C.Windmills, May. 1. 1794.

224

petals. This takes a lot of practice to achieve. Spring flowers are best painted with transparent watercolours to suggest their fragility, while the sturdier blooms of summer and autumn can be well expressed in gouache. When painting white flowers, you might add hints of blue and red to create the delicate shadows.

Weeds and grasses

Humble weeds and grasses can be beautiful—think of Queen Anne's Lace for example, which has superb dramatic form. You can either choose to do individual studies, or do a picture which shows the pattern of weeds and grasses interlacing. Again, draw in the main features with pencil, then lay in the background wash. This might be green and brown. Then pick out some of the more distinctive plants to act as the central focus of your picture, and paint in their detail. Finally, add the interlacing grasses and smaller weeds. These can be scratched in on top of gouache with your fingernail, or a sharp-edged object like a razor-blade; this is an excellent way of capturing the intricacy of the intertwining plants.

Portraiture

There is a common misconception that watercolour is unsuited to portraiture. As a result many students avoid the medium for this form of expression without ever having tried it. In fact, watercolour is ideal for spontaneous, informal portraits (of family and friends, for example) so it is worth experimenting with it to find out what you can achieve. To begin with use lots of small sheets of paper, rather than one large one, and resign yourself to the fact that many of your initial attempts will be disappointing. Many beginners are especially anxious to achieve likeness, but it's best not to worry about this at first. Just concentrate on doing a good painting. The likeness will take care of itself in time as you become more experienced and more observant.

The basic construction of the head should be your fundamental concern. Likeness depends far more on this than on small variations in the shape of particular features. Although human beings communicate through facial expression, feature movement is of little significance for the portrait painter compared to the dominant shape of the skull.

Approach the painting as a sculptor would and try to build up the three-dimensional mass of the head. The skull is covered by a web of muscles moving across sections of the surface and into its structure. These muscles are continually moving, flexing, relaxing and changing shape as you observe, talk, breathe and turn. Any action changes the appearance of the head although the fundamental bone structure remains constant. Try to become aware of what is going on underneath the skin and hair of your model as you are doing the painting. This will

Opposite: A clump of weeds is transmuted into a watercolour and gouache work of stunning beauty. The Great Piece of Turf (1503) is one of Albrecht Dürer's masterly botanical studies, and is typical of his loving, perceptive vision of the natural world.

help you to understand and analyze the information coming to you through your eyes—why a certain movement appears to cast a particular shadow or throw a hitherto unnoticed feature into highlight and so on.

The ability to draw well is particularly important in portraiture. Before you even attempt a painting it is advisable to practise drawing heads as much as you can, until you feel confident that you understand the basic construction of the head's anatomy and the peculiarities of its most important features. You will not use much of the detail in the paintings but the understanding you have gained through the drawing exercises will be invaluable.

If you wish to attempt a self-portrait certain practical considerations should be taken into account. You should be able to work in comfort and in a position where there will be a constant source of light. A bedroom may well be the ideal place. It provides some privacy and there is likely to be a large mirror perfect for the task. Position yourself in front of the mirror so as to establish a strong contrast of light and shadow and also to allow for a minimum of movement between board and mirror. This goes for any working situation in fact. It is amazing how often people position themselves in such a way as to necessitate a considerable movement from subject to board.

Fortunately, the very nature of the watercolour medium, whereby the board is kept almost horizontal, facilitates an economy of movement which is impossible when working in oils. Rotate yourself in front of the mirror to see what changes occur to the shape of the head from full face to three-quarter view. Observe which angle most clearly describes the surface. A full face emphasizes the basic geometry of the head, but does not easily allow for a clear understanding of the spatial movement from the chin across the mouth, nose and forehead. The three-quarter view allows for a clearer understanding of these elements. Pose yourself or your model under a single constant light source so as to obtain simple straightforward shadow shapes. Position yourself about 1 m or 1 yd from the mirror (or your subject); this distance will enable you to see the smallest facets of the head clearly. Use a fairly smooth paper allowing for fine linear detail when necessary.

Begin by constructing the over-all shape of the head, mapping in quickly with a fine sharp 2B pencil the dome of the skull, the relative flatness of the side of the head and the shallow curve of the forehead. Look critically at the various points on the head which remain constant: the cheek bones, part of the eye socket and the bridge of the nose. These ridges of bone provide a basic foundation upon which you can build. Watch how the muscles operate in the neck, helping to support the head and give it mobility. Having established the basic three-dimensional shape of the head, begin to pinpoint the position of the mouth, nose and ears, relative to each other. Establishing the correct eye level is critically

important. Observe how the relative positions of eyes, ears and mouth are quite different on an adult head from those on a child's. The eyes, like the nose and mouth, are positioned on a curve around the front of the head and have a slightly forward tilt which you may not have noticed. Notice, also, how the shape of all these features is radically altered depending on the angle of the head. Your initial sketches should simply suggest these basic shapes and proportions. Do not attempt to fill in too much detail at this stage. The details of the individual features will be completed with your brush and washes not your pencil. A

Above: This Elizabethan miniature of Sir Walter Raleigh, painted by Nicholas Hilliard is an excellent example of a favourite tradition of portraiture.

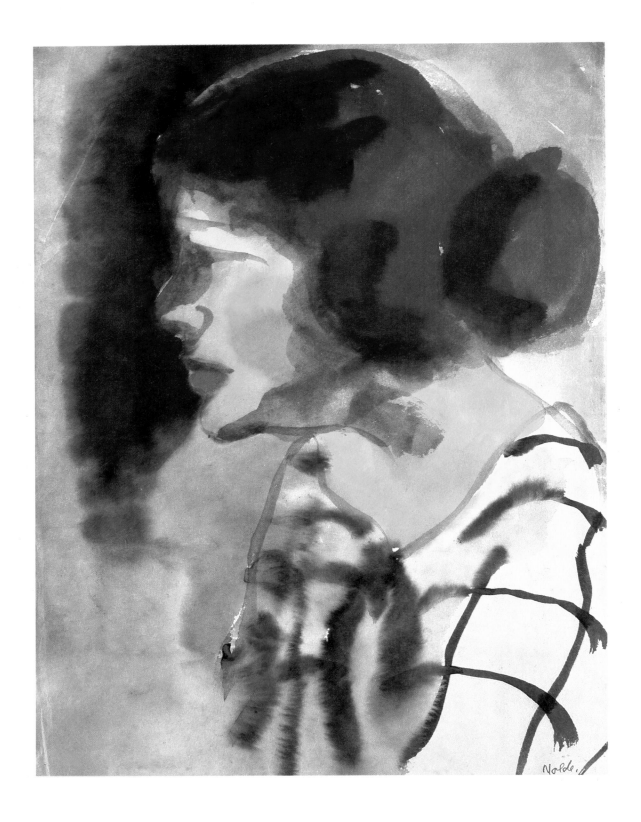

228

common mistake is to deal first with the features and then build the rest of the form around them. This is like trying to put a roof on a house before constructing the walls. In the finished portrait these details may well be very indistinct. The eyes in shadow, for example, would not be more than a blurred shape with no sharp edges or definite detail. Too often information is included which cannot actually be seen but is known to exist.

The hair can often pose particularly intractable problems. Many artists spend ages trying to capture its soft elusive texture with the result that the picture becomes overworked and loses its spontaneous qualities.

Opposite: An evocative portrait in watercolour painted c. 1933 by the German Expressionist painter Emil Nolde. Nolde's extraordinary ability to handle colour is well illustrated. Below: A pencil and watercolour study of people's faces called Sunday Afternoon. *Painted by Richard Lindner in 1954, the work has a very powerful quality.*

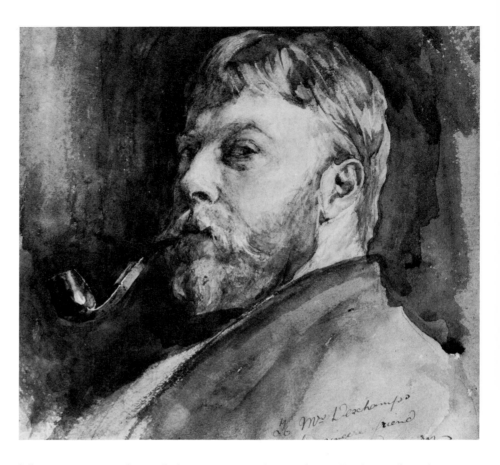

Right: Self portrait in watercolour by Edward John Gregory, (1850–1909).

There are a number of things to watch out for. The boundary between the hair and the skin should never be too harsh or clear-cut. Soft, irregular transitions are what is called for. This is much more difficult to achieve with dark-haired subjects than with blondes. Remember also that even the darkest of brunettes rarely has absolutely black hair, just as the fairest of blondes often has quite substantial patches of dark colour among the golden strands. The texture and highlights of hair can be suggested by a number of techniques, drybrush, for example, or use of the tip of the brush handle or your fingernail to scratch out light lines on the wet surface.

Colour often proves a problem in portraiture. For this reason it can be a good idea to begin your experiments with shades of one colour, black, for example, or sepia. This will give you the opportunity to improve your techniques before tackling the problems involved in colour. As mentioned in the chapter Handling Colour, human skin is particularly receptive to light and it is very difficult to capture the myriad subtle changes of tone and colour which any skin surface exhibits. Naturally most beginners are particularly concerned about how to mix

flesh colour. Unfortunately there is no simple answer to this problem since there is no one flesh colour. As a general rule a mix of Cadmium red and Cadmium lemon will produce a basic flesh tone. Some people prefer to use a yellow ochre rather than lemon. You must experiment to find out which you prefer. Remember a touch of yellow goes a long way. This will provide a very healthy colour. For more sallow skinned people add a little blue or green to the mix to mellow it.

Figure Painting

The structure of the human body has such infinitely subtle variations that it presents the greatest challenge of all to the artist. The problems

Left: One of George Grosz's beautifully observed figure studies called A Married Couple. *Notice how he has used the same baggy outline shape to depict them both.*

Right: Egon Schiele's study Standing Nude with Crossed Arms *is a stunning example of flowing line and dramatically used colour washes.*

posed are much the same in a general sense as those presented by portraiture. The solutions to the problems are therefore related.

All too often the beginner is obsessed with detail but, as in portraiture, it is advisable to concentrate on gesture and attitude rather than on specific features. Make the subject of your picture the way the model is standing or sitting or reclining. Pay as much attention to the position of the model, the lighting and the colour scheme as to his or her individual features.

The importance of the sketchbook cannot be over-emphasized. It is essential to prepare yourself for figure painting by gaining as much understanding, through observation and drawing, of how the human body operates.

When using a model, place him or her in as comfortable a position as possible and one that is easy to hold while you make your studies. In a reclining pose the muscles are subjected to little tension but that is not to say they are inactive. The seated figure relies more positively on the vertebrae and attendant muscles; the legs help to maintain the position, but the chair, stool or seat is the chief means of support. When standing, the figure exhibits a tension throughout itself; muscles change their shape and nature considerably. Establish the major proportions of the figure before attempting to capture the details. Pay special attention to the relative proportions of the head, torso, arms and legs, and notice how these proportions are quite different in human beings at different stages in the life cycle. If the figure is seated with legs towards you there may also be problems of perspective and foreshortening. Sometimes it helps to place the figure against a familiar background containing simple constants—a door, chair, window, and so on—against which you can measure more easily the new elements of the subject. Be especially careful about establishing scale. This can be avoided to some extent with landscape but not with figure painting. If your model is clothed, observe the way the folds and creases in the materials drape over and around the body. Simplicity of approach is, as always, the keynote of success. A few well-placed strokes of the brush can suggest the movement of soft fabrics most effectively.

Above: One of Blake's illustrations from Paradise Lost. *This shows Satan arousing the rebel angels.*

Still life

Still life has never been a particularly popular subject with watercolourists, possibly because the characteristics of the medium have always been identified with landscape. Also, it is an undeniable fact that oils are better able to reflect the wide variety of textures, depths of colour, and materials of the groups of objects used in 'set pieces'. Still life artists deliberately choose and juxtapose china, glass, fabrics, fruits etc. in order to express the full range of their expertise.

There is no reason why the watercolourist, who has gained some

*Above: Although still life has never been regarded as the ideal subject for watercolour, some artists have produced fine still life studies in the medium. Here is an example by the master of the genre, Cézanne—*Still Life with Apples.

sense of his brushwork and colours, should not paint beautiful still-life compositions. Cézanne shows how successful watercolour can be in this tradition in his painting *Still Life with Apples*. A more contemporary example is Daphne Sandham's *Still Life,* where bright, primary colours are used to dazzling effect.

Very few still life pictures are 'found' by the artist just as they are. The objects and setting are cunningly chosen to contrast and harmonize. You'll find that in your search for suitable components for still life, you develop quite a magpie instinct. Common household items like jugs and pots in earthenware, pewter, copper or porcelain can be placed on a scrubbed wooden table, alongside glowing fruits, perhaps an unusually shaped bottle, maybe even a dish of golden butter.

For a still life scene outdoors, you may find a straw hat, gardening basket, flowerpots, some small gardening tools, and arrange them on a wooden chair. You could add a fine cabbage or cauliflower. These are simply suggestions, of course. In fact, you should avoid crowding your

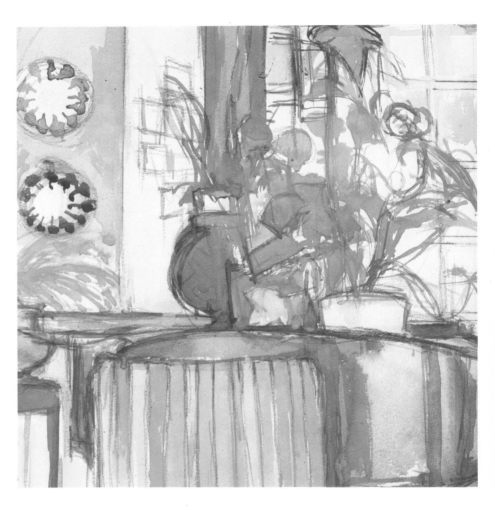

Above: The artist Jane McDonald has arranged the elements in this charming watercolour still life to bring out the contrasts in colour and texture to the finest effect.

composition, and concentrate on really strong, simple design. Some of the most beautiful still life pictures have only a few objects in them. Keep arranging your group until you are satisfied with the composition, and when you are working indoors, experiment with different ways of lighting the group.

Once you are happy with your arrangement, sketch in the major shapes lightly with pencil. Apply the background wash first, and then work on the details of the objects themselves. The textures and surfaces are vitally important, they provide a sensuous dimension to the work, making each item seem to breathe a life of its own. Work carefully on shapes, keep on checking that you have the correct fall of shadow. Also remember that your colours will influence each other quite strongly, and you can exploit this very well in still life. Where you need a thick impasto effect, you can use the aquapasto jelly medium to gain a really thick, creamy texture.

Techniques

The development of techniques in painting tends to grow as much out of trial and error in practical work as it does from theoretical information. It is very important to discover your own particular skills and aptitudes through constant experimentation. The beginner can be guided in the direction of ideas, but it is how the individual puts these ideas into practice that counts. If the following techniques don't work for you, then don't be discouraged, they are simply provided as interesting suggestions for further exploration. This chapter introduces several new ideas, including a discussion of line drawing with inks and watercolour washes, monochrome work, tempera painting, and a whole range of intriguing ways of adding texture and unusual elements to your work. It should be stressed however that you must avoid becoming dependent on 'the tricks of the trade', and constantly develop your basic painting skills, otherwise your work will be based on special effects rather than on a sound foundation of good observation. This is not meant to put you off using extra techniques—in fact they can be great fun to try out—but you should beware of over-indulgence.

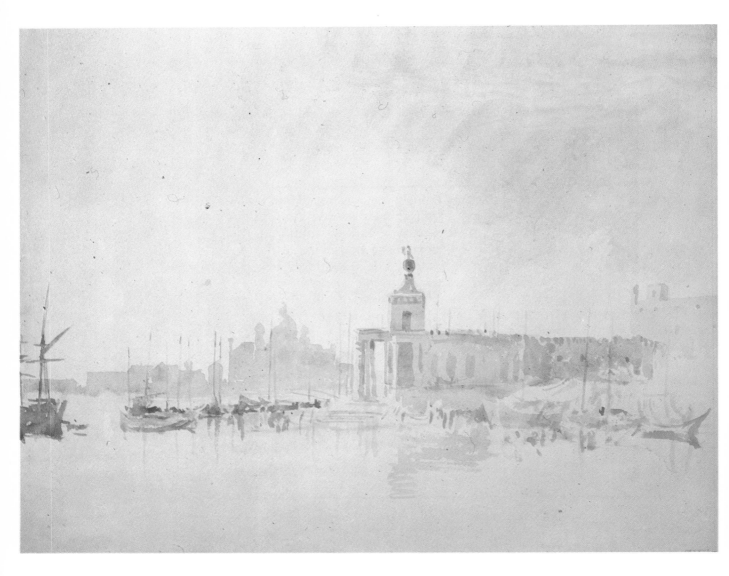

Above: One of Turner's beautiful views of Venice. Notice how he has used the brush to draw in detail as well as to apply the fleeting, delicate washes.

Line drawing and watercolours

Although line drawing can be described as a separate skill from painting, the greatest painters have always been superb draughtsmen. The ideal level of skill to which the painter aspires is such excellent competence at drawing, that the main outlines of the work can be applied straight from the brush, so that in fact he draws with the brush itself. This level is only reached when the artist is so fluent in his draughtsmanship that line work is completely natural to him. Major painters like Turner, Constable and Girtin all had this wonderful quality in their watercolours, their work seems to have flowed effortlessly from the brush. Many water-colourists tend to emphasize line work rather than blending it into the

wash or body colours. For example, Klee uses pen and wash frequently, using the line work as a very strong element in his pictures. In his work called *They're Biting* , the fine outlines of the pen work and the delicate nuances of the wash colours work together to create both a dreamy translucent quality, and a witty, humorous touch, produced by the graphic line. Line is a vital element in cartoon work; you will see this very well expressed in Cruikshank's cartoons, where, again using pen and wash, he creates a great deal of action and humour with his lively, vigorous pen work and bright primary washes. Blake uses his long experience as a draughtsman and engraver to enormous effect. In many of

Left: Line is a crucial element in this pen and wash painting by Paul Klee called They're Biting.

Right: Cartoon work is a medium in which line is predominant—washes are merely used to strengthen the visual drama. This cartoon is by George Cruikshank (1792–1878).

his paintings, line is very much the dominant element, and the washes are often used just to strengthen the visual drama.

Improving your drawing skills

Obviously the preceding discussion on excellence in line drawing does not imply that you should abandon your career as a watercolourist simply because you can't draw like William Blake. However, you will soon discover for yourself that any restrictions on your ability to draw may frustrate your progress. You can certainly gain some fundamental principles from books, and if you are able to find a good drawing class, so much the better. Classes in drawing will help you in many ways— you'll find that your sense of composition improves, and most of all you'll find that you gain much more confidence in putting down your preliminary sketches, and the thought of learning to draw straight from the brush will not hold so many terrors. You will be constantly encouraged to do lots of fast sketching exercises, and by learning to work quickly, you'll improve your painting.

Using pen and inks

The foundation of pen and wash work lies in learning first how to exploit the medium of line. A good way of starting is to use pen and

inks, which, as we have mentioned before, are made up from dyes. They are available in a wide range of colours, and you can do your line work with the ink at full strength, and then dilute it for your washes. You may find that some inks tend to separate into granular patches if you are using ordinary tap water. The best way to overcome this problem is to dilute the inks with distilled water, which you can buy at any pharmacy. Another problem with inks is that they have little resistance to light, and will fade after a time. Ink washes are applied in exactly the same manner as watercolours, and can be used both for monochrome work and for traditional colour ranges.

Pens

There are many kinds of pen suitable for line work. Look at the selection in your art supply store, and choose one that can be fitted with different sized nibs. This provides you with a wide choice of thickness and strength of line. You could also supplement the ones you buy with some home-made pens, which you can make from bamboo and quill feathers. A home-made bamboo pen gives an effect very much like Chinese calligraphic work, and is great fun to use. To make one, select a piece of ordinary garden bamboo cane, and cut a length of about 20cm (8in). Make sure that you cut well above a knot. Then, using a Stanley knife, cut the top at an angle, and trim down the sides of the angle to make a point. Finally, slit the point to make the ink channel. (See fig. 1). You can also make goose-quill pens by the same method, visit your butcher, and ask him for some quill feathers. After a while, quill pens soften at the ends, but you can re-cut several times. Once you've

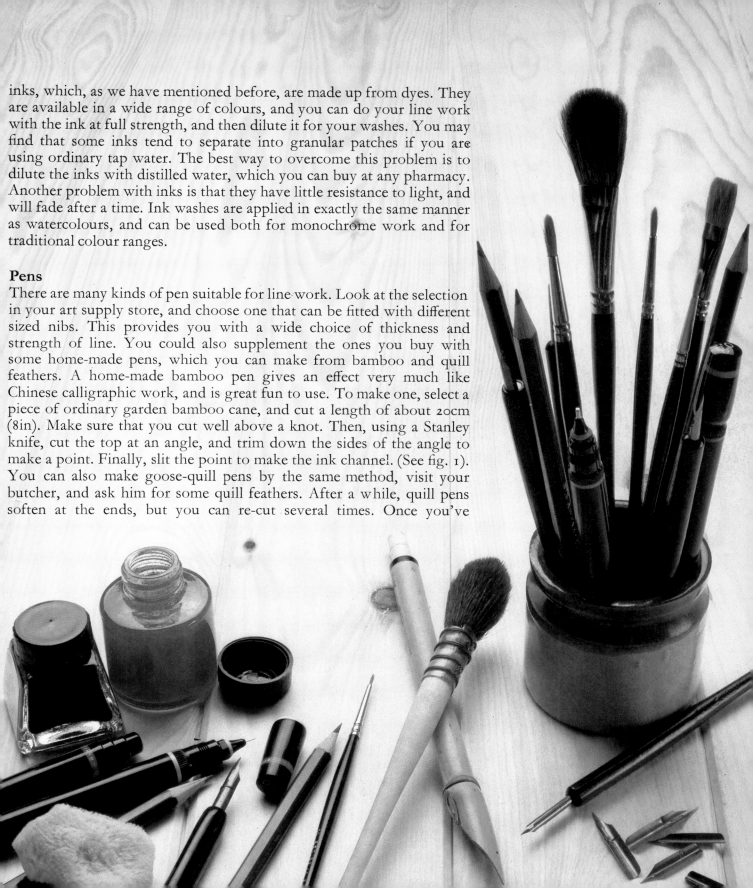

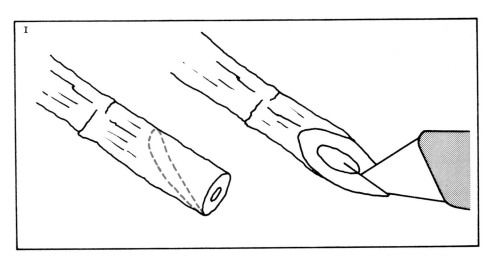

Fig. 1 Cutting a home-made bamboo pen.

practised using these pens with your inks, you'll find that you'll really enjoy working with them, and discovering their particularly fine qualities.

Monochrome work

Monochrome work simply involves working in one colour, and exploring all the nuances of that one hue throughout the painting. You will find that this is a particularly challenging area of work, and it will show you how much the painter depends on colour to provide texture and depth to his work. When using one colour, you have to create all these effects through light and shade, and you will be amazed at how beautifully haunting and subtle your work can be using this medium. It is possible to work monochrome both in ink and in watercolour. A really fine example of lyrically perfect ink and wash monochrome work is found in Samuel Palmer's *A Rustic Scene* (fig. 2). Here he combines a strong drawing technique with an incredibly suggestive use of shade and tone, exploiting the full range of shading from only one basic colour in a truly breathtaking picture.

One of the problems about monochromatic work in the hands of a beginner is that it can lack texture. Later on in this chapter, you'll discover a whole range of techniques for adding texture to your work, and you can select the ones most appropriate for your painting.

Impasto

The use of impasto is very new to the watercolourist, for the traditional pigments have not been suitable to mix into the thick, creamy consistency of paint needed for working. In the chapter on materials, the recently discovered jelly medium known as aquapasto was mentioned, as well as advice on how to mix it with various kinds of watercolour

paints. If you are going to work with impasto, you should first of all make sure that your paper is strong enough to hold that density of paint without cracking. You might consider cardboard, especially if you intend to do a large area of impasto work. Don't forget also that the technique uses a large amount of paint, so mix up a generous amount on a large surface palette—a white dinner plate is ideal. Once you have mixed your impasto to the recommended proportions, it can be applied either with a hogs' bristle brush, or with a palette knife. Never use a sable brush with impasto, as it is likely to be ruined.

Working with such a thick texture of paint can be fascinating, and you can try out all sorts of effects, including stippling. This involves building up areas of colour with lots of small dots applied with the tip

Below: Ink and wash monochrome work can be used to produce beautiful haunting effects when used with skill. Fig. 2, Rustic Scene, *is by Samuel Palmer.*

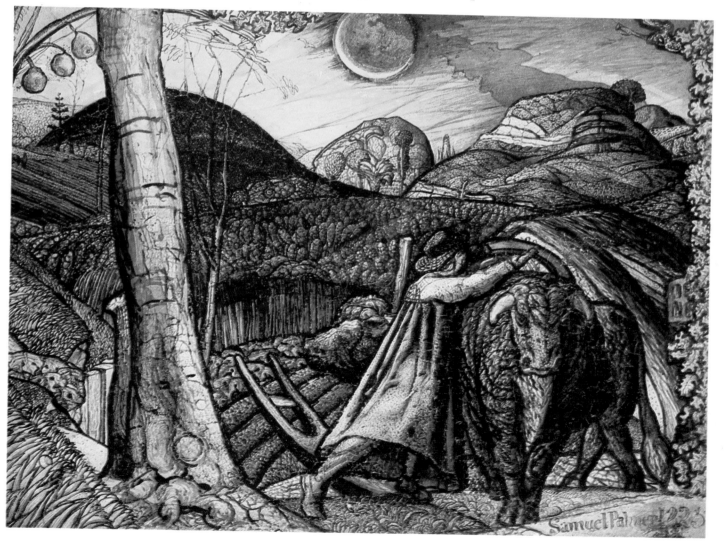

of the brush or knife, either with a mix of colours, or with shades of one. It is basically a pointillist technique, as used by Seurat in his wonderfully evocative oil paintings and is also used with tempera, as discussed later on. It is thoroughly absorbing work to do. Now that aquapasto is available, even a traditional oils technique is possible for the watercolourist to employ. Impasto is also an ideal surface on which to use the following technique, known as sgraffito.

Sgraffito

Sgraffito is simply a method of cutting or scratching the surface of your paint to reveal the ground. Depending on what instrument you use to do this, various effects can be achieved. For example, you can use a razor-blade to cut out tiny strips of the colour to make highlights, perhaps to suggest light catching an area of glass or metal. The flash of white paper suddenly revealed can be really vivid and powerful. You can also scratch or cut with scalpels, knives, sandpaper, pieces of cuttlefish, palette knives—whatever you can think of. Always experiment first however, and always take care that you don't damage the surface of your paper. Sgraffito should be a well controlled technique. A slight variation in effect can be achieved by using a very soft rubber eraser. This is particularly suitable for transparent watercolour also; if you want to achieve an effect like rays of sunlight, for example, you can draw the eraser gently along the dry surface colour. Don't rub too hard, or else you'll damage your painting.

Wax resist

Wax can be used as a resist element in a variety of ways. You can apply it on an area of wash, and then apply another wash over it to achieve an interesting mottled effect. You can experiment with variations of the amount of wax and colour used, and also repeat the resist in different areas of the painting, waxing over various layers of colour. The simplest form of wax to use is an ordinary white candle, but you can also try out different coloured wax crayons. Another variation would be to make a wax relief rubbing, and then float colour over the surface texture. Try it first on a small piece of paper, perhaps with a coin as the relief surface. Another way of exploring wax resist is with heelball, which you can buy at art supply stores. It produces an extremely waxy surface, which will not take paint. To reduce the waxiness, take a piece of clean blotting paper, and press with a warm iron. This will remove the surplus wax, and allow a more controlled wash to be laid over the surface. A brilliant example of wax resist used to fine effect is the work *Pale Shelter Scene*, by Henry Moore (fig. 3). Here the artist has used wax to create superb highlights, giving a rather ghostly effect to the work—a technique he frequently uses.

Isolation

Often you will need to keep areas of white ground completely free during your painting. This is possible by using a technique known as isolation, which involves covering the chosen area of ground, applying your colour, and then removing the protective covering material. Some artists use masking tape, which is fixed in place before the first wash is applied. The main problem with this method is that occasionally the wet

Above: Strange, ghostly highlights are created with wax resist, one of the favourite technical devices of Henry Moore. This study is called Pale Shelter Scene *(Fig. 3).*

paint seeps under the edges of the tape and, also, there is the danger that the surface of the paper could be damaged when the tape is peeled off. A good alternative would be to use a latex rubber adhesive. This can be brushed on the area that you want to leave white, then, when the colour washes have dried thoroughly, it can be rubbed off with a piece of soft art gum.

Lifting off colour

The previous isolation technique preserves areas of completely untouched paper, which can then either be left white, or washed at a different density from the rest of the painting. There are other methods of bringing areas of light into your work however. The basic technique used is that of lifting off layers of colour to express the lighter tones beneath. Various materials can be used to do this, ranging from brushes to absorbent items such as blotting paper, tissues, paper napkins etc. Before attempting any of these techniques on a finished painting, try the methods out on pieces of pre-painted paper. Some can be used when the paint is dry, others while the work is still wet.

Dry surfaces

When you have a dry surface, one method of lightening an area is to dampen a soft large brush (your mop would be ideal) and brush the area you choose lightly. Rinse the brush and repeat. Try this several times, giving the surface a little time to settle in between, then, when most of the pigment is cleared, blot the area with a tissue. You can experiment with various sizes of brush, perhaps exposing only brush stroke areas. A stiffer brush, such as a small stencil brush, can be used for a quick 'once-off' effect, re-wetting the area only twice and then blotting. To control and vary the shape of the area that you are exposing, you could use a small sponge and various masking agents. Firm cardboard can be held to make crisp edges while you are wetting and blotting, or you could make stencils in various shapes, wetting and blotting through their outlines.

Wet surfaces

While the paint is still wet, you can try various ways of removing layers of colour. A medium-size brush, used barely damp, can brush off pigment, and you can vary the way you apply the brush, for example press it on in a circular motion, or with short, flat strokes. If the paint is too wet, this method will not be successful, but you will soon learn to assess the correct drying time. Blocks of paint can be removed by scraping with a firm piece of cardboard, or any flat-edged surface. You can also mop up the paint with absorbent materials like blotting paper, natural sponges, tissue paper, and textured paper napkins.

Adding texture and pattern

By trial and error, painters have discovered a wide range of methods to create interesting patterns and textures on the watercolour surface, either to enhance or contrast with the wash. Before using any of these techniques, however, you should experiment on scraps of paper until you are really sure that you can control the method. Also make sure that they really do add to your work, and don't use them merely for their own sake. You will need 10cm (4in) squares of paper, which you can keep for future reference, labelled with the technique that you have used. You should try the techniques with both gouache and transparent watercolours.

Unstable colours

Unusual effects can be achieved by using unstable colours. These are pigments that separate while drying on paper, thus creating a mottled surface effect, Cobalt green and Alizarin crimson for example. If used with restraint, this technique can provide real visual sparkle to your work. Another interesting colour to use for this effect is Davy's grey, which is a relatively slow-drying paint, manufactured from ground slate. Lemon yellow also gives a mottled appearance when laid over another colour, and dries to a good, strong shade.

Other textures and patterns

Waterspotting Using clean water, drop spots onto barely damp areas of colour. As the paper dries, the spots spread out into unusual patterns.

Pigment spatters Dip a damp toothbrush into your pigments, and pull the bristles back with your thumb to spray the colour onto the painting. You could mask out the area to control the shapes of the spatters.

Water spatters Dip the toothbrush into clean water and flick droplets onto the painting. Make sure that the surface is nearly dry to achieve the best results.

Cardboard stamping Take pieces of cardboard cut into different shapes, and brush paint onto them. Stamp these onto wet or dry areas of paint to make different patterns on the surface.

Other stamp materials Paint can be stamped on your surface with all sorts of materials. Try leaves, pieces of wood, whatever works to make interesting patterns.

Meshes Any materials with a mesh like gauze or pieces of wire screen can be brushed with paint and then pressed onto the work surface. Alternatively, the paint can be brushed on through the mesh.

Salt Salt can be spread onto damp paint, and will absorb pigment into the grains while drying. When it has dried, brush off the grains, and the resulting patterns left by the crystals will resemble snow or rain effects.

Sand Sand and other non-absorbent kinds of grit can be sprinkled onto

Various techniques are shown here. Opposite (top) stamping with stencils, (middle) waterspotting, (bottom) stamping with paper scraps. Above: Overdrawing with palette knife and brush; Below: Sgraffito incisions in the paint surface, made with a scalpel blade.

the wet paint. While drying, the colour will concentrate around the granules, which can be brushed off when thoroughly dry.

Ink rollers Apply paint to an ink roller, and apply to either wet or dry paint. Avoid rolling too much, or you will get a muddy effect. Use short, definite movements.

Palette knife You can use your palette knife to dab on patterns, or to drag pigments along wet or dry paint.

Tempera and gesso

As you develop your technical range, you may find yourself becoming increasingly curious about exploring different qualities of paint, and also alternative grounds to hold your pigments. Tempera painting can be quite difficult, but it is a medium which is worthwhile in itself. Tempera is basically an emulsified pigment—an extra agent is added to the basic colour to provide it with a unique texture. Throughout the centuries many kinds of emulsifying materials have been used, but the purest form is made with egg yolk. The characteristic brilliance of the colours used in medieval wood panels is typical of tempera work, and it was often used with large areas of gilding. Tempera achieves its fullest translucency and richness when laid on a gesso ground, and the instructions for making this are supplied later. As a technique, it is regaining popularity with watercolourists, though it has largely been used by oil painters as a medium for underpainting.

Making tempera

The method described here uses egg yolk as the binding medium for tempera. You can, in fact, buy ready prepared tempera colours, and although these are very good, the addition of the egg yolk provides an unrivalled brilliance of colour. You can use all the watercolour paints, though you should remember that if you use gouache, or add any white pigment, you are going to lose the unique translucent quality which is the basic strength of the medium. The egg yolk is first separated from the white, then, holding the yolk over a glass jar, pierce the membrane and let the liquid yolk drop into the jar. Discard the membrane. The yolk should not be kept for more than one day, even if you refrigerate it, its binding qualities may be affected. Once you have freed the yolk from the membrane, add about a third of a teaspoonful of water, and mix thoroughly. Place your pigments onto a palette—if you are using dry pigments, mix them to a paste first, otherwise use tube or poster colours as they are. Add an equal volume of yolk binder, and mix with a palette knife. Some pigments vary in the amount of binder they need, so you should experiment to find the correct proportions. Brush the mix onto a clean palette, and leave to dry overnight. The paint should peel off cleanly, without flaking or crumbling.

Painting method

Draw your preliminary sketch very lightly onto the gesso ground, and then apply the first tempera wash. This should be kept as light as possible, using a little colour, a little egg binder and a good amount of water to create a very pale wash. Once the basic areas of wash have been established, the structure of the painting is built up using a stippling technique, where dots of colour are applied with small brushes to amass areas of colour. Use the tempera without extra water for stippling. As long as you avoid using gouache, or an extra white pigment, you'll find that your colours have a really astounding luminosity, and it is very easy to understand why the medium is so attractive.

Left: Egg tempera is becoming increasingly popular with some modern artists. In her work The Jacobs *Suzie Malin uses the medium brilliantly, and fully exploits the rich, glowing colours typical of tempera.*

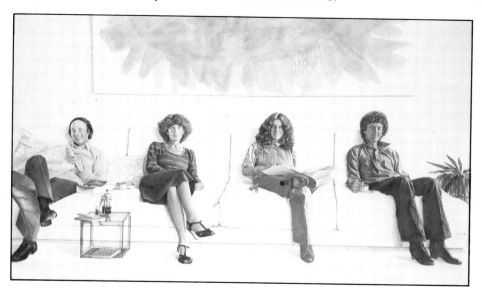

Making a gesso ground

Gesso is simply a chalk mix applied to a rigid surface—usually a wooden panel. It would crack if laid onto paper, and a seasoned wood, marine plywood, or good quality, thick hardboard would be the most suitable supports. Usually the panel is kept rather small, to avoid excessive warping as the gesso dries. Certainly for a beginner the largest dimension should not be more than 30cm (12in). The panel should be lightly sanded and sized before applying the gesso. Size, and the other gesso ingredients can be obtained from art supply stores.

To make the gesso mixture, take 25gm (1oz) of dry rabbit skin glue, and soak it overnight in 600ml (1pt) of water until it swells. Heat the mixture in a double boiler until the glue is completely dissolved, but do not allow it to boil. Remove from the heat, then gradually stir in enough kaolin, whiting, or marble dust to make a fairly thick cream. If there are any lumps, strain through a sieve. Apply to the sized panel either with a

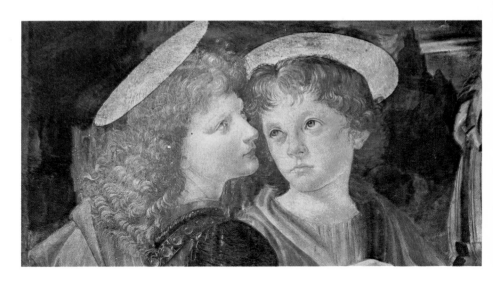

Right: Detail from The Baptism of Christ *by Verrochio. The work is painted on panel in egg tempera, a medium used extensively by the Renaissance painters to add brilliance to their colours.*

large hogs' bristle brush or a felt-covered roller. Leave it to dry, then smooth the surface with fine sandpaper. Apply a second coat, which has been re-heated, and when this is dry, sand again for a really glossy surface. Some painters use several coats of gesso to make a thicker ground. Even if you decide not to use the gesso panel for tempera work, you'll discover that it is excellent to use as a ground for ordinary watercolours, and is especially suitable for laying on thick amounts of impasto. Sgraffito techniques can then be exploited fully, since you can penetrate right into the gesso surface for extra depth and texture.

Mixed media

Given the wide range of techniques and materials that you have at your disposal, it is an irresistible temptation to see how they work together. You will already have used transparent watercolour and gouache in combination, as well as line in pen, pencil, charcoal and ink with washes. Don't forget also that pastel is an excellent additional material to use, especially with gouache; you can buy boxes of pastels at art supply stores, and they can be used for making preliminary drawings for your paintings. If you use pastels for this purpose, make sure you fix them with spray fixative before you add paint. You can also add strokes of pastel after you have laid on your colour, and they are suitable for use with transparent watercolours in this manner.

Fixing pencil sketches

A final tip from the experts: if you have no aerosol fixative to spray on your preliminary pencil sketch, paint a film of cream-free milk onto it. Skim milk is ideal. Any residual cream in the milk would resist colour being laid on top of the surface.

The Finished Painting

Decorative surrounds in the earliest visual work such as Roman mosaics were in the form of friezes, which separated one image from another and at the same time interlinked them. The richly gilded frames of Gothic altar pieces strongly reflect the architectural order of their time and also serve physically to link the wooden panels. In the Renaissance the inter-relationship between architecture and mural was often enhanced by painted architectural motifs within the mural itself. In the Sistine Chapel ceiling for example Michelangelo binds the whole sequence of images together with painted architectural friezes. Seurat considered the frame to be such an integral part of a painting that he hand-painted some of his frames in pointillist style. Framing is largely a matter of taste. In the Turner retrospective exhibition in London, at the Royal Academy of Arts, a number of paintings were displayed in really austere frames, contrasting radically with the more traditionally ornate frames on the paintings surrounding them. They looked splendid.

Today the range of frames to choose from is immense. They come in all sizes and an assortment of materials, including aluminium and plastic as well as the more traditional gilt and wood.

Many works are conceived without frames, such as the work of Barnett Newman and Morris Louis. Apart from the question of aesthetics, the frame has an important function as a means of protection, especially for the corners as well as the surface of the painting.

Mouldings

Today most towns have small framing shops in which a vast array of frame mounts and mouldings are available. Some of these shops will sell the prepared mouldings, and will make frames of your choosing from the stocks they have available. Always look carefully at what is available within the context of the painting you want framed. The sample display of moulding sections can be misleading. Note the ready assembled frames on display, they will probably be more helpful in guiding you toward a decision.

An alternative place to purchase mouldings would be a good wood supplier where raw sections should be available, though not in many

abundance of patterns. Some do-it-yourself centres may be able to order mouldings. Another possible source of supply is old junk shops, markets or auction rooms. Many hardwood frames with excellent mouldings are available at relatively small cost, though gilt and maple tend to be expensive at present. Finally you could purchase prepared wood and construct a frame from it. By far the simplest solution is to have the work framed professionally, and many artists work closely with their framer. This can be expensive depending on the ornateness of the moulding chosen.

Making your own frames

Sometimes a professionally made frame can be disappointing. The home-made article often has a pleasing simplicity and looks instinctively right where the professional job seems pretentious and ill-chosen.

To make your own frames you will need the following tools (most are probably readily available in the average household). You'll need a tenon-saw, screwdriver, tapping-hammer, drill and bit, countersunk bit, Stanley knife, pencils, screws, nails, picture nails, wood, glue, bevelled straight edge or thin steel ruler. The key pieces of equipment are a clamp used in conjunction with a mitre box which should guarantee the perfect cutting of 45° angles. Lastly you'll need some thin slats of wood and some gum or masking tape. Before deciding on the type of frame you want, remember that it will include a sheet of glass; any work carried out in the traditional watercolour medium is highly vulnerable to damage, particularly from damp. The size and nature of the work will to some extent influence your choice of frame. As a rule the larger the work the simpler the frame, for the work should have sufficient scale for it to exist in the average domestic space and be viewed comfortably without a large frame. If a work is tiny however, it can be completely lost on a wall, particularly if competing with other paintings, so the frame should have sufficient impact to attract scrutiny while at the same time being sympathetic to the work. The subject of the painting will be another deciding factor. For example it would be unwise to place a bright ornate frame around a very dark small painting: you would see nothing but the frame.

Mounts

Frames are usually used in conjunction with cardboard mounts. The mount has a dual purpose; firstly it provides a visually compatible surround for your work, secondly it separates the painting from the glass facing. There are certain rules to observe when cutting a mount: the side panels should always be the same size or slightly narrower than the top panel, while the bottom panel should be between a quarter and a third as large again as the top. If the mount were cut symmetrically

there would be an optical illusion that the bottom section was thinner than the top. Mounts are traditionally cut with a bevelled edge, however if you consider a square cut mount to be the ideal for a particular image do not hesitate to have it. Consider carefully, in relation to the size of the painting, how substantial a mount you require. Remember the mount needs to give support to the painting so the cardboard frame should not be less than 5cm (2in) wide at any point. The colour of the cardboard also influences how much mount you will want on view.

Cutting a mount

You will need to cut the aperture fractionally smaller than the painting to ensure a crisp divide between mount and painted surface. Assuming you have a cardboard mount 52.5cm (21in) by 40cm (16in) and a painting 37.5cm (15in) by 30cm (12in) subtract the painting measurements from those of the mount height. 52.5cm–37.5cm (21in–15in) = 15cm (6in); 40cm–30cm (16in–12in) = 10cm (4in).

Thus the side measurements are a fraction over 5cm (2in) each and working approximately on the basis of the top being a third to a quarter smaller than the base split the 15cm (6in) in a ratio slightly over 6.3cm (2½in) to 8.7cm (3½in). Mark out these measurements carefully on the facing side of the mount; place it on a soft cutting surface, take the steel rule, align with the measurements making sure the rule covers the actual mount, and cut holding a sharp Stanley knife at an angle of approximately 40° to 45°. Be careful when approaching the end of a straight run not to overcut, thus ruining the mount, but do not hesitate along the cut. Having cut the straights pick up the cardboard, insert the knife, gently cutting the remaining corner sections. Any fine shreds of cardboard can be removed with a fine sandpaper gently rubbed along the inside edge. Remove any plot marks with a kneaded eraser. You will find it impossible to cut straight through if it is thick. Always exert an even pressure, do not force the knife.

Even when cutting a square rather than bevelled mount, always cut from front to back, as a slight burning occurs on the back edge no matter how careful you are when cutting. Don't hesitate to break up the plane of the mount with lines drawn in ink or watercolour if the ink is too dominant (see fig. 1). Attach the painting to the back of the mount with masking tape, then back the mounted painting with another piece of cardboard of identical size to give added rigidity and protection to the back of the painting. It is now possible with the dimensions of the mount established to construct a frame to fit.

Constructing a frame

First, carefully check the dimensions of the painting. All too often inaccurate measurement can mean additional expenditure on mouldings.

Fig. 1 Breaking up the planes of the mount with a line

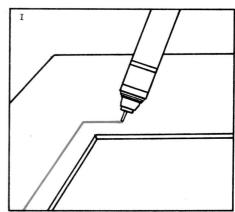

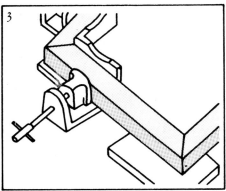

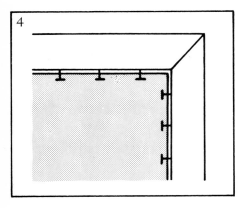

Fig. 2: Determining the length for the mouldings

Fig. 3: Support corners which are not in the clamp with pieces of wood

Fig. 4: Tacking the mounted painting onto the inside back edge of the frame

To ensure perfect joins, all the mouldings must be cut at an angle of 45°. When using the mitre block, saw gently because any unusual force could dislodge the saw from a true vertical and present real problems when joining. The lengths of the mouldings are determined by two factors, the dimension of the card plus twice the width of the moulding. This does not mean the total width minus overlap (see fig. 2). Thus you have a length of cardboard × 2 AB.

Cutting the mouldings

Cut the mouldings square first then cut the 45° angles. To join use a strong wood glue and slender panel pins [picture nails]. Apply the glue then, using the mitre clamp, grip the two pieces of frame together tightly. Drill a hole through one piece and partially into the other, knock home a nail and repeat on the other section making sure you do not allow the nails to collide. Remember the drill bit needs to be fractionally smaller than the nail to ensure a rigid joint. Under no circumstances run nails directly into the wood, or you will probably split it. Proceed with the three subsequent corners in the same way. Always support corners not in the clamp during the construction with pieces of wood of the same thickness as the base of the mitre clamps, otherwise the tension caused by the weight of the frame could open up the freshly glued and nailed joints (see fig.3).

Framing under glass

The best protection for any painting is certainly glass, and this means the work has to be mounted first. There is a wide range of glass available, including a non-reflective variety, which shows the work most clearly.

Finishing the mouldings

If constructing a large frame that has a good deal of pliability it will be necessary to lay several pieces to support the straights as well as the corners while joining is in progress. When the glue is dry, countersink nails and use a commercially available filler to fill the small holes. Any surplus glue oozing from the joints should be wiped away while still wet with a clean damp rag. If your cutting has been inaccurate try to align the front face and fill in the gaps at the back where they will not show. Trying to camouflage the front can be difficult.

When thoroughly dry place the frame down on an old blanket to avoid damage to the facing surface. Slot in the piece of picture glass (today there is a non-reflective glass on the market) which should be fractionally smaller than the frame inset to allow for any movement in the frame. Clean thoroughly with a rag soaked in methylated spirit which will remove any grease and dirt; polish with a clean rag and place the mounted painting into the frame. Fix in place with 2.5cm (1in) panel pins

[picture nails] tacked into the inside back edge of the frame (see fig.4). Complete the procedure by taping over the nails, completely sealing the gap between cardboard and frame. As a further protection against the penetration of damp, glue heavy-duty paper over the back of the frame. This makes the back secure and keeps out dust. The simple moulding suggested here will be relatively cheap and visually attractive.

Clean the front of the glass and the job is complete except for actual hanging. Fixtures for hanging will be discussed later in the chapter. An additional feature used in framing is the inset (or slide) which is simply an inner frame which slots into the main structure. Insets are constructed of wood but are decorated in a variety of ways ranging from gilding through to velvet. However they often provide a pleasing visual contrast between painting and outer frame.

Constructing an inset
Should you be unable to purchase insets from a framer you can make your own, though with some difficulty. Use a thin hardwood 2.5cm (1in) by 1.25cm ($\frac{1}{2}$in) with a 45° bevel on the edge, measure accurately then cut at 45° as with the frame, and sand thoroughly. Lay several pieces of newspaper down on a perfectly flat surface. Glue the joints, press together with the face upwards, remove all surplus glue and allow to dry for 24 hours. When dry lift up the complete inset and tear off any newspaper stuck to it. Any remaining lumps can be cut off with a Stanley knife and sanded with fine sandpaper. Prime and paint it whatever colour you require—something fairly neutral, or the critical judgement of colours used in the painting could be seriously upset.

Decorating the inset
The raw mouldings purchased direct from a wood supplier are usually in need of a thorough sanding before any surface treatment. If the wood is of good quality it can be stained with transparent pigments—a thinned acrylic paint would be excellent for this purpose. The most suitable shades would be raw umber, burnt umber, raw sienna, ochre or a mixture depending on the colour required. The fast-drying acrylic allows for several coats of thin paint to be applied quickly. If you are not satisfied with the matt result then a coat of varnish could be applied. This would enrich the natural grain of the wood. Here you might choose to experiment with proportional mixes of gloss and matt varnish, or simply use a commercial stainer. Having sealed the wood you might explore the possibilities of stippling. Alternatively, try out plain emulsion finish or the high gloss lacquers.

Other frames
Gilded frames are always popular and certainly not impossible to

produce, but some specialized knowledge is necessary for their construction. If you make your own frame from prepared wood using a 5cm (2in) by 2.5cm (1in) or 5cm (2in) by 1.25cm ($\frac{1}{2}$in) frame as a base you could ornament it in a variety of ways by using different styles of beading and battening. These ideas are time consuming but worth considering particularly if you are good at carpentry.

A large number of superbly designed aluminium framing kits with a variety of finishes are available. They are rigid and have a simple right-angle locking system with screw attachments that hold the frame under any circumstances. Another recent innovation in this market are the shallow plastic box frames. These frames give excellent protection and hand-made papers without mounts look superb when secured to the back base. They can be, however, rather expensive.

Wall attachments
For the average-size framed painting, simple screw eyes inserted into the wood frame on either side at the back, and one picture hook will have sufficient strength. Picture hooks with steel pins can be purchased in any local hardware shop. They are either single or double pin. If screw eyes seem unsatisfactory there are alternatives such as the screw with ring attachment or ring with triangular plate. The triangular plate attachment has three screws and its strength makes it useful for heavy paintings. Unless you have a custom built rail with aluminium rods on your wall the most satisfactory support for heavy paintings are heavy-duty screw eyes. Tie a double length of heavy nylon cord between the two eyes, tensioning as required. With such weights an ordinary picture hook will be useless but a couple of 7.5cm (3in) screws set at a downward angle of 45° or 50° will take most weights.

Storing unframed paintings
You will not be able to frame all your paintings even if you should want to. Cost is one factor governing this, wall space is another, so some adequate storage is vital. The ideal place would be an architect's plan chest, but they are expensive and bulky. The alternative is a portfolio, though you should mount the paintings first. Portfolios come in a range of sizes and types from the cheapest cardboard ones to rather sophisticated plastic ones with individual plastic envelopes for added protection. The plastic range is probably the wisest buy, giving excellent protection against dust and having the added advantage of a handle, making them easy to carry. The size required will depend on the scale of your work but buy a size which will accommodate a fairly wide range of your paintings. Should you choose to purchase a cardboard folio make sure it has interior flaps to help stop damp or dust from penetrating the folio.

Introduction

Oil painting has for centuries been the most favoured medium for creative visual expression. One reason for this is simply the ease with which the paint can be used—unlike watercolour, which is normally used in thin applications that dry quickly, oil paint càn be used thickly to provide fascinating textures, or thinly to allow for the build-up of delicate glazes of colour. It dries more slowly too, and a painting can

Below: War was a typical subject of the Renaissance canvas. Shown here is The Battle of San Romano *(c. 1455) by Paolo Uccello.*

therefore be worked on over a period of time so that ideas can be developed and the image improved. Another reason for its popularity is that oil paint is more durable. It has a greater resistance to damp than watercolour and can be successfully used on a variety of surfaces from paper to canvas. But above all this, is the paint's immense superiority over other media in terms of colour. You have only to look at the paintings of Rembrandt, the master of muted shadow from which warm earth colours sparkle out in detail, or the work of Monet who

Opposite: Another great theme of classical painting, the birth of Christ. Nativity *by Piero Della Francesca (c. 1472).*
One of the most famous of Jan van Eyck's paintings (below), the dignified and moving Marriage of Giovanni Arnolfini *(1434).*
Jan and Hubert van Eyck are the two Flemish painters who are often believed to have 'discovered' oil painting.

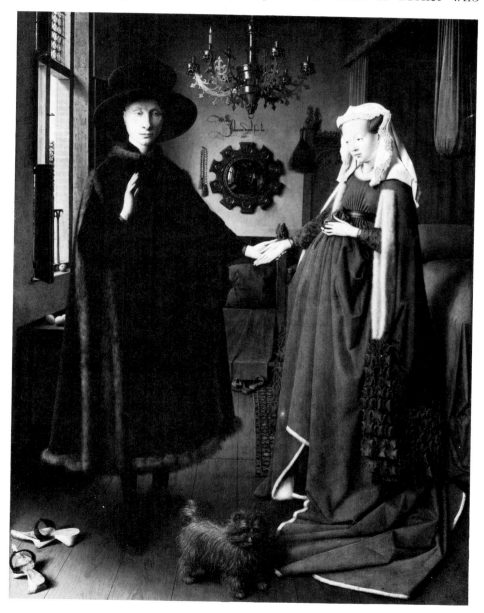

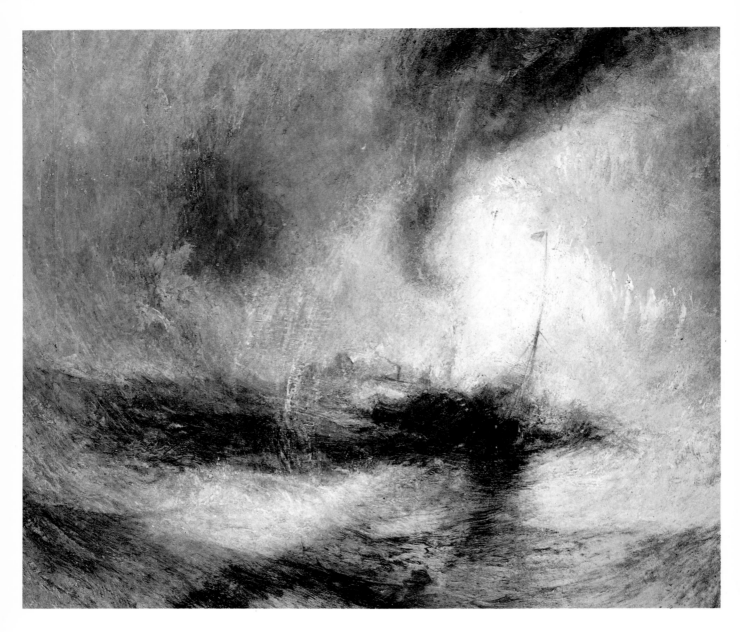

The dramatic and violent aspect of nature was frequently explored by Turner. Shown here is Snowstorm-Steamboat off a Harbour's Mouth *c. (1842).*

manipulated oil colour until it captured the iridescence of light as it played upon his surroundings, to realize how very much more versatile and rich the finished work can be.

It is always advisable to understand the background history of any skill before crossing over to a study of its methods and principles. Often this will supply you with an amazing wealth of inspiration as you learn to translate what has been accomplished in the past into your own terms. This is especially true of oil painting.

Throughout the fifteenth and sixteenth centuries the main theme for painting was religion, as it had been for centuries before the advent of the oil medium. The Roman Catholic Church was, after all, the dominant force politically and financially, and it often provided the most obvious patronage for works of art which illustrated its teachings. During (and after) the Renaissance there were also individual private patrons, such as the enlightened Medici family in Florence, whose support of the visual arts encouraged the development of new approaches to subject matter: portraiture, Arcadian themes, historical glorifications of the city state—in Florence and Venice particularly. It was a time of discovery and innovation. Each creative mind was contributing to new concepts both

One of the major artistic movements of eighteenth century France was the Neo-Classic school. Shown here is one of its famous examples The Death of Marat *by David (1793).*

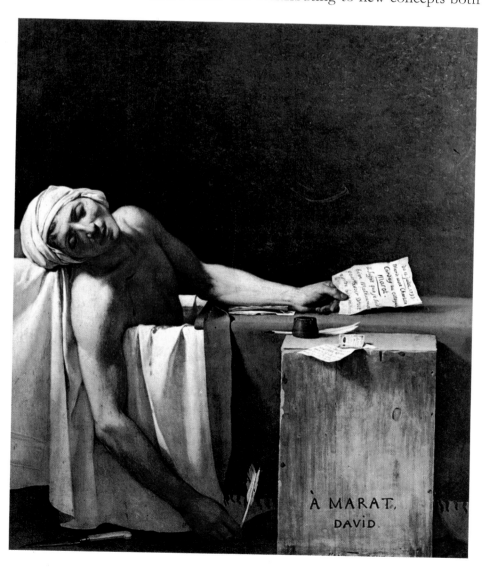

À MARAT.
DAVID.

aesthetic and technical: Uccello's overriding obsession was perspective; Botticelli's a poetic, ephemeral world; and Piero Della Francesca instilled a quiet humanism into his work.

The opulent wealth of Venice supported the ultimate in glorification with the grandiose paintings of Titian, Tintoretto and Veronese. Many of the works of these men, although technically of religious subjects, became vehicles for individual artistic vision, and the original theme became subservient to it. By the sixteenth and seventeenth centuries, Claude and Poussin were still painting idyllic landscapes and figure composition based on allegorical themes, but the gradual evolutionary process had begun, and subject matter and the approach to painting were changing.

The Impressionists completely transformed the subject matter of painting, firmly removing it from the studio to the open air. Renoir's Luncheon of the Boating Party *(1881) typically captures an ordinary daily event.*

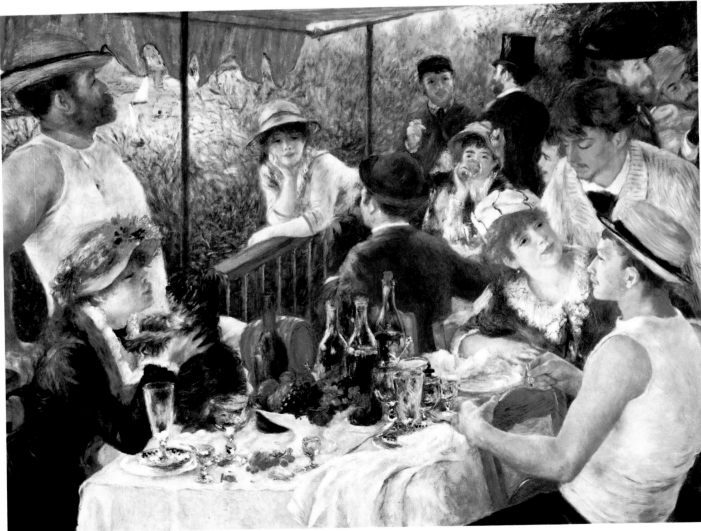

The stability of the southern church continued, but the authority of the Roman Catholic Church was seriously questioned in Northern Europe, then swept aside by the Reformation. The Dutch, having gained religious, and with it political independence from the Spanish, proceeded to establish powerful mercantile trading links across the known world. With success came the rise of a wealthy merchant class which, in its turn, created a new patronage for different types of works of art: seascapes, townscapes, interiors, landscapes and portraits. Accurate, realistic on a domestic scale, these paintings were not just works of art but records of the life-style and attributes of the rich middle class of the time. Genre painting, as it became known, gives a vivid record of the life-style of the wealthy in seventeenth-century Holland.

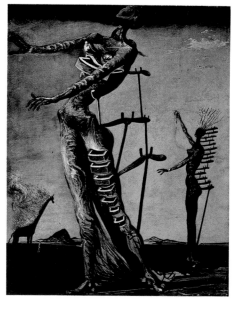

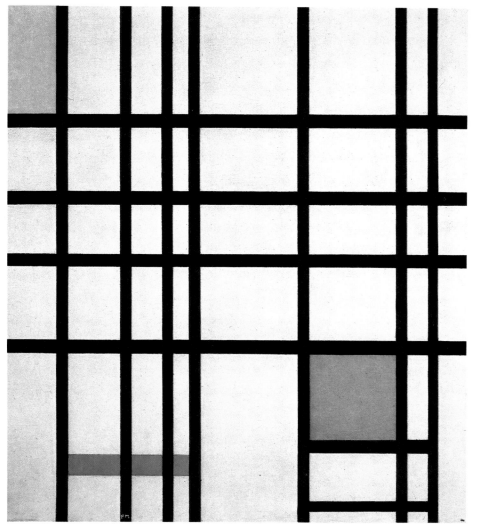

The twentieth century continued the revolution in painting begun by the Impressionists. Above: The Burning Giraffe *by Salvador Dali (1935) and Left:* Composition in Red, Yellow and Blue *by Mondrian (c. 1940) show how diverse the styles of modern painting can be.*

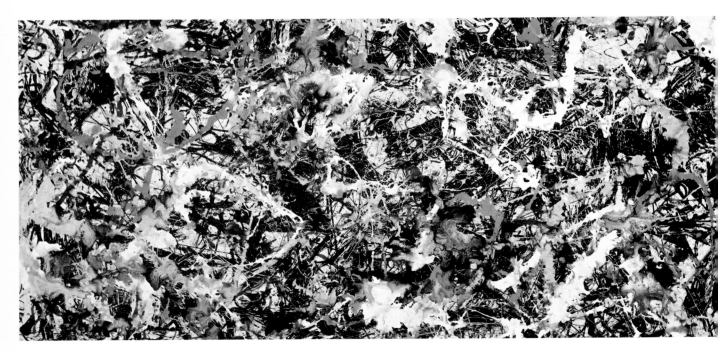

A detail of an Abstract Expressionist work titled Convergence *by Jackson Pollock (1952).*

By the eighteenth and nineteenth centuries the activity of painting was also changing. Whereas before even landscapes had been firmly anchored in the studio, now there was a change. In England, for example, there were Turner's and Constable's powerful landscapes; one so dramatically capturing the violence of natural phenomena, the other casting a sensitive and affectionate eye on the wind, rain and sunlight filtering onto his Suffolk landscape. They were important not only because they were producing major works of art but also because, although the projects were still being completed in the studio, both artists went outdoors, to the subject, for the first important sketches. In Spain political themes were added to the range of subject matter when Goya's vicious loathing of misused power in which the common people were pawns, was translated into visual terms. It was in France however, where artistic factions were torn between the Neo-Classicism of David and the highly emotional Romantic work of Delacroix and Gericault, that the next major step was made, the repercussions of which are still felt to this day. A small group of artists—Rousseau, Millet and Corot—were the major figures. Settled around Barbizon, they began painting directly from nature, recording the everyday scenes of life— the fields attended by labourers, humble village life and the landscape itself—a theme which was further subscribed to and glorified by Courbet. The seeds of change began to grow furiously. The Impressionists pursued the issue of open-air painting and enlarged even further upon subject matter. Landscape remained the core of interest to all except

Degas; but new, seemingly outrageous, subjects became a basis upon which to build their overriding obsession with light—rail stations, street scenes, women at their toilet, café scenes—nothing was taboo. With Lautrec came even more startling works, with his rapid studies in oil of brothels and prostitutes.

The criteria that had imposed standards of approach and translation of subject within fairly strict confines were finally swept away, leaving the way clear for the successive artistic revolutions of the twentieth century. Picasso, Braque, Léger, Matisse, the Dadaists and Surrealists are well known for their innovations in subject matter, traditional dimensional space, colour, and so on, and the strides made then have been sustained through the Abstract Expressionist work of artists such as Jackson Pollock, Franc Kline, and Mark Rothko. The reaction which followed this last movement produced what is called Post-Painterly Abstraction; Kenneth Noland is a prime example. Pop Art, with experimenters like Claes Oldenburg, Andy Warhol, David Hockney and Alan Jones dominated the early sixties. Today realism is back in favour; but it takes on an infinite number of dimensions, which range from the work of the American Photo Realists, Chuck Close, Donald Eddy and Tom Wesselmann, who seem literally to copy photographs, to the quiet interiors, still life studies and figures of William Bailey.

The history of painting has been one of continual experimentation and innovation. Genuine creativity has been left to a relatively few artists who, in expressing their ideas, have extended the oil painting medium by developing techniques that allow the artist's intentions to flourish without making him a slave to those techniques.

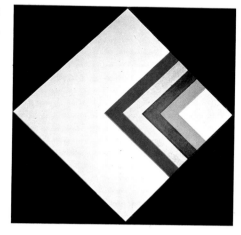

Style often develops by reaction—here against Abstract Expressionism—and finds a new identity, (Post-Painterly Abstraction). A part by Kenneth Noland (1965).
The sixties was the era of Pop Art. Here Whaam! (1963) an acrylic work by Roy Lichtenstein takes its inspiration from pulp comics, and is an excellent example of Pop Art style.

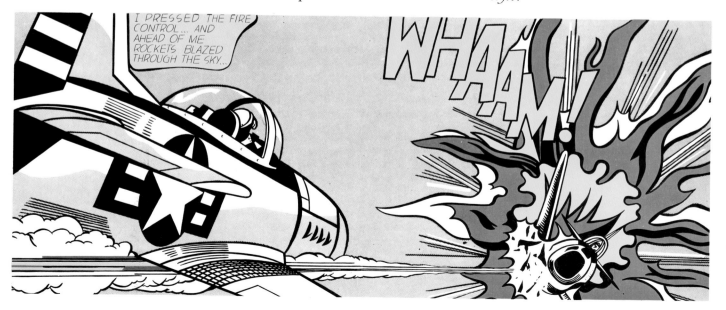

Airstream by Ralph Goings (1970) is a superb example of the Photo-Realist technique, which quite literally seems to imitate photographs.

Although it is impossible, and indeed wrong, to say that you should paint in a certain style, it is important to realize that progress can only be made by working on paintings where an end intention or purpose exists. The desire to present your ideas visually is the root from which will grow your skill in using your painting materials to portray that intention. Thus, ideas and techniques progress side by side.

Ideas develop from continual observation of the richness of the colour, form and texture of the visual world. No individual lives in a vacuum; everyone is influenced to some degree by the things around them. As your perception develops, ideas for paintings will emerge. The technical aspects and physical limitations of the medium will, of course, influence how you choose to present such ideas. It is not so much that there are rules you 'must' follow, rather that it is necessary to understand the correct way to use your materials, and the principles of colour and design, in order to execute your ideas properly. Discovering the potential in yourself through a confident use of the medium is what painting is all about. As with any skill there are certain rules—hence the term 'artistic discipline'—but beyond a certain point your sensibilities, allied to your imagination, will become the guiding factor to progress.

Try not to rely upon technical tricks. Each new work should be a fresh challenge. That is not to say that what has been learned from previous attempts should be ignored, but try to avoid such habits as feeling that you know what the result will be before you start, that you have acquired a fixed way of doing something. Remember that each new idea is unique and presents a fresh challenge. This way you control the medium, rather than it controlling you.

Materials

What do you paint with? This might seem a naive question, but there are literally dozens upon dozens of different brushes, an ever expanding colour spectrum of oil paint and a wide range of surfaces upon which to paint. Many of the brushes have specific uses, and each of the surfaces has a very particular quality—some are smooth, some slightly textured, others heavily textured.

A good artists' supplier is an Aladdin's cave of beautiful and expensive things, and deciding what to purchase can be difficult. For the beginner a little money wisely spent will provide sufficient equipment to work with when developing painting skills; as confidence grows, and with it more particular needs, the equipment can be augmented.

Brushes

Brushes have been developed over several hundred years and each one has been designed for a very specific purpose. For instance, it is unwise

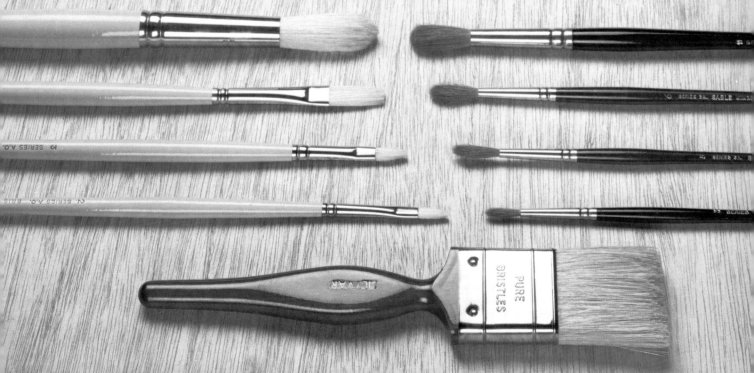

to use a delicate sable hair brush to lay in a large area of colour on a canvas surface. It could be done, but in the process the brush would probably be ruined. The hogs' bristle brush is the work horse. Its stiff bristles are ideal for the transfer of oil paint to canvas as it holds the paint well and makes a crisp fresh mark when applied to the canvas or board.

Sable hair does not have the physical stamina to act as a work horse. Thin, pointed sable hair brushes are for fine detail work and a large flat sable or ox-hair brush is essential for applying thin glazes of colour. It is important to state that although good brushes are expensive—particularly sables—they are worth the investment, for if they are maintained properly they will not only last longer but will retain their

A detail of Mountain of St. Victoire and the Dark Chateau *by Cézanne. The brushwork is an excellent example of block technique.*

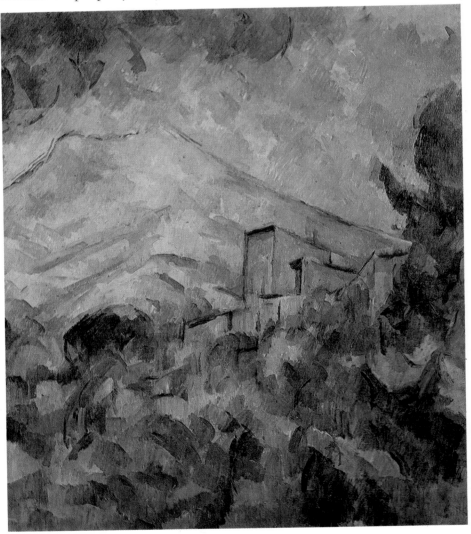

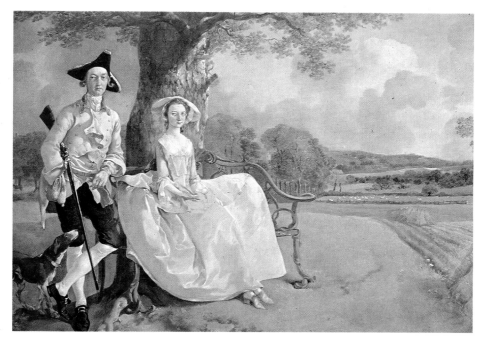

Gainsborough's fine sable brushwork is beautifully shown in his painting Mr and Mrs Andrews (*left*) *while Van Gogh's typical use of thickly applied paint results in complete contrast in style. Below is shown a detail of* The Fields of Arles.

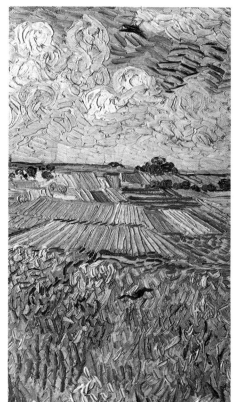

shape better than the less expensive types. Once a brush loses its shape, when loaded with paint it will not respond in the specific way it is meant to.

Although a hogs' bristle brush is tough even it can be ruined, so avoid 'scrubbing' paint onto the canvas surface. Be sure the brush has a sufficient paint load otherwise it will soon cease to be of any use.

At the beginning it is wise to purchase just a few bristle brushes: basically, to begin with, you will need an equal number of round and flat brushes, and large and small ones. One of each no. 2 or 3, no. 6, and no. 10 will give you all you require. As your ability develops you can explore other brush sizes and types, finding ones that might be really useful to you. Augment the basic selection with one or two 2.5cm (1in) and 5cm (2in) decorating brushes. They are used for laying in large areas of oil paint and of course are needed for priming the canvas before you actually start on the work itself.

Brushes made of sable, ox-hair and squirrel are much more delicate and are used for fine work such as detail and glazing. The fine elegant tips of these brushes are extremely sensitive to the amount of pressure applied when putting the brush to the canvas. They should be used with thinned oil paint or small amounts of pure paint.

Good sable hair brushes, the finest being kolinsky, are extremely expensive, and the finest are hand-made. For the professional such brushes may be necessary, but for the novice one small no. 2 or 3 and a medium no. 5 or 6 should be more than adequate and should not be

excessive in terms of cost. If larger soft hair brushes are required, an ox-hair or squirrel is the best choice, although they are not of the same quality and are less durable than sable hair.

In recent years, because of the scarcity and increased cost of sable, a number of brush manufacturers have been exploring the use of synthetic fibres for brushes, mainly nylon and polyester.

Initially, because of the poor design of the fibre shape, the brushes would not hold or carry the paint well. But recent improvements have solved this particular problem, and a wide range of synthetic brushes is now manufactured both for oil and watercolour painting. They are relatively cheap and very hard wearing, though they do vary greatly in quality and are really no substitute for natural hair brushes.

Brush maintenance
Brushes, if taken care of properly, will last for many years and still retain their particular characteristics.

Avoid using brushes for mixing large amounts of paint; this is the purpose of a palette knife, although for small amounts the brush is the sensible tool.

When you have finished work for the day, rinse the brushes in a jar of white spirit to release the bulk of paint trapped in the ferrule (the metal ring joining the bristles to the brush handle). Pure turpentine will do the same task but it is more expensive and should be used only to thin oil paint when painting. Blot the brushes by drawing the bristles back and forth on a piece of rag. Then, with white soap and warm water, work up a rich soapy lather in the palm of your hand and gently press the brush into the lather. Do this several times, renewing the lather until all the paint is removed. Rinse the brush in clean water, shake off surplus moisture and press into shape between finger and thumb. Stand the brushes vertically in a jar with the bristles uppermost and leave them to dry. Do not cram the brushes into the container; allow them plenty of space and they will be less likely to become damaged. The brushes can be left in the container until the next time they are required.

Storage
All too often brushes are thrown into boxes, thrust into bags and left without any sort of protection until they are to be used again. Sable and ox-hair brushes are by their very nature particularly prone to damage if treated this way. If the point is damaged or the shape lost, the brush is ruined and will never again be able to do the job for which it was originally designed, so it is important that some form of protection be devised. This can be done easily by making a small tube of stiff paper that will fit around the head of the brush and slightly overlap the handle. For hogs' bristle brushes make a cardboard cylinder blocked at one end

to provide protection. There are ready-made containers for brushes on the market but it is less expensive to make your own.

Palette and painting knives

The brush is, of course, the basic tool for paint application, but it is by no means the only one. The knife is a relatively inexpensive tool and very useful. Two basic types of knife exist for the painter: the palette knife, specifically designed for scraping the palette or canvas and for mixing paint, and the painting knife which has a fine springy neck and blade with the sensitivity of touch characteristic of brushes. It is used solely for applying paint to canvas. Painting knives come in a variety of blade sizes, from very large to very small for really delicate, fine application, allowing you literally to draw with the knife.

Below: The Boat *by Nicolas de Staël (1954). This artist is well-known for his work with the palette knife.*

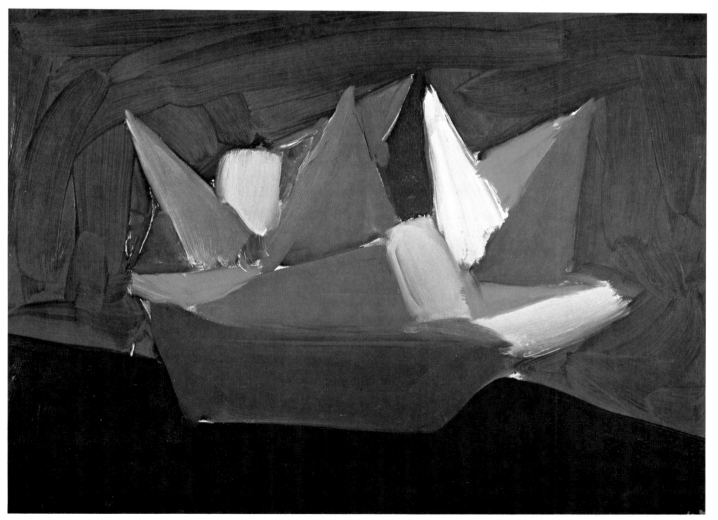

Paints

The colour charts available in art supply stores will give you an idea of the immense range of colours available. To try and make a selection without knowledge or advice is impossible and to consider purchasing all the colours available is an unnecessary expense.

Oil paints are divided into two groups, determined by the nature of the pigment: organic colours, those whose colouring agent is found in nature, and mineral (inorganic) colours, pigments derived from the soil and chemical processes. Mineral colours have greatly extended the range of colours available and they are more permanent (fade less quickly) than the organic colours—a useful attribute for good craftsmen who wish their work to maintain its true colour. Check the manufacturer's colour chart which should indicate the permanence of the paints as established by them.

Oil paints are available in two qualities—student and artist: for the beginner, student oil colours should be purchased. Although their quality is not as refined as artist oil colours, they will allow you to become accustomed to the texture and the mixing and thinning possibilities of the paint at substantially less cost. The following colours are recommended for a student palette: Ivory black, Titanium white, Cadmium yellow, Cadmium lemon, Cadmium red, Alizarin crimson, Ultramarine blue, Cobalt blue, Winsor violet, Viridian. These will supply the basic colour requirements, and from them you will be able to mix any additional colours you will need. (The chapter Handling Colour explains the advantages of these as basic colours to begin working with.) As confidence and ability grow, and with it an understanding of the medium, it would be practical to begin using artist colours. Their colour is richer and more vibrant and the paint covers the canvas really well.

Different colours dry at different rates due to differences in their chemical make-up: some are slow, some are moderately fast, some very fast. The drying time is further altered by the mediums you may be using and thickness with which the colour is applied. Most paint manufacturers should be able to supply you with a list of drying times. This obviously influences the results and the way you work: you may want to scrape away a very dark colour to substitute a lighter one, only to find the darker colour dried and immovable.

Mediums

A medium is used to thicken or thin the paint, making the colour richer or else extending the pigment to allow thin glazes of colour to be laid over one another. The key medium is spirit of turpentine (turps). It is mostly used for thinning the paint and thus is obviously useful when

mixing colours. Always purchase turpentine from an art supply store as you are then assured that the quality is pure and will in no way discolour the pigment.

Linseed oil is the most useful additive if you want to try glazing or thick impastos of paint as it gives the paint the necessary flexibility for these techniques. Disadvantages of linseed oil are that it slows down the drying process, can yellow the paint and can also lead to cracking and wrinkling of the paint surface. A very refined linseed oil (stand oil) is less likely to lead to these problems, so check the grade of the oil before purchasing.

Varnishes

Varnishes are resins dissolved in oil or spirits, and are fast drying. They are used primarily for providing a coating or protective skin over the

finished work. They are also used by some artists when mixing colours to help speed drying. The most commonly used is retouching varnish.

One of the great advantages of oil over other paints is the barely noticeable change in colour from the wet state to the dry. What does happen, though, is a dulling or deadening of the colour, and if nothing is done to counter this you will find that as each day of painting passes, you will be inclined to use duller and duller colours to adjust to the colour already drying on the canvas. Therefore, before resuming work on the canvas, take a large, really clean brush (no. 10 flat squirrel is ideal), load it with retouching varnish and paint the areas that have deadened during drying. As soon as the varnish is applied, the original

Au Salon de la Rue des Moulins by Toulouse Lautrec shows thinly applied layers of colour with some of the original sketch work showing through.

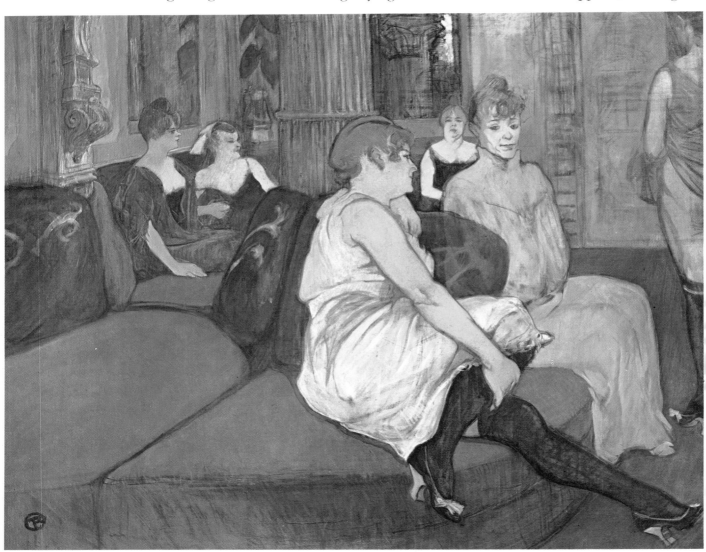

freshness of the colour will reappear, allowing for really accurate colour matching. Fresh paint can then be applied over the retouching varnish without any technically detrimental side effects. For the same purpose, retouching varnish can be used in small quantities as an additive to the paint.

If you are using retouching varnish as a protective coating on a finished painting, apply the varnish quickly once or twice when the painting is thoroughly dry—six months is usually an adequate drying time. Avoid disturbing the surface too much or the colours could be dislodged. Always remember to store the painting carefully while the varnish dries to avoid dust settling on the sticky surface. Alternatively, you may choose to use clear picture varnish as a final protection, although this results in a high gloss surface that interferes with viewing the work. Clear picture varnish is actually retouching varnish in a more concentrated form. The great advantage with modern varnishes is the unlikelihood of any darkening with age—a problem that so besets the Old Masters. The varnish can usually be purchased in several sizes for economy and is also available in aerosol containers which give splendid control during application. When using either, be sure that the painting and the work area are free of dust.

Although many other types of mediums and varnishes exist these will provide all that is required for the beginner; many professionals use no more.

As mentioned earlier, paint drying times vary and just how much time you have available in any one day, week or month to set aside for drying will influence your work. For the beginner a regular period set aside several times a week to allow the paint to dry is necessary if any progress is to be made. Without help, many colours dry very slowly, but there are now special oils available which can be added to the paint to speed up the drying process. Particularly useful are strong drying oils no. 1 and no. 2, poppy oil drying and linseed oil drying.

Strong drying oil no. 1 consists of boiled linseed oil and lead driers, and should be thinned with pure turpentine. The only unsatisfactory thing about it is that it tends to darken the colour.

Strong drying oil no. 2 consists of boiled linseed oil and cobalt driers. Like oil no. 1, it will increase the drying rate at some expense to the colour's brightness. Its advantage is that it is paler and more fluid, making it easier to mix with the paint. If thinning use pure turpentine. Poppy oil drying is a mixture of refined poppy oil and cobalt driers and is extremely useful for accelerating the drying time of white and pale colours.

Linseed oil drying is a combination of raw linseed oil and manganese driers. It is probably the most satisfactory of the four listed as it has little influence on the oil colour.

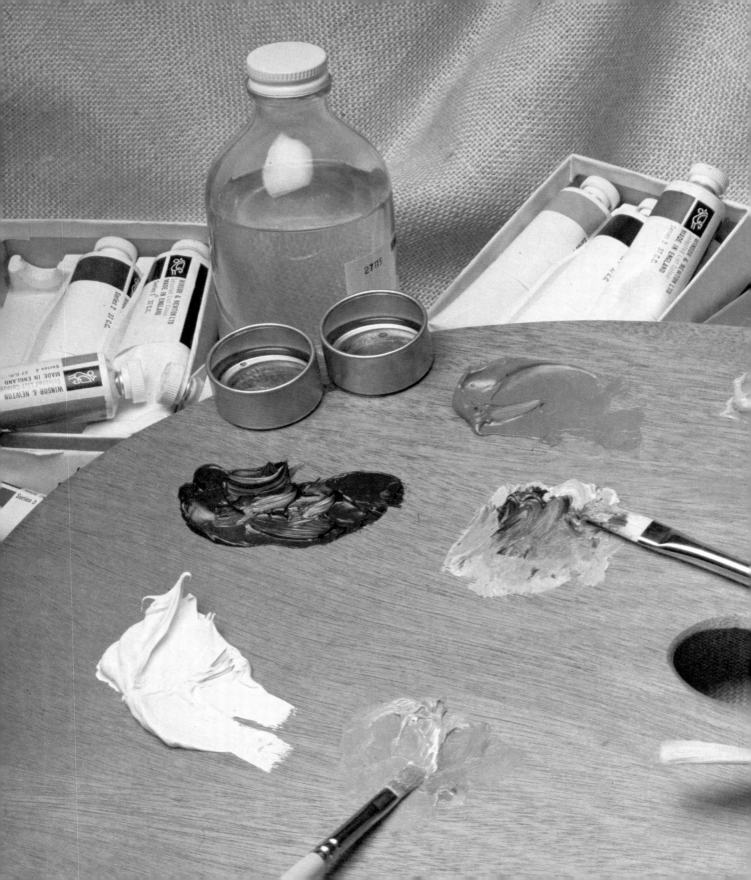

Palettes

The traditional view of the artist holding an oval-shaped palette is somewhat misleading. That is not to say it is not used—it certainly is. The great advantage of all hand-held palettes is the close proximity of the mixing surface to the canvas, which really does aid judgement in mixing accurate colour. There are literally dozens of shapes and sizes available: some are large and best for studio work; others are small, rectangular and ideal for putting into a shopping bag for outside work.

When purchasing a hand-held palette try it for balance. If it seems uncomfortable it can lead to considerable annoyance when working. With this form of palette it is convenient to use dippers as containers for turps and other mediums. Dippers are small cups available in several sizes as singles or doubles and simply slip onto the edge of the palette.

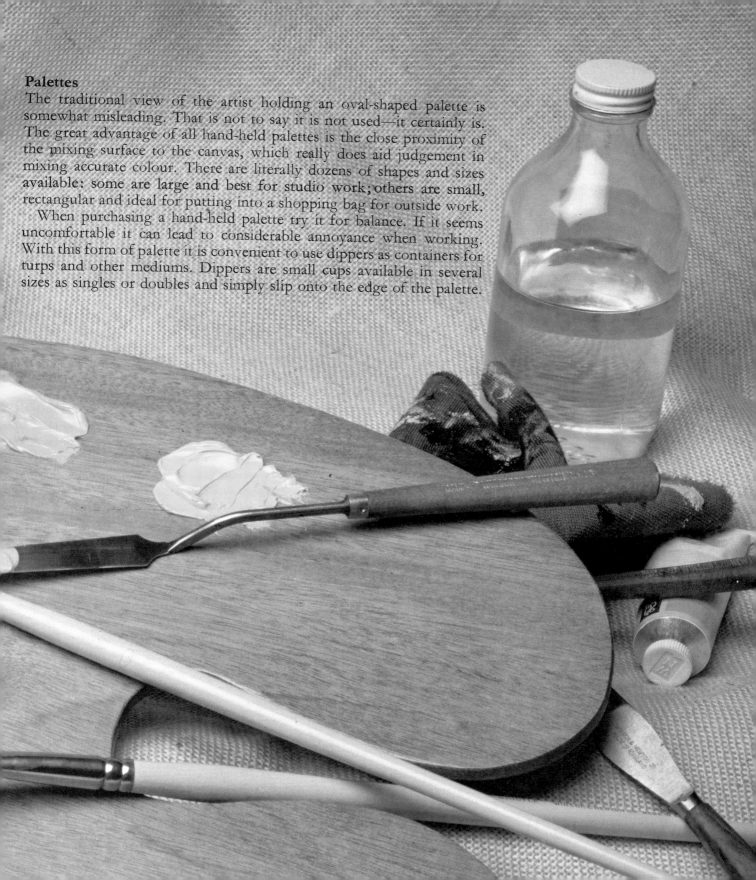

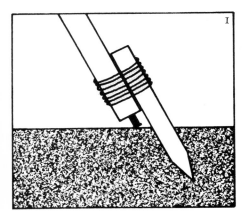

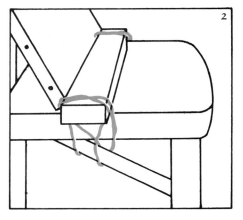

Support for an outdoors easel is often necessary.
Fig. 1 Here the easel is bound to pegs in the ground.
Fig. 2 An impromptu easel can be made from an old kitchen chair with a bar of wood tied across the seat as a support for the canvas.

Because of the natural size restriction of a hand-held palette the actual mixing area is quite small and, for large-scale work, or for working exclusively indoors, you will find an old tabletop provides a more substantial area. Also a tabletop serves as a shelf for brushes and other materials not actually in use but readily available should they be required. Even if using the hand-held palette it is useful to have a small table close by on which to lay your equipment and supplement your mixing space.

Easels

This is the single most expensive piece of equipment you will require. As with the other materials, several types exist, from the light compact sketching easel to the large studio ratchet type. The most sensible easel, as it provides excellent stability in the studio and is convenient for outside work, is the sketch box type. This easel folds into a compact box that has a carrying handle and provides storage for paints and other equipment.

Outdoors in any sort of breeze, a lightweight easel with a canvas attached is likely to blow over. To counter this problem, carry some sharp pointed pegs of wood and some nylon cord plus a small hammer. Having placed the easel in position, tap the pegs into the soil parallel to the leg positions and bind the tops of the pegs to the legs (fig. 1). This will provide a fairly rigid support for the easel.

A short-term alternative, but useful only for indoor work, is an old kitchen chair with a bar of wood tied across the seat. The canvas is propped between the bar of wood and the back of the chair (fig. 2).

Canvas

The finest canvas support is linen. It is certainly the strongest fabric for oil painting and has the best textural quality, but cotton duck is extremely popular and reliable and is far cheaper. The very best canvas has few faults in it. To check the quality hold it up to the light—the closer the weave and the fewer the joins the better. Ready-primed canvases can be obtained from good art supply stores and although without doubt they can be excellent in quality they are also extremely expensive. Ready-stretched canvases are available in a wide range of sizes and quality should the idea of stretching your own be daunting or too much trouble. However, purchasing your own unprimed canvas to be stretched at home is the most satisfactory solution both from aesthetic and cost points of view: it is cheaper and you have complete control regarding the size and quality.

Stretching canvas

The wooden framework over which the canvas is stretched is called a stretcher. Ready-made ones are available in varying lengths and the

best have machine-made mitred corners which slot together for easy assembly. A less expensive alternative is to make your own stretcher frame.

Using ready-made stretchers
First fit the stretcher pieces together using a set square to ensure that the corners form right angles. Lay the canvas on a flat surface, smoothing

In his work Jealousy *Munch has applied paint very thinly, allowing the texture of the canvas to show through.*

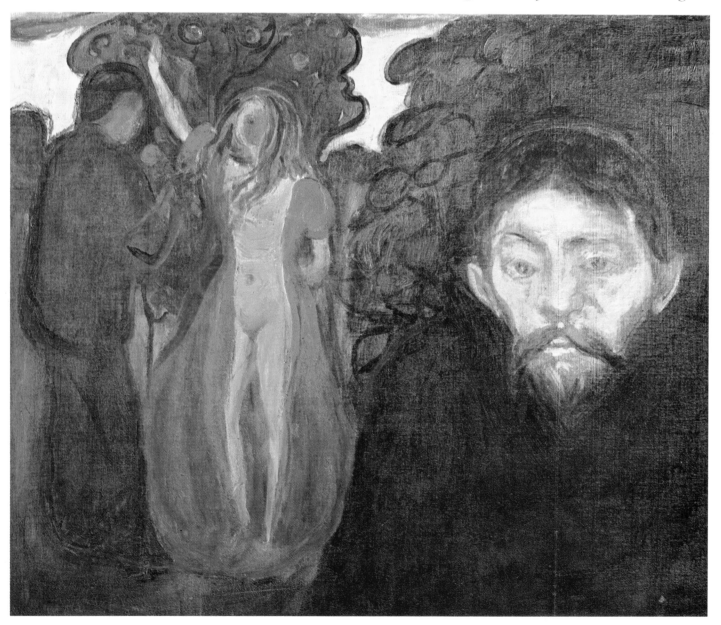

out wrinkles, and put the stretcher onto the canvas, placing it squarely on the weave of the canvas. Do not worry about folds and creases in the canvas due to storage; they will disappear once the canvas is sized. Cut the canvas leaving a 5cm (2in) margin all around the stretcher (fig. 3).

Make sure you have the stretcher the correct way around. The front facing surface (the side which is laid face down on the canvas) will have rounded and bevelled edges so that the actual face of the stretcher slopes away slightly from the canvas (fig. 4). This prevents a ridge from forming on the stretched canvas.

To attach the canvas to the stretcher, use either 6mm ($\frac{1}{2}$in) upholstery tacks or a staple gun—the latter is certainly easier, as one hand can be used to stretch the canvas on the frame while the other fires the gun.

Canvas must be stretched before it can be used.
Fig. 3 A 5cm (2in) margin is left all around the stretcher when cutting the canvas.
Fig. 4 The face of the stretcher slopes away slightly from the canvas.

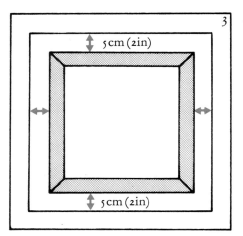
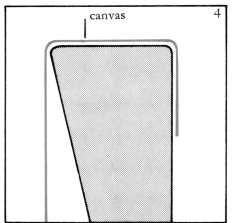
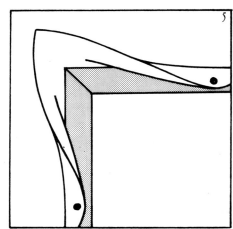

Fig. 5 The canvas is attached at the centre of each stretcher piece.
Fig. 6 Sequence of working.
Fig. 7 Mitre the fabric at the corners. Tack or staple, making sure that mitre fold aligns with corner of the stretcher.
Fig. 8 When stretching a canvas over 1.5m (5ft) square, use canvas pliers to grip and pull fabric.
Fig. 9 A mitre box

However it is a fairly expensive investment for a beginner to make so, by all means stick to tacks if you prefer.

Having checked that the bevelled edge is face down and that the warp and weft are aligned at right angles with the stretcher, all is ready to begin. Fold one edge of the canvas over the stretcher piece and tack or staple in the centre to the uppermost edge. Repeat this operation with the opposite side, then the two other sides, pulling the canvas evenly over the stretcher. The canvas is thus attached at the centre of each stretcher piece (fig. 5). Working from each centre point, either side of the tack or staple and from side to opposite side, carry on pulling the canvas evenly across the stretcher, tacking or stapling every 5cm (2in) to within 5cm (2in) at each end. Fig. 6 shows the order in which to work. Mitre the fabric at the corners by neatly folding one side under the other (fig. 7). Tack or staple securely, being sure that the fold of the mitre aligns with the corner of the canvas stretcher. The canvas should be taut but not excessively so since when the size is applied it will shrink. Stretching a canvas in excess of 1.5m (5ft) square will prove awkward

without the help of canvas pliers (fig. 8). These are used to grip the canvas, pull it over the stretcher, and hold it in place while tacking.

Making a stretcher frame

The equipment necessary for the construction of home-made stretchers should be available in the average household except possibly the clamp used in conjunction with a grooved mitre box (fig.9). This is used to cut mitre joints and holds corners while glueing. It is also used for framing. Other necessary tools are: tenon saw, screwdriver, tapping hammer, drill and bit, countersink bit, ruler, pencil, screws, panel pins [picture nails] and wood glue. Prepared 5cm x 2.5cm (2in x 1in) wood is an ideal dimension to use for average-size stretches from 51cm x 76cm (20in x 30in) and will be adequate up to 1.5m (5ft) square as long as a reinforcing bar is added across the middle.

Decide upon the dimensions of your stretcher and mark the lengths on the wood. Place the wood in the clamp and saw the angles along the length as shown in fig. 10. Then glue and screw each corner together. Alternatively, use corrugated corner fasteners (fig. 11).

To lift the canvas away from the stretcher attach a ridge of beading with glue and panel pins [picture nails] (fig. 12).

Large stretchers can be constructed in the same way with the addition of a central reinforcing bar, but due to the extra tension, it is wise to reinforce the corners either with an L-shaped metal angle plate or some triangles of hardboard glued and nailed to the back of the stretcher at each corner (fig. 13). Stretch the canvas as described.

Linen canvas, though tough, is very susceptible to atmospheric changes and should always be used on wedgable stretchers. A real disadvantage of home-made stretchers is that they cannot be wedged and cannot re-tension the canvas should it become slack.

Wedging

Manufactured stretchers have a distinct advantage over home-made types as they incorporate in the cut joint a small slot into which a triangular wooden wedge can be tapped. This allows the canvas to be re-tensioned should it become slack during the application of paint. Building up paint areas with a knife or scraping away paint are both likely to cause slackening.

Do not wedge after stretching as any slackness in the raw canvas will be taken up with the sizing. When wedging is required place two wedges per corner and tap them in gently until the canvas is re-tensioned. On large canvases with a full cross bar, you will find additional slots cut where the bar joins the stretcher piece. Wedges are usually supplied with the stretchers. All that wedging does is to open the corner joints slightly.

Board

Man-made boards, particularly hardboard, provide an excellent and resilient base for oil painting. Hardboard, if of relatively small dimensions, is sufficiently rigid not to need battening supports, but once above 51cm x 41cm (20in x 16in) it has a natural pliability and will require reinforcement. To do this, construct a frame of 5cm x 2.5cm (2in x 1in) wood as you did for the canvas ground. Smear the facing surface of the frame with wood adhesive and lay the hardboard onto the frame. Use 2cm ($\frac{1}{2}$in) countersink panel pins [picture nails] at 5cm (2in) intervals along each edge to secure the board to the frame. Wipe away surplus glue.

This same reinforcing procedure applies to any other pliable board, such as plywood. Unfortunately, board surfaces when primed are extremely slippery, unpleasant surfaces on which to paint. To counter

Fig. 10 Sawing the angles of the wood for the stretcher.
Fig. 11 Fitting the corners with corrugated corner fasteners.
Fig. 12 To lift canvas away from stretcher, attach a ridge of beading.
Fig. 13 Large stretchers need their corners reinforced as shown here.

Right: Painters use a wide range of surfaces. The Lady of Shalott by William Holman Hunt is worked in oil on a wood panel.

this problem a toothed (textured) surface can be provided with butter muslin [cheesecloth] sized onto the board. Cut a piece of muslin [cheesecloth] allowing a 5cm (2in) margin all around to fold to the wrong side of the board. Apply size to the board and stretch the muslin [cheesecloth] across it. Smooth out any ridges that occur or they will prove a real nuisance when painting. The size not only provides a sealer but firmly attaches the muslin [cheesecloth] to the board.

Paper

Paper is often used as a painting surface, but it needs to be stretched first and then sealed (priming is optional) before it will provide an ideal surface. Various qualities of paper exist from smooth through to coarse. What you use depends on personal preference, but it must be of good quality if it is to provide a reasonable base. Ordinary drawing paper will not be suitable, particularly at the stretching stage. Stretching is done by soaking the paper in clean water until saturated. Make sure the paper is not creased in any way; this would cause a fault and the paper

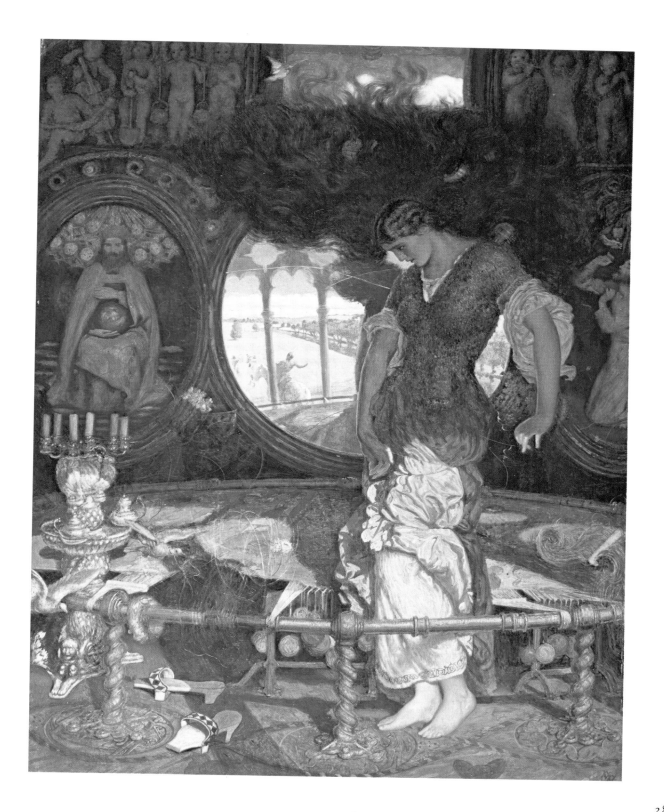

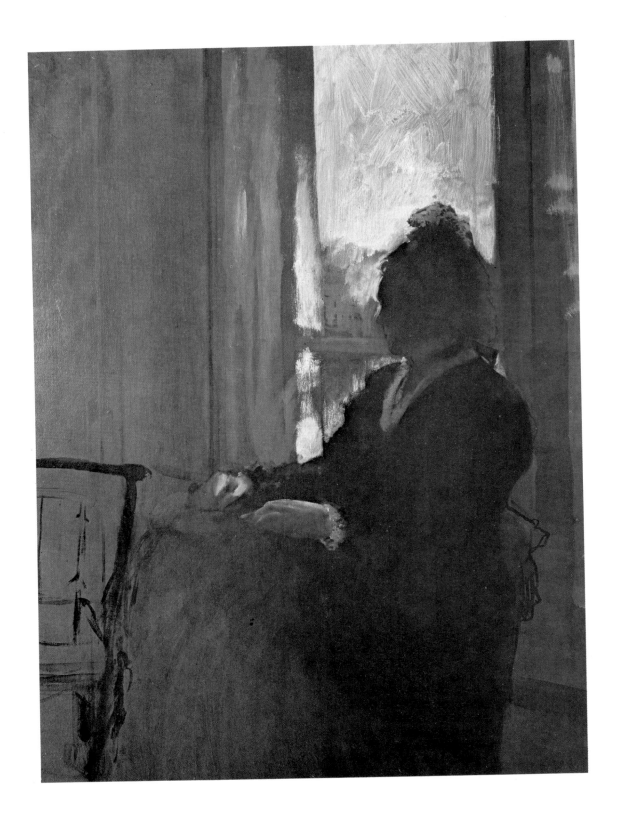

would rip as it stretches. Carefully remove the paper from the bath allowing water to drain off. Lay the paper on a drawing board making sure the right side of the paper is facing upwards. (In most hand-made papers it is relatively easy to see the right side on which to work, but with some of the good quality manufactured types it is difficult: if scrutinized carefully, the wrong side will be seen to have a fine orderly mesh texture on it.) Gently wipe the paper with a clean dry cloth, eliminating any bubbles as you would when wallpapering, then quickly lay a moistened 5cm (2in) wide gummed paper strip around all four sides overlapping 2cm ($\frac{3}{4}$in) on the paper and 3cm ($1\frac{1}{4}$in) on the board. Leave the board flat as this will allow the paper to dry evenly. If the board is stood on end the paper will dry unevenly because the moisture drains from the top to the bottom, keeping the bottom gum strip wet so that it does not glue firmly to the paper. As the uneven drying continues the bottom edge will separate from the gum strip. If this happens, the stretching process must be repeated. The paper will always cockle during drying, but as long as it is kept flat it will dry into an immaculate smooth surface.

Although it is advisable to size and prime the paper, it is possible to work directly on an unprepared paper. Beware, though, of paint sinking into the paper surface.

If stretching paper is too troublesome and canvas too expensive, there are various manufactured alternatives: canvas boards made of cotton canvas mounted on thick cardboard; oil sketching boards with a canvas graining incorporated into the prime coating; and heavy coarse grained or medium grained paper sketching pads made especially for oil paints.

Sizing

Oil reacts upon canvas causing it to rot, but a canvas should be coated with an oil-based primer before you paint your picture on it. A coating of size, applied directly to the canvas, provides a barrier between it and the primer, so preventing the possible gradual destruction of the canvas. Traditionally, the finest size is rabbit skin glue, purchased in small sheets from art supply stores. If not available ask for the best alternative. It is brittle, so be careful when breaking it into small pieces as it is very sharp.

To prepare the size allow it to soak in water until soft and then heat through slowly until all the solids have dissolved. Do not boil. Allow the mixture to cool and apply to the canvas just before it begins to gel, using a large clean brush. The size must be applied as evenly and smoothly as possible to facilitate easier and even application of the primer. If the size is too hot it will soak directly into the canvas fibres rather than form a film covering to protect the fabric from the oil primer. Make up only a sufficient amount for the canvas you are sizing as the

Although it is mainly regarded as the surface for watercolours, paper is often used by oil artists too. Shown opposite is Woman by a Window (Degas), *a beautiful oil on paper work.*

mixture will deteriorate in a very short time, and give off a really foul, penetrating odour. Discard any excess immediately.

When applying the size an immediate shrinkage takes place, tensioning the canvas and removing any odd creases that might have remained after stretching. This is particularly so with linen canvas; cotton canvas should be tensioned more than linen at the stretching stage.

Other commercial sizes are available and will, if used as suggested, prove to be equally as efficient, but perhaps less flexible after application.

Priming the canvas
When the glue size is thoroughly dry proceed to apply a coat of oil-based primer as evenly as possible, using a large decorator's brush. Although two coats should cover most canvases adequately, it very much depends on the coarseness of the canvas you are using and how you are going to apply the oil paint. If you are working with thin paint on coarse canvas a third coat would be useful and provide a smoother surface, otherwise, you could find yourself fighting the texture of the canvas. Make sure each coat is absolutely dry before applying the next, or the prime coat will inevitably crack. With properly prepared canvas there should be no evidence of primer seeping through to the back. If this should happen, it could be one of two things: the size has not been applied correctly or the weave of the canvas is so open that it is impossible for the size to establish a fine skin.

An alternative to oil-based primers is acrylic primer. This is water-based and fast drying—a distinct advantage over oil-based primers. It is not necessary to size canvas or boards before applying this type of primer. There are, however, two problems with acrylic primer: one is that the colour of the oil paint tends to become dull when applied over it (although this can be countered with retouching varnish); the other, though not proven, is the possibility that the oil paint might in time peel off an acrylic primed canvas because of the difference of elasticity.

Gesso is a combination of gypsum and glue size and was used for priming wooden panels and coating surfaces prior to gilding. Today gesso comes in two forms: one is a glue composed of glue size and Titanium white paint which has excellent covering capacity; the other is an acrylic gesso. Both may be used to prime canvas as well as rigid board or panel.

As both gessos are water-based be sure that the surface to be primed is completely oil-free before applying, otherwise they will not adhere to the surface. Glue gesso will prove to be very absorbent to oil paint, so seal the gesso surface with a thin coat of size. This will provide a beautifully smooth surface on which to paint, ideal for highly detailed work.

Handling Colour

The principles involved in using colour do not vary among the visual arts: for oil, as for watercolour, coloured inks, pastels and crayons, the cardinal rule is to experiment first to see how the different colours mix. Only by trial and error will you finally know whether you should put down a layer of one colour first, then a layer of a second colour on top of it, or whether it would be better to mix them together in the palette

A Bigger Splash (*acrylic on canvas*) *by David Hockney uses really pure, brilliant colour to achieve its effect.*

first. Either method can be satisfactory, so work out what's best for you, given the medium and materials you are using. Whenever experiments here call for white, always use a good, opaque white ground. Colour, even cream, in the ground would influence the applied colours.

Selecting colours

The names given to colours and the colours themselves vary considerably from manufacturer to manufacturer—crimson or violet, to name only two examples, can vary remarkably from one range to another. Since individual colours tend to have traces of other colours in them, it is very difficult to find a 'true' red, a 'true' yellow and 'true' blue. Of course, an easy compromise, to take care of any problems, is to choose two versions of each primary colour. Although there are many colours to choose from, some of which are mentioned in this chapter, a basic set of colours could be based on the list which follows:

Cadmium yellow —contains some primary red
Cadmium lemon —contains traces of primary blue
Cadmium red —veers toward primary yellow
Alizarin crimson —contains some primary blue
Cobalt blue —contains a little primary yellow
Ultramarine blue —contains a little primary red
Ivory black —as neutral a black as possible, one that is dense
Titanium white —other whites tend to be either transparent, silvery or bluish white

Because the mixing theory does not work in practice (the impurities interfering again) you cannot achieve a clear purple by mixing; so try, say, Winsor violet. Green can cause similar problems.

Making a colour wheel

A colour wheel explains at a glance how colours relate to one another. Every artist makes one up at some point, and it provides an invaluable method of teaching the mixing of colours. Keep it; you will find it useful.

Prepare a pure white ground. At first use the colours straight from the tube and be particular about using only very clean brushes so that your colours remain pure. First paint an area of Cadmium yellow, then next to it an area of Cadmium lemon. From Cadmium lemon, work around in a circle adding Cobalt (a blue containing yellow) followed by Ultramarine blue, Alizarin crimson followed by Cadmium red. (In other words, first paint the chosen primary colour influenced first by one other primary, then with the other, until you quite literally come full circle.) Try mixing all three of the primary colours together on a palette until you have a neutral grey. You will find it impossible to do this by combining equal amounts of each colour, because some colours are inherently darker or stronger than others; you must gauge the quantities

needed by watching the mixtures. When the grey is as neutral as you can get it, paint a patch in the centre of the wheel.

The three *primary* colours are red, yellow and blue. In theory, you should be able to mix all the colours you wish using different proportions of these three primary colours, for they represent all the colours that exist. In practice, however, various chemical properties in the manufacture of different brands of paint do influence the colours when they are mixed together. Again, theoretically, by mixing all primary colours together you should get black; but in practice, because of paint's variable properties, you would be more likely to end up with a darkish grey, a 'non-colour'.

Secondary colours are pure colours mixed from any two primaries. Orange, green and purple are all secondary colours. Experiment with Cadmium yellow and Cadmium red until you get a clear orange, midway between yellow and red. Paint an arc around the outside of the corresponding yellow and red areas of the wheel. Continue the exercise by

Completing the colour wheel (fig. 1). Making a wheel of your own explains very quickly how colours relate to one another.

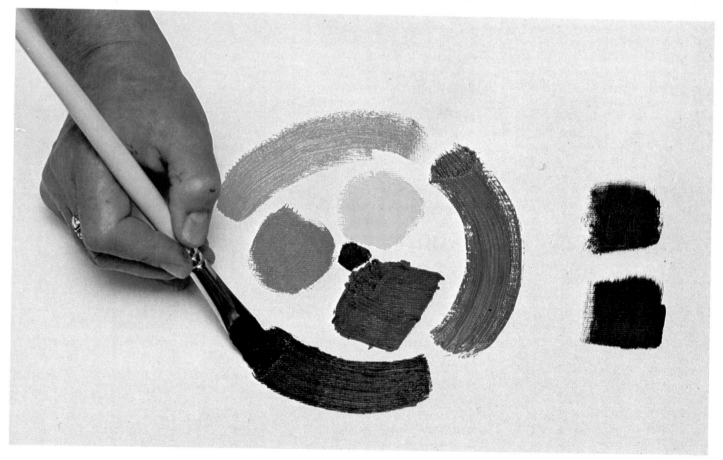

Alyscamps at Arles *by Gauguin shows how an unusual and often non-realistic use of colour can give added life and vitality to the painting.*

making a green from Cadmium lemon and Cobalt blue and paint a green arc around the corresponding yellow and blue section. Purple is more difficult to make, but see what you can come up with by mixing Alizarin crimson and Ultramarine blue, then paint in the obligatory arc. (Fig. 1 shows how the colour wheel should appear when finished.)

Each of the secondary colours is a mixture of two primary colours: for instance, purple is a mixture of red and blue. The primary colour not concerned in the making of purple is yellow, and yellow is therefore the *complementary* colour of purple. If you mix any complementary colours together they will go grey or 'non-coloured' because you are, in effect, combining the three primary colours.

From the painted wheel you can spot the complementary pairs. Look at a primary colour area, then look for the arc of colour opposite it on

the far side of the circle; this is the complement. Those colours which are called complementaries are genuine opposites. Think of them as colour combinations for clothes. Would you wear red with green, yellow with mauve or purple, blue with orange? You cannot say, as they used to in the past, that 'red with green should not be seen', since the right choice of red with the right green could look stunning. Most likely, because they are opposites, you would think twice about wearing them together. All opposite or complementary colours should therefore be used together both wisely and sparingly. Experimenting with the various components of the colour wheel helps to give some idea of the variety of colours that can be mixed using the suggested palette of primary and secondary colours. These colours probably won't provide all of your colour needs, but as you become more experienced in colour mixing and matching, you can be a better judge of which other colours you might need. Now that you have begun to mix secondary colours, experiment further, using other colours, so that you can have a better idea of what is possible and what is not. For instance, you could experiment with different proportions of colour. Some pigments have tremendous strength and others have only a little (a very little black has an obvious influence on Cadmium lemon and will turn it green).

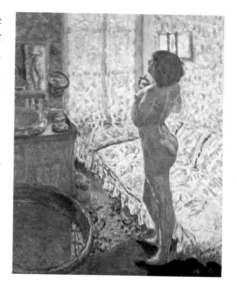

Above: Nu à Contre Jour *by Pierre Bonnard. The nude is a subtle surface on which light falls in fascinating ways. Here the artist is exploring the shades of colour influenced by the source of light, both on the model's skin and on the room itself.*

Any colours other than primaries or secondaries are known as *tertiaries,* that is, mixes of three colours or more. For example, try mixing a purple-grey using black, white and a touch of Winsor violet. If it is not sufficiently purple add Alizarin crimson; because of the yellow tinge, Cadmium red would not really be suitable, for when it is mixed with the black element, the grey would move towards a brown.

Do not hesitate to explore: paint small areas of the experimental mixes onto a sheet of paper, carefully listing all the colours used. Then pin the paper to the wall as a reminder to you when you start painting.

Green will make a red dull, but the right blue may darken the red and leave it fairly pure. A very small quantity of black will darken a colour, but its purity will disappear and it may be changed into another colour entirely. Remember black mixed with yellow will produce a dirty green-ish brown, compared to the bright green obtained by mixing Lemon yellow and Cerulean blue.

So colour mixing is a question of degree. As previously stated, either black, green or blue could be used to darken a red, depending on how colourless or 'un-red' you want the result to be. The same holds true for the other primary colours. Blue can be darkened by a little red, black or orange; black will possibly kill its purity (less so if it is Ultramarine, more so if it is Cerulean); orange will neutralize it, making it greyer or browner according to the amount used; a hint of red will keep it basically blue, but will turn it purple or mauve if used too freely. Yellow can be darkened by a little red, black or mauve, but it will be

Above: Ice *by Richard Lindner.*
The painting shows an effective
use of primary colours.

quickly tainted and will soon lose its 'yellowness'. Red may deepen it before turning it orange; black, we have already seen, will turn it into a dull green; and mauve will neutralize it by pushing it towards grey or brown.

So brown can be made by mixing complementaries together, being arrived at before grey by varying quantities slightly. Red mixed with black will also produce brown.

Sometimes a mixed colour (especially brown or green) will be more satisfactory than one straight from a tube.

Darken a brown by using blue, especially Ultramarine. This gives a much richer, deeper colour than by adding black.

To darken secondary colours (orange, mauve and green) without making them dull, add their darkest natural ingredient: red for orange, blue for mauve or green. A crimson added to an orange which was made with Cadmium red will alter it subtly, making it less 'fiery'. A similar thing will happen to a mauve when Ultramarine or Monestial blue are added instead of the original Cobalt or Cerulean. White, of course, will lighten a colour, but so will yellow if it is added to orange, red or green.

Remember that when using any paints, not just oils, the more colours you mix together, the duller or greyer the result. This is why a professional artist will use artist oils or watercolours: they have more colour pigment in them and can therefore be mixed further before dulling occurs. For this reason it is impossible to get a bright mauve or turquoise from lesser-quality paints, but fairly easy to do with artist oil colours.

Indeed, when you do mix a grey in artist oil colours, you will find that it is possible to achieve coloured greys which are much, much more interesting than grey made by mixing black and white alone; a whole picture could be built around them. Sometimes a mauve-grey or greenish grey, for example, is more satisfying to look at, and is richer, than a straightforward mauve or green. If you place such a colour next to its opposite, in this case against yellow or red respectively, you will see an optical vibration occur that may even be quite disturbing to the eye (see the experiment with cut-out colours in this chapter).

Indeed, there are two major ways to achieve this vibration or glow with colour. Both are visually dangerous tools, but ones which produce spectacular results when successful.

One is called the law of 'simultaneous contrast'. If you were painting a sun and you placed a cold Lemon yellow next to a warmer Chrome yellow, both being surrounded by shades of cream and Naples yellow of similar tone, the result would be a radiant glow of colour. If there were small, pure white gaps between the colours, and if all the colours were exactly the same light tone, the glow would be increased enormously. Imagine a whole painting done this way.

Similarly, two opposite or complementary colours placed next to each other will produce a different kind of vibration or 'flicker' because of their different optical wavelengths. At extremes, it is difficult to focus a red next to a green, hence the flicker. This can also be demonstrated using black and white, as in fig. 2 by Bridget Riley. Here the lines are so cleverly controlled that we cannot focus on them (try counting them!). The strong difference between black and white short-circuits the eye, and pairs of opposite colours can be produced by staring at the picture

closely; move it very slightly to create a wave-effect. Such paintings, some of which are 6m (20ft) across, can actually induce a violent feeling of sickness.

So, by placing, say, simultaneously contrasting yellows next to various shades of their complementaries (light mauve), we can produce a glow which is stronger and certainly richer than any effect achieved with fluorescent colours.

Remember that some pure colours are naturally stronger than others. A very rich colour, and therefore one which can only seldom be used pure, is Geranium Lake. Put your brightest colours on first, then put pure Geranium Lake onto your picture, and the others will pale into insignificance. But mix it with a mauve or purple and where they were previously dull they will take on a new lease of life.

Crest by Bridget Riley (acrylic) fig. 2 *demonstrates the flickering effect produced by two opposite colours, in this case black and white, when used next to one another.*

Fig. 3 Preparing squares of colour to demonstrate the effect (sometimes known as induced colour) obtained by placing a tertiary colour next to other primary and secondary colours.

The act of painting reduced to its simplest terms is about colour. It is now time, therefore, to consider the effects and the optical influence of one colour against another. Primaries are relatively stable and are not much influenced by other colours; neither are secondaries. Tertiaries, however, can be influenced very much indeed—in fact, their appearance can be radically altered by the nature of surrounding colour, a phenomenon which is sometimes referred to as induced colour. The exercise illustrated by fig. 3 demonstrates how colours can change one another. In order to achieve the desired effect of this exercise, equal proportions and complete cleanliness of colour are mandatory, so it is wise to adopt the painting and cutting-out method in order to avoid any smudging of colour or rough edges which could affect the results.

Take seven average-sized sheets of drawing paper and paint one a middle blue-grey and one each black, green, blue, yellow, red and purple. Make sure the colour is as opaque as possible but not too thick or it will take a long time to dry. When the paint is dry, divide the blue-grey sheet into 2.5cm (1in) squares and cut out the squares with a craft knife or scissors. Cut a 10cm (4in) square from each of the coloured sheets, then arrange the large squares on a sheet of white cardboard or paper, leaving about a 4cm (1½in) gap between each one. Finally, attach a small blue-grey square to the centre of each large coloured square. The results will be quite surprising for each of the small blue-grey squares will appear to be different hues of that colour. You can experiment in this way, *ad infinitum*, using, for instance a primary or secondary colour for the central square. Even in the case of primaries, apparent visual change will

certainly occur though it will not be as pronounced as with a tertiary.

In the case of primary colours, the amount used in relation to another colour determines the extent to which the primary will be influenced. For although they are stable, if they are used only in small proportions they can be influenced—a fact which is true for most colours. Fig. 4 used Cadmium red as the primary and two sizes of centre square, leaving A and C with a very narrow border and B and D surrounded by a heavy border. In squares A and C the borders have no obvious optical influence over the red, so they remain identical. But in squares B and D the two border colours induce a colour change on the red.

From these experiments you can gather how colours can influence one another. By now, having observed colour and shape as they occur within your natural environment, the terrors attached to using (or misusing) colour should evaporate, and it will become easier to make colours work for you so that you can achieve the effects you wish to create.

Fig. 4 Although a primary colour such as cadmium red is usually very stable, and not easily influenced by other colours, as these sample squares show, if used in small proportions, the primary can be affected (in squares B and D).

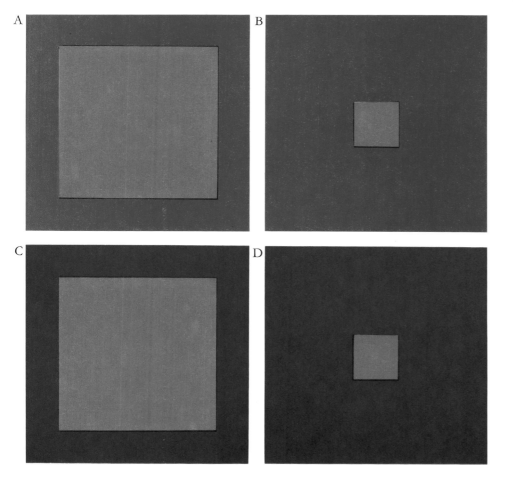

Fig. 5 Nu Dans le Bain *by Pierre Bonnard explores the most challenging surfaces for the painter —water and human flesh.*
Fig. 6 *Monet's* Rouen Cathedral, West Facade *is one of several studies of the same subject, constantly seeking the changing facets of light and colour throughout the day and into the early evening.*

Colour at work

Colour has symbolic value in every society and has had since the beginning of history. Black in many cultures, for instance, is worn to indicate death and mourning. Twentieth-century industrial culture has developed its own colour symbols within its transport system; red for stop, green for go are obvious examples; many others exist. There is an established order of colour within the universe too: the sky is generally blue, the grass nearly always green, a grape either green or black, and so on. Such colours found in nature are called *local colours*, that is the colour of the natural object as it actually is, without being altered or influenced by light or shadow. Obviously, however, such objects can and are influenced—by natural as well as artificial sources of light—and these forms can produce a profound alteration on the appearance. It is always important to remember the influence of light when painting. The landscape in the distance seemingly becomes bluish-grey in colour because distance and atmosphere diffuse the local colour. The most obvious influence of daylight or artificial light can be seen on the surface of water. Water literally mirrors the colour above it or around its perimeter. Another highly receptive surface is human flesh. Added to the complex and fascinating contrasts inherent in the human anatomy, it is what makes painting the nude one of the most challenging—and somewhat exasperating—problems the artist has to deal with. The Bonnard painting (fig. 5) of a figure partly submerged in a bath tackles both of these problems. Not only was he trying to capture the effects of light on the water surface but also on the partially submerged figure.

297

The influence of daylight on the shiny surface of an orange is less evident, as orange is a powerful local colour. But on close viewing, it is possible to notice a colour change if you move the orange from a brightly lit surface into an area of shadow—a blue light (remember blue is the complement of orange) will appear on the shaded areas of the orange, thus altering the appearance of the local colour. On a matt (dull) surface, the influence would appear to be more subtle because the surface is not very reflective.

Fig. 7 Another beautiful example of Monet's skill with light and colour is shown in his work Water Lilies.

Although several nineteenth-century artists, Delacroix, Turner and Constable to name three prime examples, explored the influence of light on colour in the environment, it was only with the advent of the Impressionists that the essentially Renaissance influence on colour perception was modified and changed. Traditionally, light had been used solely as a means of seeing what was being painted, now, with the Impressionists, it was being used deliberately, and as part of the composition, to suggest how it revealed and affected the colour of the subjects being painted. For a short time the Impressionists directed their

Fig. 8 Theories on the subject of colour also fascinated the Neo-Impressionists. Paul Signac's painting The Rotterdam Harbour *(1907) is painted in dots of pure colour, a technique often called pointillism.*

energies toward exploring the influence of light on both environment and colour. It was Monet who pursued the issue in the most single-minded way. The studies he did of *Rouen Cathedral* (fig. 6) and *Water Lilies* (fig. 7) are among the most obvious examples of paintings influenced by this line of thought.

On the other hand, the Neo-Impressionists (Seurat, Signac and Cross) developed an elaborate theory of colour, constructing their pictures using dots of pure colour. Fig. 8 shows a painting by Signac demonstrating this colour-mixing technique. This same technique is used in modern half-tone reproduction printing.

Although the Impressionists still influence the visual scene, there are no longer any absolute rules about how colour should be used; it can now be used in any way the artist wishes to use it, to expand and explain his interpretation of his visual world. From the muted richness of a Flemish master to the shimmering dot constructions of Seurat, to the strong simple areas of inter-relating colour used by painters such as Ellsworth Kelly (fig. 9), you can see that colour can be used both to portray the subtleties of the subject being painted, or, indeed, it can itself become the subject of the painting.

Fig. 9 Blue, Black and Red *by Ellsworth Kelly is an effective use of primary colours in strong, simple masses.*

Project:
A Still Life

Now that you have tried out the paints and brushes in the exercises given in the previous chapters, you will want to put your knowledge to some practical use. The sooner you begin to paint in earnest, the better.

People paint because they are stimulated by what they see and want to give expression to their feelings in a visual way. Subject sources can be

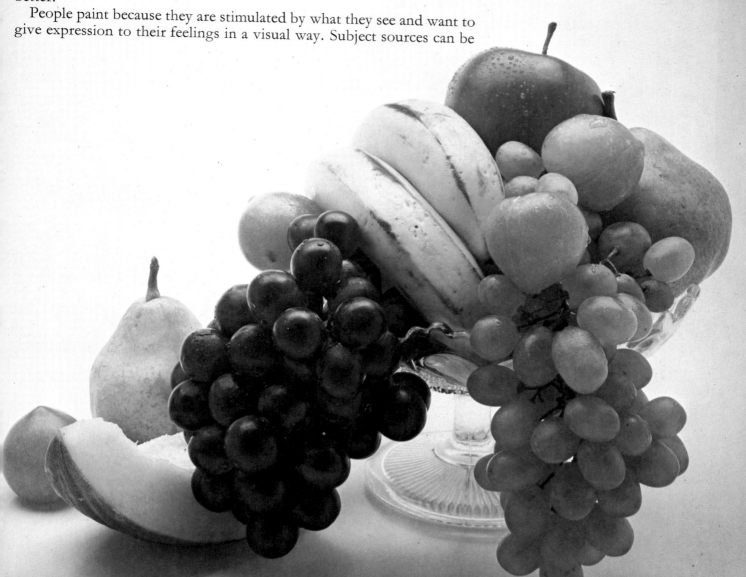

divided into three basic groups: landscape and townscape, the figure (groups, portraits and self-portraits), and still life.

The still life group is not necessarily an easier subject to paint than landscape or figure composition, but it does present very definite advantages for the beginner that should be considered seriously. First, you have the opportunity to select objects that you personally like. Painting the luxuriant colours in fruit, vegetables and fabrics has long been a favourite challenge and traditional subject source for the artist, from the seventeenth century through to contemporary artists. Simple utensils like a jug, plate and vase, or a mixture of natural forms—flowers, apples, oranges or the potato—are popular combinations. But although the subject matter does not alter dramatically from artist to artist, the artist's treatment of the subject does—look at the variety of still life paintings and you will see the possibilities inherent in even the simplest objects. For example the work of William Scott demonstrates his endless explorations of kitchen utensils (fig. 1). For Braque, as for Morandi, still life provided a central anchor around which he developed his ideas. These ideas were based on a thorough knowledge of the objects which surrounded him in his studio and in addition, they were objects of affection.

Fig. 1 Still life can be successfully explored through the most simple domestic objects. In Winter Still Life, *William Scott pursues his constant fascination for kitchen utensils.*

302

Another great advantage of still life is that the object or the group of objects can, in most cases, be kept for indefinite periods. They can then be considered and observed in all their dimensions and you can consider the various approaches available to you. This is possible with other subjects like portraiture, but inevitably the painter will become concerned with the sitter's comfort. With a still life group there is no such worry; you are able to experiment as much as you require for whatever time span you choose.

As stated before, the still life provides you with the opportunity to select those objects you personally like or find interesting. You can then arrange them in a space that you have control over; you control the

Above · Still life groups can be deliberately arranged to enhance particular qualities that the artist sees in various objects. For example, in this painting called Studio Cupboard and White Chair *by W. G. Gillies, the vein formation in the marble table top is subtly echoed in the leaves of the plant, which has been carefully placed to achieve this effect.*

depth of field, that is the distance between the objects. Working close-up, for instance, allows you to avoid complex perspective problems and, with careful positioning, the light—either artificial or natural—can be controlled. Natural light is recommended for it tends to be much more delicate and produces far more subtle colour and tonal relationships. Try and place the group near a north-facing window where the light is going to be fairly constant throughout most of the day.

Once established, the group can be left undisturbed if necessary. For obvious reasons don't arrange the still life on the kitchen table. The facility of being able to view the group and paint it over a period of time presents tremendous advantages. The lack of urgency and the private nature of the activity permit serious experimenting. You will not be influenced by the fear of embarrassment to which most people in a classroom situation find themselves subject. You will also be able to allow time for each coat of paint to dry.

Not being pressured will allow you to explore and resolve what you are trying to achieve in the painting. Is it the influence of light on colour? The two-dimensional decorative aspects of the group or the three-dimensional structural aspects of the objects and the space surrounding them?

The other great advantage is a purely practical one. The materials can be left ready to be used at a moment's notice.

Keep your materials in good order. Remember to clean the palette mixing area with a palette knife and rag after each painting session or a muddy film could build up and destroy any attempt to mix colours with accuracy, particularly delicate ones. If you will be working each day the colours laid out around the palette can be left without any harm; keep them in tin lids, for example, covered by water—the water will prevent a skin from forming. If, however, a skin does begin to form, scrape off the colour and wrap it in wastepaper before throwing it away.

Arranging the still life and beginning the painting

Take the chosen objects and arrange them as swiftly as possible. It is easy to become too self-conscious over an arrangement, moving this way then that and finally arriving at a balance that is monotonously even. Try and produce something quite natural. Rather than fiddle too much with the group, move yourself around the collection of objects and find a position that you think is interesting. No progress will be possible otherwise.

When you begin painting, remember that patience is a virtue, that your decisions can and should be made slowly. You will find from experience that eventually such decisions will come more quickly and spontaneously, but you must not expect miracles overnight. Don't be too concerned about where you place things on the canvas, just be sure

you incorporate all you wish in the initial line drawing before painting begins. Rather than immediately painting in areas of colour, map out the positions of the objects with a small hogs' bristle brush and a well-thinned colour, such as Ultramarine blue.

What you choose to paint is, in the last analysis, entirely up to you, and the activity should be one of pleasure. Anything that exists is a source of subject matter. Always keep an open mind as well as open eyes.

Analyzing what you've done

Before you can begin to analyze the results of your first attempt at painting, it is important to consider how you actually see things: to appreciate something of how the optic nerve operates in conjunction with the brain, and also how different societies look at images.

With the optic nerve, light waves from the sun or some artificial

Still life work (Table with Oranges) *by Howard Nicholls.*

Right: Toilette devant la fenêtre *by Braque (1942) uses flat, vertical planes to strong effect. Still life is the cornerstone of Braque's art, and this painting is typical of his fascination with the influence of natural light on common household objects.*

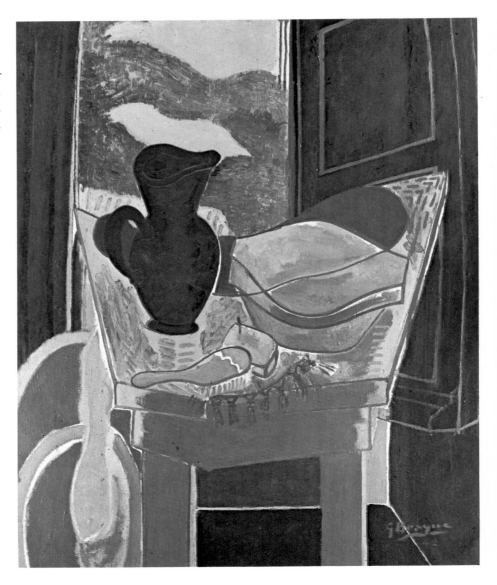

light source are bounced off objects. Within these light waves are varying wavelengths and variations of brightness. These factors produce differences of colour. The light rays reach the eye and are focused by the lens on to the retina. From the nerves, impulses are sent to the brain. These impulses set in motion a complex set of functions allowing you to combine the visual information with information that has been accumulated since birth, through word association and example, into a comprehensive picture of what is identifiable as the visual world. This is, of course, a very simple explanation of the situation, but its implications are obvious; we are conditioned to perceive things in a certain way.

With a learning process by example the question arises as to how people view paintings. Viewing or reading bears a direct relationship to the society in which we exist. Some societies read from left to right, others the reverse. Twentieth-century European man's surroundings are far different to medieval European man's, as are their ways of living. Thus, when viewing a medieval painting it is extremely difficult for contemporary man, although appreciative of the painting's visual qualities and the artist's skill, to respond in any way as the artist originally intended.

An understanding of how and why you see things as you do will help in the evaluation of your achievements in oil painting. How pleased or displeased are you with the results so far? And what can be done to improve them? The initial difficulties will be practical: is colour mixing proving difficult? Has too much white been mixed into the colours, giving the painting an overall chalky look? Are the reds used too orange? It is worth referring back to the chapter on colour to review the examples of mixing. Is the consistency of the paint proving a problem? Used thickly without turpentine, or with very little, the paint will prove difficult to mix and take much longer to dry than paint with a high turpentine additive, and once dried the surface will be difficult to rework because of the underlying texture already established. No amount of scraping with a palette knife will remove the dried paint totally. Also the risk of damage to the ground, particularly if it is canvas, is high. It is wise, therefore, to begin painting with fairly thin opaque colour. This requires that the paint be mixed with turpentine and possibly linseed oil, although the oil will slow the drying of the paint, and give it a somewhat slimy consistency. Remember to mix the paint really thoroughly with a palette knife or old brush so that the colour will not be streaky as it is applied to the painted surface, wasting materials as well as time. Remember to load the brush well or, despite the tough nature of the bristle, the brush will get damaged as the paint is forced to cover more surface than it would naturally. For the beginner it is wise to stick to a fairly thin opaque paint consistency giving easier control throughout; it is also more economical. The density of colour will increase as layer builds upon layer.

Absolutely central to the success of any painting is the design or composition. This means the art of combining the visual elements into a satisfactory whole. The design reflects the selection and organization of space, colour, line, form and light as well as it reflects the artist's intention or reason for the painting. Lack of design suggests that all these issues remain confused. So to progress further, it is wise to persevere with still life as it presents those very particular advantages discussed earlier in this chapter—static subjects, control over composition, and light and comfort.

Fig. 2 In his painting Interior with Eggplants, *Matisse shows his fine skill in handling rich, highly active colours, and also an interesting sense of composition.*

Dismantle the still life you were working with and choose a new group of objects. Do not include an object, or objects, similar to those used in the previous attempt that proved impossible to cope with. Be patient, and a time will come when it will be possible. If composing a satisfactory group continues to prove difficult, look around the house or garden shed, for often casually placed objects create a most exciting visual proposition.

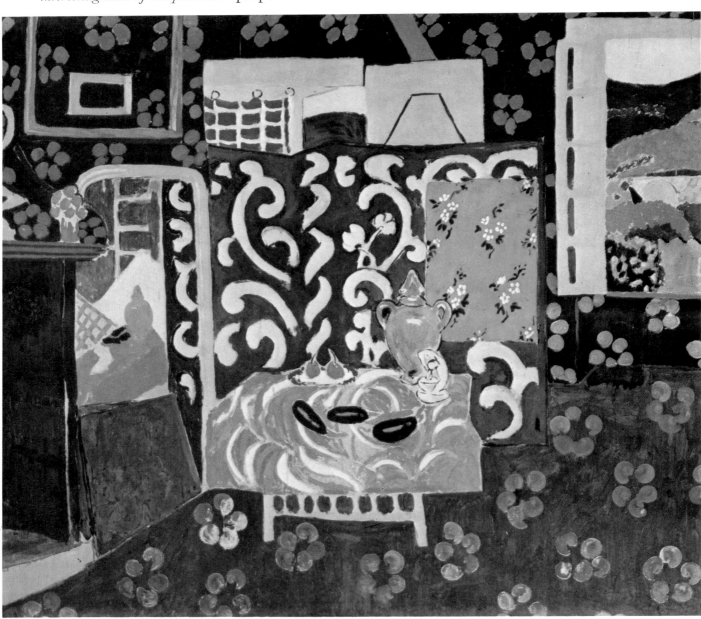

Another issue that could prove troublesome is the amount of colour involved in the group. Although bright, strongly coloured forms might seem attractive, twentieth-century urban environments as well as contemporary advertising bombard the retina with their brilliant and often violently contrasting hues, and it is an enormously difficult problem for a beginner to cope with such strong colour. This use of vibrant colour has its origins in the Impressionist, Post-Impressionist,

Fig. 3 In contrast to Matisse (opposite) Giorgio Morandi's Still Life with Bottles deals with subtle muted colours and textures, and an uncomplicated arrangement of the whole composition.

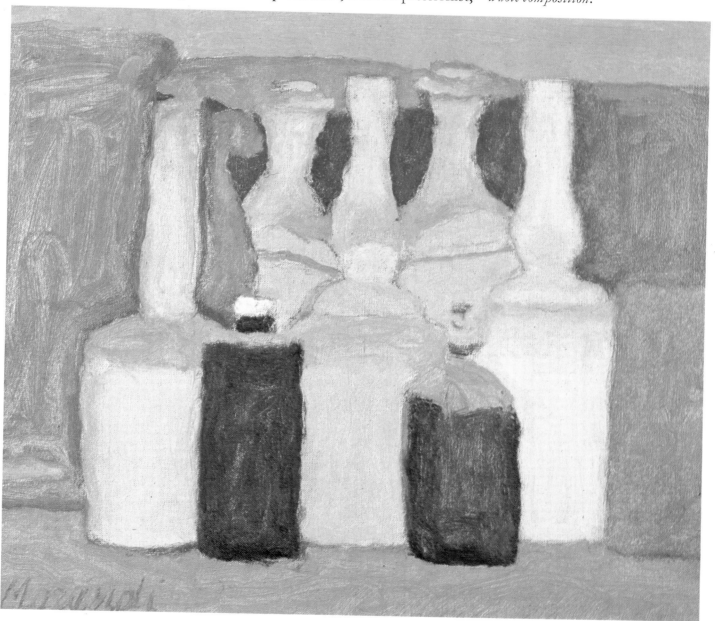

4a

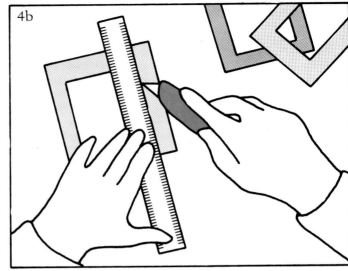

4b

A viewfinder helps to focus on the interesting elements in the scene before you. It is very easy to make your own, as shown in the illustrations above. First measure the dimensions of the viewfinder (left) then cut out the shape (right).
Opposite: In his painting Pottery (1969), *Patrick Caulfield controls a mass of strong, bright colours by using a powerful overlapping design technique.*

Expressionist and Fauvist movements of the late nineteenth and early twentieth centuries. Matisse (fig. 2) is a fine example of an artist who had the ability to control rich, highly active colours.

It is probably advisable to begin afresh with a very restricted group consisting of perhaps one or two brightly coloured forms balanced against a whole range of quiet ones, such as ambers, greys, cool greens and dark blues. This will help make progress toward a total visual harmony easier. The colours, although simple and perhaps somewhat conservative, will provide exciting visual and technical problems. Look at the quiet dignity of the Giorgio Morandi still life (fig. 3): a few simple objects are brought together in an uncomplicated arrangement of three-dimensional form and beautifully observed colour.

Having decided upon a satisfactory grouping you should now, before beginning to draw and paint, cut a number of viewfinders. These are small frames of cardboard with windows of different proportions cut in their centres. The window should be no larger than 10cm (4in) to 15cm (6in) square, and the surrounding frame roughly 2.5cm (1in) deep. The cardboard used for cereal boxes is ideal for the purpose. Measure and cut the window (see figs. 4a, 4b) to the proportion considered necessary. The 2.5cm (1in) wide frame will provide a sufficiently rigid viewer than can be easily held. If the frame is too thin the viewfinder will be floppy. So as not to cause delays in beginning the work, relate the proportion of the window directly to the porportions of the canvases or boards that you will be using.

Consider the photograph of the still life group in fig. 5 from which the drawings shown are derived. The first design in the square format is a deliberate attempt at bad design. The objects have been badly

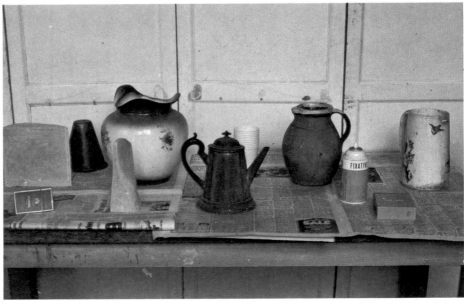

placed along the bottom edge of the square and the total surface area has become dominated by the patterned wall behind. There is no sense of depth or three-dimensional space. The objects are swamped by their setting. There is also a strong movement toward and out of the bottom line of the picture surface that is visually very disturbing. There is no critical sense of balance whatsoever; the objects are simply stuck there.

The second drawing shows a very traditional arrangement. Three-dimensional space is important although limited by the shape of the table. Symmetry is established with the formal, straightforward position of the table and creates a quiet, stabilizing influence against the asymmetry of the objects on the table.

The third design is a dramatic change from the previous compositions. Three-dimensional space has been eliminated because the tabletop has been tipped up and flattened and almost entirely fills the canvas surface. Upon this seemingly flat surface are the objects. The painting is still about still life but the design is more positively about the interplay of the flat two-dimensional shapes of the objects within the painting's surface.

These examples of how things may be arranged in a still life should be a useful indication of some of the problems inherent in achieving a satisfying design. There are innumerable possibilities in organizing a design, of course, and practice is the most positive way of learning and gaining confidence. Also, looking at the achievements of others and relating what you see to your own experience will help in understanding the reasons behind successful design composition.

Before elaborating further it is important at this stage to stress that painting is not about copying. Consider the transitory natures of the sun,

rain, wind, snow and light and it is obvious that to copy is absolutely impossible. The camera and light sensitive film can only register the amount of light coming from the object; that is how it translates the visual world. It is thus a question of translating all these elements into your own terms, then finding values with paints that in some way equate, when placed together on the flat surface, with the visual and emotional sensations confronting you. Consider the Renoir still life painting (fig. 6). Although words can be used to identify the objects, the painting is really an obsessional study of atmospheric light and colour falling over the various forms and surfaces incorporated within the picture plane. The effect of colour laid against colour is the subject of the picture. It is not a painting about roses—the flowers are purely the point of departure for the idea.

Opposite: A useful series of examples of how to arrange a still life. The main study (fig. 5) is the source from which three drawings are taken. The first (5a) is completely out of proportion, the second (5b) chooses a traditional composition, while the third (5c) radically alters the perspective in a positive manner.
Below: Guitar, Glass and Bottle *by Picasso shows his skill in choosing a few, highly evocative objects.*

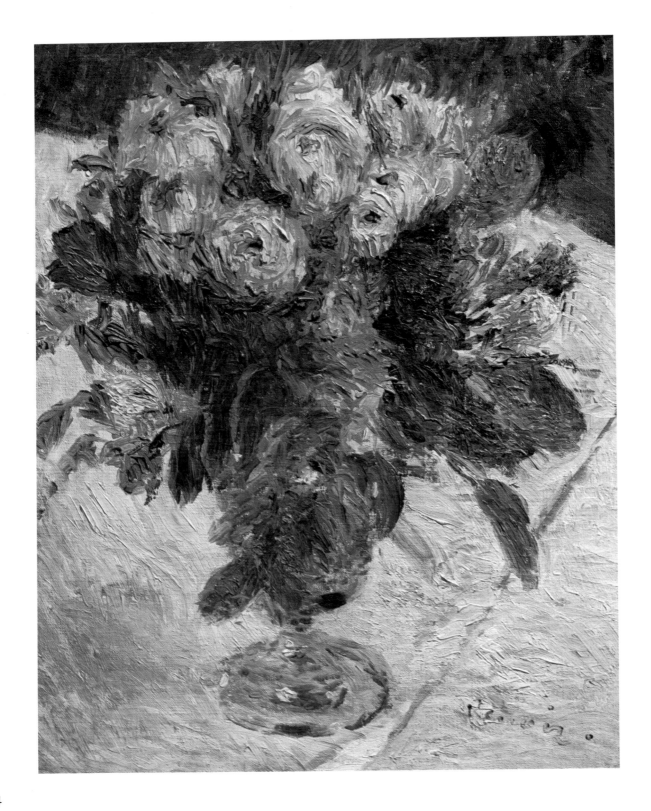

314

Now, try the various viewers: holding them before your still life half an arm's length from your eye, move them up, down or across until an interesting balanced arrangement can be found. Make a mental note of the important points that are to be incorporated and then arrange the easel and other equipment so that the viewfinder can be fixed to it by means of an armature while still keeping the chosen area in its frame. It is important that you endeavour to keep the position of your head constant as the slightest movement in relation to the viewfinder automatically alters what can be seen.

Proceed to work out a preliminary study of the painting in charcoal on paper to establish the main shapes and tones (how light or dark areas of the group are). The paper used for the drawing should be in the same proportions as the final painting. Endeavour to draw and place the objects on the paper as critically as possible. If things go wrong, and at some stage it is inevitable, just flick the drawing with a clean cloth or rub out the charcoal with a kneaded eraser or putty rubber. Then rework the drawing until you are reasonably satisfied with the results. This preliminary study will be really useful, helping to give a greater perception of the relationships within the still life group. When the drawing is finished, blow off the surplus dust and spray it with fixative at least twice. (Fixative is a resin and spirit mixture which can be sprayed onto the drawing to secure it to the paper; it is available in aerosol cans and in bottles.) Charcoal is a notoriously messy medium but perfect for setting out line and tone.

Since this drawing is a small preliminary study, it is quite easy to transfer the drawing onto a larger canvas accurately. This procedure is known as squaring up. (For these exercises it is best to use canvas paper.) For example, to transfer a drawing of say 24cm x 20cm (10in x 8in), to a canvas of 48cm x 40cm (20in x 16in) draw a grid of 2.5cm (1in) squares over the drawing. Double the dimension on the canvas and draw a grid of 5cm (2in) squares. The scale is now two to one. Then you simply transfer the detail from the squares on the paper drawing to the empty canvas squares. Use an H or HB pencil for drawing up the grid and be sure it is drawn as lightly as possible on the canvas, otherwise the grid could show through the final painting as many colours are semi-transparent by nature. Use thin paint (a neutral colour is best) and a small brush (a no. 3 flat or round hogs' hair is ideal) to plot the shapes onto the squared-up canvas.

The next exercise eliminates colour altogether. Use black and white and mix to make shades of grey to create a painting that is dealing strictly with tone. Tone means how light and dark things are; it is the amount of light reflected by the objects. The camera for instance operates on this basis. A few hours before beginning the painting, cover the canvas with a stain of very thin neutral coloured paint.

Fig. 6 Roses Mousseuses (*opposite*) *by Auguste Renoir is a beautiful study of a traditional still life subject, expressing a lyrical sense of atmospheric light and colour.*

Obviously, use a large brush to allow easy and even coverage. Place the canvas flat to achieve an even film of colour and leave it flat to dry. If stood up on end, the paint would run and create streaks. This stain will be invaluable as you begin establishing tones, for it immediately provides a middle tone from which to work toward black and white. Any mark other than the palest grey would register as dark on a pure white background and make accurate tonal judgements extremely difficult.

When the stain is dry, square up the canvas and work an outline map of the basic images on it, using the method described with a small hogs' bristle brush and thinned oil paint that has greater colour density than the stained canvas—something approaching black would be ideal. Using thinned opaque paint, lay in the large tonal shapes very quickly, endeavouring to find the darkest and lightest points first. (Remember the darkest tone might not be pure black or the lightest pure white.) This establishes the tonal scale within which to operate throughout the painting. Having laid in the large shapes in the opaque paint it is wise to allow the canvas to dry for a day, otherwise, for the inexperienced artist, the canvas can become a grey mess as over-painting and re-adjustments develop.

When the canvas is dry, continue gradually by adding more accurate shapes and tonal information to the large forms already indicated. To see tonal values with greater accuracy, half close your eyes and look at the still life through your eyelashes. This allows the light and dark shapes to stand out more clearly and not become confused with the local colours. For example, look at several objects that are of very different colours, such as a dark blue jug, a medium light red box and a light green book, in shadow (blue, red and green being the local colours). Because of their position in an area of shadow the objects will read tonally almost the same. Having completed the black and white tonal exercise try applying what you have discovered to the use of colour. Take a fresh sheet of canvas paper, square it up and plot the shapes onto a white ground as this will give greater brilliance to the colour being applied. Then, using opaque colours, establish the brightest colour and the richest dark colour first, leaving the intermediate shades and detail for last. If progress is to be made, a high degree of analytical study is required, looking at shapes and mixing colours as accurately as possible. This will develop a critical visual sense and result in a growing confidence through experiencing the medium. The most important point when viewing the result is how pleased or displeased you are; you are the sole deliberator.

Should you feel the results are disappointing, perhaps because the objects were too complicated, a simpler group can be constructed. Use some really simple shapes such as a cardboard box, a cylinder and a ball.

If this seems to be too restricting, add one or two more objects that are constructed out of the three forms already in use, such as a funnel. The advantage of doing this is that the absolute simplicity of the objects allows the shapes to be seen clearly without any confusing overlay of decoration. Proceed as before—tone, then colour. The problems are identical to those confronted in each of the previous paintings—rhythm (in painting, where the eye naturally follows), colour, line, shape, but these are somewhat easier because there is no decoration or texture to contend with. Additional possibilities exist with this set-up, for having explored tone and the object's natural colour you could then pick up and paint each actual object a different solid colour with emulsion paint. The same group then takes on a completely different personality, although the objects are the same and identically placed as before. From this exercise comes recognition that a change of colour means a change of image. This exercise further reinforces the need for a knowledgeable perception of shape, colour and rhythm within the surface of the painting.

Finally, there is the additional complication of the ability of the optic nerve to switch its point of focus. The eye is an ultrasensitive piece of equipment that can focus intently on foreground, middle distance or background. When designing, a decision must be made on the optic restriction to be imposed, otherwise an obsession for switching from one detail to another, or indeed one part of the painting to another, could occur, and, as a consequence, the basic intention of the painting would be lost. This is probably the most singularly difficult problem to deal with. A way of combating it is, having set up the group, actually to write down what is interesting and refer to that statement regularly during the act of painting.

Fig. 7 Les Musiciens à l'Orchestre *by Degas is an excellent example of how the most dramatic and large elements in a picture can sometimes be secondary to the focal point—in this case the dancers.*

In the Degas painting (fig. 7), although the artist is dealing with a large dramatic shape in the foreground which is crucial to the design and helps build the atmosphere of the subject, it remains secondary to the focal point of the dancers in pink, while the whole image reflects the overriding interest in light and colour and movement.

Numerous alternative approaches to painting exist beyond an analytical observation of a scene. For example the interest could be toward decorative, two-dimensional movements and rhythmic interplays of objects on a painted surface or, like the Impressionists, be involved in exploring pure colour.

Elements of Composition

This chapter encourages you to try painting a landscape, and explains some of the problems of composition that you will no doubt encounter; picture construction, perspective, and ways of thinking about colour and its uses in such a painting.

The English artist John Constable (1776-1837) did much to popularize landscape painting. His painting, *Dedham Vale* (fig. 1) epitomizes what is for many people the purpose of such a painting: the capturing of an idyllic moment of peace and contentment in contrast to the noise and bustle of the average person's environment. Impressionist artists like Sisley in his painting of *The Regatta at Molesey* (fig. 2) contributed in much the same way, using a less realistic approach.

What is it about a landscape that interests you? You are not living in the time of Constable or Sisley, although aspects of their visual stimuli still exist—natural light, trees, fields and so on. But a great deal has changed in our present surroundings. Man's presence is more positively felt through more buildings, both domestic and industrial; electricity pylons and telephone cables that stretch for miles across most of the natural landscape. Ask yourself whether it is this aspect of the environment that appeals to you. Although it is a less traditional theme, it is still worth portraying. On the other hand, your interest may be aroused by the sense of peace you experience when you have escaped from the city for a day. The rich changing surface of trees, ploughed fields, hedges, pasture-land, domestic animals, crops of different colours forming a patchwork on a hillside—all these have been painted many times by many artists, but how you translate them into visual terms will be original and unique.

You will notice as you go through this chapter that you are given the choice of building your landscape picture either completely from your imagination, or from observation. It could, if you wish, be a combination of the two.

Observation plays a vital role in many artists' work. Even an abstract painting can be 'tightened' up and mistakes corrected by adapting information gleaned from observational work. But by no means think that working from observation gives your picture greater merit than if

it were purely imaginative. You may even split your work into two separate compartments—perhaps observational drawings and freely imaginative painting. A good idea is to do detailed sketches from observation of features which are to be incorporated into your picture, and then take what information you require from them for your painting. Better still, carry a sketchbook around with you; draw in it, write down thoughts in it, plan pictures in it. This is, in fact, what artists throughout the centuries have done. Even in these modern times, contemporary artists use their notebooks in much the same way as Leonardo da Vinci used his at the end of the fifteenth century.

Working Outdoors

Working outdoors requires preparation and organization. You will need an easel as well as paints, brushes, turpentine in jars that won't leak, oil-medium, rags, a rectangular palette (for easy storage), a sheet of plastic to sit on unless you have a collapsible stool, and two or three small primed canvases of varying sizes. Also, considering the fickle nature of the weather, a sunhat and plastic raincoat would not be amiss. It might be worthwhile, before you set off for a vista miles from home, to view your own and your neighbour's back gardens as possible sources of inspiration.

Fig. 1 Landscape painting presents one of the most difficult challenges in composition. Constable was one of the first English painters to fully master landscape. Shown here is his fine study Dedham Vale.

For your first attempt at landscape painting try to avoid a view with numerous buildings that would necessitate drawing too many acute angles, at least not before you are confident you have mastered the rules of perspective, which are explained later in this chapter.

Beware of incorporating too wide a view for the shape of your canvas; this can easily happen when you are confronted by the huge expanse of a landscape. You would only end up trying to condense the forms to accommodate the canvas shape. Your viewfinder should be a useful tool in helping you decide your composition. A further useful device is the selection of a *focal point*. The focal point creates a natural pause in the eye's movement around the painting, and is thus a centre of interest. It might be, say, a group of trees that you feel are particularly important. You can accentuate them by increasing their size slightly or making the colour stronger. Alternatively, there might be a natural focal point in the landscape itself that needs no adjustment.

Fig. 2 Sisley's painting of The Regatta at Molesey *is a beautiful contribution from the Impressionist school to the genre of landscape, using a much less realistic approach when compared with Constable's work (opposite).*

Painting outdoors invariably means that you must work marginally faster. Finishing a painting in one day is certainly not wrong; you alone decide when work has reached the point beyond which you choose not to continue.

But remember that with one day's work you are only going to be able to achieve one application of paint. You will have to be confident about the decisions you make regarding colour and composition. Obviously, if you can return to the location several days running you will be able to develop your thoughts more fully. Traditionally, some artists, Constable among them, have done the bulk of the preliminary work outdoors and then returned to the comfort of their studios to develop the final paintings. If you are both patient and systematic you could confine your painting outdoors to the summer months, spending the winter indoors finishing the work started earlier in the year. In this case you may choose to buy a daylight colour-matching bulb for your working area, so that you can approximately match the colours found outdoors.

Painting and Imagination

Where do ideas for pictures come from? You may be lucky and find them easy to come by. Certainly they come more easily with experience.

The aim of the following pages is to familiarize you with the principles of landscape painting so that you have a structure to begin working within. Hopefully, by the time the painting is finished it will contain extra ideas and special touches of your own that make it into a purely personal picture. No doubt you will experience that strange blend of satisfaction with dissatisfaction that keeps you painting and seeking to improve.

Imagined landscapes have occupied artists for hundreds of years, although not always as a way of expressing a response to a beautiful scene. They offer a structure, an excuse for the artist to develop his own language of personal expression, which fundamentally is what painting is all about.

A major feature of most landscapes is the horizon. The words horizon and horizontal are obviously connected: on a piece of paper draw a shaky line horizontally across the top third of a rectangle. The result is that you have split the area into sky and ground. Remember, the horizon is in the distance so that anything painted near it will be smallish and will not usually stand out from surrounding areas. This is why the horizon usually appears near the top of the canvas, allowing plenty of room to depict the intervening space.

Later, when you begin your painting, you will probably include an horizon line. This can be very faintly pencilled in or, better still, painted sketchily in light blue thinned with turpentine (be sure it doesn't run!).

Draw everything onto the canvas with a pencil if you wish, but it's really not necessary. Most professional artists would map out the composition in line with thinned paint (often blue and brown), knowing that the exact shapes and colours will be painted over them later. Never overdo the preliminary drawing on a painting, it is a waste of time.

Foreground, middleground and background

Once the horizon is sketched in, it should be balanced by some vertical lines—perhaps trees or branches. If you wish, plan all this on pieces of paper which are in the same proportions as your canvas.

The trees will be of varying sizes and shapes. Those in the *foreground* of your picture—near rather than in the distance—will be tall, perhaps as high as the canvas (see fig. 3a). Don't make them too straight and don't worry about leaves and other details at this point.

Many people, left to their own devices, tend to draw their trees too small, as in fig. 3b. Generally, this is wrong and stems from a desire to give everything its proper amount of space, without giving it too much and thereby obscuring other parts of the picture.

There are good reasons for doing the trees as shown in fig. 3a. In fig. 3b an impression of looking down from above the trees is created and you may later find that you have trouble filling the canvas.

The main reason, however, is that fig. 3a more accurately represents what you see in real life. Look through your viewfinder at a section of landscape and consider the scale change from foreground, the part of the view nearest to you, to *middleground*, the space between foreground and *background*, which is nearest to the horizon.

Remember a *two-dimensional* or flat painting can only show an illusion of *three-dimensional* or solid space, so certain 'tricks' have to be used, and these help to create realism and depth.

Stand at a window with a view encompassing trees, buildings, cars and so on. Think of the window as your picture. Extend your hand at arm's length and use it to obscure a building, or any object that you know to be hundreds of times larger than your hand, as in fig. 3c. You are now well on the way to understanding the importance of foreground, middleground and background.

Your ideas for the painting should now be expanded, so that you are thinking of enough things that will give the feeling of depth to, and reasonably fill, the space across the canvas. One hint: overlap some of the trees or other features. A picture without any overlapping areas will look flat and artificial. Look out of the window; you will see how many things overlap in life. Those parts of your painting which are being given priority should, at the most, be only partially obscured: this is the beginning of the process of selection which you will eventually find yourself following when organizing your picture.

Above: Using trees in a landscape to express the vertical lines, and to demonstrate the principle of foreground, middleground and background.

So what actually goes into a landscape apart from the horizon and a few trees? Partly it depends on what you are trying to express. If, like Turner or Constable, you are fascinated by the moving shapes in clouds, you will place the horizon lower to give the sky greater importance.

Plan your picture initially from front to back, but keep the total structure in your mind as you progress. Work out the foreground first, since, if you try to create the impression of an enclosed woodland space with a very limited amount of depth, you will need less middleground and virtually no background, with a greatly reduced area for the sky. On the other hand, if you design the background first, with the size of everything reduced by distance, you could find that the foreground will later obscure much that you have already drawn.

Fig. 4 The foreground of a picture can be used to give a very intimate close-up contact.
Fig. 5 When viewing a subject for a landscape, it is useful to mentally divide the picture into several sections.

Imagine the painting to be your own field of vision, and decide how close the closest part of the foreground is to be. A bird perched on a branch could occupy nearly half of the canvas. Alternatively, it could still be the biggest feature and only take up one-twentieth. Individual flowers, leaves, branches, blades of grass, etc., could in this way virtually fill the canvas with foreground detail (fig. 4).

This creates an atmosphere of intimacy with the subject and will inevitably catch the eye. It can be contrasted with the grandness of rolling plains and distant hills which might be created by concentrating more on the middleground and background. Such a picture might cause a few more problems in filling up space and in relating one area to another, but these difficulties can, however, be overcome quite easily. Divide your picture mentally into sections as in fig. 5. Each section can be thought to contain the same amount of area on the ground, but on

your picture becomes smaller as it rises into the distance. A panorama of nothing more than fields stretching into the distance could be constructed using this system of division. Without being too systematic, you can ensure that the unevenness in size found between fields does not conflict with their appearing to get smaller as they go into the distance. A further point to remember: draw the fields with sloping lines at their sides rather than verticals parallel to the canvas sides. Such vertical lines create the impression of climbing into the sky. This illusion occurs because, as mentioned earlier, on a flat two-dimensional canvas you are painting an impression of solid or three-dimensional space. The painting by Vincent Van Gogh in fig. 6 illustrates these effects.

For this reason, and for a better visual appeal, do not have roads or rivers going straight from the bottom of the picture to the top. Make them bend and zig-zag through all or part of the canvas, becoming

Fig. 6 Van Gogh's Crows Over a Cornfield *(detail) is an excellent example of how to paint fields—notice how he achieves a three dimensional effect.*

gradually narrower as they approach the horizon. Return to the window; you will probably see that you cannot follow with your eye any visible roads or streams all the way to the horizon. They will go out of sight before getting there, even if they reappear from behind a hill, forest or village later.

Incidentally, the snaking of a road or river is helpful in making the viewer's eye travel around the picture, thereby keeping his interest alive. In other words, it also serves to link features of the painting together. A road may pass through a village, cross a stream, or fork in several directions. It may climb hills or descend into valleys. It may pass from danger into safety. It could contrast the difference between urban and rural life: setting the scene for an industrial town which is gloomy and grey surrounded by refreshing hills and mountain waterfalls.

Fig. 7 There are several traditional kinds of methods of composition. Bruegel's Hunters in the Snow *illustrates the 'L' shape, which has a vertical feature balancing a horizontal, both in the foreground.*

Consciously or subconsciously, in giving one thought priority over another, you will start to create the 'feel' of your landscape. A quaint village in the distance, set near a lake and at the end of a mountain valley, must create a different impact to a close-up of some tragic scene taken straight from the news headlines of the day.

Some principles remain constant however, and you will not want to forget to incorporate some overlapping. Hills covered by woods may partly obscure a valley behind. Broken layers of hills will suggest that your scene is just part of a vast expanse of space, again enhancing the impression of distance.

You have so far been considering, fairly separately, the elements of a picture which comprise firstly the foreground, and subsequently the middleground. What you put into the background will not essentially be different from the middleground, although it is of course pointless to include details here which are vital to the picture's impact—they may be overlooked. Any background details must form part of the extras which give your picture more than just a passing interest. Paintings should appeal in two ways: first, they should attract the viewer's interest, and then should keep his interest alive; this is, in part, the function of the background. Hills or mountains in the distance may help contain the eye and stop it following a road or similar feature straight out of the picture.

Fig. 8 Another method of composition, used here to employ large areas to focus on a smaller, significant area is a rough foreground frame around the outside of the picture.

More about Picture Composition

Keeping interest alive stems largely from sound picture composition or arrangement, and most successful compositions have a *focal point*.

Diagonal lines, in the form of branches, roads, people pointing, cranes and so on, move your eye from one part of the canvas to another and to and from the focal point. If one diagonal leads to another, continuous visual movement can be achieved.

Look at paintings by old and modern masters. See if there are any recurring compositional features—the following three are most common:

1. The L-shape, with a vertical feature balancing a horizontal, both in the foreground. The vertical can be on either side of the horizontal. Bruegel's *Hunters in the Snow* (fig. 7) is an example of the L-shape.

2. A rough foreground frame around the outside of the picture. This will focus attention on the middleground. It is best not to have the focal point dead-centre as this can look artificial and boring. Fig. 8 shows how this feature could make use of large areas to focus attention on a smaller, more important, area.

3. The Triangle. This arrangement was much used in the Renaissance period, and its uses are still applicable today. Curiously it provides a circular motion for the eye, which counterbalances the more dynamic

uses to which the diagonal is usually put. Look at fig. 9: line **a** could be represented by someone kneeling and pointing up to a figure, who in turn is looking down at something else along line **b**. Line **c** may just be a continuous line created by their costumes draping on the ground. *Déjeuner sur l'herbe* by Edouard Manet (fig. 10) is a sophisticated example of triangular composition combined with the fairly anonymous framing mentioned in 2. An additional element is the bundle of clothes. Probably a purely compositional device, providing a diagonal lead-in to the picture, this contributed to the storm with which this picture was received when it was entered for the annual *Salon* for established practising artists in Paris, 1873. The painting was rejected as indecent at the time—more probably for the men's calm acceptance of the naked woman, than for the idea of incorporating a nude into a work of art: a fairly commonplace occurrence. Notice as well how the horizontal lines break the triangle up into the more important foreground group of three figures and the additional figure of the woman in the background.

Figs. 9 and 10 Both these pictures illustrate the classic triangular composition. Below: Déjeuner sur l'herbe, *Manet.*

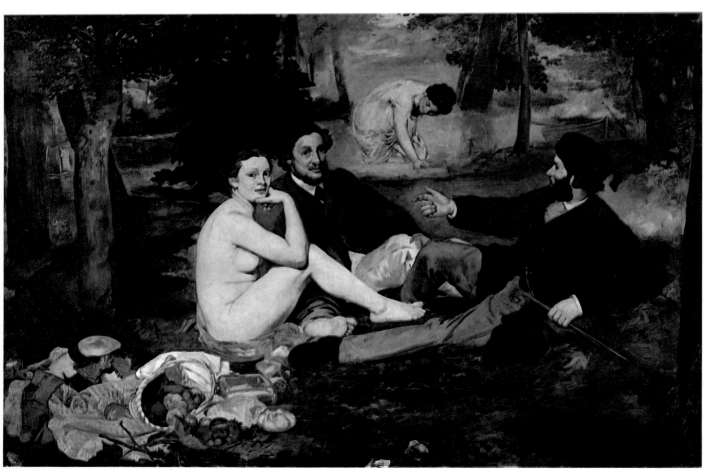

11a

11b

Perspective

Another structural device which is used in the middleground and elsewhere is perspective. Mention has been made of the shape of fields, of not having roads climbing straight up the canvas, and so on. You should now learn the basic rules of perspective from which these points were derived. Without understanding them you may end up with parts of your picture looking absurdly wrong, but now know how to alter them for the better.

Compare the drawings in figs. 11a and 11b, both of which represent overlapping buildings. If fig. 11a has anything to recommend itself, it is in the context of design and pattern. As an approach to realism, fig. 11b is more lifelike and more visually satisfying—for two reasons. One is that it incorporates side views as well as front views of the houses. Try looking at rectangular objects around you, in your room and outside. You have to place yourself in extremely odd positions to view tables, chairs or buildings from one side only, without seeing all or part part of at least one adjacent side. We see everything at an angle, and in three dimensions.

Now consider the second reason for drawing the houses as in fig. 11b: what if the rows of houses stretched further into the distance? How would we achieve a gradual reduction in their size?

There are subtle differences between figs. 12a and 12b. Fig 12a achieves the desired result, but not at all smoothly. Fig. 12b, by contrast, achieves it more smoothly and portrays the basic principle of perspective.

Imagine the unlikely event of your looking straight down a railway line towards the horizon. You know the lines are parallel, but you can

Figs. 11a to 12b Various devices can be used to explore perspective, as shown in these examples.

12a

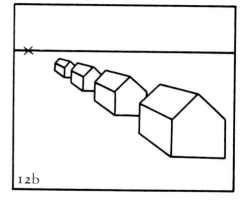

12b

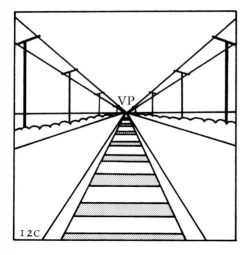

12C

see they appear to come to a point (fig. 12c). The rule that governs this happening is that parallel lines going towards the horizon appear to converge at the same point on the horizon. This is called the *vanishing point*.

Returning to fig. 12b, we can see that the row of houses follows this rule. Don't forget there are different types of line in fig. 12b: including those which are not going toward the horizon and, in that diagram, are therefore not in perspective—vertical lines, sloping lines and lines parallel to the horizon.

Try drawing the boxes in fig. 13 in perspective by joining them to the vanishing point (VP). Notice the difference between the number of sides which are now visible. Why are they different? Simply because one is below the horizon, the other above. Just because the corners are con-

Fig. 12c demonstrates the theory of the vanishing point.
Fig. 13 Draw boxes in perspective and join to the vanishing point; note the effect of the horizon.
Fig. 14 A curved line uses a variety of vanishing points. When the houses are parallel to the horizon, they are no longer in perspective.

14

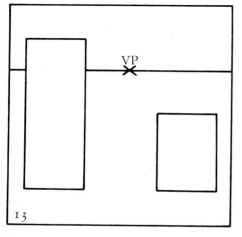

13

nected to the horizon in perspective does not mean that the boxes have to be the full length of the lines to the vanishing point. Looking again at fig. 12b we see the houses are cut into suitable house sizes, which reduce toward the horizon (things in the distance appear smaller).

For a row of houses or a street which curves, we use a variety of vanishing points (fig. 14), even if one of the vanishing points is off the picture. Where the curve of the road puts the houses parallel to the horizon, they are no longer in perspective. Let us now compare the drawings in figs. 15 and 16. You can see that in fig. 16 the house has two vanishing points. The rule here is that each surface that is turned toward the horizon has its own vanishing point.

Finally, remember that perspective is in evidence everywhere. Look

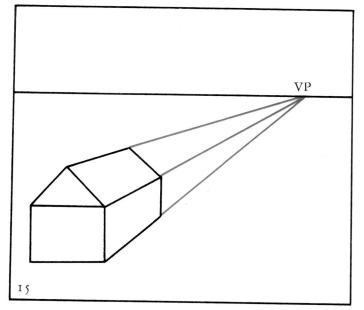

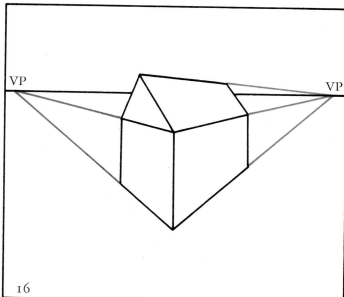

at fig. 17 and see how it applies in a living room; here the horizon or eye-level (the words mean much the same thing) is imagined. Notice that curved objects can be rendered in perspective too, and also that with anything supposedly divided in two (the window), the nearer half is depicted as larger.

Look for perspective in everyday life, especially in magazine photographs of kitchens and living rooms, etc.

It is not possible here to go into greater detail about perspective, a subject about which many books have been written. Visit your local library or bookstore if perspective is to play a major part in your work, but don't use perspective until you have mastered enough for your needs. Perspective is one way of making your picture look right, but in the final analysis, if you have achieved this without perspective you have still created a successful picture.

Putting everything together

We have discussed working outdoors, working from imagination, using foreground, middleground and background, and, finally, the uses of composition and perspective. Things will have been falling into place already, so that you will now have an idea of what your picture will look like.

Before transferring everything on to canvas, put it all together on paper first if you have not already done so. Three sheets of very clear tracing paper (in the same proportions as the canvas), placed on top of one another and drawn on in felt pen, should give an indication of how

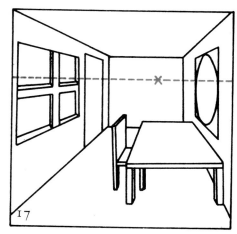

Figs. 15 and 16 illustrate the rule that each surface that is turned to the horizon has its own vanishing point.

Fig. 17 Perspective occurs everywhere, as in this living room. Make a habit of noticing how perspective functions in daily life.

well organized your picture is; how well the foreground, middleground and background go together. Is it too cluttered or too empty? Are the most important features prominent enough, and so on. The final piece of tracing paper should see the complete picture built up, after omitting or rearranging conflicting features.

Future pictures will almost compose themselves in your mind. You will find you can visualize increasingly well and will not need to separate foreground, middleground and background as you plan your pictures.

Size and proportion of canvas

You may already have chosen the size and proportion of your canvas. Some people (especially those working outdoors) choose the size and shape first and then fit a suitable scene into that shape. Others decide what they want to include and then choose the best proportions.

If you have trouble deciding what is best for you, consider the following points. Whether your picture is to be excessively large or else a miniature, you will need to consider carefully the factors of composition, contrast, balance and texture. So, for the moment, you should probably choose a fairly standard shape and size for your canvas. One which is 45cm (18in) square will provide a reasonable area to paint. But you may react against the regularity of a square canvas and opt for one that is, say, in the proportion of $1\frac{1}{2}$ to 1. This decision will automatically direct your activities to an incredible extent. In fact, it is one of the first serious decisions you will have to make (and then accept the consequences!).

Of course, commonsense plays a part as well. Imagine you are painting a picture of one of those gigantic South American waterfalls: you would be unwise to turn your picture sideways. In other words, a tall image requires a tall canvas. But a canvas turned horizontally can be ideal for many panoramic landscape situations.

What if you start painting and find that you have chosen the canvas proportions badly? You can hope partially to remedy a wrong decision about the proportion of the sides by focusing attention on the centre of the picture. Any unavoidable detail in the side areas should then be painted so as not to contrast too strongly with the background colours. The Cubist artists, principally Picasso and Braque, sometimes produced oval shapes in the centre of their pictures. A parallel situation on television is the use of a vaselined or blurred lens. This creates sharp detail in the centre of the screen with a blur at the edges. There is nothing to prevent you painting a blur of shapeless colours at the sides in order to increase the focal interest of whatever is in the middle of the picture. In fact this can be a very exciting technique.

The time has now come to start putting your ideas on to the canvas, but approaching an empty white canvas can be intimidating to many

people. If this is a problem for you, try daubing some thinned paint on immediately, using a colour that is appropriate to the final image, with no concern as to whether it will remain in the picture later. Certainly the first stage of blocking-in very rough, biggish areas of the canvas in diluted colour should not worry you too much. By using turpentine and other mediums which speed drying you can paint over anything you've already done within a day or so. The first stage, then, need not be too precious.

However you paint, you stand a better chance of achieving a successful picture if you roughly block-in the whole painting first. Here it is as well to give consideration to how much tonal contrast you intend having in your picture: how light will the lightest areas be and how dark the darkest? Is there a particular source of light? If not, it would be as well to imagine one, even one that is off your canvas. In this way the direction of the shadows will be consistent. Similarly, you could decide on a time of day or year: shadows are longer in strong evening light; all shadows will be muted on a dull winter day.

Once these decisions have been made, take a small hogs' hair dipped in a suitable thinned colour (or use a pencil if you prefer) and draw in the outlines of everything you need on your picture. Some details will be left out at the preliminary stages. As stated earlier, you should not overdraw; features like blades of grass or ridges on a tree can be tackled later. That is why you are using oil paints—to create an effect that pencil drawing cannot give you.

Unless you are easily confused, you may even allow lines to pass through each other at this stage. It is only unsightly for a short period of time, and it can prove useful. Consider the 'visual logic' of your picture —whether things look right or add up on the canvas. Quite often a beginner will forget this visual logic when overlapping and will not notice that he has created an impossible situation. Look at fig. 18 and imagine the figure without the tree. His arm is unbelievably long! So, check the visual logic of your picture. If you have made a mistake, don't spend too much time correcting it just yet: merely repaint an outline, perhaps in a slightly stronger colour.

Blocking-in

Now start blocking-in (filling in) the whole canvas. This is the time when your painting will be at its least attractive; but it is essential to establish the major colour areas before you begin the details and other elements of the picture. Once the surface has an 'undercoat', it approaches being a painting. So block-in with diluted paint, thinned with turpentine or a quick-drying medium to ensure you can get to the next stage reasonably quickly. You may want to block-in all your darker colours first, to give a kind of instant contrast (or polarization) to the canvas. If you do this,

Fig. 18 Every picture must have a visual logic. Imagine the figure in this picture without the tree. His arms would be absurdly long.

just indicate which areas are dark by using greys, browns, blues or greens which are a shade darker than middle-grey. By going to extremes too soon, you could destroy the picture's unity.

As an alternative to starting with the darker colours, you might block-in the sky first. In this case, remember that the idea of a sky being blue is only half the truth. More often it is whitish-grey with greyish-blue patches. Don't put your brightest blues on to the picture too early. Be economical with all bright colours until you can control them. As with the first notes played in a piece of music, the first few colours will determine the 'pitch' of the picture. Similarly, too dark a grey will also dominate. Extremes of colour or tone can come later.

A good idea is to block-in the sky with three related colours of similar tone (say three basic blues, greys or off-whites, with just one slightly darker). Accept that these will change as you go on.

It is perhaps worth mentioning that, should you incline toward the use of brighter or more imaginative colours, your sky can be any colour you wish: green or crimson skies are not unheard of in real life. Even if they were you could include them as you are master of your own ideas. Extra care and thought would of course have to be given to the colours used elsewhere in the picture.

Cover the rest of your canvas in the same way. Establish three main tones—light, middle and darker. You can either block-in using colours which are related to the final colour, or in colours which are softer and more neutral. This method establishes a tentative kind of unity in the picture. You will then think twice before breaking that unity with a discordant colour.

Maintaining colour unity

Having started off with the whole picture in mind, aim to keep its unity throughout. Refer back to the colour wheel in the Handling Colour chapter. If your main areas of colour include all the complementary pairs (or some of them): red and green; blue and orange; yellow and mauve; or colours similar to them (e.g. *pink* and green), you are likely to destroy your picture's unity. You will see from the painting in fig. 19 that it is possible to incorporate all of these into one painting, but the problems are increased. Once you have decided which colours are essential, you can plan the rest to suit the unity of the picture as much as its realism. For instance, the colour of a tree is not necessarily brown. Trees are grey, green with moss, whitish-brown, reddish-brown and so on, so you could adapt their colour if desired. If you want a particular colour for painting, say, an elm tree, it is useful to know that one way to harmonize colours is to add a hint of colour taken from an adjacent feature. They will sit better together on the canvas and, if it is not overdone, both colours will retain their identity.

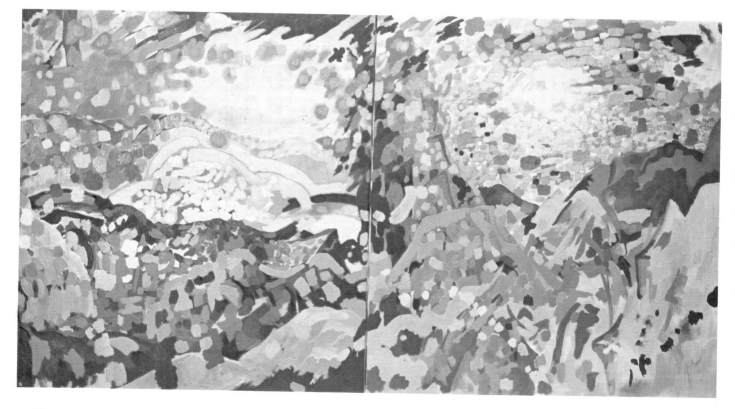

The natural division into sky and ground can lead toward either disunity or harmony within a picture, depending on how they are coloured. For example, an orange sunset about a blue seascape would need an extra unifying feature to pull the two together. This might be something vertical (a tree on land, a lighthouse). Alternatively, a pale blue-grey sky against a misty sea may need a stronger colour in the foreground to give it vitality.

If you find colour control a problem, limit yourself to part of the colour wheel as the maximum colour range for the larger features of your canvas. This may be as narrow a range as blue, blue-green and purple, plus their associated greys: blue-grey, mauve-grey, with perhaps brown added (blue being an ingredient in the making of brown).

A further way of keeping harmony within a picture is to make every colour the same tone. In other words no colour is lighter or darker than any other. If they are all to be light, white must be added to make a blue as light as a yellow. Conversely, if they are all dark, the yellow will need darkening, making it the same tone as the blues. Remember, however, that yellow is the most easily destroyed colour, and that darkening it may turn it slightly green or brown. This is an artificial method, especially if you lighten the tones. Lightening tones is associated with

Mountain Landscape (fig. 19) by David Rose is very much about the relationship of colours, while the rocks and mountains provide a loose structure in which to explore this.

335

some modern artists who use bright colours. It was used initially in the last century by Turner and then by the Impressionists who were all vitally concerned with the changing effects of sunlight. Very often they would paint in early morning or early evening light, staring straight toward the rising or setting sun. They would even paint in mist and fog. These lighting conditions automatically made the tones more even (provided the painter positioned himself to take advantage of them). These artists had a natural affinity with bright colours, one that contributed later to the momentum of twentieth-century art. Much of this century's art has abandoned or lessened the importance of absolute realism. Consequently painters have been free to experiment with the optical effects of colour.

Equally-toned colour has a natural tendency to give an ambiguous spatial effect. Its evenness, for example, tends to create flatness. On the other hand blue creates the feeling of distance, and red of closeness. Consequently the flatness is balanced by the artificial illusion of depth.

It was fascination with ambiguities such as these that inspired Turner, Monet and Seurat in the nineteenth century. Matisse and Bonnard followed with their particular interests in colour early in this century; the trend has continued up to the present time with the work of Albers, Vasarely and, most recently, Patrick Caulfield.

Since the development of photography, artists have been less concerned with pure realism, because it can be captured instantaneously on

Norham Castle, Sunrise *by Turner. The effect of painting through a misty, early morning sunrise is beautifully shown here, and gives an even quality to the tones in the painting.*

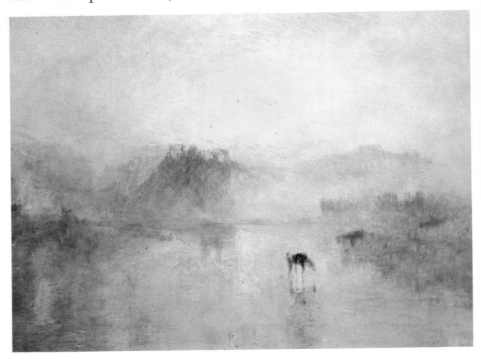

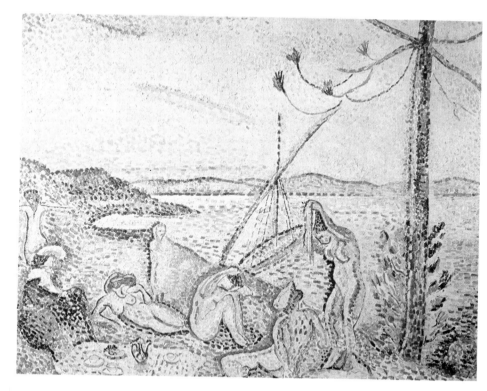

The questions posed by different effects of light and colour were explored throughout the nineteenth century, and well into our own era. Matisse uses interesting combinations of primary colour with a style unusual for him in his work Luxe, calme et volupté.

film. You can see that, in the case of the artists mentioned above, the link between them would be an interest in the different effects that can be achieved through a masterly use of colour. They are all serious artists, yet the latter ones have been concerned with design, composition and optics without realism as much as Turner and Monet were involved with depicting what they saw.

As you gain experience in painting, you may well find that many prejudices against modern art will evaporate. Not all of them will, since even some artists fail to understand one another; but you may gain a degree of tolerance for their work by understanding the problems that they have faced.

Returning to the question of the picture's unity, it is possible to formulate a rule for avoiding disharmony. One could say that a colour range covering the whole colour wheel, painted in dissimilar tones and with a lack of structuring, is a formula for disaster.

By avoiding all the pitfalls you may find you have fallen into the equally dangerous trap of creating a bland or anaemic picture—one that is 'nice' but uninteresting. Be bold in your decisions and let your boldness show through occasionally in your work; but at the same time remember at the back of your mind the question of unity, the totality of your picture.

Toward a finished picture

You are now virtually on your own. Unless you paint at evening classes this next, most important, stage of your painting will be done without being overseen by a teacher or experienced artist. Painting can be a solitary business and often many of the problems can only be resolved through experimentation. On the other hand, it is not a bad idea to join an art club or circle to experience some constructive comment and criticism.

Let us, as far as possible, be practical about the final stage. We talked earlier about whether it was feasible to start painting at the top left-hand corner of your picture and continue by working across and down. Generally, and this is important to the 'look' of your picture, paint distant features first. This is logical, since if you paint a tree before the

Landscape doesn't only encompass country vistas of trees and fields. An urban/industrial scene like Lowry's (below) shows how strongly evocative this genre of painting can be.

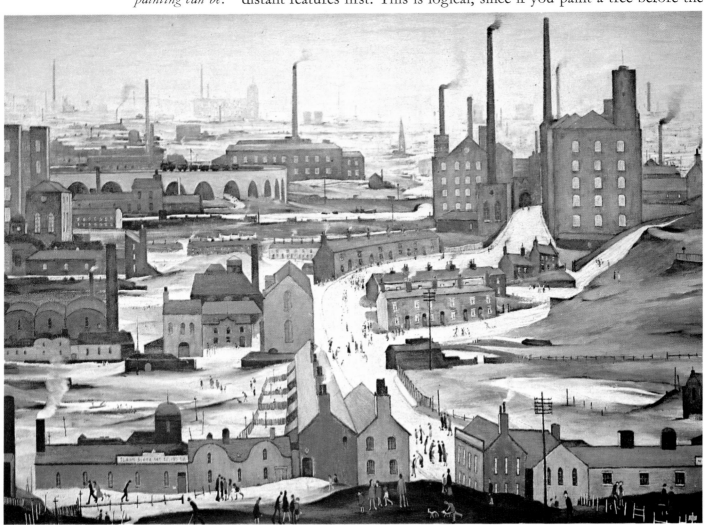

sky behind it, there may be an almost invisible overlap, making the sky look as if it were coming forward around the edges of the tree. Similarly, paint large areas before smaller ones.

Much has been said about the different directions your picture could take. Decide now whether you want to aim for as real-looking an image as possible, or whether you are more concerned with a decorative design loosely based on landscape. Choose whether you will paint each separate area with one flat colour or aim to create the impression of solid reality by using light and shade as much as possible. There is no in-between measure. It is strange that a tree painted in, say, two shades of brown will look worse than one painted flat or one painted in several shades.

Try looking at a brand new red car in bright light; you automatically accept its colour as red. Upon close inspection you will see there are several shades of red: in fact, where there are reflections on its shiny surface, you may wonder whether you are looking at a red car at all. Look again at the whole car. It is still undeniably red, its colour creating a total impression first that only on scrutiny is revealed to be made up of several other colours and tones. The total colour impression, in this case red, is known as *local colour*.

Ponder for a while on what it is that makes all these colours so different and yet combine to give an impression of 'redness'. This phenomenon is not restricted to brand new cars. The clothes you are wearing, the wall against which you are standing, everything has its own local colour which is affected by its surroundings, by lighting and so on. In fact, this is one of the ways we perceive objects to be three-dimensional. Stereo-scopic vision without the effects of light and shade would be useless.

It is worth noting that before the time of Turner and the Impressionists in the nineteenth century, shadows were automatically represented by very dark tones. Shadows were not excluded from their work; instead blues and mauves, dark greens and browns were substituted for darker, more blackish colours. This lightened their pictures by comparison with, say, the chiaroscuro of Caravaggio (see fig. 7, Techniques).

Black, sometimes called the queen of colours, is also about the most dangerous colour to use straight from the tube. Pure black is not found in visible nature. Even black clothes are a very dark shade of grey. Try squeezing out a little black paint from the tube and then look for something around you that is as black as the paint. You will probably find this impossible. The nearest you get will probably be something man-made. Apart from this, black can easily kill the effects of other, lighter colours. To a lesser extent a dark black-grey without any added colour may also disrupt your picture's harmony.

There are, however, always contradictions in art (which accounts for part of its fascination), and you may find once or twice that black is just the colour needed to set your picture off.

339

Figs. 20a to 20c Partial realism is best achieved by painting the subject in patches of colour.

Always mix your colours; avoid, where possible, using them straight from the tube. Even your brightest colours should be mixtures. Colours straight from the tube, if used in large areas, will lack depth and be unsatisfying.

If you are aiming for partial realism at least, and consequently for a variety of colours on any one object, paint your colours in areas or patches. Don't just follow the contours of a tree when painting one. Most subjects can be painted in two directions. The tree (fig. 20a), which is basically vertical in its structure, will look better if painted in a way which also takes account of its roundness (fig. 20b). For this reason, many professional painters temporarily disregard the obvious structure of what they are painting. Once the basic colour is blocked-in, they might paint in patches of colour, using here a small dab of paint, there a longer brush stroke. There may be areas of colour which if scrutinized appear to be of a strange shape, as in 20c. Upon analysis, however, their role is clearer. The shape here is an ideal compromise between upward and curved horizontal strokes. By standing back from your painting you can inspect it to check how it works as a whole. In this way you may paint a dab of colour in one part of the picture and then another far away from your first mark. You may not choose to paint in this way, but there are good reasons for doing so. First, if you build up the depth of colour on one side, it will eventually need balancing elsewhere. Secondly, it is best to keep returning to an area, adding small refinements until you have built an image that may have literally dozens of adjacent colours.

As a mental exercise think about putting, say, twenty slightly different shades of red in an area 5 cm (2 in) square. Inspection of Monet's *Water Lilies* shows that he would paint dozens of very similar colours adjacent to each other. What we see in an instant is really the product of a great deal of time and repeated attention by this artist. He would continually return to one particular area, in between painting other parts of the canvas, adding a subtly different colour here, another there. In this way he achieved a final richness which is a veritable profusion of colour. It is of course not necessary to go to these lengths. Indeed, Monet's paintings are an acquired taste and you may yourself prefer to have less fussy detail by painting with fewer colours than he did. Undeniably, however, such paintings will first catch your attention and then keep it, making you look again. A real work of art should be relished or savoured. One day you may well discover a painter whose work captures your imagination completely. Such a reaction is different from admiring technical skill, although such skill may well be present too. Indeed, what is technical skill? Is it the ability to paint photographically, so that you feel you could almost pick an apple from a painted still life? Or is it the ability to convey in paint an idea or emotion which may be totally unconnected with realism? For the moment, imagine that you do want to

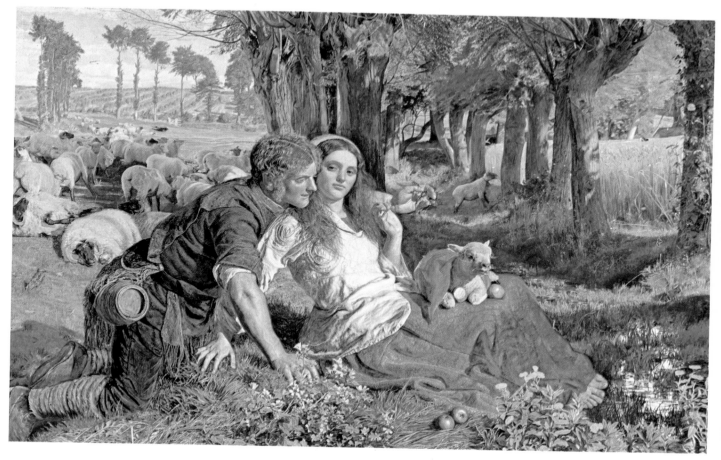

achieve a kind of realism. Two factors will be involved: first, the totality of painting and, secondly, your accuracy in matching painted colours to their counterparts on the object or scene to be depicted. A painted tree is an illusion; it is not a real tree. So, can a man-made product, your oil paints, be used in such a way as to match natural colours exactly? Certainly the relationship between colours can be matched exactly to the original. Practice will make your colour matching more accurate. The tendency when first trying to match a colour is to keep adding fresh paint to an approximately correct colour. Often the result is that you mix ten times the amount of paint needed, it gets out of control through being too thick and oily, and it may even then be the wrong colour! In this situation you are faced with a choice. You can temporarily make do with the approximate colour and refer back to it later. Alternatively, you can halve the amount of paint already mixed and then add another colour to correct it. Each time you add a fresh colour, split the quantity of paint in two, so that you are only altering a small amount. This should prove more economical, as well as allowing you to go back one

The Pre-Raphaelites attempted to depict reality by capturing every detail. Sometimes this created an opposite effect of unreality, as in this work called The Hireling Shepherd *by William Holman Hunt.*

or two steps should it go wrong: instead of adding, say, Alizarin crimson to a colour, you might return to it and now add Cadmium red. The ensuing change may be exactly what is needed.

Compare the colour you are matching with the nearest tube colours. To see what is required to alter it refer back to the chapter Handling Colour.

To match colours exactly you should have continuous access to what you are painting. If you do not want to paint outdoors, but still want to capture nature's colours accurately, you can compromise. A few different coloured twigs and broken branches picked up on a walk will give you a reference for tree colours as well as some tree shapes in miniature. A small piece of rock is different from a gigantic cliff in scale alone. The effects of water can, perhaps, be imitated at home by placing a neutral-coloured bowl of water near objects of similar colours to those you are painting; in this way the water will pick up their colours and reflections. House or garden plants can be adapted: their colours are the colours of the countryside, their shapes can become the shapes you require; woodland or even jungle. Flowers are easily obtainable for painting at home.

In his evocative painting Early Sunday Morning *by Edward Hopper, the artist has used shadows as a source of contrast.*

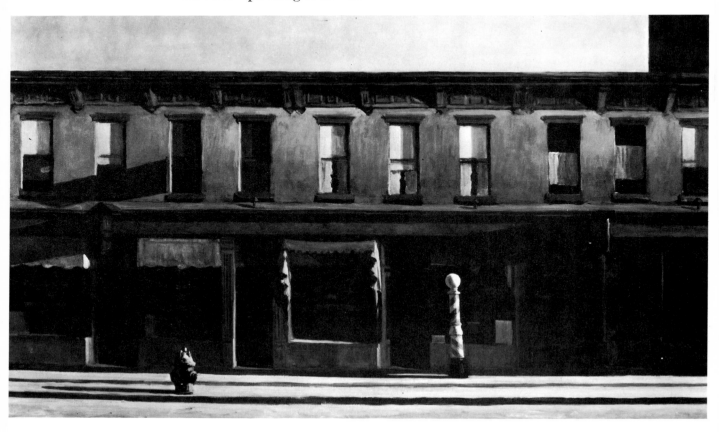

There are some problems which remain if you work at home. How do you paint green grass across two-thirds of your picture without it becoming boring? And how do you get variety into the colour of the grass? The easy way out is, of course, to avoid the situation and not paint anything with a gigantic expanse of one colour. Failing this, use observation to show you the variety of colours that one field of grass may contain. Otherwise, you have to develop a fertile imagination. For instance, it may be true that one field is to occupy two-thirds of your canvas, but blades of grass in the foreground of the field can be painted to obscure much of the distance. Because the grass is in the foreground you can use a variety of different greens, not all of them pure or bright, interspersed with patches of a ginger or brown colour to suggest earth. They may be twisted or bent because of the way they have grown, or because of bad weather. A few thistles or flowers may poke through. Clouds in the sky may create a slight shadow effect which breaks the distant part of the field into two areas of green and blue-green. Within these areas there may be other, more subtle variations of colour. The clue to solving the problem is to break the large area down into small, individual shapes and units which require a particular kind of handling, and thus remove the problem of not knowing what to do with a large shape.

Much the same situation is found in painting the sky. Here the colour range may be tremendous, but it must all fit together. There may be a dozen different shades of grey and blue-grey with an occasional near-white. Sketching or just observing for a few minutes at a time will improve your rendering of skies. To start with, perhaps you could go to extremes and tackle a sunset with strong colours (but not too strong) or a dull day with virtually no colour variations. The in-between type of sky where there are lots of colours, but ones which need a maximum of control, could come later. Paint the bulk of the sky with horizontal brush strokes; a sky painted vertically, diagonally or haphazardly will look peculiar. One tip in painting clouds is to remember that they hardly ever stand out in strong contrast all around. In other words, if a silvery cloud is *highlighted* against blue sky on its left edge, you may find that its right and bottom edges are *blended* into the sky. There may be a gradual series of colour changes within the cloud shape. There will be times to be bold, however, and you will need to include some strong line occasionally. Look at fig. 21, you will see this effect very often in skies, draped fabric and even shadows. One side is in strong contrast to its background, on the other it blends gradually. Look around you for similar examples of this happening.

All shadows are strongest where they originate; for example, a tree's shadow will be strongest where it touches the base of the tree and will fade gradually as it moves out from it.

Fig.21 When painting clouds or fabrics, notice that often one side is strongly contrasted, while the other blends gradually.

Paint shadows on foliage first, adding highlights where the light catches the outer leaves later. Don't bother with painting each leaf as a separate colour. Break the foliage down into three or four shapes of colour; one for the darkest area in the middle of the tree, a not-so-dark area to one side of the tree, and a very light area on the opposite side. These can be left quite distinct initially. When you paint dabs of colour for the highlights into shadow areas, or odd shadows into the lightest area, the shapes will break up to form an over-all mottled effect. This is much more economical and satisfying than painting every leaf separately, although flowers can be painted either in this way or petal by petal.

More unusual items, such as the colours of a bird, can be obtained by direct observation, or if necessary from photographs. Do not rely completely on photographs as a source of material. The development of your creativity or imagination is just as important as the development of technical skills.

So your landscape painting should now be approaching completion. When it is finished, make a point of hanging it. Do not be shy about your work; your paintings are something you have created that nobody else in the world could do. The only person qualified to judge them in the long run is you. You will certainly criticize your work when it is on the wall, and perhaps be dissatisfied. But you will discover bits in it which you like as well; often accidental parts are the most fascinating.

Try putting your pictures on the wall before they are finished. Tack them up with masking tape, prop them on chairs and leave them for a few hours or days. If you're busy with a job, or have housework to do, you won't be able to paint non-stop. It helps to keep the painting in your mind's eye as much as it helps to leave it occasionally. Let your living room be a bit messy for awhile: mull over your picture from an armchair.

It is difficult to sit doing nothing, just looking at your picture, waiting for a reaction to it. Don't force yourself to analyze. A conviction will grow on you that may confirm something to be wrong, or reveal what the next step should be. Play some music in the background to create the same 'feel' as your painting. Do this perhaps while you are painting too. Probably the secret is not to be too systematic; don't be scared of turning your picture upside-down or sideways to see if there are any obvious mistakes. It is surprising how this will work.

Once your painting is finished you will have already learned much about picture-making, both from the point of view of technique and of what makes a successful painting. Do you like what you have done— are you partly or completely satisfied? Perhaps now you will feel sufficiently motivated to carry on and find out more about painting. The next section takes what you have learned a stage further, and applies it to other aspects of the media, namely painting the human figure.

Improving Observation

Figure painting

Once you have attempted the still life and landscape projects in the previous chapters, you will be in a position to tackle some figure painting, having discovered much already about colour, tone, shape and composition. These remain the essentials of painting the figure, except that your powers of observation, or drawing, will now play a greater role.

Artists have drawn and painted the human form for hundreds of years. Even today it still occupies very many contemporary painters. Why is this? It is possible to attempt a landscape painting without once looking at a landscape. Your own style and sense of what looks right may be enough to carry you through, but in figure painting you cannot make guesses. The greatest artists drawing a person from imagination would probably not be able to do as good a picture as a reasonably good artist working from continuous observation.

Nevermore by Gauguin—one of the painter's langorous and exotic Tahitian nudes.

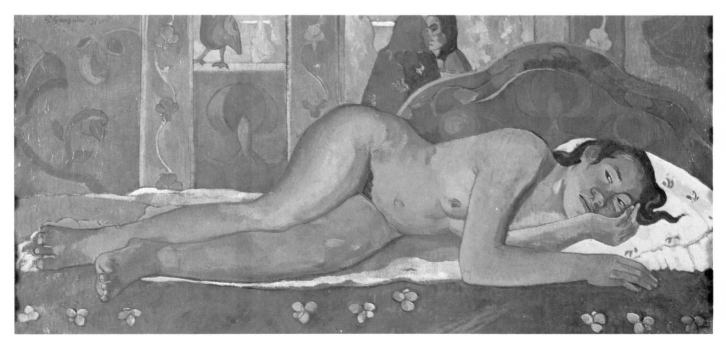

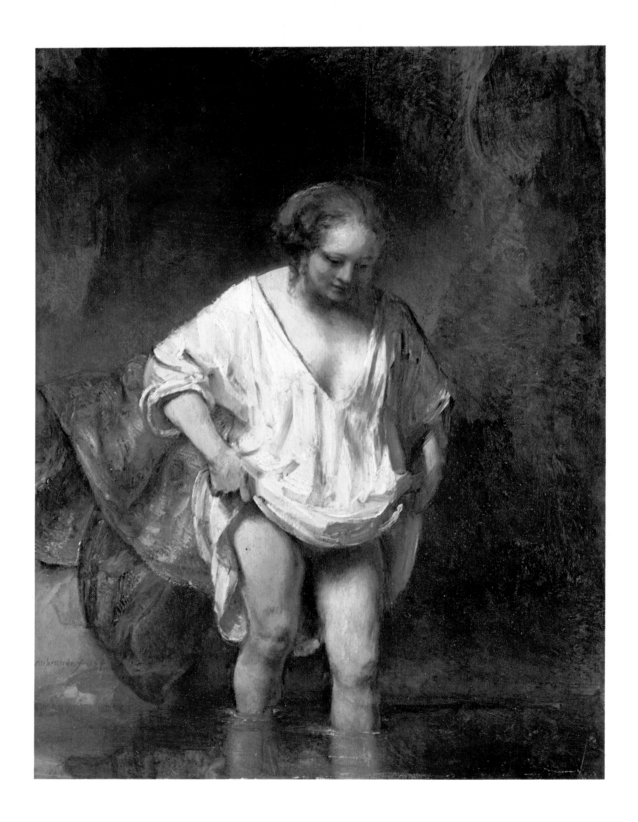

346

The human body is made up of a series of surfaces, or planes, which run smoothly into one another, and yet each of the planes will have its own exact shape.

Look at Rembrandt's *Woman Bathing* (fig. 1). Study first of all the outline, itself complex enough. Notice that it would be possible to trace the basic shapes with a ruler: that the figure can be broken down into a series of straight lines and angles (fig. 1a). It is always a good idea to look for angularity in the human form, but look closer and see how many curves are present too, just in the outline of the basic shape. There is a concave curve on her right arm, which, if it were any more pronounced, would look ridiculous, and yet it is just right. See how the opposite side of the arm is balanced by a very firm tensing of the muscles. There is much, much more to this picture than just a woman bathing. Rembrandt's drawing and painting style are compatible with the scene. He has created an impression of a girl who is decidedly feminine, but at the same time, sturdy. Compare it with the generous roundness of *Nude in the Sunlight* by Renoir (fig. 2). There the straight lines are kept to a minimum, enhancing the softness of her figure.

So, understanding the basic pose in Rembrandt's picture, look now at the painting style. If the painting were not in front of you, you would probably say that, generally, flesh colour is pink. There is not much pink at all on the woman's body, the colour is created entirely with dull creams, greys and browns, with perhaps a tinge of green. There may be just the merest hint of a creamy pinkish colour on her chest. Notice the softness within each area of flesh: the gradual changes of colour. The colour has several roles to play. It has to suggest the curves within the form (for example across the right thigh) by showing accurately where the body responds to light and shade.

Consider the difference for a moment between the roundness of a coin and that of an orange: the coin is round in one dimension, and can therefore be drawn easily on a flat surface. The orange is round in every dimension and is thus harder to depict on a flat surface. The same problems of capturing shape and volume are present in painting the figure.

Additionally, the colour emphasizes the intimacy of the situation. The background is in muted browns; the figure's shadows are in brown, too. Consequently, she is partly standing out from the background, partly merging with it. Remember that it was painted in 1654 and represents a very delicate scene: a young, partially-clad woman bathing. Rembrandt has handled the pose masterfully and yet delicately. There is a suggestion of private enjoyment on the girl's face, with her rich-looking clothes abandoned behind her.

Notice the different types of brushmark. The shift is painted with very bold brush strokes which remain visible for what they are; on the body

1a

The figures here and overleaf show the artists' use of straight lines and curves to define the complex planes of the human figure. Opposite: Woman Bathing (fig. 1) by Rembrandt. Above: The body can be broken up into definite lines and angles (fig. 1a).

they are blended more into one another. The *Nude in the Sunlight* was painted 221 years later, in 1875. Can you see that the setting is identical in concept to Rembrandt's: an intimate scene of a naked girl seemingly in the middle of a wood?

Now look for the differences. Renoir's painting seems much less discrete, more deliberately voluptuous. The creams and browns which go so well together in Rembrandt's picture have been replaced by pinks and greens, virtual opposites. This makes the figure 'jump out' of the picture.

Fig. 2 Renoir's Nude in the Sunlight *has an identical setting to Rembrandt's painting which was painted 221 years before. The two paintings make an excellent study in contrasting styles and methods.*

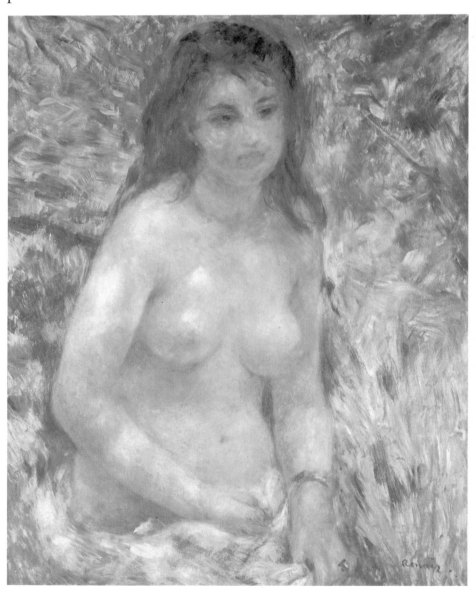

Look at the flesh colour. This time it *is* pink. But it is also mauve, blue and green in places too. Why has Renoir broken the figure up into a series of blotches? The reason is interesting in that both he and Rembrandt were passionately interested in the effects of light. But in Rembrandt's case it is lighting—the use of light to create a dramatic effect. Renoir is trying to say that the figure cannot be painted as totally separate from its surroundings because it will pick up the colours of those surroundings. So, ultimately, is Renoir's painting that different from Rembrandt's whose figure was integrally related to its background as well? Perhaps the differences are those of time, personality and society. The similarities are a reflection of what may be a constant in art: the challenge of mastering a figure or still life arrangement and imposing your own personality on it.

Structurally, Renoir's picture is very simple, perhaps deceptively so. The head is leaning towards our left, balancing the body's slight tilt to the right. If the head had continued the direction of the body it might well have created a feeling of leaning or toppling over.

There are a few straight, angular forms, notably in the arms and in the over-all pose, which balance the exceedingly soft shapes elsewhere. But there is nowhere a suggestion of tensed muscles; the feeling is one of complete relaxation, perhaps even abandon.

Just because Renoir's picture is softer throughout than Rembrandt's, do not make the mistake of thinking that it is less well drawn. The forms are all exact, the brushwork loose but controlled. A few dabs of colour are enough to suggest a wistful expression on the girl's face. The shapes of stomach, breasts and arms are all precisely observed, but they do not claim to be more important than the over-all impression created by the setting. Remember that when drawing or painting the figure, the setting is an important part of the whole. It can be painted precisely, as were many society portraits, to show details of a drawing-room or the sitter's possessions. It can be merely hinted at, as in the two pictures mentioned. You are creating an atmosphere or environment whenever you paint the figure.

Practise drawing figures as often as possible. Sit in a park and draw bits of people as they walk past—a successful figure painting is made up of accurately observed parts. Get your family to pose for you.

Eventually, you will have to decide whether you want to paint the figure nude or clothed. If you would prefer to paint the nude, you might enquire at your local library to see whether there is a painting group nearby. This would allow you to deal with the body's shapes and colours direct. You may even decide to form an art group and hire a model yourself. Painting clothed figures also requires an understanding of the form beneath. Clothing hanging on an arm or leg will often blur an outline, but will irrevocably be linked to the shape below.

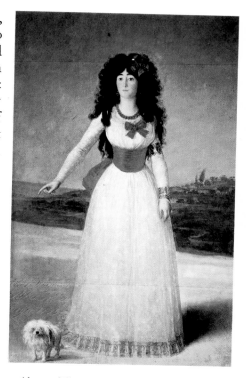

Above: The Duchess of Alba *by Goya (1795). In portraiture, the background can be very important in conveying a sense of the personality and the texture of the subject's life.*

It is, therefore, very important to get experience of drawing the nude figure from somewhere. If you do not have a model you can obtain books on anatomy for artists. The changing curves and straight lines on our bodies are directly linked to the bones and muscles below the skin. Get to know what positions the body can and cannot adopt. For instance, a leaning pose will need to be balanced by a support of some kind: the arms resting on a chair, against a wall, etc. When using a model, remember to take into account his or her comfort. The model will need frequent breaks from an awkward pose, so you will need to chalk in the position of the feet.

Right: Nude *by Howard Nicholls.*

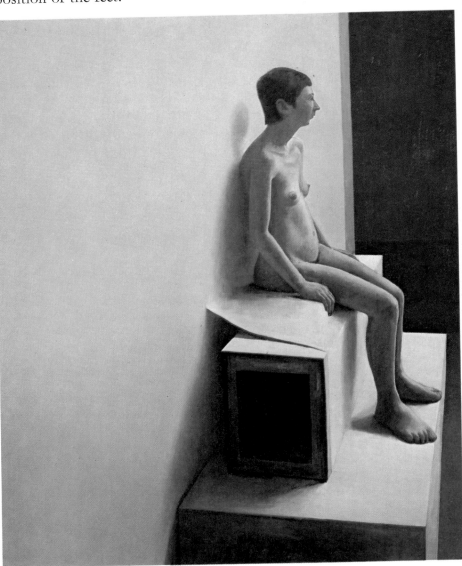

Your poses should be interesting. Don't just place a figure standing upright, hands at the sides, looking straight toward you. There can be a difference of stress between the top of the body and the lower part, between the left side and the right. For example, suppose you were given the title 'Depression' to express in paint. You might seat the figure on a chair, with its head in its hands which are in turn resting on its knees. This would create a hunched-up, curved-back, 'tight' feel,

When posing a model, make sure you look for interesting angles and effects. La Siesta *by* Alsina *is a superb study of the body at rest.*

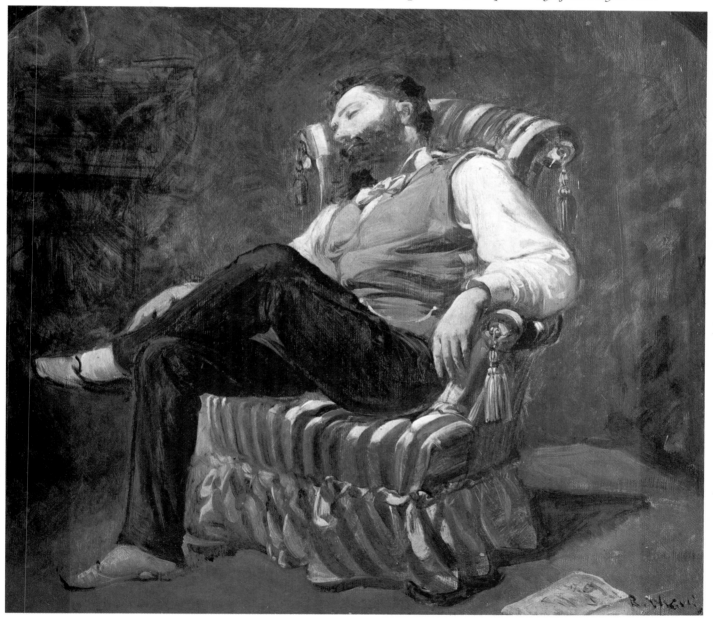

The human face can be an endlessly absorbing subject. As with figure painting, observation is crucially important. Examine the portraits on this page and opposite to see how painters use different techniques to explore personality.
Right: Portrait of Chopin *by Delacroix.*
Far right: Mona Lisa *by Leonardo da Vinci.*
Below: Self Portrait *by Vincent van Gogh (fig. 3).*

partly balanced by legs hanging straight down to the ground. Try posing the figure with its weight on one heel, arms folded, the other leg contrasted by having its toes only just lightly touching the ground.

The human body in art is a potential reserve for action and emotions. Your picture could show tension, relaxation, joy or despair by the way it is posed and by the colours and style used in painting it.

Portrait painting

You may want to paint portraits. Here the problems are the same and again observation is the key. Never take shapes, proportions and angles for granted; awareness of these factors is the backbone of good observation. Check the size of one feature against another. Remember that a face could be divided into two equal or symmetrical halves; but it is at an angle to you, the features nearest you will remain roughly the same size and those which are turned away will be more drastically altered. They are *foreshortened* or squashed into a smaller space.

One eye in Van Gogh's *Self Portrait* (fig. 3) is immediately adjacent to the nose, the other a further eye's width away. It is more interesting this way and, since the eyes are still turned towards the onlooker, quite disturbing. This is typical of Van Gogh's work. He was a tormented man, tormented by loneliness and driven by deep feelings of inadequacy. The violence of his feelings is shown in the way the paint is streaked on to the canvas. But detail is not obscured. Eyelids and creases around the

eye are minutely observed, as is the nose. Look at the shape of his head, how precisely it is carved out of the picture. The coat and background are impressions only, but still reflect his desperation in their handling.

Before you impose a definite style, such as streaked brushmarks, check you have captured the essentials. The eyes are the most important part and if they are unsuccessfully rendered, the picture will fail. Make them the first priority.

More about still life

With your new-found experience in observation you will probably return to doing more still life, landscape and imaginative pictures.

Look at fig. 4, the still life by Paul Gauguin. Like all good still lifes it is simple but bold; in its shapes it is fundamentally a realistic picture, but the artist has slightly strengthened the colour, so that the picture is basically all red and blue. In other words, the colours are approaching being complementaries. This produces the contrast between the turquoise cloth and the red sideboard. They immediately catch your attention and make you look at the more subtly-shaded fruits arranged on them.

But the turquoise and red have been modified, so that while the contrast is maintained, they are brought together by patches of grey-blue

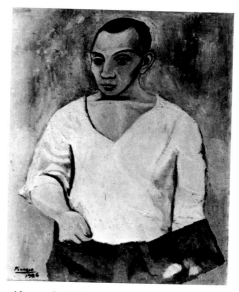

Above: Self Portrait *by Picasso*
Fig. 4 (below) Observation is very important in still life work. Notice the use of colour in this still life by Gauguin.

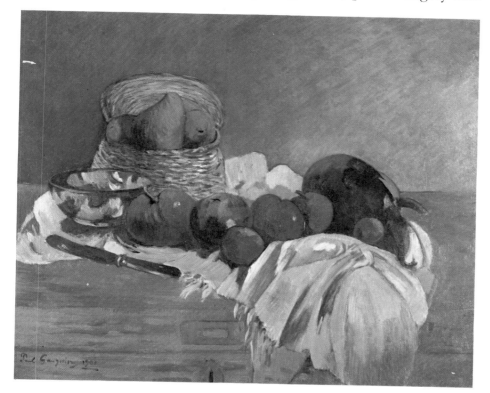

353

and greyish-red. Look at the range of reds in the sideboard: from orange through to purple, and yet none are quite pure colour.

Set yourself a still life to do using much the same colours. You will see how the finished picture could range from the stridently bright pure red against pure (but light) blue-green, to the much softer mauve-greys against purple-greys.

Gauguin's painting is half-way between the two extremes. His fruits, basket and bowl fit in with the general colour scheme, but the fruit is much darker. Being dark and in the lower centre of the picture it stands out as the focal point. The basket, by comparison, largely blends or recedes into the colour of the wall behind.

Ask yourself certain questions to help understand how this picture, which is so simple, can hold your eye as a successful painting. Would the basket recede too far if it were not for the near-complementary colours of the pear and lime in it? What would happen if the fruit was lighter in tone? What other structural devices are there?

Perhaps one of the relevant questions you could ask is: how consciously was Gauguin thinking of all these points, or did he intuitively

arrange and paint the still life that way? Certainly, he has avoided the pitfall of leaving his canvas divided into the horizontal sections created by the background, the sideboard top and the front of the sideboard. The shadows on the apples are right for the picture and are the result of accurate observation; but see how bold and original the shapes of these shadows are—they are almost a series of wavy lines. Many beginners would soften such distinctive features. Again, it becomes clear that the great artists knew when to be bold, when to be subtle. Of course we do not know how many times Gauguin repainted the colours to modify or strengthen them, but he did know when to stop, and that again is the mark of a good artist.

Try doing a series of still lifes, perhaps working on them simultaneously. Take two completely different subjects: some fruit for one—some harsh, modern, mechanical objects for another. See if you can paint the fruit in two styles: one to emphasize their 'niceness', one to give them a hard, unreal setting, but still making a successful picture. Do the same for the other subject: paint one version in a style which highlights the cold and alien nature of the mechanical objects. Then

It is excellent discipline to try to master the tones involved in highly polished surfaces and reflections. Shown here is a colour detail from The Marriage of Giovanni Arnolfini *by Van Eyck, shown previously in black and white.*

do a picture which gives them a warmth and acceptability they might usually lack. As you progress, you will discover that you are not just painting a copy of what you see. You are capturing its character, creating an atmosphere and stamping the mark of your personality on it.

Move on to attempt a subject which requires more precise observation: for example, reflections on shiny objects. Arrange together three things which are shiny in different degrees, and which take on some of the character of their surroundings by reflecting them. Perhaps their

356

outline shape should be very definite, such as a teapot with a spout, a kettle, even a mirror at an angle. Have some textured objects nearby. Control the lighting until it suits your requirements.

How can you make objects look shiny in your painting? It is done by an exact mastery of tones. Quite often you will find on a very shiny object that the lightest tones are next to the darkest, and that around both are the middle tones. Decide how different the light and dark are from each other, and you will be on the road to success. As an exercise, find something gold and something silver, even a pair of rings, and study them to decide what colours actually comprise gold and silver. You will find that they are made up of several colours which go very closely together.

Use smoothly-applied paint and thickly-textured paint appropriately, remembering that texture means detail and therefore focuses one's attention. Use thin glazes of paint perhaps to create a transparent look. Aim for variety in your still life by incorporating varied but compatible painting styles into one picture.

More about landscape painting

Look again at the following landscape paintings illustrated in this book: *Déjeuner sur l'herbe, Mountain Landscape* (figs. 10, 19 respectively, Elements of Composition) and *Water Lilies* (fig. 7, Handling Colour).

As you develop, you will either consciously or subconsciously follow a particular direction in your work. You may dislike strong colours such as those used in Claude Monet's and David Rose's pictures. You may just want to sit looking at a beautiful scene and put your admiration for it as naturalistically as possible onto canvas.

Try to get experience of painting both outdoors and indoors to see which setting suits you best. If you paint indoors you are automatically compromising between true realism and your imagination.

Which of the three paintings is the most realistic landscape? Manet's *Déjeuner sur l'herbe* appears to be, and yet the figures were almost certainly painted in his studio. In fact Monet's picture is the only one which was probably painted entirely outdoors. His imagination was perhaps the greatest, for after years of initial poverty he was ultimately able to build an elaborate garden at his home in Giverny, France. For this he imported plants from around the world, chosen primarily for their subtle differences of colour; even Monet adapted the landscape to suit his own particular passion.

Choose a subject for your next landscape which is capable of adaptation to different purposes. You might choose rocks and mountains or a view through some leaves to catch a glimpse of some mysterious or evocative scene. Paint two versions of it. In one of them set yourself guidelines which are intended to create as natural an impression as

possible. Don't make any colour dominate unnaturally; give an impression of a particular kind of light—in Monet's *Water Lilies* we feel that we are looking at the sort of diffused, even light that might occur at five o'clock on a bright summer's afternoon. Decide on the weather: even if it is unobtrusive it should be deliberately so.

In the second version decide to be more 'modern' or expressive.

Right: Another version of Rouen Cathedral *by Monet, painted at a different time of day.*

Use colours and tones to create a particular atmosphere or mood. Or you might do a fantasy picture. Richard Dadd painted some exquisite pictures of fairies and elves. His painting *Fairy-Feller's Master-Stroke* is a miniature masterpiece. You might aim to express a changing scene and to paint spontaneously, trying to avoid the problems of thought and analysis, but accepting the disciplines of an emotional response to

Fantasy can be a rewarding aspect in painting, and returns us to the unfettered vision of childhood. Left: The Fairy-Feller's Master-Stroke *by Richard Dadd conjures up a whole miniature world.*

the landscape. To do this you might choose a range or *family* of colours beforehand and mix them together first, so that the immediacy of your response need not be diverted by the practicalities of mixing paint. To this end you could use a series of palette knives; several would be needed to avoid having to stop too often to clean them.

Some places, such as Glencoe in Scotland, are associated with events which leave an impression of tragedy in the atmosphere. A painting of Glencoe might use dark versions of the mauves and purples associated with Scottish heather to create a feeling of foreboding.

You may be retired from work and want to express the joy you feel in relaxing in your garden, looking at the flowers and trees you have lovingly planted. What colours would you use to achieve such a feeling of joy? It may be easier to answer the opposite question: which colours would you leave out? There may be no place for dark greys and black in your picture.

Do these paintings on something less expensive than canvas until you are sure of your continuing direction. If they turn out successfully, it is still possible to frame pieces of hardboard or paper.

Other directions

In David Rose's *Mountain Landscape* you can see that the rocks and mountains provide the loosest possible structure for what is a painting about colour relationships allowing the movement of your eye around the picture. Henri Rousseau's paintings created a private world to

which only he had the key—an escape perhaps from the restrictions of his job as a customs official.

Observational work continues to play a great role in art. But equally, since photography and motion pictures were developed, the visual arts have been freed from the need to be about a real or conceivably real situation. This inevitably places a greater importance on the painter's own way of seeing and responding to the world about him.

Henri Rousseau's painting The Snake Charmer (*1907*), *inhabits a mysterious exotic world, both physically and imaginatively. Notice his use of horizontal lines in the water, and verticals in the plants to express the perspective.*

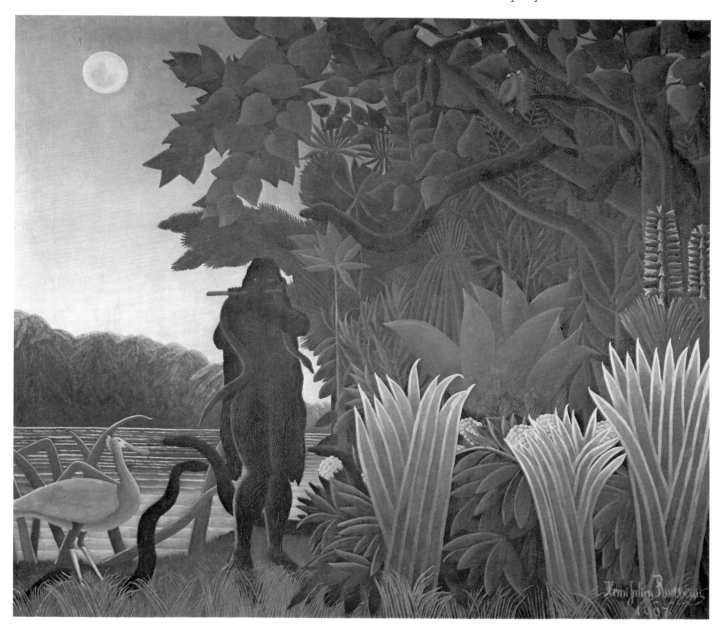

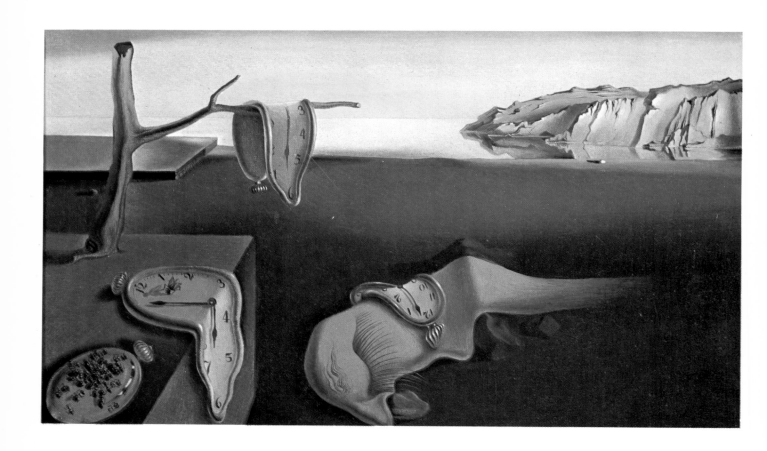

Surrealistic art depends both upon keen observation and technical expertise. The Persistence of Memory (*above*) *by Salvador Dali is a brilliant combination of realism and optical illusion.*

The Surrealist's work outraged many. The paintings of Salvador Dali have developed a blend of realism with optical illusions: comprising see-through people who seem totally naturalistic at first and then abstract. One of his paintings is supposed to be three separate and different pictures which change according to how far back you stand from the painting. His success with this approach depends on having the technical skill to achieve this ambiguity. Other artists combine painting with sculpture to make *kinetic* (moving) relief pictures. Some artists paint diptychs and triptychs—pictures in two or three sections or panels, each one having an independence of its own, but also relating to the other panels. Bridget Riley (fig. 2, Handling Colour) is concerned with optical effects.

Only you can decide which direction you wish to take. You may be radical and avant-garde, or traditional in your use of colour, form and tone. However you develop, you will need to learn some sort of technical control over your materials and some form of judgment in assessing your pictures. Apart from that, art is completely what you make it.

Techniques

Before you begin to paint specific subjects, it is important to consider what can be achieved in oil paint using the materials and tools that are at your disposal. The materials suggested in a previous chapter in this book will provide you with all that is required, and if they are used as advised there should be no technical problems.

Having already experimented with the colour mixing qualities of oil paint, you will have gained some experience of the types of marks your brushes will make, but a more thorough investigation will now be very useful. Try the hogs' bristle brushes with paint thinned with turpentine, turpentine and linseed oil and thick paint without thinners. As you work think about how much control the brush gives you over the various paint consistencies. Switch to the sable hair brushes and consider how they in their turn respond—which combination of brush and paint consistency is best to draw detail with? What sort of texture can you develop?

Fig. 1 The painting knife can be a very effective way of applying paint: Josef Albers used knife application in his series Homage to the Square.

Don't forget the painting knife. You will probably find that the paint must be used without thinners so that it will not drip off the knife or the canvas. Beyond this, a great variety of marks and textures can be developed. Josef Albers used a knife application in his series *Homage to the Square*. The painting in fig. 1 is part of this series.

The simple techniques described in this chapter will provide a basis from which to develop your own personal approach to oil painting methods. One thing to remember, no matter what technique you adopt, is to allow time for drying between each day's work. Otherwise in the end the paint will crack. Thinned oil paint will dry more quickly than paint straight from the tube, and drying agents will be useful.

Impasto
Impasto is the name given to the technique of applying thick paint which may have been slightly thinned, although it is more likely to be used at tube consistency.

With this technique, thorough mixing is important or unpleasant streaking will result. Use a palette knife for this purpose and be sure that a sufficient amount of paint has been mixed for a given area—otherwise you could be faced with the difficult task of mixing a fresh batch of paint identical to the first.

Apply the paint either with a brush or a painting knife depending on the type of the surface you wish to develop. Thick, heavily applied paint can look extremely attractive but use the technique with caution. Try not to be influenced by the thought that you have used a great deal of paint and so it must be all right. View the results in terms of the painting and whether it works in visual terms or not. The rich textural surface will catch the light and become quite active visually, so consequently such an application is not suitable for quiet zones or deep shadow areas. However, if you are dissatisfied with the result the area can be removed even a day later (unless driers have been added).

Always endeavour to apply the colour directly to the given area and try to avoid too much floundering around or the areas will start intermixing, possibly creating a muddy sludge and destroying all vitality of mark and colour. By adding drying agents to the paints you will be able to work fairly regularly. When the impasto is dry, consider the possibilities of glazing over the painted surface. Some quite stunning results can be achieved. Compare the detail from the painting by Turner (fig. 2), who often used impasto in conjunction with glazing, with the de Kooning (fig. 3), where the paint surface is built up with direct gestural marks of thickly applied paint. Obviously, such an active

Impasto involves a very thick application of paint, and is a technique which should be used very carefully to maintain the liveliness of the colours. In his painting Light and Colour, *fig. 2, a detail of which is shown above, Turner combines impasto with a glazed surface to achieve really glowing effects.*

Fig. 3 (left), Secretary *by Willem de Kooning, 1948 is a highly energetic work in the Abstract Expressionist tradition. The paint is applied directly and vividly, achieving an effect of great spontaneity.*

surface gives energy and vitality to the subject. This approach would be totally alien to the sense of peace in David Inshaw's painting titled 'Remembering mine the loss is not the blame'. Here the surfaces are controlled in a careful and restricted way, both in terms of colour and the fine application of the paint.

Glazing

Glazing is a popular traditional technique, used extensively by the Old Masters as a finishing-off process over a tempera underpainting (tempera is the name given to pigment mixed with egg yolk used as a binder;

it was widely used by medieval painters before the advent of oil paints) to give richness of shadow and luminosity of colour. Gradually, oil became the only medium used, but paint application remained methodical as the works were highly complicated pieces of design where everything was clearly established at the drawing and underpainting stage. Little intermixing of colour occurred, and richness and tonality were achieved through many carefully applied layers of glazing. Glazing is essentially a very thin film of colour evenly applied to the surface of the painting, preferably with a soft brush (a sable or ox-hair is ideal). Beware of thinning the pigments with turpentine only, as the addition of linseed oil is essential to help the paint retain its pliability.

Before trying out the technique on a painting, explore how the process responds to various surfaces and colours. Glaze over impasto, scumbling (see below), pale tints (that is, colours mixed with white) and rich dark colours, taking note of the changes that occur. Be aware that some colours are denser and more opaque than others and will require a great deal of thinning; this in turn will influence the drying time.

Glazing can be used throughout the painting process and, for the beginner who wishes for fairly immediate results, it will initially prove a slow process. However, glazing can be used in small areas too soon to achieve what one colour alone would not: deep shadows, reflections in a

The Agony in the Garden (left) by El Greco is an excellent example of glazing. Here he has used cadmium red as the final glaze, which gives a particular vibrancy to the white underpainting on the robes.

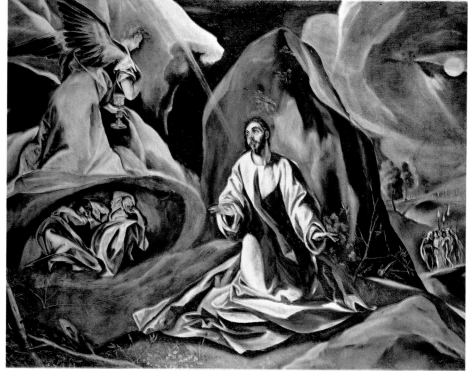

Fig. 5 In his painting Abstract Composition *Poliakoff uses a combination of techniques in which he builds up very fine layers of paint, using the underlying colours to influence the top colour.*

mirror or on water and glassware are just a few of the subjects that lend themselves to this technique. Though, technically speaking, it is not glazing in the absolute sense of the word, the work of Poliakoff (fig. 5) uses a technique of fine layers of paint in which the underlying colours profoundly influence the top colour. This method is somewhere between glazing and scumbling.

Scumbling

Scumbling is the name given to a technique of freely brushing rather dry paint that is either opaque or semi-transparent, depending on the nature of the pigment, over a coloured ground, thus allowing the underpainting to break through. A coarse textured ground is best for this technique for, as the brush is dragged over the surface, the paint will be transferred to the high points only. The result is an overlay of colour with a broken surface that gives added sparkle to the picture surface. Scumbling is useful for areas such as sky, middle distance landscapes and interiors through which light is filtering. If you ever consider painting a picture of a sunlit sea, for example, where light (playing across the surface of the water) would be an important part of the composition this technique could be used to portray this effect. Fig. 6 is an example of scumbling.

Fig. 6 Scumbling, the application of dry paint over a coloured ground is used in this painting Honeycomb Still Life *by William Scott.*

369

Chiaroscuro

Chiaroscuro is an Italian word used to describe the technique of constructing a painting on the basis of strong lights and darks. The technique was used extensively by the Old Masters to help establish the sense of 3D form. Caravaggio in the early seventeenth century developed a very organized system of chiaroscuro, and the painting in fig. 7 is an example of his work. If you decide to paint in this manner you will need a strong directional light; spotlights are ideal as the light source is then fixed and constant.

Staining

Staining is the free application of thinned oil colour to unprimed canvas. It is used by some artists such as Helen Frankenthaler (fig. 8) and can produce exciting visual images. It is technically unsound, however, because the oil can rot unprimed canvas, and the painting may not have such a long canvas life as traditional oil paintings can expect.

Fig. 7 Chiaroscuro is the technique often used by the Old Masters to construct a painting on the basis of very strong contrasts of light and dark colours. The Calling of St. Matthew (*below*) by Caravaggio, c. 1597 is a typical example of the tradition.

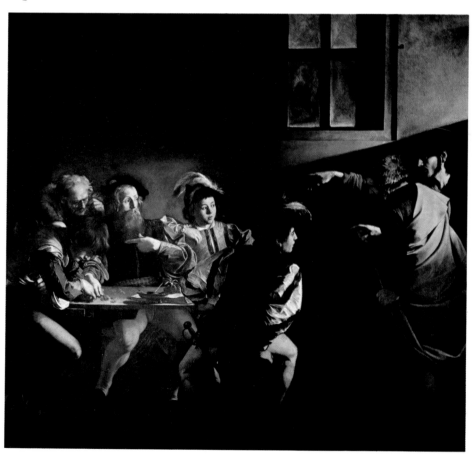

Flat opaque surfaces

The middle twentieth century has seen a massive expansion of abstract painting, much of which relies on superbly applied flat opaque colour surfaces. The painting in fig. 9 by Stuart Davis shows the application of this technique.

This might seem a straightforward proposition, applying several layers of colour evenly, one over the other, but it will work effectively only if the colour is truly opaque. Many oil colours have semi-transparent qualities; it is best therefore to first mask out the area to be painted with masking tape and then underpaint it with a tint of the final colour to be applied i.e. the colour plus white. This will provide an overall constant opaqueness. Make sure that the tint it not too far removed from the pure

Fig. 8 Staining is a technique which involves applying thinned oil colour directly onto unprimed canvas. Used imaginatively it can produce very exciting visual effects as Helen Frankenthaler's painting Mountains and Sea *(1952) brilliantly demonstrates.*

371

Fig. 9 In his painting The Paris Bit, *Stuart Davis uses flat opaque colour surfaces.*

colour, though, otherwise its very whiteness will break through, giving the final layer of colour an optically uneven visual effect. This particularly applies to Alizarin crimson which is very transparent. The tint should be of a smooth creamy consistency when applied and not thin or it will be insufficiently opaque; also, the paint would probably bleed under the masking tape.

Always use a large soft brush and endeavour to work away from the taped edges thus avoiding unsightly ridges. As with all painting, but particularly when working with large flat areas of pure colour or when glazing, the priming must be immaculate to allow for even application and drying.

If you wish to paint a crisp edge without the aid of masking tape, you could use a ruler to act as a guideline. Don't lay it flat on the canvas, but hold it 30° away from the surface. It should provide the guidance you require, for example in outlining the crisp horizontal edge of a table in a still-life group or the edge of a building. This technique requires fairly thin paint and a pointed sable brush. You can then paint the flat surface you require up to the established line. This system is also useful for picking out linear detail, such as fences or railings, or a view through a window where the frame is included in the subject. Few of us have rock-steady hands!

Left: Cataract 5 *by Bridget Riley (emulsion on canvas), 1967.*

Stippling

Stippling is the name given to the technique of building up areas of colour with small marks. A small round hogs' bristle brush is ideal for this purpose. The texture that results could be used in conjunction with glazes, impasto or other techniques—for example, consider an immaculately cut lawn such as the putting green of a golf course, surrounded by trees and unkept grass. A controlled fine stippling set against impasto and scumbling might ideally establish the visual contrast that exists. Bear in mind that this style of dotting brushwork is a monotonous process, so don't try rushing it. Explore different sized round brushes of varying stiffness; these will influence the final mark. If you want to overlay another colour allow the first to dry.

The pointillist technique of Seurat and his fellow Neo-Impressionists is essentially one of stippling, and it can certainly produce an interesting optical colour mix when controlled. Look closely at the Signac painting in fig. 8, in the chapter on Handling Colour. By placing dots of blue and

yellow side by side the colours appear to mix optically and become green. So not only do the dots provide a bright shimmering surface texture, they serve as colour mixes.

Drawing upon your experiences so far, how you decide to use the medium is entirely up to you. Try to remember the simple rules of using thoroughly clean brushes at all times. Should the palette become choked with paint, remove the excess with a palette knife. Make sure the turpentine and oil are clean or the results of the exercises and subsequent paintings will be seriously impaired. Follow the simple advice given and the colours, surfaces and tools at your disposal will operate satisfactorily.

Below: Composition No. 7 *by Kandinsky (1913). Once you have mastered the basic techniques, you can explore lots of painting styles with complete freedom.*

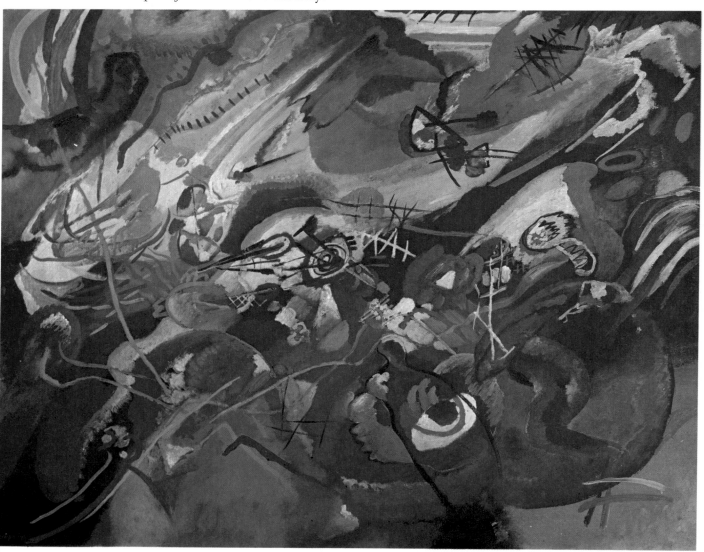

The Finished Painting

Decorative surrounds occur in the very earliest of visual work: Roman mosaics had decorative friezes that at once both separated one image from another and interlinked them. The richly gilded frames of Gothic altarpieces strongly reflect the strict architectural order of their environment. During the Renaissance, the inter-relationship between architecture and mural was often enhanced by painted architectural motifs within the mural. This is best seen in Michelangelo's Sistine Chapel ceiling; the whole sequence of images is bound together with painted architectural frames (friezes). Several centuries later, the Neo-Impressionist painter Seurat actually experimented with pointillist hand-painted frames for some of his work, so concerned was he about the issue.

Below left: Roman wall paintings often had their own friezes.
Below: Architecture and mural are perfectly combined in the Sistine chapel.

But decisions on framing are largely affected by taste. The twentieth century has seen a change of attitude concerning framing—the traditional idea of the picture being a window in the wall, enhanced by the use of a frame, was challenged by the Cubists who reversed the traditional format. Today, immense variations occur and often paintings that were initially conceived of without a frame, like the work of Morris Louis seem to have had the original critical sense of shape and space altered by the addition of frames, no matter how discreet they might be.

Added to the aesthetic issues involved in framing, is the simple practical one of protection. In transit or storage, corners and surfaces of painted canvases can be damaged. The frame physically protects the work, both corners and surface, for it is usual for the frame to project above the surface. With work carried out on paper it is all the more

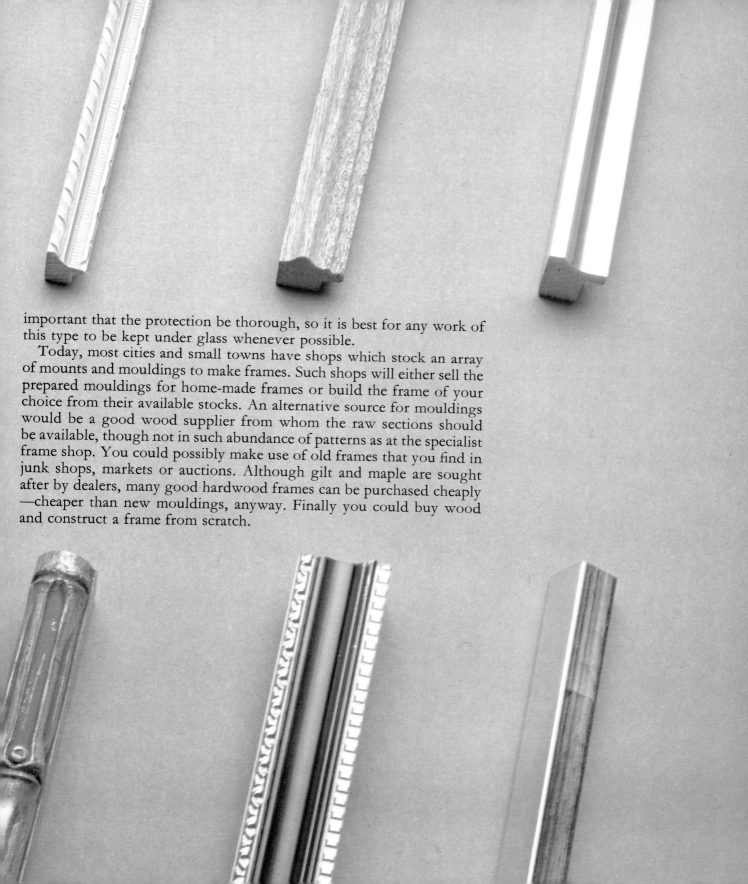

important that the protection be thorough, so it is best for any work of this type to be kept under glass whenever possible.

Today, most cities and small towns have shops which stock an array of mounts and mouldings to make frames. Such shops will either sell the prepared mouldings for home-made frames or build the frame of your choice from their available stocks. An alternative source for mouldings would be a good wood supplier from whom the raw sections should be available, though not in such abundance of patterns as at the specialist frame shop. You could possibly make use of old frames that you find in junk shops, markets or auctions. Although gilt and maple are sought after by dealers, many good hardwood frames can be purchased cheaply —cheaper than new mouldings, anyway. Finally you could buy wood and construct a frame from scratch.

By far the simplest solution is to have the work framed for you, but this can be expensive, and arriving at a satisfactory solution can be difficult. It is all too easy to rush in and buy what seems to be a beautiful frame only to find afterwards that it totally dominates or is not at all sympathetic to the painting. Always look carefully at what is available within the context of the work you want framed. In fact, easily the most satisfactory method is to take the work you wish to be framed along to the shop and try the various different types of frame on it. The sample displays of moulding sections can be really misleading otherwise: how can you envisage what the final frame will look like, particularly if you are to include inserts? Look at the made-up frames on display, they will be more helpful in making a decision.

If you intend to construct your own frame then you will find that the materials you require differ little from the selection for stretcher making, (dealt with in the chapter on materials) with the addition of some small wooden blocks and countersink nails. The first consideration is what

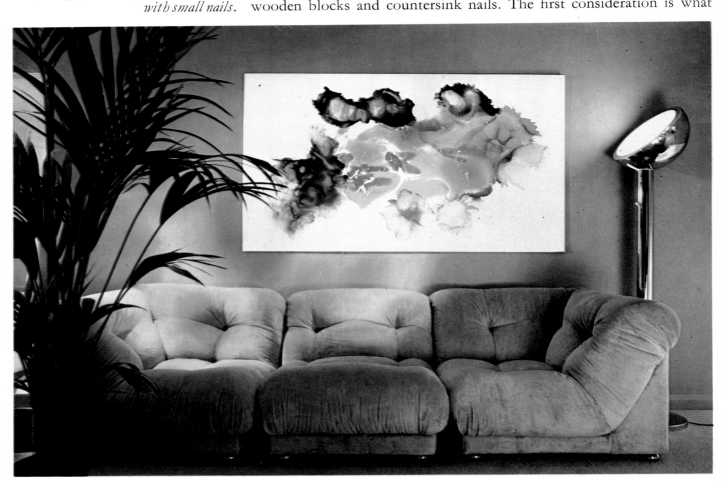

type of frame will suit the painting: a simple surround of plain wood that butts up against the edge of the painting, or a coloured mount around the picture and protective glass over it?

These issues are dictated to some extent by the size of the work to be framed. The larger the work the simpler the frame, because the work has sufficient scale for it to exist in the average domestic space and be viewed comfortably without much support from a frame. If a work is tiny it can be completely lost on a wall, particularly if it is competing with other works. In this case, the frame must provide sufficient impact to catch the viewer's eye and it must also be sympathetic to the work. The nature of the painting, whether landscape, portrait, still life, bright and lively or dark, has a profound bearing on the choice of frame and, for example, it would be unwise to put a bright, ornate frame around a very dark small painting; you would only see the frame.

3

1

2

4

Constructing a simple frame with back-bend moulding

First carefully check the dimensions of the painting. All too often inaccurate measurement leads to additional expenditure on moulding.

To ensure a perfect fit, all corners must be cut at 45°, and although the mitre clamp should hold the saw vertically, cut steadily and don't force the saw or it could move slightly off the vertical. This would ruin the angle and present problems when joining. Cut the moulding into the four lengths required as for making a stretcher. The lengths are determined by two factors: the dimensions of the canvas plus twice the width of the moulding. That does not mean the *total* width of the moulding—you exclude the part that overlaps the canvas. In other words, looking at fig. 1, it is AB x 2 + the canvas length.

Be absolutely sure that the width is measured accurately or the frame and canvas will not fit correctly. To join the corners use a clear-drying wood adhesive and slender round countersink nails.

Constructing an insert (right).
Fig. 5 Use hardwood with a 45°
bevel on one edge.
Fig. 6 Attaching a small ridge
to the underside back edge of the
insert.
Opposite: Many Victorian
paintings had very ornate frames.
James Collinson's sentimental
study The Empty Purse *is an*
excellent example of this style of
framing.

Make sure that the angles fit together perfectly and then apply glue to each cut edge. Clamp the corners together in the right-angle clamp and drill a small hole through the edge of one piece, and just into the other (fig. 2). Knock in the nail two-thirds of its length. Repeat the procedure on the other piece, making sure the nails do not collide. Remember, the drill bit needs to be fractionally smaller than the nail to ensure a rigid joint. Under no circumstances run nails directly into the wood; always drill a small hole first. Repeat with the three remaining corners. Always support the corners not in the clamp during the construction with pieces of wood the same thickness as the clamp base, or the frame's weight could open up the freshly glued and nailed joints (fig. 3). Wipe away any surplus glue.

If constructing a large frame that has more flexibility it will be necessary to support the straight as well as the corners while joining is in progress. When the glue is dry, countersink the nails and use a wood filler to conceal the hollows. If your cutting has been inaccurate try to align the front face and fill in the back edge where it obviously will not show.

Place the frame face down on an old blanket to avoid damage to the facing (many manufactured frame surfaces are very fragile), slot in the canvas and pin by running several small nails into the inside back edge of the frame (fig. 4).

Complete the framing by gluing heavy-duty brown paper over the back of the frame and stretcher giving a tidy finish that keeps the dust out. This frame type would be ideal for medium-size paintings 51cm x 76cm (20in x 30in) up to 102cm x 127cm (40in x 50in).

For a small painting, as already suggested, a more substantial width of frame is visually necessary. This can be achieved in two ways: either by using a really wide moulding which might prove to be visually too dominant and expensive, or a fairly narrow moulding with an insert (or slide). Most inserts are fairly narrow and made of wood that can be

painted or covered in linen or velvet. The insert is simply an inner frame that visually increases the weight of the frame and provides a pleasing visual break between the painting and the outer frame.

Constructing an insert
Use a thin hard wood 2.5cm×12mm(1in × ½in)with a 45° bevel on one edge (see fig. 5). Attach a ridge to the back underside edge of the insert (fig. 6) to provide an abutment when inserting the canvas. Sand the insert thoroughly and then paint with an acrylic gesso mixed to the desired colour for the insert. Use a fairly neutral colour—blue-grey, pink-grey, and so on, depending on the colours used in the painting. The corners should be mitred and glued.

Raw mouldings
Raw mouldings can be purchased from a local wood dealer and are usually in need of a thorough sanding before any decisions about surface treatment can be made. If they are of a good quality wood they can be stained with a transparent pigment. The most suitable solution would be a thinned acrylic paint such as raw umber, burnt umber, raw sienna, ochre or a mixture to achieve the desired colour. The fast drying acrylic paint will allow several coats of thin paint to be applied quickly. If you are dissatisfied with the matt result then a coat of varnish could be applied. This will enrich the grain. Here your experiments with gloss and matt varnish could be invaluable. If you are not happy with this procedure use a commercial wood stainer.

Many alternative finishes are possible. Having sealed the wood some exploration of stripping with a darker tone might prove useful. Plain emulsion paint finishes can be tried, or even high gloss lacquers. Gilded frames are always popular, and certainly not impossible to produce, but some specialized knowledge, perhaps the result of classes, will probably be necessary for satisfactory results.

Painting under glass
If you wish to frame an oil painting carried out on paper it is certainly worth while mounting it under glass. This entails mounting it on a cardboard mount before placing it behind the glass and frame. This is not quite as straightforward as it might seem. The important thing to remember with mounts is that the side widths should be the same or slightly smaller than the top width of cord, while the bottom width should be between a quarter and a third as large again. This is necessary to counter the optical illusion of the painting dropping out of the bottom of the mount if top and bottom are identical. Mounts under frames are traditionally cut with a bevelled edge. This is visually more attractive than a square-cut mount. The cardboard mount will slot into

the inset area and be the same size as the glass. Knowing the overall size of the mount and the work to be placed behind it is all that is needed. Remember that the cut-out section of the mount must be slightly smaller than the painting to be mounted so as to provide an overlap for attaching the painting behind the mount. Choose the colour of the mount before cutting as changing the colour, although not impossible, will prove difficult with a fine bevelled edge exposed.

To cut a mount

Assume you have a cardboard mount 38cm x 30cm (15in x 12in) and a painting 33cm x 23cm (13in x 9in). You would need to cut a window in the mount slightly under the dimensions of the painting, that is 32cm x

The frame on the picture below is made in heavy metal to enhance the collage materials which include metal pieces on oil paint. The work is called Towards a Definitive Statement on the Coming Trends in Men's Wear and Accessories, *and is by Richard Hamilton.*

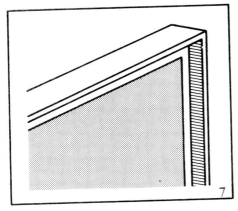

Fig. 7 Using battens to make a box-type frame.
Fig. 8 Styles for batten framing.
Fig. 9 Using a straight plate to hold the canvas in place.

22cm (12½in x 8½in) would be ideal, assuming you don't lose a critical part of the painting. On the length this would be 6cm (2¼in) of cardboard and on the width measurement just under 5.8cm (2⅛in). The side sections will be of 3cm (1⅛in) depth each, the top at least the same, but that would leave too large a base strip. About 3.3cm (1½in) against 4cm (1½in) would seem ideal. Draw out these measurements lightly on the top surface of the cardboard. For cutting the amount, use a very sharp craft knife or scalpel and a heavy metal ruler. Do not attempt to use a wooden ruler as the knife would cut into its edge should you falter while cutting. Place the cardboard on a cutting surface and align the ruler just inside the cutting line. Hold the knife at 45° against the ruler and cut from one corner to the other. Cut slowly and evenly without hesitating, and avoid overrunning the corner. If you are using really thick cardboard it may take two or three cuts. Repeat on the remaining sides. When these cuts are completed it is likely that the corners will still be slightly attached. Sever these by sliding the knife along to the corners, being sure to hold it at the same angle as the initial long cuts. Cut the final attachments. If cutting a mount with a bevel, again cut from front to back as a slight burring occurs on the back edge no matter how careful you may be. Attach the painting to the mount with clear adhesive tape then glue a sheet of thin cardboard of identical size onto the back of the mount to give additional protection. When the glue is dry, fix the mounted picture in the frame behind the glass with a few panel pins [picture nails], as for stretched canvas. Seal thoroughly to stop the possible infiltration of dust and dampness between glass and painting. Always make sure that the glass and mount are immaculately clean before final sealing.

By combining different widths of backing and adding decorative beading or other wooden trims, a variety of frames can be created. For example, a 12mm x 2.5cm (½in x 1in) batten attached first and set slightly back from the surface and then a 6mm x 3.5cm (¼in x 1¼in) batten fixed to it and projecting forward (fig. 7) would make an attractive box-type frame. The battens could be stained or painted different colours for added interest. Fig. 8 shows several possible combinations.

When making up the length for this type of frame, glue and clamp the pieces securely and be sure they are completely dry before nailing, otherwise they will split. Cut and fix corners as for moulding frames.

To secure the canvas in this type of frame use a straight plate across the corner (fig. 9) which will not only hold the canvas firmly in place but also reinforce the corner joint. One thing to remember, if you intend to use batten frames, is to be sure to carry the paint around the edge of the canvas so that no raw canvas will be left exposed.

Use a strong gummed paper strip to seal the area between the frame and the canvas.

The
HOME
ARTIST

Index

Acknowledgements

Albertina Museum, Vienna: 136BR, 224, 232. Allen Memorial Art Museum, Oberlin College: 6. Courtesy Amon Carter Museum, Fort Worth: 182. Ashmolean Museum: 4, 147, 243. Aspect: 55 (Pierre Jaunet). Atkins Museum, Nelson Gallery: 134T. Autocar: 205. Chris Barker, photographer: 121 (Courtesy Boleskine House Collection), 231, 233. G.P. & J. Barker Ltd: 126. Jake Bell, Artists Cards: 158, 199 (Piccadilly Gallery), 235. Courtesy of the Bethlem Royal Hospital and Maudsley Hospital: 209. By courtesy of Birmingham Museums and Art Gallery: 143, 218. Bodleian Library: 136TL. Museum Boymans – Van Beuningen, Rotterdam: 299. British Library Board: 146. Trustees of the British Museum: 79, 86, 87, 96BR, 113 (photo: R.B. Fleming), 114 (photo: Jerry Tubby), 131 (photo: J.R. Freeman), 133, 134BL, 135 (photo: J.R. Freeman), 137, 138, 184, 216, 238. Bronte Museum, Haworth: 219B, 244. C.A. Burland: 104 (Museo de America). Bührle Collection: 353B. Bulloz: 352TL (Louvre). Marie Caboue: 65. Courtesy of the Art Institute of Chicago: 15. City Art Galleries, Manchester: 283, 341. Bruce Coleman: 49BR. Cooper-Bridgeman Library: 206 (Fox Galleries), 262 (Phillips Collection, Washington), 308 (Musée Grenoble). Reproduced from 'Country Diary of an Edwardian Lady' published by Michael Joseph/Webb & Bower: 220. Courtauld Institute Galleries, London: 33, 284, 345. Alan Duns: 128. Edinburgh University Press: 303 (Mrs. D. MacInroy). Escher Foundation, Gemeentemuseum, The Hague: 116. Fitzwilliam Museum, Cambridge: 208. Robert Fraser Gallery, London: 383. Giraudon: 10 (Lehmann Coll. New York), 18, 36 (Musée Municipal, Grenoble), 38, 72 (Cabinet des Dessins, Louvre), 88 (Musée Municipal, Cambrai), 96TL, 115B (Bibliothèque National, Paris), 122 (Musée Lazaro Galdiano, Madrid), 263TR (Musée Basle), 268 (Ishibashi Coll. Tokyo), 291 (Musée Royaux des Beaux-Arts, Brussels), 317 (Louvre), 328 (Louvre), 352BL & TR (Louvre), 353 (Philadelphia Museum of Modern Art), 358 (Louvre). Glasgow Museum and Art Galleries: 176. Göteborgs Konstmuseum: 155. Melvyn Grey: 51, 52. Cliche Hachette: 168. Hamburger Kunsthalle: 84. Harrison Artistic Enterprises, Birmingham: 26. Hartley Reece & Company (Rotring): 17. William Heineham Ltd: 118. Reproduced with permission of the controller of Her Majesty's Stationery Office: 1, 2. Hirmer Fotoarchiv: 130. Hirshhorn Museum & Sculpture Garden, Smithsonian Institution: 365. Hans Hinz: 129L, 141, 222. Michael Holford Library: 107, 129R, 133 & 195TL (British Museum), 195BR (Lady Hulton, London), 263 (Tate Gallery), 269TL (National Gallery, London), 290 (Louvre), 337 (Ginette Signac Collection), 338 (Bradford City Art Gallery), 381 (Tate Gallery). Royal Horticultural Society: 223. Hunterian Art Gallery, University of Glasgow: 109 (Mackintosh Coll.), 161 (Birnie Philips Gift), 215. Jeu de Paume, Paris: 5BR. Sidney Janis Gallery, New York: 300 (Max Wesserman Coll. Massachusetts). David Kelly: 32. Felix Klee Collection, Berne: 374. Courtesy of the Knoedler Gallery, London: 11, 37, 265TR, 287. Kunsthistorische Museum, Vienna: 326. Lefevre Gallery, London: 200. Neil Lorimer: 124. Mansell Collection: 132TL, 240. Marlborough Fine Art Ltd: 186. Mas: 367 (Toledo Cathedral). Frederico Arborio Mella: 115TR, 136BR (Albertina, Vienna), 349 (Palacio de Livia, Prado). The Metropolitan Museum of Art, New York: 46, 80TL, Peter Meyers: 7, 145. The Minneapolis Institute of Arts: 59. David Moore: 49BL. Cliche Musée Nationaux, Paris: 140 (Musée Nationale d'Art Moderne), 175 (Louvre), 306 (Musée National d'Art Moderne), 314 & 321 & 348 (Louvre), 361 (Musée National d'Art Moderne). Museo Civico di Torino: 369. Museum of Modern Art, New York: 362. Courtesy of the Trustees, National Gallery, London: 63, 257 (photo: J.R. Freeman), 258, 259, 269TL, 298, 346. National Gallery of Art, Washington D.C.: 48 (Rosenwald Coll.), 297 (Chester Dale Coll.), 371 (on loan, Collection of the Artist). National Museum, Vincent Van Gogh, Amsterdam: 60. National Portrait Gallery, London: 14, 227, 230. Neue Gallerie Sammlung Ludwig, Aachen: 266. Norfolk Museums, Service (Norwich Castle Museum): 191. Oslo Kommunes Kunnstamlinger: 279. Patrimoine des Musée Royeaux des Beaux-Arts, Brussels: 64. Philadelphia Museum of Art: 47. Roger Phillips: 301. Photo Meyer: 40. Photo Researchers: 213T. Picturepoint, London: 41 (Galleria Nazionale, Oslo), 139 (Tate Gallery), 211, 212, 213B. M. Pucciarelli: 194 (Brera Gallery, Milan), 249 (Uffizi, Florence), 370 (Luigi dei Francesci, Rome), 375BR G.R. Roberts: 49TR. W. Robinson: 3. Rowan Gallery: 293, 373. Sächsische Landesbibliothek, Dresden: 57. Robert & Lisa Sainsbury Coll. University of East Anglia: 44. Scala: 13 & 70 (Gabinetto Disegni, Uffizi, Florence), 80TR, 106 (Institute of Art, Siena), 132BR, 228 (Thyssen Coll. Lugano), 261 (Musée Beaux-Arts, Reims), 269BR (Monaco Germania Neuepinakothek), 351 (Museum of Modern Art, Barcelona). Scottish National Gallery of Modern Art: 271, 309. Snark International: 264 (Albright Knox Gallery, Buffalo), 274 (Musée Toulouse-Lautrec, Albi), 296 (Musée National d'Art Moderne, Paris). Sotheby Parke Bernet & Co: 234. Städelsches Kunstinstitut, Frankfurt: 318. Stedelijk Museum, Amsterdam: 117, 325, The Tate Gallery, London: 27, 99, 139, 144, 159, 170, 188, 198, 202, 231, 239, 260, 263L, 263B, 302, 311, 313, 336, 359, 360, 364, 368, 381. Rodney Todd-White, photographers: 61, 97, 152, 179, 180, 203, 210, 248, 305, 350, 366. Jerry Tubby: 378. Turin Royal Library: 43. Victoria & Albert Museum, Crown Copyright: 34, 61, 89, 107, 142, 149, 152, 172, 173, 179, 180, 185, 203, 207, 210, 214, 233, 320. Waddington Galleries, London: 165, 366. Malkolm Warrington: 1 (H.M.S.O.), 21 (Cowling & Wilcox), 22/3, 42, 68/9 (The New Neal Street Shop), 102/3 (Artists note books: TL. TL. Kate Wickham, BL. David Gordon, M. Steven Mantej, BR. Jane McDonald,) 162/3, 220, 221 (artists sketch books: Jane McDonald, David Rose), 237, 241, 267, 272/3, 276/7, 294, 354, 363, 376/7. John Webb, photographer: 159, 160, 188, 202, 239, 245, 311, 360. Whitney Museum of American Art: 192, 193 (photo: G. Clements), 229, 292, 342, 372. Whitworth Art Gallery, University of Manchester: 167, 177. Royal Windsor Coll. Reproduced by Gracious permission of Her Majesty Queen Elizabeth II: 5TL, 95, 112. Joseph Ziolo: 98 (Robert Laffont), 153. Copyright "(c) by A.D.A.G.P. Paris 1979": 34, 44, 160, 263TR, 271, 291, 296, 306, 360, 362, 368, 374. "(c) by S.P.A.D.E.M. Paris 1979": 6, 10, 15, 46, 47, 65, 84, 88, 96TL, 115, 140, 141, 155, 168, 170, 175, 222, 262, 263L, 284, 297, 298, 299, 308, 313, 314, 318, 337, 348, 353TR, 358." (c) COSMOPRESS, Geneve and S.P.A.D.E.M., Paris 1979": 195BR, 239.